World of Art

Veerle Poupeye is a Belgian Jamaican art historian, curator and critic. She was educated at the Universiteit Gent in Belgium and at Emory University in Atlanta. She served as the executive director of the National Gallery of Jamaica from 2009 to 2018, having previously worked there as a curator and museum educator. She has also served as coordinator of the visual arts programme of the MultiCare Foundation, a Jamaican inner-city development foundation, and as research fellow, lecturer and curator of the CAG[e] gallery at the Edna Manley College of the Visual and Performing Arts in Kingston. Her publications include *Caribbean Art* (first edition, 1998) and many book chapters, dictionary entries and exhibition catalogue essays on Jamaican and Caribbean art and culture. She has also contributed to journals such as *Small Axe, Jamaica Journal, Caribbean Quarterly, Raw Vision* and the *New West Indian Guide*.

1 Colin Garland, *In the Beautiful Caribbean*, 1974 (detail)

World of Art

Caribbean Art
Veerle Poupeye

New edition

For my parents

First published in 1998 in the United Kingdom
by Thames & Hudson Ltd, 181A High Holborn,
London WC1V 7QX

www.thamesandhudson.com

First published in 1998 in the United States
of America by Thames & Hudson Inc.,
500 Fifth Avenue, New York, New York 10110

www.thamesandhudsonusa.com

This new edition published in 2022

Caribbean Art © 1998 and 2022
Thames & Hudson Ltd, London

Text by Veerle Poupeye

Art direction and series design by Kummer & Herrman
Layout by Adam Hay Studio

British Library Cataloguing-in-Publication Data
A catalogue record for this book is available from the
British Library

Library of Congress Control Number 2021943306

ISBN 978-0-500-20478-8

Printed and bound in China through Asia Pacific
Offset Ltd

Contents

6 Foreword

9 Introduction

Chapter 1
27 **Prehispanic and Colonial Art**

Chapter 2
53 **Decolonization and Creative Iconoclasm**

Chapter 3
70 **Modernism and Cultural Nationalism**

Chapter 4
103 **Popular Culture, Religion and the Festival Arts**

Chapter 5
140 **'Dangerously Close to Tourist Art'**

Chapter 6
156 **Political Radicalism, Abstraction and Experimental Art**

Chapter 7
192 **The Land, the Sea and the Environment**

Chapter 8
212 **The Personal and the Political**

Chapter 9
238 **The Caribbean Contemporary**

279 Bibliography

289 List of Illustrations

295 Index

Foreword

When *Caribbean Art* was first published in 1998, a body of literature on the subject was already in existence, which consisted mainly of exhibition catalogues to which multiple authors had contributed – most of the scholarship at that time was nationally focused. *Caribbean Art* was the first general survey of Caribbean art history written by a single author and it retains that distinction today, even though the literature, scholarship and criticism on the subject have grown tremendously. The book was, and still is, an ambitious undertaking and a perilous, high-stakes one at that, as presenting such a survey is inevitably couched in the highly contested and contentious politics of representation of the postcolonial Caribbean art world.

When the first edition of *Caribbean Art* appeared, its reception was mixed. Most published reviews welcomed what was deemed a valuable and indeed necessary addition to the literature, and the book has certainly made its contribution to the scholarship on its subject by serving as a reference and generating further research queries; but there were also negative responses, almost all of them from within the Caribbean. The book was scrutinized over national quota, over actual and perceived underlying assumptions and biases and, most of all, over which artists, and art works, were and were not included. The cautionary note in the introduction which asserted, perhaps naively, that the book was not meant to provide an encyclopaedic overview was clearly not sufficient to allay those concerns. Questions about who spoke, whose stories were being told and to whom the book was addressed, as well as whose interests were served by the narrative presented, were also raised. None of this was, with hindsight, surprising, nor was it undesirable, as such considerations have shaped the very course of art in the postcolonial Caribbean and similar questions have, in fact, been asked about all major publications and exhibitions on the subject.

There have also been significant, and related, changes in the politics and practice of the discipline of art history itself. The first edition of *Caribbean Art* was admittedly still torn between the genealogical thrust, evaluative vocabularies and canonical hierarchies of the 'old art history' and the critical, sociological and self-reflexive focus of the 'new art history', which is rooted in cultural theory and criticism frameworks to which Caribbean intellectuals have, not coincidentally, contributed. Since then, there have been even more fundamental challenges to the ideological premises and institutions of conventional art-historical practice and their foundational connections to histories of colonialism, Eurocentricity and white supremacy. Simultaneously, the development of online resources and social media has created a new, democratized economy of knowledge and opinion about art and its representation which has added significantly to this line of questioning. Some have declared that the discipline of art history is now in terminal crisis and there is no clarity or consensus about the most productive alternatives or way forward.

How the stories about art in the colonial and postcolonial Caribbean are told is of particular importance in this context, but this offers no comfortable or correct answers to the question of how to write or revise a book such as *Caribbean Art*. An introductory survey for general readership, which is what *Caribbean Art* is, must provide a 'big picture' overview that is painted in broad strokes. It must identify parallel developments and moments of convergence and exchange, shared ideas, concerns and contexts, as well as crucial departures, and it must illustrate these issues with instructive examples. It must have sufficient didactic clarity to be readable and useful, but it cannot provide the analytical or theoretical depth and nuance that is offered in more narrowly focused specialist monographs. It is difficult to avoid the mechanisms of canonical art history altogether in such a general publication.

Part of the problem is that it is easier to challenge and deconstruct dominant narratives and canons when these were already securely articulated and established. While there are well-established, and hotly contested, national narratives and canons in the many Caribbean territories, and artists from the Caribbean (such as Wifredo Lam and Jean-Michel Basquiat) who now hold a secure place in the global hierarchies of contemporary art, there are no established 'master narratives' about Caribbean art in general against which one can argue and offer alternatives. What can and needs to be done, however, is to acknowledge and engage the politics and dynamics involved in producing art-historical narratives about Caribbean art in a

critical, self-reflexive manner, and to make these considerations an active part of the discussion.

It was therefore decided to retain the general approach of the first edition, which had a hybrid chronological and thematic structure, and to revise and update the original chapters thoroughly, with the earlier-mentioned issues in mind. Two new chapters have furthermore been added that help to provide a more comprehensive picture. The first of these is on the public statues and monuments of the Caribbean, many of which date from the colonial era or represent colonial figures and values and have been contested accordingly – a subject that has significant currency in the present, iconoclastic cultural moment. The second new chapter explores the role of tourism in Caribbean art. The Caribbean is one of the most tourism-dependent regions in the world and the intersections between art and tourism in the colonial and postcolonial period have been problematic and controversial, raising important and troubling questions about cultural representation.

This second edition of *Caribbean Art* is thus offered as one of many possible perspectives on its subject, a perspective that is wide-ranging, as a survey needs to be, but makes no claims to being definitive or complete. It is hoped that in its new, revised and expanded form the book will make a further contribution to the understanding of Caribbean and postcolonial art and its context, and that it will be as useful, engaging and indeed provocative to those who are not familiar with the subject as to those who are well-versed in it, in ways that invite productive conversation and encourage other readings on the subject.

Introduction

The Cuban painter Wifredo Lam (1902–1982) is often cited as the paradigmatic Caribbean artist. Like many Caribbeans, he was of mixed racial ancestry – his father was a Chinese immigrant and his mother was of African and European descent. He spent most of his adult life outside the Caribbean, as is the story of many modern and contemporary Caribbean artists and intellectuals; he was an active participant in the Cubist and Surrealist movements while he lived in Europe, and a friend of Picasso.

In Cuba, Lam grew up in an environment where the Afro-Cuban Santería religion was commonly practised and he returned to this heritage as a source for his mature work. Following a long Caribbean tradition of cultural dissidence, he used African Caribbean culture as a vehicle for socio-political commentary and once described his art as 'an act of decolonization'. His most famous painting, *The Jungle* (1943), which was painted in Cuba, has been described as the first visual manifesto of the Third World. It is part of the collection of the Museum of Modern Art in New York City, where for many years it hung ingloriously near the coat room but is now part of the permanent exhibitions, a move which reflects the shifting position of Caribbean artists in the global artistic hierarchies.

The use of Lam's art as a benchmark illustrates the complexities and tensions that surround any attempt to define and position Caribbean art. Writers, curators and cultural administrators often approach the subject prescriptively, in terms of what they feel art from the Caribbean should be, a problem that affects Caribbean art professionals and outsiders alike. Consequently, aspects of Caribbean art that do not match these preconceptions are often overlooked or dismissed. It is doubtful, for instance, that a work such as the minimalist metal and fluorescent light sculpture *Avis Rara* (1981) by Bismarck Victoria (b. 1952) would be considered for the average publication or exhibition of Caribbean art. Victoria, who is from the Dominican Republic, was studio assistant to Isamu Noguchi

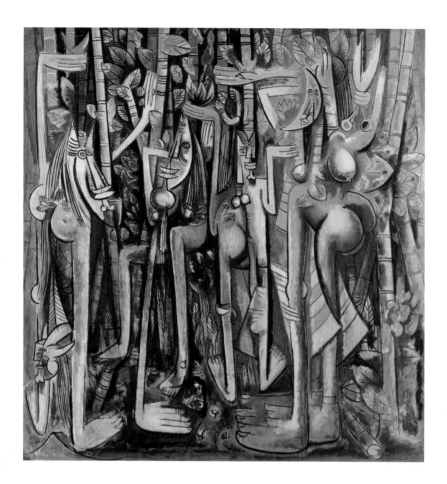

in New York for ten years, an experience that greatly influenced his purist artistic outlook, but the reason for excluding *Avis Rara* would probably not be that its maker has spent part of his adult life abroad (after all, so did Lam), but that its content and form are 'too western' and not recognizably 'Caribbean'.

For the purpose of this book, Caribbean art is defined in its widest and most inclusive sense, both as art made in the Caribbean and as art made by artists of immediate Caribbean descent who live and work elsewhere. The term 'Caribbean art' is thus used generically and does not suggest or impose specific characteristics or cohesion. There are well-recognized national schools in the Caribbean but they have developed in relative isolation from each other, and there are many other artistic expressions that defy such labels or are part of other, transnational networks, as is the case with a lot of

contemporary art. Some of the artists discussed in this book do not, in fact, define themselves as Caribbean.

This sense of fragmentation is exacerbated by the island geography and the linguistic variety of the region but, in spite of this cultural 'balkanization', general developments have been remarkably similar throughout the Caribbean. Most national schools originated in the early decolonization process, for instance, and the quest for a grounded cultural identity has remained a driving and unifying concern. Caribbean art is therefore usually in some way recognizably 'Caribbean', although the departures from this norm are nonetheless significant and provide a better understanding of the history and fraught dynamics of Caribbean art. The introduction of abstraction in the 1950s and 1960s, for example, also amounted to a universalist reaction against the prescriptive Indigenist canons and labels of the early nationalist schools, of wanting to be an artist first and Caribbean second. It was also a challenge to the assumption that the metropolitan west 'owns' modernism and that artists from places such as the Caribbean should stay in their 'designated lane'.

Caribbean art has developed in a polemical context, and debate about its 'Caribbeanness' has played an integral part. The Trinidad-born Nobel Laureate for literature, V.S. Naipaul, controversially argued in *The Middle Passage* (1962) that 'history is built around achievement and creation; and nothing was created in the West Indies' – a reflection of the existential anxieties and cultural self-doubts arising from colonialism.

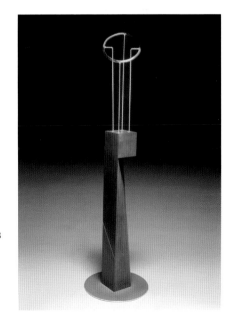

2 OPPOSITE Wifredo Lam, *The Jungle*, 1943
3 RIGHT Bismarck Victoria, *Avis Rara*, 1981

It is a common notion, consequently, that authenticity and validity in Caribbean art is measured by its independence from the western artistic canons. This perception has been a factor in the international success of 'primitive' Caribbean art, a context in which such art is often regarded, but deeply misunderstood, as culturally pure and therefore authentic. Caribbean intellectuals have also questioned the metropolitan western influences in modern Caribbean art, which many see as a product of cultural imperialism. Whereas some Caribbean art is indeed derivative and aspirational, these views fail to recognize the complexity and dialectic nature of the relationship between Caribbean and metropolitan western culture.

The art of the Caribbean has evolved in a fraught relationship with the dominant artistic canons of the metropolitan west, which were imposed on the region as part of the colonial enterprise. This has included foundational ideas about 'art', its definitions, conventions and vocabularies, its civilizational discourse, and its conceptions of value, hierarchy and teleological development. While these ideas still hold significant sway, questioning and challenging these canons, and the ideologies and power dynamics behind them, has been a driving force in the development of Caribbean art. As we will see in this book, national canons have also been vigorously contested, along with the local social hierarchies those represent. What the work of many artists from the Caribbean has in common is the belief that art can and needs to challenge and change the cultural order, as well as the attendant politics of social visibility, hierarchy and power. Much of the art of the Caribbean is an inherently critical intervention into its moment and, to return to Wifredo Lam, conceived as 'acts of decolonization'.

Modern and contemporary Caribbean art cannot be understood without considering its geographical, historical, intellectual and general cultural background in some detail. Geographically, the Caribbean is commonly defined as the chain of islands from Cuba and the Bahamas in the north, to Trinidad and Barbados in the south. Most definitions also include the Dutch islands of Curaçao, Aruba and Bonaire off the coast of Venezuela; the small island group of Bermuda in the Atlantic; Guyana, Surinam and French Guiana in South America; and Belize in Central America.

The Island Caribbean is often subdivided into the Greater and Lesser Antilles. The former consists of the larger islands of Cuba, Hispaniola (which is shared between Haiti and the Dominican Republic), Jamaica and Puerto Rico; the latter comprises the smaller islands in the eastern Caribbean. The term West Indies, which once applied to the entire region, is still used to describe

the English-speaking part of the region, although the term 'Commonwealth Caribbean' is a postcolonial alternative.

The mainland territories of Guyana (formerly British Guiana), Surinam (formerly Dutch Guiana) and French Guiana are collectively called 'the Guianas'. Politically, economically and culturally, the fate of the Guianas has since Prehispanic times been tied to the Island Caribbean rather than South America. Because of the colonial history of the Guianas, the national languages are English, Dutch and French, respectively, which adds to the cultural separation from Brazil and Hispanic South America. This is reinforced by the geographic barrier of near-inaccessible rain forests that cover much of the vast, sparsely populated Guianese hinterlands. The Guianas differ from the islands because of their size (the largest island on Guyana's mighty Essequibo River is larger than Barbados) and, culturally, because of the presence of a substantial Amerindian population. The colonial and modern history of Belize (formerly British Honduras) is also closely linked to that of the islands, although it is more isolated because of its location in Central America and its Maya heritage.

There are definitions that go further and include the sections of Central and South America that border the Caribbean Sea, which are culturally related and to which people from the islands have migrated – Caribbean labour, for instance, played an important role in the construction of the Panama Canal and the banana industry in Costa Rica in the early twentieth century – and many remained there. People from the Caribbean have, in the modern era, migrated in large numbers to North America and Europe, and the resulting Caribbean diaspora is close in numbers to the population of the Caribbean itself, and maintains active social, cultural and economic links with the region. Aspects of the Caribbean culture, such as the music and literature, have spilled even further beyond the Caribbean's borders and have a global impact. It is therefore no longer possible to define Caribbean culture along geographic lines, and the term 'Global Caribbean' – which was the title of a seminal series of exhibitions curated by the Haitian American artist Edouard Duval-Carrié (b. 1954) – is increasingly used to describe what is now indeed a globalized Caribbean cultural sphere.

Geography is, however, fundamentally important to Caribbean culture and art. Maps are of particular interest as definitions of the historical and cultural space of the region. They are commonly used as symbols of identity and feature prominently in the national iconography of Caribbean states. They can also be regarded as diagrams of the power structures that have shaped the region, from the half-imaginary maps of

the 'discoveries' to modern map projections that represent the Caribbean as the 'backyard' of North America. The map is a recurrent theme in contemporary Caribbean art, along with other national symbols such as the flag. The Puerto Rican artist Rafael Ferrer (b. 1933) was among the first to explore the possibilities of the map image. In the series of five lithographs *Istoria de la isla* (Island's Tale) (1974), maps of Puerto Rico were combined with motifs that evoke that country's complex political and cultural history, from its Prehispanic past to its controversial modern status as a commonwealth of the United States of America. Although the map images seem to shift and fall apart, their outlines remain reassuringly familiar and suggest resilience and survival in the face of internal and external pressures.

4

The Caribbean region is quite large, but its archipelagic land mass is small and at once fragmented and united by the Caribbean Sea – as the Barbadian poet Kamau Brathwaite has put it, also alluding to the diasporic connections with Africa, 'the unity is submarine'. The region also forms what the Cuban writer Antonio Benítez-Rojo has described as an alternative (and inherently more diffuse) 'island bridge' between North and South America or, culturally, between Anglo-America and Hispano-America. While this definition fails to consider the special cases of the French- and Dutch-speaking territories and Belize, it usefully argues that Caribbean culture is American culture, in its hemispheric sense. The late Cuban president Fidel Castro described Cuba as an 'Afro-Latin' country, which calls attention to the African elements in Cuban culture as a distinguishing characteristic, but also to the close association with Latin American culture. Castro's definition can be extended to the other Hispanic islands, although it is untenable to define predominantly Protestant, non-Hispanic countries, such as Jamaica and Barbados, as 'Latin'.

The African presence does not in itself separate the Caribbean from the continent, however, since a significant part of the continental Latin and North American population is also of African descent. The Caribbean region can be placed in the larger context of what has been termed 'Plantation America'. Geographically, Plantation America ranges from the southern United States to north-eastern Brazil. This vast area has a common history as European plantation colonies were sustained by African slave labour, an experience that has generated a significant part of 'New World' culture. It is also useful to remember that the Caribbean is an Atlantic culture, which has its primary cultural relations within the Atlantic sphere, between Africa, Europe and the Americas.

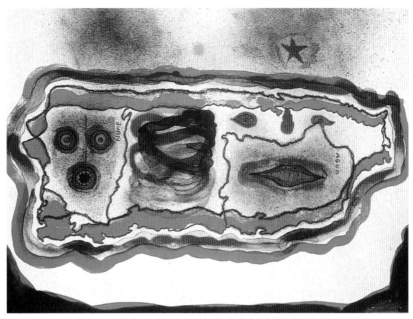

4 Rafael Ferrer, a lithograph from the *Istoria de la isla* (Island's Tale) series, 1974

There is thus no simple or single cultural definition for the Caribbean and its fluid characteristics derive from combined factors such as the island geography, migration and diaspora, the long and complicated colonial history, globalization, the linguistic and religious diversity, the near extinction of the Amerindian population, and the dominant African presence. The Caribbean islands were the first part of the Americas to be colonized by Europe when Christopher Columbus and his crew arrived in 1492. And although decolonization started early, with the Haitian revolution (1791–1804), the region's colonial history is one of the longest in the world and continues into the twenty-first century. Colonialism is a part of the recent, lived reality of many. This contrasts with continental Latin America where most states became independent in the 1820s and 1830s, although the entire Latin American and Caribbean region has, because of its strategic importance, also been subject to geopolitical dynamics that have produced new imperialist pressures, primarily coming from the neighbouring United States of America.

The colonial Caribbean was initially controlled by Spain, although France, England and the Netherlands claimed their share in the seventeenth century. The Amerindian population was practically annihilated during the first decades of

15

European settlement and replaced by West and Central Africans who were transported to the region in large numbers as slaves. They were the ancestors of the majority of the modern Caribbean population. During the nineteenth century, several other ethnic groups started migrating to the region, primarily from India, China, and Syria and Lebanon, and while these groups remained minorities in most countries, 'East Indians' now make up about half the population of Trinidad and Guyana, and just over one third of Surinam. (In the Eastern Caribbean, the term 'East Indian' is commonly used to differentiate persons of Indian descent from the Amerindians.) The old colonial affiliations have resulted in some surprising migration patterns – about fifteen per cent of the Surinamese population is of Javanese descent and there are Hmong farming settlements in French Guiana.

The Caribbean can thus be described as a repopulated space and its inhabitants as displaced people who, as the Jamaican-born cultural critic Stuart Hall has put it, do not historically 'belong' there but have developed a rootedness in the region (or in those metropolitan areas to which many have in turn migrated). Language has been a significant part of this process – while Latin America is in essence united by language, the Caribbean is divided into four language groups. The Hispanic group is the largest and makes up nearly two-thirds of the Caribbean population, the Francophone and English-speaking groups are roughly equal in size and Dutch is spoken by a minority. Dividing the Caribbean according to these official languages is not always tenable, however, since the Creole languages of the masses present a different picture. The Papiamentu of Curaçao and Aruba, which were important mercantile centres in the colonial era, is a mixture of Spanish, Portuguese, Dutch and West African languages and does not even resemble standard Dutch. Similarly, the Creole language of St Lucia is French-based, while the official language is English, a result of the country's complicated colonial history. Haitian Creole or Kreyol, as it is known today, while recognizably based on French, also differs substantially from the French that is spoken by the elite.

The four language groups represent broad cultural entities, but there are considerable variations within these groups. This is certainly the case for the republic of Haiti and the French Overseas Departments of French Guiana and the French Antilles, which share French as their official language. The former has, in spite of its considerable social and political difficulties, been independent for nearly two centuries and has a distinctive cultural identity with strong African influences.

French Guiana and the French Antilles, on the other hand, have enjoyed relative stability and prosperity and have a closer, albeit ambivalent, cultural relationship with metropolitan France. Migration to North America has further complicated the linguistic balance of the region and has resulted in an ambivalent attitude towards the English language, especially in Puerto Rico where it is associated with US imperialism. Within the Caribbean itself, the status of the Creole languages is also an area of contestation, as these have been primarily used by the popular masses and are thus strongly associated with social class and hierarchy. The cultural and political importance of these languages is increasingly recognized, however: Kreyol now has official language status in Haiti, and Papiamentu has been similarly recognized in Curaçao and Aruba.

The term 'Creole' initially meant 'locally born' and usually referred to the white colonial elite, although it was also used to distinguish locally born slaves from those who came from Africa. 'Creole', and its derivatives 'creolity' and 'creolization', are now also used in a more general sense to describe the syncretic, or, as Benítez-Rojo has termed it, 'supersyncretic' character of Caribbean culture. The notion of 'creolization' is central to Caribbean cultural theory and provides a useful vantage point from which to understand Caribbean culture and art.

It is now well understood that creolization is an ongoing process, and that hybridity, plurality and open-endedness are fundamental characteristics of Caribbean culture. The Cuban anthropologist Fernando Ortiz played a pioneering role in articulating these issues. In 1939 he introduced his famous 'ajiaco' metaphor – *ajiaco* is a traditional Cuban pepper stew of Amerindian origin, which is cooked over a long period by continuously adding new ingredients to the simmering mixture. Like the 'ingredients' of Creole culture, additions maintain their identity to varying degrees – some dissolve fully into the mixture or may even evaporate, while others remain more distinct.

Much of this creolization process is involuntary, but the subversive appropriation of ideas and images is also a central characteristic of Caribbean culture and art. The nineteenth-century Jamaican artist Isaac Mendes Belisario (1795–1849) recorded an interesting example of this tendency in his lithography series *Sketches of Character* (1837–38). The series is best known for its depiction of the African Jamaican Jonkonnu masquerade, which dates from the plantation period when the slaves were allowed free time around Christmas. The 'Actor Boy' character of Jonkonnu wore a white mesh face mask and an 'aristocratic' European outfit, with a fantastic feathered and sequinned headdress, and entertained his audience by

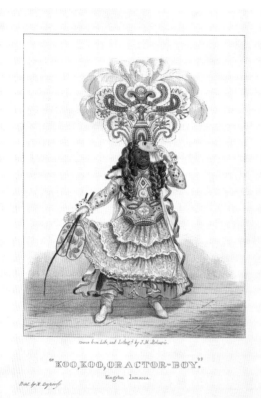

Drawn from Life, and Lithog.d by J.M. Belisario.

"KOO,KOO, OR ACTOR-BOY,"

Kingston JAMAICA.

Publ. by M. Duperly

5 LEFT Isaac M. Belisario, *Koo-Koo* or *Actor Boy* from the *Sketches of Character* series, 1837
6 OPPOSITE Eddie Chambers, *Untitled*, 1994

reciting random passages from Shakespeare plays. Another Jonkonnu character wore a headdress in the shape of a plantation house, also combined with a white face mask. These so-called fancy-dress Jonkonnu characters were not imitating but parodying the Jamaican plantocracy and its 'European' culture or, to paraphrase the St Lucian author Derek Walcott, what started in imitation ended in invention.

The subversive inversion of images and symbols frequently appears in the modern era as well. It is an important aspect of the work of Eddie Chambers (b. 1960), a British artist and curator of Jamaican parentage. In 1994 he participated in a project for which artists were invited to design flags to be flown at Liverpool Town Hall. This was an interesting challenge for a black artist in Britain where the national flag has sometimes become uncomfortably associated with the extreme right. Chambers replaced the colours of the Union Jack with the Rastafarian red, gold and green, an intervention reminiscent

6

of the African American artist David Hammons's *African American Flag* (1990) and Chambers's own anti-fascist collages of the early 1980s. While the Actor Boy Jonkonnu mockingly adopted a 'white' identity, Chambers imposed a 'black' identity on a quintessentially 'white' symbol and its display on the Liverpool Town Hall was a provocative symbolic act of conquest. Predictably, the flag was removed after one day, although, unwittingly adding to Chambers's intervention, this was done ceremoniously – he received his flag folded according to the protocol usually reserved for 'real' national flags.

Race is a central issue in Caribbean culture – modern Caribbean society was born out of racial oppression and exploitation, and, as we will see throughout this book, racial activism has ever since played a major role in the region's socio-political and cultural development. In spite of the culturally repressive nature of the plantation system, the African heritage is of fundamental importance to Caribbean culture, and it is one of the achievements of the postcolonial period that this is now well-recognized. Caribbean culture should not, however, be defined solely as African Caribbean

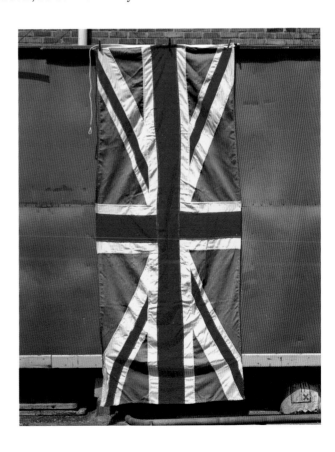

or black culture, as is often done, since this ignores the substantial contribution of other racial and cultural groups such as the Amerindians, East Indians, Chinese, Lebanese and Europeans. Because of colonial history, it is particularly difficult to assess the European elements in Caribbean culture dispassionately, but Europe is part of the Caribbean mix, even though whites are a racial minority, albeit a privileged one, in most Caribbean countries.

As Ortiz's *ajiaco* metaphor reminds us, Caribbean culture is always in a state of flux. Caribbean societies have changed in recent times from predominantly rural to urban, and it can be argued that 'the city' has succeeded 'the plantation' as the main generator of Caribbean culture. The metropolitan areas of Havana, Santo Domingo and San Juan now have more than two million inhabitants each and Port-au-Prince and Kingston over one million. Mass migration to Europe and North America has reinforced the urbanization of Caribbean culture, as most of it has been to major urban areas.

The question arises, however, of how Caribbean culture can maintain any degree of autonomy in the context of global cultural and political power dynamics. Caribbean policy makers used to express concerns about North American 'cultural penetration' and with good reason, given the remarkable reach of the American mass media. More recently, this reach has been significantly intensified by the new networks and identities created by social media. The fact that Caribbean migrants are helping to shape modern urban culture in North America and Western Europe is however often overlooked. Miami, for instance, is de facto a Caribbean city with a politically and economically powerful Cuban exile community known for its strong anti-Castro sentiments, and although there are many Jamaicans and Haitians, Spanish is the primary language of southern Florida, largely because of this Cuban presence. Likewise, a substantial part of the population of New York City and its environs is of immediate Caribbean descent, mostly from Puerto Rico but also from Haiti, the Dominican Republic, Jamaica and the smaller islands.

The impact of Caribbean migration can indeed be seen in Caribbean and metropolitan art alike. The painter Jean-Michel Basquiat (1960–1988), whose meteoric and self-destructive ascent in the New York art world was emblematic of the 1980s, had a Haitian father and a Puerto Rican mother. The Caribbean presence in New York contributed significantly to the graffiti street culture Basquiat used as his point of departure. Basquiat, who lived in Puerto Rico for two years in his early teens, has in turn become a romantic anti-hero for many young Caribbean

7

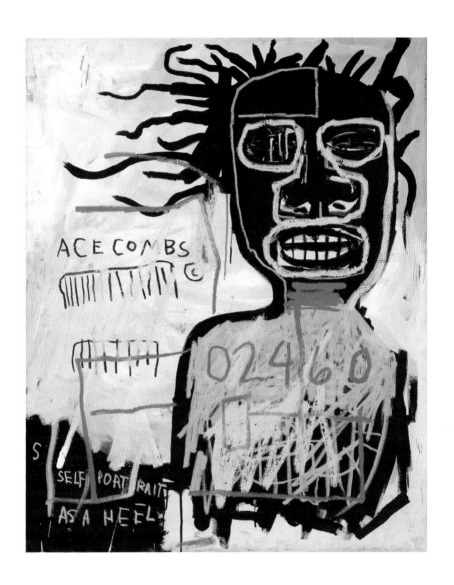

7 Jean-Michel Basquiat, *Self Portrait as a Heel*, 1982

artists who see him as a martyr of the 'system', as well as an aspirational success story, posthumous as most of this success may be. Many artists born in the Caribbean, or of immediate Caribbean descent, now work in North America or Western Europe. Although most of these artists have faced marginalization, a few have become part of the artistic mainstream, which has sometimes come at the expense of their perceived 'Caribbeanness'.

The Haitian-born painter Hervé Télémaque (b. 1937) moved to France in 1961 and became a noted representative of New Realism. His rebus-like works often contain references to his Haitian background, but he is now commonly described as a French artist. He had the following to say about his relationship with the western mainstream: 'I want to position myself at the other side of this painting from the Third and Fourth World that is always subjected to interpretations, to slip to the side of those who do the interpretation; but it nevertheless remains that all I do is Haitian.' Télémaque's statement also points to the fact that Caribbean artists have historically had little control over the power structures that determine their access to the metropolitan western art world, which is after all what 'international' success usually amounts to.

The questions of cultural identity and its relationship to the international status of Caribbean art preoccupy contemporary

8 BELOW Hervé Télémaque, *Currents No. 2*, 1987
9 OPPOSITE Flavio Garciandía, from *A Visit to the Tropical Art Museum* series, 1994

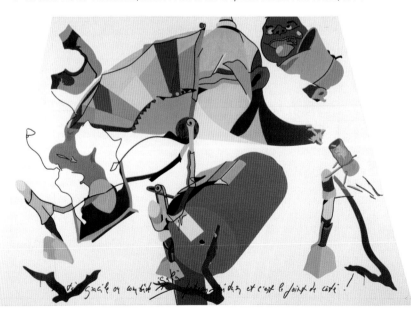

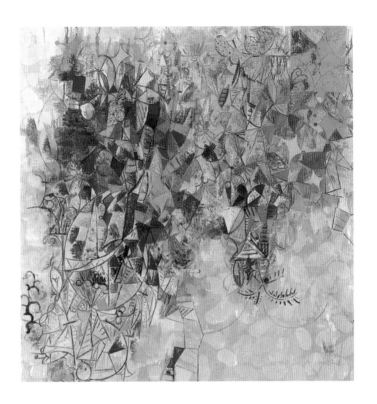

Caribbean artists. In 1994 the Cuban conceptual artist Flavio Garciandía (b. 1954) started a group of paintings entitled *A Visit to the Tropical Art Museum*. They are painted in an abstracted 'tropical' style, reminiscent of Lam and his contemporaries. Without being literal or specific, Garciandía's 'museum' explores the paradoxical issue of vernacular artistic language in an eclectic, continuously changing postcolonial culture. His ironic appropriations remind us of the imposed and self-imposed preconceptions about Cuban and Caribbean art and the dilemmas caused by the region's peripheral economic and political status.

9 Garciandía devised his *Tropical Art Museum* during the severe economic crisis that hit Cuba after the collapse of the Soviet Union, a period that coincided with unprecedented international interest in Cuban art. Like many of his contemporaries, Garciandía left Cuba during that time and he now lives in Mexico. Some of his paintings include bean-shaped forms which can be read as a formalist pattern but also as a reference to the beans that are a typical ingredient of the Cuban diet, reminding us of the connection, on a national and personal level, between art

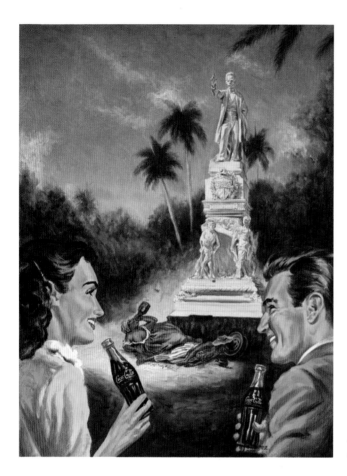

10 Pedro Alvarez,
Ron & Coca-Cola, 1995

and economic survival. The *Tropical Art Museum* thus also
comments on the fundamental contradiction of marketing
cultural identity.

Economically, the Caribbean is usually the asking party in
its relationship with the north. Although mining, agriculture
and services are important, the Caribbean is now the most
tourism-dependent region in the world, which in a postcolonial
situation has significant implications for cultural development.
Although Caribbean tourism depends primarily on the physical
beauty of the region, it also involves the commodification of
vernacular culture, redesigned and staged to meet market
requirements. This places much of the Caribbean in ideological
conflict, where the plantation era is idealized as a romantic
past. The Cuban painter Pedro Alvarez (1967–2004) explored
this dilemma by combining appropriations of the work of the

10

nineteenth-century Spanish-Cuban artist Víctor Patricio de Landaluze (1828–1889) with tokens of capitalism that have reappeared in Cuba along with a revived tourism industry. Landaluze used to be denounced for his colonialist outlook but now holds an important place in Cuba's cultural marketing efforts as a Cuban 'old master'.

The relationship between Caribbean tourism and art has always been uneasy. Haiti, in particular, has had art tourism since the late 1940s when its 'primitive' school came to international attention. This has resulted in a system where artists work specifically for certain galleries or dealers who often direct their output according to market demands. Some dealers are in essence wholesalers of Haitian art and cheap, mass-produced and highly stereotypical Haitian paintings can be bought as souvenirs throughout the Caribbean. It is ironic, given external preconceptions about authenticity in Caribbean art, that much of the mass-produced 'primitive' art of the Caribbean is specifically created to meet western expectations. While this extreme commodification is culturally deplorable, the demand for such Haitian art has provided employment for thousands of people, something that cannot easily be dismissed since Haiti is the poorest country in the Western Hemisphere.

Discussions about Caribbean culture are heavily steeped in perceptions of race and ideology, which makes it necessary to pay some attention to terminology. Terms like 'primitive' and 'naive', for instance, are highly problematic and, certainly in the context of the Caribbean, heavily burdened with racial and social preconceptions. The Jamaican art historian David Boxer recognized this problem and, in the late 1970s, introduced the term 'intuitive' as an alternative, which emphasizes the untutored, often visionary nature of these artists' work. The term has gained some international currency but is still primarily used to describe a selective canon of Jamaican self-taught, popular artists. Yet the use of another term does not resolve the questions that surround the categorization and, indeed, segregation of these artists, which are often based on primitivist assumptions that are unilaterally imposed on their work as well as on the popular culture in general. Their classification is nonetheless a historical reality, especially in Haiti and Jamaica, and has significantly impacted the development and reception of such art. I have therefore used the terms 'primitive' and 'intuitive' only for these two countries, and only in the context where those terms have been used historically. Otherwise, such labels are avoided and used only where they are needed for the clarity of the argument, in which case the term popular is used as a generic term.

97

The spelling of the words used to label and describe African Caribbean cultural practices is also a vexed issue that comes with significant baggage. The spelling of Haitian 'Voodoo' is a good example that is burdened with troubling racial and cultural stereotypes. Some scholars prefer 'Vodun' or 'Vodoun', which emphasizes the African, Dahomean origins of the religion. It is nonetheless important to make a distinction between Dahomean Vodun and its creolized Caribbean counterpart and I therefore decided to use 'Vodou', as this is now the commonly used spelling for its Haitian exponent.

While the scholarship and literature have grown significantly since the first edition of this book was published, the study of Caribbean art is still an emerging field. Much of the recent work has been done for exhibitions, such as the massive survey 'Caribbean: Crossroads of the World' exhibition held in New York in 2012 at El Museo del Barrio, the Studio Museum in Harlem and the Queens Museum, which was subsequently shown, in a smaller, more compact form, at the Perez Art Museum in Miami in 2014. While most of the curators and researchers who worked on this exhibition were from the Caribbean, but lived elsewhere, and the exhibition was shown at museums that have a long association with the Caribbean and its diaspora, it is noteworthy the exhibition was never shown in the Caribbean itself. Such questions also apply to this book, which is published by a major international art publishing house and written by a white, Belgian-born art historian who has lived in Jamaica since 1984, but who will always hold an ambiguous insider-outsider status in the Caribbean cultural sphere. The question of who brokers and controls the representation, and who Caribbean art is represented to, thus remains unresolved despite all the challenges of these dynamics, and the current global interest in Caribbean art ironically only amplifies this problem. This has as much to do with economics as it has with cultural politics, as most Caribbean institutions do not have the resources to fund and support such overview projects. While there are changes, including several small Caribbean publishing houses that focus on the arts, the tensions arising from the external gaze on and power dynamics within Caribbean art remain almost as acute as they were in Wifredo Lam's time.

Chapter 1
Prehispanic and Colonial Art

The ideas and circumstances that sustain modern Caribbean art have a long ancestry and are better understood if placed in a historical context. Prehispanic and colonial-era Caribbean art provides a revealing visual record of the social and cultural history of the region. The colonial era also introduced some of the images and concepts with which artists from the postcolonial Caribbean have argued, such as the definition of 'art' itself and the relationship of Caribbean artistic production to the dominant European canons.

By the time of the European conquest at the end of the fifteenth century, the Caribbean islands were dominated by two related ethnic groups whose ancestors had migrated from the Orinoco River basin: the Taíno (Island Arawak) in the Greater Antilles and the Bahamas, and the Kalinago (Island Carib) in the east. The Taíno were the larger and more settled group, with a total population estimated at more than one million, and their territory was divided into loosely associated kingdoms, provinces and villages. They were seafaring, with large dug-out canoes, and practised trade, hunting, fishing and farming – their main crop was cassava (manioc). Taíno religion was based on shamanic practices and the worship of a pantheon of *zemis*, nature divinities and ancestral spirits, headed by the sky god, Youcahuna. Their creation myths placed the origin of humanity in Hispaniola – they were obviously firmly established in the region.

The Taíno and their island neighbours did not produce any large-scale stone architecture or monuments, and much of their art was lost or destroyed during the early years of colonization, so Prehispanic Caribbean art may seem insignificant when compared with Mesoamerican art. Aided by new research and exhibitions such as 'Arte del Mar' (2019–21) at the Metropolitan

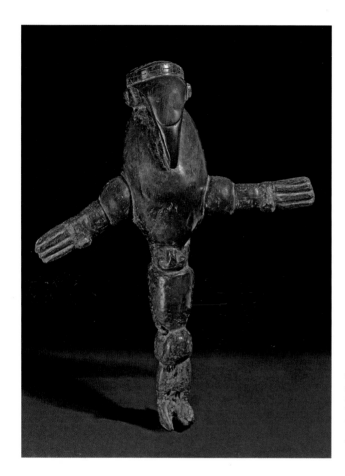

11 LEFT 'Bird Man', Taíno, c. 1000–1500, found at Carpenter's Mountain, Vere, Jamaica, in 1792
12 OPPOSITE Cotton reliquary *zemi*, Taíno, c. 1400–1500, Dominican Republic

Museum in New York, the scholarship on Prehispanic Caribbean art is growing, however, as is the appreciation of its cultural significance and expressive and formal qualities. There are notable collections of Prehispanic art and artefacts in the Caribbean, primarily in the Dominican Republic and Puerto Rico, and important archaeological sites, such as the ceremonial ball-court complex in Caguana, Puerto Rico. Most significant Amerindian finds made during the colonial period were, however, taken to European museums. Three major *zemi* woodcarvings were, for instance, found in 1792 in a cave in Carpenter's Mountain in south-western Jamaica and taken to England, where they are now in the collection of the British Museum in London. This includes the 'Bird Man', a hybrid creature – part man, part bird – that personifies the totemic bond between its makers and the animal world. With its stylized

11

form, smoothly bulging surfaces and balanced asymmetry, it is a fine example of Taíno woodcarving. Although at least 500 years old, the 'Bird Man' still has part of its original shell inlays – incrustations made from gold, guanin (a gold-copper alloy), shell or bone were commonly used in Taíno sculpture.

Another remarkable example of Taíno art is a nearly intact cotton reliquary *zemi* from the Dominican Republic, which is now in the collection of the University of Turin. The figure is ingeniously constructed from woven and wrapped cotton thread on a natural-fibre frame. The head was built around the frontal part of a human skull, probably of a *cacique* (chieftain), and shell inlays were used for the eyes. The cotton figure closely resembles surviving wooden, stone and ceramic *zemis*, with its general stylization and details like the cotton wraps the Taíno wore around their limbs. Cotton was an important part of Taíno material culture and such fibre objects, which are not easily preserved, may have been more common. The wide-open

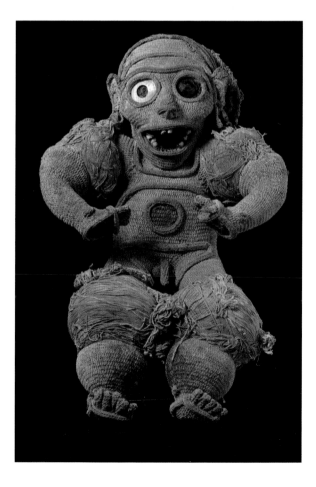

mouth, staring eyes and animated pose make the figure extraordinarily expressive. It is easy to see why the early Spanish missionaries, with their late medieval sensibilities, described such effigies as malevolent spirits.

The Taíno population was decimated within decades of Spanish colonization due to disease, ill-treatment and collective suicide. The Kalinago were more resilient and retreated to the less accessible islands of the Eastern Caribbean, from where they waged resistance against the European colonizers until the eighteenth century. Although there are Amerindian traces in much of the Caribbean population, which are now being documented in genome research, the remaining traditional Amerindian groups on the islands are small, consisting mainly of a few hundred racially mixed Kalinago in Dominica. The Garifuna of Belize and environs descend from a group of Afro-Amerindian 'Black Carib' from St Vincent, who were deported there after a confrontation with the British in 1796. Larger groups of ethnically related Amerindians still live in the Guianas, where they make up three to four per cent of the population, and where there has also been considerable intermixing with the African, European and, more recently, the East Indian population.

While the Amerindians have left few visible traces on the Island Caribbean, their culture survives in various aspects of Caribbean life – in place names, language, art, the cuisine, national emblems and the oral traditions. This was helped by the Maroons, freed and runaway Africans who established communities in remote areas and absorbed part of the dwindling Amerindian population. There are probably also Amerindian influences in primarily African Caribbean religions like Haitian Vodou and in the festival arts of the region, although this is yet to be conclusively studied. The identification with the Amerindian past is, however, becoming more pronounced and politicized, and revival movements have emerged, initially primarily in Puerto Rico and the Dominican Republic and with organizations such as the United Federation of Taíno People. The Taíno revival has been criticized as a rejection of the African Caribbean heritage, which has been a factor in Puerto Rico and the Dominican Republic, where that heritage is treated with greater ambivalence. More recently, however, this movement has also positioned itself as a rejection of the colonialist narratives about Caribbean identity that does not have to contradict African diasporic identifications. There is also greater official recognition, and restitution requests for the Jamaican Taíno sculptures at the British Museum and the cotton reliquary in Turin have been announced by the Jamaican and Dominican governments, respectively.

For the Spanish conquistadores, the Caribbean was a stepping-stone for the colonization of the American continent. It is only in the Greater Antilles, mainly Hispaniola and Cuba, that substantial settlement took place and the earliest surviving colonial art forms appeared in early urban centres on these islands. Historical documents show that several painters and sculptors were involved in the construction and decoration of major churches and public buildings in Havana and Santo Domingo during the sixteenth century, although little is known about these artists. The decoration of these structures is consistent with the Spanish Plateresque style, but early signs of creolization were also evident, with the inclusion of local motifs such as the pineapple and possibly even Taíno imagery.

The African slave trade to the Caribbean started in the first decade of the sixteenth century. Tragically, the importation of enslaved Africans was initially justified by advocates like Bartolomé de las Casas as an attempt to save the Amerindian population. In a matter of decades, the black population exceeded the white settlers in most Caribbean territories, except for the Spanish colonies where the rate remained lower. Estimates vary considerably but it is believed that some 4.5 million Africans arrived in the Caribbean during the seventeenth and the eighteenth centuries – combined with the numbers sent to the American continent, this makes the Atlantic slave trade the largest forced migration in history. Many more did not survive the brutal Middle Passage.

Despite the violent, repressive nature of the slavery system, the African diaspora quickly became a major constituent of Caribbean and American culture. The enslaved brought their beliefs, traditions and material culture with them, and creolized African Caribbean cultural expressions emerged in response to the new environment and often served as symbolic resistance. Seventeenth- and eighteenth-century Jamaican sources, for instance, mention the use of funerary carvings and protective spiritual objects by the black population, although only utilitarian objects have survived from that period. Those utilitarian art forms are, however, just as telling – the Jamaican pottery tradition that originated on the plantations and in urban centres, for instance, combines Taíno, West African, Spanish and English influences and represents an instructive material record of the island's complex cultural history.

During the seventeenth century, the other Western European powers challenged the Spanish monopoly. The Caribbean was soon divided – politically, economically and culturally – between France, England, Spain and Holland, with small areas controlled by Denmark, Sweden and later even Prussia. By the eighteenth

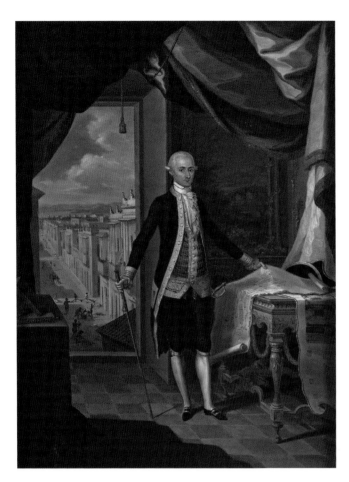

13 José Campeche,
*Portrait of Governor
Ustariz*, c. 1792

century, a certain political stability had been achieved,
although there were ongoing territorial disputes between the
European powers and frequent slave uprisings. A successful
agronomic economy developed, based on slavery and the
large-scale cultivation of sugar cane and other export crops
like tobacco, spices and indigo. Creole society emerged and
the first nationalist sentiments were articulated in defiance
of central colonial government by the increasingly powerful
and wealthy Creole aristocracy.

This Creole elite aspired to a metropolitan lifestyle and
was wealthy enough to patronize the arts. The conditions
were therefore right for colonial schools to develop, although
differences in settlement patterns also played a role. In the
British West Indies, for instance, absentee landownership was

common, which explains why the West Indian plantocracy was more inclined to patronize itinerant European artists who travelled with them to the region and to commission work in Europe. There are several monuments in Jamaica and Barbados by prominent English neo-classicists such as John Bacon, John Flaxman, Richard Westmacott and Sir Francis Chantrey. The profits from Caribbean colonialism also generated significant new wealth in the colonial 'mother countries'. Much of Britain's wealth at that time was, for instance, generated by the slave trade and related economic activities, and this funded the construction of new public infrastructure and impressive country estates and town homes, as well as contributing to the flourishing of the arts of that period.

In the Hispanic Caribbean, the Creole elite was well settled and there was also a substantial professional and mercantile urban middle class. It was in these countries, and in the urban areas, that the first recorded Caribbean-born artists appeared. They satisfied the demand for religious art and portraits of the Creole elite and, surprisingly, they rarely painted landscapes, but merely used them as backgrounds to their figure compositions. Not many of these artists ever visited Europe, so they were exposed to European art by what trickled down to the colonies. Apart from a few original European works, this included engravings, painted copies and the occasional treatise on art. Visiting European artists also made their mark. The output of these early Creole artists was modelled on European art – as their patrons no doubt demanded – and they are often dismissed as provincial imitators, though their work also reveals the emergence of new, vernacular visual languages.

The Puerto Rican José Campeche (1751–1809) was probably the most accomplished Creole artist of the period. He painted religious works and sensitive portraits of the local elite that were influenced by Rococo and Neoclassicism but deviated from the colonial norm with their lively compositions, ornamental colours and penchant for the bizarre. Campeche's official portraits often include historically significant background details, rendered with great precision. His *Portrait of Governor Ustariz* (c. 1792), for instance, includes a view of the paving of the streets of San Juan, an accomplishment of Ustariz's administration. As the Puerto Rican art historian Haydee Venegas has pointed out, this urban view is based on lived experience of the intense light of the tropics rather than on academic convention.

The racial background of these early Creole artists is significant and reflects the colour caste system that was

13

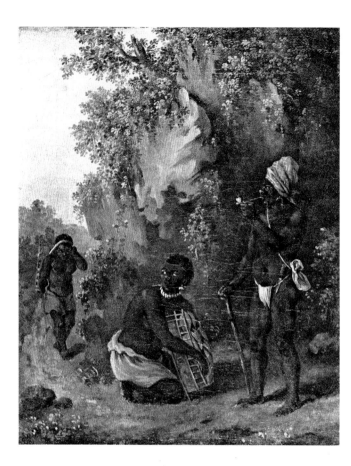

14 LEFT Agostino
Brunias, *Chatoyer,
The Chief of the
Black Charaibes, in
St Vincent with his
Five Wives*, c. 1770–80
15 OPPOSITE George
Robertson, *Rio
Cobre*, c. 1773

developing in the Caribbean. While barred from interaction with
the white elite on an equal basis, free persons of colour could take
up professions, including painting and sculpture. Some acquired
wealth and social standing and some even held slaves. Campeche
was the son of a black slave who had bought his freedom and
became a successful gilder and decorative painter. The Sephardic
Jewish community in the Caribbean, who established themselves
as part of the merchant class, also belonged to this social middle
group and produced artists such as Isaac Mendes Belisario, the
first Jamaican-born artist on record.

Several European artists travelled to the Caribbean during
the eighteenth and nineteenth centuries, often in the company
of a wealthy patron such as a high colonial official or planter,
and some eventually settled in the region. Their drawings and
paintings served as records of the landscapes, scenes of local
life and other 'curiosities' seen during these travels and doubled

as powerful symbolic assertions of their patrons' ownership and control of their estates and the colonies. Frequently, these works were published in print or book form to meet the growing European interest in documentary images of the Caribbean.

14 The Italian itinerant painter Agostino Brunias (1730–1796) is a fascinating case. He was in Dominica, a British colony, from 1771 to 1773 as the personal painter of the governor, Sir William Young, and subsequently settled there. He also frequented St Vincent, where Young owned land, and visited Barbados and Grenada as well. Some of Brunias's paintings and sketches were engraved to illustrate the Jamaican planter-historian Bryan Edwards's book *The History, Civil and Commercial, of the British Colonies in the West Indies*, published in London in 1793. Unlike most of his contemporaries, Brunias did not focus on the landscape or portraits of the colonial and Creole elite; instead, he painted closely observed genre scenes in which the free coloureds and the St Vincent Kalinago take centre stage. His sensualist preoccupation with the exotic 'other', especially the woman of colour, and interest in ethnographic detail prefigure orientalism and Paul Gauguin's primitivism, but his work gives us a rare, revealing glimpse into the complex race, class and gender dynamics of Creole society.

15 George Robertson (1748–1788), another itinerant artist, came to Jamaica in 1773 with the English portraitist Philip Wickstead,

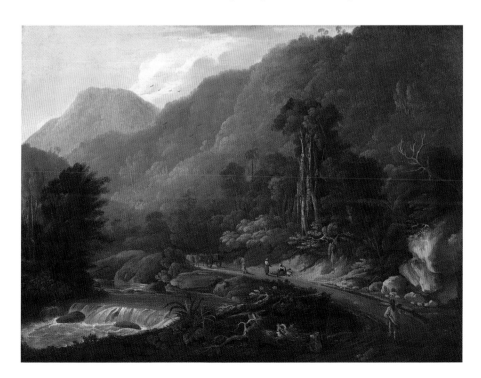

under the patronage of the planter-historian William Beckford. Robertson was captivated by the spectacular beauty of the island and painted several landscapes in a lyrical, early Romantic style. On returning to England, he successfully exhibited his Jamaican work and had six landscapes published as aquatints. Robertson is an early example of what became a trend of itinerant landscapists in the nineteenth century. Others were primarily scientists and topographical artists, although their work is often of artistic interest as well. This applies to the German naturalist Alexander von Humboldt, who visited Cuba in 1800, during his travels in Central and South America, to study the plantation system there.

The representation of slavery is often avoided or significantly sanitized in such art but there are exceptions. While they still fail to capture the punishing realities of slavery, the English artist William Clarke's *Ten Views in the Island of Antigua* (1823), for instance, provide a detailed account of the processes of cultivating sugar cane and producing sugar and at least allude to the power dynamics involved. There was no such avoidance in the Abolitionist campaigns of the late eighteenth and early

16

16 William Clarke, *Cutting the sugar-cane*, from *Ten Views in the Island of Antigua*, 1823

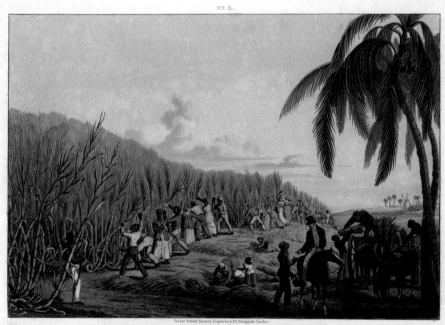

CUTTING THE SUGAR-CANE.

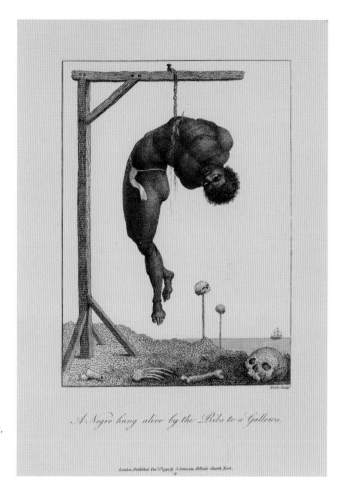

A Negro hung alive by the Ribs to a Gallows.

London, Published Dec.r 1.st 1791, by J. Johnson, S.t Paul's Church Yard.

17 William Blake, *A Negro hung alive by the Ribs to a Gallows*, 1792

nineteenth centuries, in which the abuses of slavery were foregrounded rather than concealed. The plates in *The Narrative of a Five Years Expedition against the Revolted Negroes of Surinam* (1796) by the Dutch-born, Scottish colonial soldier John Gabriel Stedman include sixteen engravings by William Blake (1757–1827) that were based on Stedman's sketches. While aestheticized, and in some instances troublingly eroticized, they are among the most graphic and impactful representations of the horrors of slavery.

The socio-political order of the Caribbean changed dramatically in the nineteenth century. In 1791 a slave rebellion in Saint-Domingue, the wealthy French part of Hispaniola, escalated into a full-scale revolution led by the former slave

17

Toussaint L'Ouverture. His successor, Jean-Jacques Dessalines, proclaimed Saint-Domingue's independence in 1804, changed the country's name to Haiti (its ancient Taíno name) and permanently abolished slavery. While prompted by the French revolutionary ideology of Liberté, Egalité et Fraternité, the Haitian Revolution was in effect the only successful slave revolt in Caribbean and American history. Haiti was the second nation in the Americas, after the United States, to become independent and the effects of the Haitian Revolution was felt throughout the hemisphere – Simón Bolívar's campaign to liberate Venezuela from Spanish rule, for instance, set out from Haiti in 1816, with assistance from southern Haiti's president Alexandre Pétion. The Spanish-speaking, predominantly coloured eastern part of Hispaniola seceded from Spain in 1821 but was in turn occupied by Haiti. The area became independent as the Dominican Republic in 1844. The United States, which was rapidly becoming the dominant hemispheric power, declared its interest in the region with the Monroe and Manifest Destiny doctrines of the 1820s and began to influence economic and political developments.

The aftermath of the Haitian Revolution, along with the declining profitability of the plantation system and the Abolitionist campaigns, prompted the abolition of slavery throughout the Caribbean. The Dutch were the first to do so in 1820, Britain followed in 1834, France in 1848 and Cuba was the last country in the Western Hemisphere to start the process in 1880. To provide new labour for the plantations, indentured workers were brought in, mainly from India and China, but also from West and Central Africa, Madeira, Ireland and, in the case of Surinam, Java. Towards the end of the century, Lebanese and Syrian merchants also settled in the Caribbean, many of them Christians and Jews who were seeking to escape persecution in the late Ottoman empire. These new migrations added to the ethnic, racial and cultural diversity of the region.

Significant artistic developments took place along with these momentous social changes and, although not much is left, the artistic production of revolutionary Haiti is of special interest. Haiti's new black and coloured rulers were active art patrons who commissioned portraits, history paintings and religious works from Creole, European and even American artists, including the Englishman Richard Evans, who is best known for his portrait of Henri Christophe (*c.* 1817), the king of northern Haiti. Evans ran an art school, one of several small, short-lived academies established in Haiti during the post-revolutionary period, at the king's legendary Sans Souci Palace.

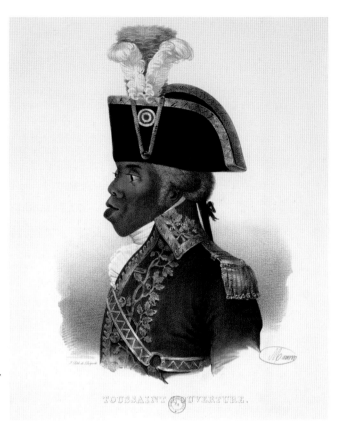

18 Nicolas
Eustache Maurin,
*Toussaint
L'Ouverture,*
early nineteenth
century

Although these artists and their patrons emulated French
and English academism, significant shifts took place: for
the first time in Caribbean art, black and coloured people
were routinely represented with the decorum and respect
for individual personhood until then reserved for the white
colonial elite, instead of as subordinates, curiosities or
victims. An eyewitness report describes religious paintings
in the chapel of Sans Souci in which Christ and Mary were
represented as blacks – it is thus justified to speak about a
Haitian revolutionary aesthetic that prefigures the artistic
ideas of early twentieth-century black nationalists such as
Marcus Garvey.

18

The extant portraits of Toussaint L'Ouverture date from
around or after his death in 1803 in a prison in the French
Alps and were made by artists outside of Haiti, based on
contemporary descriptions. Several of these can only be
described as caricatural and racist, as part of efforts to

19 Sir Harry Johnston, Photograph of a 'voodoo shrine', Haiti, 1908–9

vilify the Haitian Revolution as an act of savagery. Two prints, both published in Paris, have been particularly influential on the subsequent iconography of Toussaint and the Haitian revolution: an anonymous equestrian portrait that represents him in heroic fashion and an 1856 print by the French artist and historian Joseph Saint-Rémy, although this image has elements of caricature. The equestrian portrait not only resonates with the representation of French revolutionary figures such as Napoleon, who was Toussaint's main opponent, but also with the iconography of Ogou, the Vodou *loa* (spirit) of metal and war (Ogou's identity and representation are syncretized with the Roman Catholic saint, Saint Jacques, who is conventionally represented as an equestrian warrior). These two images continue to inform how Toussaint L'Ouverture is represented today, in popular and mainstream art alike, a fact that illustrates the endurance of the Haitian revolutionary iconography in the modern era.

19

A photograph of around 1908–9 of an Hounfort, or Vodou temple, by the English photographer-explorer Sir Harry Johnston, illustrates that this revolutionary iconography is also evident in the popular culture and has influenced Vodou, which is not surprising since the religion played an important role in the uprising that led to the Haitian Revolution. Certain *loas* (Vodou divinities) are customarily represented in the military and naval uniforms from the time of the revolution. Toussaint and Dessalines even became part of the Vodou pantheon.

Little is known about pre-twentieth-century popular art in the Caribbean, not only because of the culturally repressive nature of plantation colonialism but also because much of it was not recognized and preserved as 'art'. Modern African Caribbean religions such as Haitian Vodou and Cuban Santería use a remarkable array of sacred arts, but the oldest surviving objects date from the mid-nineteenth century, so their earlier history has to be reconstructed from descriptions in historical documents. Some of these sacred arts are ephemeral, such as the altar installations and intricate *vèvè* ground drawings of Vodou, or are kept in secrecy, which is consistent with their ritual purpose and imposed prohibitions. The forced evangelization of the slave population in the colonies of Roman Catholic countries is one of the reasons why many African Caribbean religions appropriated mainstream Roman Catholic iconography. In Vodou and Santería, for instance, popular images of saints acquired a double meaning and came to represent divinities of African origin – the Cuban patron saint El Virgen de la Caridad del Cobre also represents Ochún, the Yoruba-derived goddess of love.

Among these popular sacred arts, the Puerto Rican *santos* carving tradition is unusually well documented. The *santos* are small woodcarvings of saints invoked for assistance in domestic rituals – small silver ex votos are often attached. The tradition can be traced back to the late eighteenth century and has survived into modern times. Many were made by artist families whose skills were handed down the generations, like the Rivera family which was active from the mid-nineteenth to the mid-twentieth century. Most *santos* follow conventional Roman Catholic iconography, although there are some interesting transformations – the Three Magi, for instance, were particularly popular with black Puerto Ricans because of the presence of a black figure. In Puerto Rico, Melchior is the black king instead of Balthazar. Another notable type is La Mano Poderosa, an allegorical representation of the genealogy of Christ consisting of a hand, with each finger surmounted by a tiny representation of a member of the Holy Family. The Puerto Rican scholar Doreen Colón Camacho has suggested that the image is of Franciscan origin. It may also be possible to trace the image to the Islamic influences in Iberian and

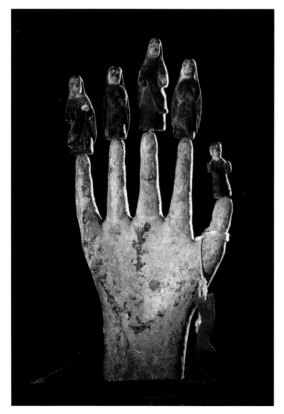

20 LEFT Caban group (Puerto Rico), La Mano Poderosa, c. 1875–1925
21 OPPOSITE Víctor Patricio de Landaluze, *Día de Reyes en la Habana* (*Epiphany Day in Havana*), second half of nineteenth century

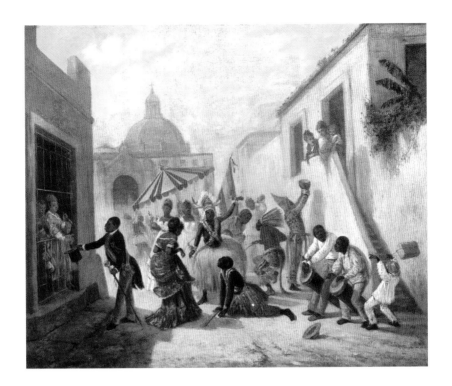

African culture since, in the Islamic world, the hand symbol is associated with the immediate family of the Prophet Mohammed. Hand symbolism appears frequently in the popular religions and occult practices of the Americas.

Caribbean popular painting and sculpture traditions are closely related to the festival arts, especially carnival and other masquerades. Most of the information we have about the earlier history of these traditions was recorded by mainstream artists interested in the picturesque – for instance, the principal historical source on Jamaica's Christmas-time Jonkonnu masquerade is the *Sketches of Character* (1837–38) series of lithographs by Isaac Mendes Belisario. Similar interests are evident in the work of the Spanish-born painter and caricaturist Víctor Patricio de Landaluze, who came to Cuba in 1852. Landaluze is the best-known Cuban exponent of *costumbrismo*, the documentation of picturesque customs and physical types – a significant trend in Latin American painting and literature during the nineteenth century. While also indebted to Francisco Goya's early work, Landaluze's images relate closely to the picturesque depictions of popular Cuban life found on cigar-box labels and in the work of contemporaries

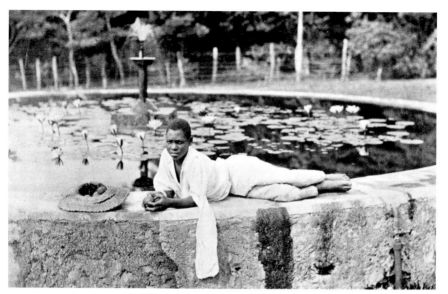

22 ABOVE James Valentine and Sons, *A Young Jamaican*, 1912
23 OPPOSITE Paul Gauguin, *La Cueillette des Fruits, ou Aux Mangos*
(*The Mango Trees, Martinique*), 1887

such as the French-born printmaker Frédéric Mialhe (1810–1881),
who was active in Havana from 1838 to 1854. Like Belisario,
Landaluze is important for his documentation of Afro-Cuban
cultural traditions in paintings such as *Epiphany Day in
Havana*. The racist, caricatural nature of his work, in which
the coloured woman is consistently depicted as a willing object
of male desire and the black man as a fun-loving buffoon,
however, also reflects the racial prejudices and dynamics of
nineteenth-century Cuba.

Photography appeared early in the Caribbean. Jamaica's
first photographer was Adolphe Duperly (1801–1865), a French
printmaker who had come to Jamaica in 1824 via Haiti and
who lithographed Belisario's *Sketches of Character*. Duperly
introduced the daguerreotype to Jamaica around 1840. By the
late nineteenth century, several photographic firms were active
in Jamaica and itinerant photographers also visited, which is
consistent with developments elsewhere in the region. The
introduction of photography revolutionized image-making
in the Caribbean and turned it into a thriving business.
Photographic portraits of middle-class black Caribbeans
became commonplace, as they were more affordable than
painted portraits, something that changed the representational
politics of the colonial era by creating a growing visual record

of black persons represented on their own terms. Many early photographs of the Caribbean were, however, produced for the emerging tourism industry. As the Bahamian art historian Krista Thompson argues, photography helped to construct a tropical Caribbean imaginary for the consumption of tourists, consisting of a problem-free, bountiful Edenic space and a receptive, suitably exotic and premodern 'native' population. Before the invention of the portable camera, tourists bought photographs from local firms to compile into photo-albums that documented their travels. Among the firms that produced and sold such photographs in Jamaica, along with their own publications of the sights of the country, were A. Duperly and Sons and the Scottish photographers James Valentine and Sons.

22

Technological developments resulted in increased mobility and communication between Europe and the region. During the latter part of the nineteenth century, several well-known European artists travelled to the Caribbean. Among them was Paul Gauguin (1848–1903), who visited Martinique and Panama in 1887. This was his first venture into the tropics and his stay in Martinique was the decisive moment in the development of his mature style and consolidated his interest in the exotic. He had no obvious contemporary influence in the region, but the influence of his work and ideas is evident in the nationalist Caribbean schools of the early twentieth century.

23

American artists also visited the Caribbean. This included the Hudson River School painter Frederic Edwin Church

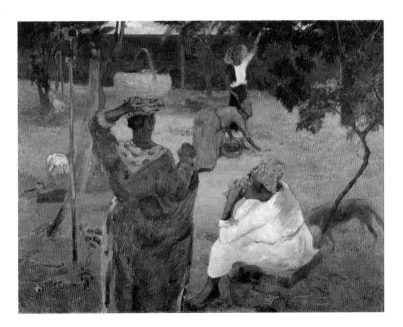

(1826–1900), who visited Jamaica in 1865 and produced a series of atmospheric tropical landscapes that infused his interest in natural science with the Romantic sublime. Winslow Homer (1836–1910) visited the Bahamas and Cuba repeatedly during the latter part of his life. The works he produced in response to these visits represent a striking departure from the idyllic, descriptive approach prevailing in pre-twentieth-century Caribbean landscape and genre art. His most famous Caribbean painting, *The Gulf Stream* (1899), dramatically represents humanity's powerlessness against the unpredictable, violent side of nature. Homer's watercolours of Caribbean fishermen and sailors also prefigure the heroic representations of the black working-class male in nationalist twentieth-century Caribbean, especially Jamaican, art.

Several well-known nineteenth-century European artists were born in the Caribbean: for example, the French painters Théodore Chassériau (1819–1856), who was born in what is now the Dominican Republic, and Camille Pissarro (1831–1903), whose family were Sephardic French who lived on the Danish island of St Thomas. While Chassériau's birthplace is of limited relevance to his work, some of Pissarro's early work relates directly to his Caribbean background, specifically the drawings and paintings done during, and shortly after, his travels to St Thomas and Venezuela between 1852 and 1855.

The painter Michel-Jean Cazabon (1813–1888) belonged to the influential 'French Creole' class of Trinidad, descendants of white and coloured Martiniquans who had settled in Trinidad at the invitation of the Spanish government shortly before the island became British in 1797. Cazabon, who was a person of colour, studied art in Paris and exhibited there at the salons. He returned to Trinidad in 1852, where his work was patronized by the Creole elite, but lived in Martinique from 1862 to 1870 in search for a more metropolitan environment. Cazabon left behind an eclectic œuvre that includes genre scenes that capture the ethnic and cultural changes in Trinidad at the time of the East Indian immigration, but he was foremost a landscapist. Influenced by French Romantic and Realist landscape painting, he was at his artistic best in his luminous watercolour landscapes, which often have an early modernist quality with tautly structured compositions and stylized details.

Although Cazabon worked in relative isolation, he was not the only landscapist in the Caribbean to move from the topographical and documentary to the Romantic and post-Romantic landscape. In Cuba, painters such as Esteban Chartrand (1840–1883) and the Belgian Henri Cleenewerck (1818–1901) sought to represent the dramatic essence of the

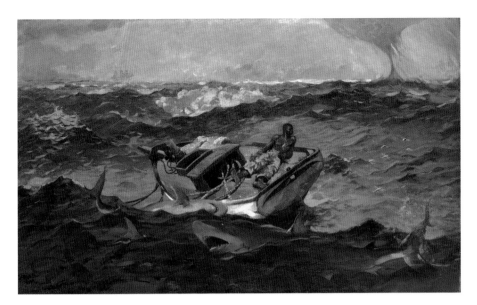

24 TOP Winslow Homer, *The Gulf Stream*, 1899
25 ABOVE Michel-Jean Cazabon, *Bamboo Arch*, c. 1840–50

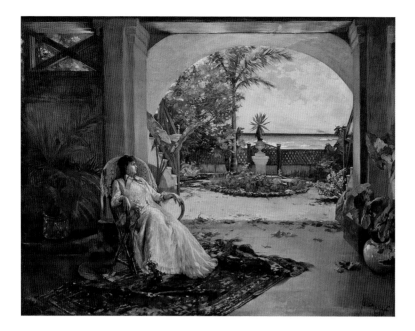

26

Cuban landscape rather than its anecdotal details. Comparable shifts are evident in the urbane, intimate portraits and figure scenes of Guillermo Collazo (1850–1896), whose *The Siesta* (1886) is an evocative, atmospheric depiction of the lifestyle of the wealthy Havana bourgeoisie. These artists are associated with an identifiable Cuban school that appeared during the nineteenth century. The cohesiveness of this school can be attributed to the San Alejandro Academy in Havana, which was founded in 1817. Its first director was the French painter Jean Baptiste Vermay (1786–1833), a student of Jacques-Louis David. The academy still functions today and is the oldest art school in the Caribbean.

While their work reflects the development of an indigenous gaze, which was committed to the Cuban environment, the apolitical, socially conservative nature of nineteenth-century Cuban art is striking, despite Cuba's lengthy independence struggle. Collazo belonged to a pro-independence family from eastern Cuba and so spent much of his adult life in the United States and France, yet this background is not apparent in his Cuban work. By the turn of the century, artists began to respond overtly to the social and political changes. Two academic painters, Armando Menocal (1863–1942) and Eduardo Morales (1868–1938), fought on the side of the Independistas and produced several paintings on the heroic events of the

Ejército Libertador, the final stage of the Independence Wars in which the ideological and strategic leader of the movement, José Martí, lost his life. Others, such as José Joaquín Tejada (1867–1943) and Juana Borrero (1877–96), turned towards the urban working class for their subjects. Only three works survive from Borrero's short career, but her best-known painting, *Pilluelos (The Little Rascals)* (1896), is often cited as a significant step in the development of modern Cuban art because it depicts Afro-Cubans sympathetically, in keeping with Martí's doctrine of racial solidarity.

The work of the Puerto Rican painter Francisco Oller (1833–1917) illustrates similar shifts in the underlying ideologies in mainstream Caribbean art. Oller studied in Spain and France and spent most of his life travelling restlessly between Puerto Rico and Europe. A friend of Camille Pissarro and Paul Cézanne, he is sometimes credited with bringing Impressionism to Spain. Although his landscapes retained Impressionist overtones, the work Oller produced in Puerto Rico was in essence realist and influenced by the style and ethos of Gustave Courbet. Oller made several short-lived attempts at establishing an art academy in San Juan and articulated ideas about a national art. In a speech to the students of the Normal School in San Juan in 1906, he stated: 'The artist must participate in the epoch in which he lives; if he wants to be authentic, he must be of his country, of his people.' His most ambitious painting, *The Wake* (1893),

27

28

26 OPPOSITE Guillermo Collazo,
The Siesta, 1886
27 RIGHT Juana Borrero,
Pilluelos (The Little Rascals), 1896

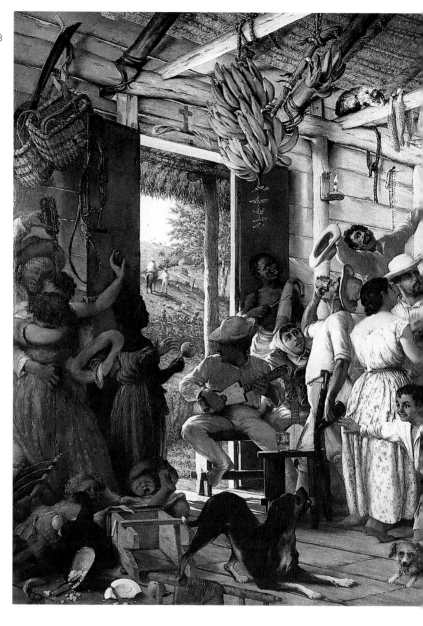

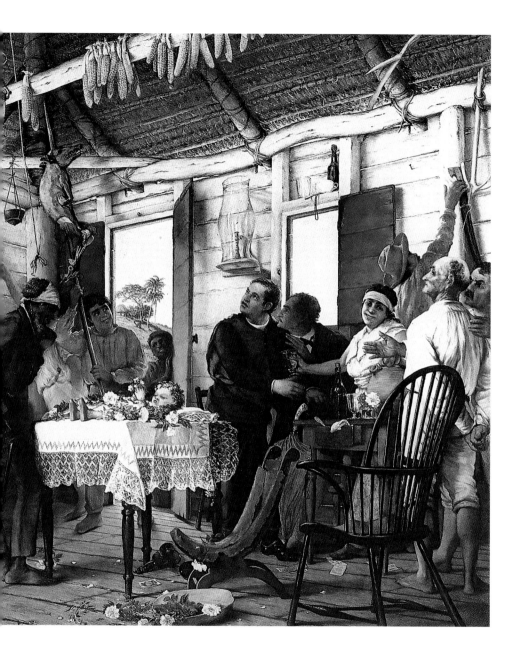

exemplifies these views. It depicts a custom of the Puerto Rican peasantry – a festive vigil held to usher a dead child into afterlife – not for its picturesque interest, but as a reflection of the artist's social and cultural commitments. Surprisingly, Oller's statement that accompanied the work to the 1895 Paris Salon condemned the practice as 'an orgy of brutish appetites under the guise of a gross superstition'. This dismissal may be explained by the social and cultural distance between the peasantry and the educated upper class to which Oller belonged and, perhaps, his insecurities about the European public's response to the subject. Before it was exhibited in Paris, the work was also shown in Havana, where it was well-received by the Cuban intelligentsia. Oller's ideas may be rooted in European Romanticism and Realism but their application to the Caribbean, with all the ambivalence and contradictions this involved, represents a turning point and prefigures the nationalist schools of the first half of the twentieth century.

Chapter 2
Decolonization and Creative Iconoclasm

Public monuments and statues, because of their collective symbolic value, their fundamentally propagandist nature and association with power, and their visibility and accessibility in the public domain, often serve as a lightning rod for the social and political frictions that trouble the societies in which they stand. And, irrespective of their historical value and artistic merit (which varies significantly, as public statues are often uninspired works of art), many are indeed problematic representations that propagate oppressive and obsolete ideas, historical narratives and power structures. Such monuments are a form of symbolic and representational violence that is met with retaliatory counter-violence when they are defaced, torn down or transformed. In some instances, such interventions serve as symbolically powerful, performative acts of creative iconoclasm.

The year 2020 saw the forcible removal and defacement of several racist and colonialist public statues in the context of the Black Lives Matter uprisings and the associated Decolonial movement. Initially, the protests were limited to the United States, where several Confederate and colonial-era statues were targeted, but the iconoclastic wave spread to other parts of the globe along with the unrest. There have also been numerous new and revived campaigns to have certain problematic statues officially removed and replaced. This widespread iconoclastic fervour suggests that a major historical reckoning is in progress, in which an unjust but persistent political and ideological order is being fundamentally challenged. In such contexts, symbolic actions matter greatly, and careful attention should be paid to what is communicated and negotiated in the process.

By far the most publicized and visually eloquent of these 'take-downs' was the dramatic removal of the statue of the

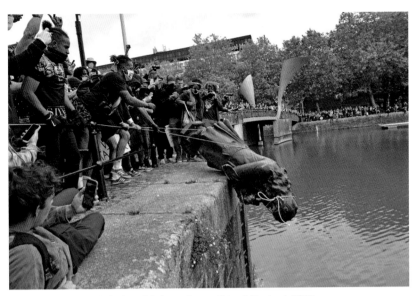

29 Removal of Edward Colston Statue, Bristol, England, 2020

29 pioneer slaver Edward Colston in Bristol, England, an 1895 bronze by the Victorian artist John Cassidy, which was pulled down from its base, splashed with blood-red paint, rolled down the streets and dumped into the River Avon by a group of protesters. As several observers have noted, there were haunting parallels with the manner in which ill or rebellious enslaved persons were thrown overboard from slave-ships, resulting in a kind of symbolic justice.

The toppling of the Colston statue attracted significant attention in the international media and may have spurred actions and campaigns against other statues. Soon after, the Mayor of London, Sadiq Khan, announced the establishment of a Commission for Diversity in the Public Realm to make recommendations on the removal of statues of slavers around London, along with other problematic colonial-era markers and street names, and their replacement with initiatives that more appropriately reflect the city's diversity. This initiative may include a long-overdue slavery museum and a Windrush memorial – the Empire Windrush was the ship on which the first major group of Caribbean migrants arrived in England in 1948, marking the beginning of post-war migration from the Caribbean and elsewhere in the colonial world, and it has become a symbol of the social changes and conflicts that occurred alongside. A statue of the slaver Robert Milligan was removed from outside the Museum of London Docklands

in the summer of 2020 and two more such statues, of William Beckford and John Cass, are due to be removed from the City of London Guildhall.

In Oxford, protesters have long demanded the removal of a statue of the imperialist Cecil Rhodes from the University's Oriel College – an interesting case given the prestigious Oxford scholarship that is named after him. Many key intellectuals in the Anglophone Caribbean are, ironically, Rhodes scholars and the question therefore arises whether this scholarship should also be renamed. In the summer of 2020 Oriel College announced that the statue of Rhodes would be removed but nearly a year later controversially reneged on that decision, citing government planning and heritage policies.

It is worth taking a closer look at the removal of the Colston statue in Bristol, as this statue exemplifies the deeply problematic nature of many colonial monuments. The dedication plaque reads as follows: 'Erected by citizens of Bristol as a memorial of one of the most virtuous and wise sons of their city'. That a person could be involved in the brutal Transatlantic slave trade and related exploitative mercantile activities, as the main source of his wealth, and still be lauded as an exemplary city father and philanthropist, illustrates the blind spots of history, as it has been conventionally narrated and understood in the west.

The statue had been a source of contention for many years, in a city with a very active civil society and a large, restive black population, many of whom are of Caribbean descent, and there had been numerous calls for its removal or recontextualization. A municipal decision to replace its dedication plaque with one that would speak to Colston's role in the development of the slave trade was delayed for years, because of disputes about the wording and who should appropriately write it – the representational stakes are extremely high in such matters and progress is paralysingly slow.

There had also been several artistic interventions into the Colston statue. Perhaps the earliest of these, in 2006, was by the Guyanese Scottish artist Hew Locke (b. 1959), who overlaid a large-scale photograph of the statue with symbols of the fabled riches Colston had accrued. In 2018 the statue was 'yarn-bombed' with a giant ball-and-chain knitted in red wool and attached to the figure's legs, a clear reference to Colston's role in slavery that also drew subtly humorous attention to the figure's improbable pose and expression. While rarely destructive and usually impermanent, yarn bombings are gendered 'craft' interventions that use visual humour to talk back to power in ways that also question and subvert the stodgy, patriarchal 'high art' status of monumental sculptures.

That same year, an installation consisting of life-size figures laid out in the familiar shape of a slave ship diagram appeared at the base of the statue – many felt that this unsanctioned, 'guerrilla' intervention, which aptly contextualized the historical significance of the statue, should have been kept permanently. And soon after the statue's removal in 2020, the graffiti artist Banksy, who is from Bristol, suggested in an Instagram post that the discarded statue could be repurposed in a monument to its removal – it was not clear whether he was serious, but he was onto something. What these examples illustrate is that the meaning of colonial and racist statues can be effectively questioned and altered with creative interventions that do not always have to involve destruction or permanent removal. Indeed, it is not necessarily advisable to silence what has been a momentous part of history, no matter how problematic and contentious.

The Caribbean is replete with statues that represent similar ideas about white supremacy and colonialism. Many of these statues date from the plantation era or its immediate aftermath – such as the statues of Queen Victoria that were erected throughout the Anglophone Caribbean, as part of a campaign throughout the British Empire to honour her supposedly benign and beneficial rule and role in the abolition of slavery. Others, such as the Columbus Lighthouse in Santo Domingo, which was unveiled in 1992, are of more recent date and are associated with oppressive political regimes in the postcolonial era. Calls have been mounting, as the recent iconoclastic upheaval inevitably – and necessarily – resonates in the Caribbean, to take down several of those statues.

There was a long-standing campaign in Barbados, for instance, to remove the bronze statue of Lord Nelson by Richard Westmacott, dated 1813. It stood for more than two hundred years on what is now called National Heroes Square (formerly Trafalgar Square) in Bridgetown, provocatively positioned in front of the Parliament building. Nelson was not only instrumental in the military defence of British interests in the Caribbean, but he was an outspoken defender of colonialism and slavery. His wife Frances 'Fanny' Nelson came from the Caribbean plantocracy, on the island of Nevis. The statue was repeatedly covered with protest graffiti and, in 2018, there was a commissioned intervention by Hew Locke into a photographic facsimile of the statue for the 'Arrivants' exhibition at the Barbados Museum and Historical Society, a work that unambiguously associated Nelson's persona and statue with the history of slavery and the slave trade. The actual statue was moved in late 2020 to the Barbados Museum and its

30

30 Hew Locke, *Nelson*, 2018, Barbados Museum and Historical Society

31 Errol Ross Brewster, *Discarded Statue of Queen Victoria Mounted by Children of Empire*, 1981, Botanical Gardens, Georgetown, Guyana

base now stands empty, waiting for a replacement that is more appropriate to postcolonial Barbados.

There is, however, a longer history of protest actions against such statues in the Caribbean, usually at times of socio-political upheaval. In Georgetown, Guyana, the Queen Victoria statue in front of the High Courts building was dynamited in 1954. It was subsequently restored, and the statue remained in place until 1970, when Guyana became a Corporate Republic (the country had become independent in 1966) and the statue was moved to the back of the Georgetown Botanical Gardens. A 1981 photograph by the Guyanese artist Errol Ross Brewster (b. 1953) captured a group of children playing and clambering on the statue there, with a girl irreverently seated on its head – an implied but potent decolonial statement that suggests that the colonial Empire the statue once represented had lost its symbolic hold over the local population.

The 1954 dynamiting, which had only partially damaged the statue – blowing off its head and left arm, along with the sceptre and orb – was a protest against colonial rule, at a time when Guyana was going through a period of leftist political radicalization which was countered with active repression by the colonial authorities (the specific trigger was the 1953 election victory of the then radical, anti-colonial People's Progressive Party). The marble statue, which dates from 1894 and was made by the English artist Henry Richard Hope-Pinker, was restored a second time and reinstalled in its original location in 1990 in what may have been a way of suggesting that Guyana had moved past its politically radical phase and was again 'open for business' and foreign investment. It remains in place today, but its re-installation generated much debate as many considered this a backward step, and there has been at least one new incident surrounding it, when it was splashed with red paint in 2018.

The dynamiting of the Georgetown Queen Victoria statue is the only major, politically motivated protest act against a colonial-era statue in the Anglophone Caribbean to date. There is, however, an interesting counterpart in Fort-de-France, Martinique, where the marble statue of Empress Joséphine was decapitated in 1991 and subsequently also splashed with blood-red paint. Joséphine was born to a planter's family in Martinique and is one of the island's most famous historical figures. Her statue in Fort-de-France was completed in 1859 by the French Empire sculptor Gabriel-Vital Dubray. Martinique is, since 1946, an Overseas Department of France, and this ambivalent neo-colonial status is a source of significant social, racial and cultural tension. There is an active separatist

movement, spearheaded by the Martinique Independence Movement, a left-wing party which is represented on the Regional Council of Martinique and in the French Parliament. The beheading of the statue of Joséphine needs to be seen in the context of this separatist agitation, with Joséphine being targeted as a symbol of Martinique's colonial history and continued dependence on France.

The beheading of the statue also makes more specific historic references. Joséphine's first husband, Alexandre de Beauharnais, was the son of one of Martinique's colonial governors and had been sent to the guillotine in 1794. Slavery had been briefly abolished by the French Revolutionary government in that same year but was re-established in 1802 by Napoleon, a decision which, it is believed, was influenced by Joséphine and her family. This makes Joséphine a controversial historical figure in Martinique, even though her name and image are very present on the island, especially in the tourism industry. Slavery was finally abolished in the French colonies in 1848. The decapitation of the Joséphine statue thus also references the tensions, historic and present-day, between the black majority population of Martinique and the planter class and, for that matter, the tourism industry.

Interestingly, there were no attempts at restoring the beheaded and splattered statue and it was kept on view 'as is', as well as being moved from its original location in the centre of La Savane Park to a more visible spot near the edge of the park. The beheaded statue thus made a very potent political statement that was dramatically different from what was originally intended, effectively becoming a critical counter-monument. Perhaps it took the surrealist imagination of Fort-de-France's poet-mayor, Aimé Césaire, to recognize this symbolic potential. Nevertheless, in the summer of 2020, the statue was destroyed by a group of activists who also tackled other colonial monuments in Martinique.

There is hardly an island in the Caribbean that does not have a Christopher Columbus statue, and some have more than one. Earlier colonial monuments in the Caribbean usually focused on historical figures who had played more specific roles in securing Caribbean territories for the dominant colonial interests; monarchs of the colonizing states; and figures of local interest, such as colonial governors. The consecration of Columbus as a key figure in Caribbean history, in contrast, does not have such a long history, and most of these Columbus statues date from the late nineteenth or early to mid-twentieth century. A few are of even more recent vintage. These statues are related to modern efforts to position

32 Gabriel-Vital Dubray, *Joséphine de Beauharnais* (beheaded), La Savane Park, Fort-de-France, Martinique, photograph taken in 2012

the Caribbean, and specific Caribbean countries such as the Dominican Republic, as the birthplace of the 'New World'. Creating tourist attractions has also been a consideration in some of the more recent commissions. Columbus is, however, a highly controversial historical figure, whose arrival in the Caribbean marked the start of a violent, genocidal and brutally exploitative colonization process that changed that part of the world beyond recognition. The 1992 Columbus Quincentennial generated intense debate around this legacy, and the anniversary was boycotted by many in the Caribbean or treated as an occasion for historical reflection and critique rather than celebration.

Not surprisingly, Columbus monuments throughout the Americas have been the target of protest actions for several decades now, although authorities have been slow and hesitant to respond. Demands for their removal have come mainly from Native American activist groups, although other groups, events and ideologies have also contributed their voices to the debate. The Columbus statue on the Port-au-Prince waterfront in Haiti, for instance, was toppled and thrown into the sea by demonstrators in 1987, as part of the *déchoucage* campaign which tackled various symbols of oppression at the end of the 'Baby Doc' Duvalier dictatorship. It has not been reinstalled since then, although the statue itself was salvaged.

This decisive dismissal in Haiti, which was de facto sanctioned by its new government, stands in contrast with the strong official investment in the figure of Columbus in the Dominican Republic, where several monuments, buildings and sites are dedicated to Columbus and his legacy and heavily promoted as such. Tourist guides to the capital city of Santo Domingo proudly state that the city was founded in 1496 by Christopher Columbus's brother, Bartolomé, and is the oldest continuously inhabited European settlement in the Americas. The Dominican Republic sought to play a lead role in the Quincentennial, which was also highlighted as the moment of the arrival of Christianity in the Americas, and the occasion involved a visit by Pope John Paul II. This investment in Columbus is, however, also related to how this country has positioned itself as a predominantly white and racially mixed society, in opposition to its neighbour Haiti, the first Black Republic in the Americas. Celebrating Columbus, by implication, also justifies the colonial project and its aftermath as a benevolent, civilizing mission, glossing over genocide, slavery and other forms of major human exploitation in the process.

This is exemplified by the 1887 statue of Columbus, by the French sculptor Ernesto Gilbert, which stands in front of

Santo Domingo's cathedral in the Zona Colonial – the oldest cathedral in the Americas, and itself a symbol of the arrival of Christianity in the hemisphere. This statue was a gift from France which was, no doubt, still smarting from the loss of Saint Domingue. The iconography of the statue is particularly troubling and features a small female Taíno figure, presumably the female warrior chieftain Anacaona, who is clambering well below Columbus's level on the base. Anacaona was executed by hanging in 1504, at what was then the plaza of Santo Domingo, but there is no acknowledgment of this violent history in the statue's design, and the gender, race and ethnic subjugation of the Taíno figure are naturalized to the point where it is represented as beneficent. Indeed, the figure is shown using her finger to inscribe 'Illustre y Esclarado Don Cristoval Colon' ('the illustrious and enlightened Christopher Columbus') onto the statue's base, alluding to the presumed (though clearly misrepresented) role of colonialism in bringing literacy and civilization to the Americas.

The modern Dominican Republic has a history of bloody, repressive military dictatorship under Rafael Trujillo, from 1930 until his assassination in 1961, and of less repressive authoritarian government under Trujillo's associate Joaquín Balaguer, who was president, with some interruptions, from 1966 to 1996. The Trujillo dictatorship is infamous for the so-called Parsley Massacre in 1937, in which as many as 30,000 Haitian migrant labourers were killed, mostly along the Dominican-Haitian border.

33 The history of the Faro a Colón (or Columbus Lighthouse) – a gigantic architectural monument in Santo Domingo eventually inaugurated in 1992 but associated with the Trujillo regime – started in the early twentieth century, when ideas began to circulate that the Dominican Republic should be the site for a major monument to memorialize Columbus's arrival in the Americas and that this should take the form of a monumental beacon. The actual project was initiated at the Fifth International Conference of American States in 1923, held in Chile by the Pan American Union (reconstituted in 1948 as the Organization of American States), and the original plan was that all member states would contribute. An architectural competition was organized, with judging taking place in Brazil in 1931 and featuring such eminent judges as Eliel Saarinen and Frank Lloyd Wright. The proposal selected was by the Scottish modernist architect Joseph Lea Gleave. Construction finally began in 1948, during the Trujillo regime, but was halted when the promised international contributions were not forthcoming. The project was revived by the Dominican Government in 1986,

33 Faro a Colón (Columbus Lighthouse), Santo Domingo, Dominican Republic

under Balaguer, and rushed to completion for the 1992 Columbus Quincentennial.

Gleave's plan, which was executed under the oversight of the Dominican architect Teófilo Carbonell, was for a giant cross-shaped beacon that would also serve as a mausoleum for the presumed remains of Columbus (which Seville in Spain also claims to have, and more credibly so), but it now also aspires to serve as a museum of world cultures, with half-hearted displays contributed by a few countries. The structure is about half a mile long and 190 feet high and its beacon consists of 157 powerful light beams, which can be seen from space when turned on. The beacon has its own power plant, even though the Dominican Republic has major power generation challenges and power outages are a frequent occurrence. The construction is estimated to have cost 70 million dollars and some 50,000 inner-city dwellers were displaced to facilitate its construction.

Conceived as an uncritical, quasi-utopian tribute to the emergence of the New World, the Faro a Colón – its monumental structure all too vividly reminiscent of Fascist architecture – represents a disturbing incursion into the Caribbean environment and represents a level of social, cultural and fiscal irresponsibility for which it has been severely criticized, both locally and internationally. 'Anti-Faro' demonstrations in 1992 cost two lives. Because of its enormous size, it is unlikely that it will ever be demolished, and its architecture is too impractical for it to be repurposed usefully.

The story of the most recent Columbus monument to be erected in the Caribbean, *The Birth of the New World* (2016), a giant steel sculpture in Arecibo, Puerto Rico, is no less troubling. It was created by the controversial Georgian-Russian sculptor Zurab Tsereteli (b. 1938), who is notorious for the gigantic, intrusive monuments he has sought to donate to and erect in various parts of the world. *The Birth of the New World* was originally conceived in 1991, with the Columbus Quincentennial in mind, and Tsereteli first proposed it to various American cities – Baltimore, Fort Lauderdale, Miami, New York City and Columbus, Ohio – all of which declined. In 1998 it was offered to the municipality of Cataño, near San Juan in Puerto Rico, which spent 2.4 million dollars in public funds to import the statue. This marked the start of significant public expenditure on this project, which has itself been the subject of several investigations and ongoing controversy.

After years of back and forth about costs and location, it was finally decided to erect the statue in Arecibo, along the Atlantic coast of Puerto Rico, to be part of a planned Columbus

theme park. There was an attempt at halting its installation by means of a petition by the United Confederation of Taíno People, which stated plainly that: 'Columbus is a symbol of genocide, not a hero to be celebrated.' The installation nonetheless went ahead in 2016 and *The Birth of the New World* is now the tallest statue in the Western Hemisphere – at 360 feet it tops the Statue of Liberty in New York City and Christ the Redeemer in Rio de Janeiro. Like the Faro a Colón in Santo Domingo, it serves mainly as a tourist attraction. The cost of this project, which is estimated at 90 million dollars thus far, is particularly problematic in this neglected US dependency that has struggled with its economic sustainability in recent years. In Puerto Rico, as in the Dominican Republic, this mega-monument to Columbus is associated with deep failures of governance, and both stand as tragically expensive, culturally tone-deaf monuments to the troubled socio-political histories of these two countries.

The cultural politics that surround statues to Columbus have been a major preoccupation in the work of Joiri Minaya (b. 1990), a contemporary Dominican American artist. In the Caribbean, this has included a proposal for the Columbus statue in front of Government House in Nassau, The Bahamas, as part of a 2017 project for the National Art Gallery of the Bahamas, but the artist's request for a temporary, non-destructive intervention into the statue, by wrapping it in colourful 'tropical' fabric, was turned down by the authorities. More recently, however, in 2021 as part of the Concurso de Arte Eduardo León Jimenes (a major art prize in the Dominican Republic), she has wrapped the Columbus statue in the Zona Colonial of Santo Domingo with a printed fabric that featured plants and flowers from the pharmacopeia and diet of the Taíno, thus symbolically restoring and reclaiming what was violently erased by Columbus and the colonial conquest – a major decolonial step, given the Dominican Republic's investment in the figure of Columbus.

Independent Caribbean states have sought to counter colonial legacies with monument commissions that represent postcolonial perspectives, but many of those have been controversial too, especially in Jamaica. The most significant such controversy in Jamaica pertained to *Redemption Song* by Laura Facey (b. 1954), which was unveiled in 2003 at the new Emancipation Park in New Kingston and which serves as Jamaica's de facto monument to Emancipation. The controversy surrounding *Redemption Song* revolved mainly around the nudity, passivity and lack of historical specificity of the statue's two figures, as well as around the identity of the artist as a wealthy, light-skinned Jamaican with roots in the plantocracy. Those concerns were amplified by

34

34 Laura Facey, *Redemption Song (Emancipation Monument),*
2003, Emancipation Park, Kingston, Jamaica

35 Jeannette Ehlers and La Vaughn Belle, *I Am Queen Mary*, 2017, public sculpture, Copenhagen, Denmark

the inherently contested nature of the monument's subject – the history and legacy of Slavery and Emancipation – and the intensive politics of representation that surround these subjects. Facey opted to present a hopeful image of unity and healing, but most of her critics wanted to see a more historically specific representation that focused on the heroic struggles for self-liberation that contributed to the end of slavery, thereby acknowledging the socio-economic and racial divisions that still exist in Jamaica. The authorities did not flinch in their support of the monument and the artist, and, while the controversy still lingers today, *Redemption Song* has become an established Kingston landmark. What happened with this statue, however, reflects a deep divide between the visual imaginary about Jamaican history and nationhood that is cultivated by Jamaica's mainstream artworld and the public's expectations and responses.

35 An interesting counterpoint was the erection of *I Am Queen Mary* (2017) in Copenhagen, Denmark, a collaboration between two contemporary artists: La Vaughn Belle (b. 1974), from the US Virgin Islands, and the Danish Trinidadian Jeannette Ehlers (b. 1973). The monument, which was part of a contemporary art exhibition project, is dedicated to Mary Thomas, the leader of the fiery, post-Emancipation 1878 'Fireburn' labour uprising that took place in St Croix in the Virgin Islands. Presented as a broader tribute to black resistance against colonialism and servitude, the statue's appearance is loosely modelled after Belle and Ehlers themselves, while the posing of the figure was inspired by the famous photograph of the Black Panther Huey Newton seated in a peacock chair. The *I Am Queen Mary* statue was a temporary intervention, meant to make visible a colonial history of which there is insufficient awareness in Denmark, but it has been well received by the public and may become a permanent bronze monument with the support of the Danish government – an indication that alternative, artist-driven approaches to monuments to colonial history may ultimately be more viable than restrictive official commissions that try to gloss over the contemporary tensions that surround the subject matter.

Chapter 3
Modernism and Cultural Nationalism

The 1920s and 1930s were decisive years in the development of modern Caribbean art. It was the heyday of nationalism globally, as new and old nations sought to find their place within a rapidly changing political, economic and social order. In the colonized world, there was a surge of anti-colonial and anti-imperialist sentiments. It is within this context that the first nationalist art movements of the Caribbean appeared.

Although forms of anti-colonial nationalism were also brewing among the peasantry and urban working class, anti-colonial nationalism in its narrow sense was spearheaded by the emerging Caribbean intelligentsia. Many of these intellectuals studied in London, Paris, Madrid or New York, or lived for extended periods in these cities that, paradoxically, became centres of international anti-colonial activism. Paris, in particular, attracted many artists, writers and intellectuals from the Caribbean, Latin America and Africa, which helped to steer Caribbean art towards modernism. The Martiniquan writer and politician Aimé Césaire, for instance, met the future Senegalese president Léopold Senghor there in the late 1930s, an encounter that led to the development of the Négritude movement, one of the most influential expressions of black cultural nationalism. Shortly before returning to Martinique, Césaire wrote the first version of his epic poem *Cahier d'un retour au pays natal* (Notebook of a Return to the Native Land) (1939), a masterwork of political surrealist poetry. Similarly, most Cuban Vanguardia artists lived in Paris for some time. Iconic Cuban paintings such as Víctor Manuel's *Gitana Tropical* (1929) and Eduardo Abela's *The Triumph of the Rumba* (c. 1928) were painted there.

Caribbean cultural nationalism is related to the Latin America movements that produced, among others, Mexican

36

36 Eduardo Abela, *El triunfo de la rumba* (*The Triumph of the Rumba*), c. 1928

muralism and Brazilian modernism. Hispanic Caribbean artists, in particular, were visibly influenced by the continental schools and several studied, lived or even taught in Mexico City. Caribbean modernism had its own character, however, and evolved in response to local circumstances rather than in imitation of the continent. Although there were some mural projects, muralism did not take hold in the Caribbean, because the necessary public or corporate patronage was not readily available and because there was evidently less concern with taking art into the public domain.

The relationship between Caribbean cultural nationalism and developments in African American culture is also significant. The migration of West Indians to North American cities contributed to this alliance and provided a new channel for intellectual and cultural exchanges. Claude McKay, a key literary exponent of the Harlem Renaissance, was Jamaican, as was the Pan-Africanist Marcus Garvey, the founder of the internationally active United Negro Improvement Association (UNIA). The UNIA was particularly influential in Harlem, where Garvey lived from 1916 until he was deported to Jamaica in 1927. Several important Harlem Renaissance figures travelled to the Caribbean, including the writer and anthropologist Zora Neale Hurston, who studied African Caribbean spiritual practices in Jamaica and Haiti as a Guggenheim fellow in the late 1930s.

The Caribbean nationalist intelligentsia paid considerable attention to the formulation of cultural ideologies such as Négritude that still influence the postcolonial discourse globally. Cultural self-affirmation was deemed a critical part of decolonization and art was recognized as a powerful nation-building tool. The national schools that emerged in this context were primarily concerned with the exploration of indigenous aesthetic values and national cultural identity. Many artists and intellectuals turned towards the culture of the masses as the paradigmatic national expression. Consequently, popular Caribbean culture was studied and documented, much of it for the first time. Previously neglected or even actively repressed African Caribbean traditions received special attention – this separates Caribbean cultural nationalism from its continental Latin American counterparts. The Cuban anthropologist and political activist Fernando Ortiz, for instance, advanced the recognition of Afro-Cuban traditions as an integral part of Cuban national culture and published several influential studies on the subject, one as early as 1906. The impact on Cuban art and literature was significant, and the movement was known as Afrocubanismo.

Despite the Indigenist preoccupation with the traditional, Caribbean cultural nationalism was a progressive, even utopian movement, dedicated to innovation, modernity and modernism. Artists sampled freely from Post-Impressionism, Symbolism, Expressionism, Cubism, Art Deco and, later, Surrealism and there was no sense that modernism uniquely belonged to the metropolitan western world – it is now well-recognized that artists from world areas such as the Caribbean and Latin America, such as Wifredo Lam, played an important role in its development and politics. Caribbean artists of that generation generally ignored the radical formalist and conceptual

explorations of early modernism – modernism was not an end in itself, but served as a vehicle for indigenous content. Paul Gauguin's romantic vision of the tropics was a pronounced influence on the nationalist schools. It may seem paradoxical that these schools espoused primitivism, with its close links to the western colonial world view, but early Caribbean modernists politicized the primitivist preoccupation with the 'native' in a nationalist context.

The educated Caribbean middle classes, to which most artists and intellectuals of the time belonged, were nonetheless socially and culturally isolated from the masses, and their appropriations of popular culture did not recognize the opaque, hybrid and often deeply subversive nature of popular culture. The Martiniquan author Frantz Fanon, who was one of the earliest critics of cultural nationalism, commented on this issue in *The Wretched of the Earth* (1961) where he wrote: 'The culture that the intellectual leans towards is often no more than a stock of particularisms. He wishes to attach himself to the people; but instead he only catches hold of their outer garments. And these outer garments are merely the reflection of a hidden life, teeming and perpetually in motion.' The Indigenist use of popular culture indeed sometimes amounted to latter-day *costumbrismo*. Wifredo Lam sought to move beyond this dilemma and told Max-Pol Fouchet, the author of a 1976 monograph on his work, about Cuba in the 1940s:

Havana was a land of pleasure, of sugary music, rumbas, mambos and so forth. The Negroes were considered picturesque…I refused to paint chá-chá-chá. I wanted with all my heart to paint the drama of my country, but by thoroughly expressing the Negro spirit, the beauty of the plastic art of the blacks. In this way I could act as a Trojan horse that would spew forth hallucinating figures with the power to surprise, to disturb the dreams of the exploiters.

The Cuban Vanguardia, which was comprehensively documented in *Cuban Art and National Identity* (1994) by Juan A. Martínez, emerged during the repressive regime of Gerardo Machado (1924–33), a period of intense political and cultural activism among young Cuban intellectuals who rediscovered the pro-independence ideas of José Martí as well as Communism. Their concerns were summarized in the 1927 manifesto of the Grupo Minorista, an influential dissident group. Part of it reads:

Collectively or individually, our nucleus has fought and is still fighting: for the revision of false and outmoded values; for popular art and, in general, new art in all its diverse forms; for

the introduction and dissemination in Cuba of the latest artistic and scientific doctrines, theory and praxis...for Cuban economic independence. Against Yankee imperialism. Against political dictatorships throughout the world, in the Americas, in Cuba.

The signatories included the writer and musicologist Alejo Carpentier, the painters Eduardo Abela (1889–1965) and Antonio Gattorno (1904–1980), and the sculptor Juan José Sicre (1898–1972). The anti-American tone of the manifesto should be no surprise since Cuba was a major target of US interventionism in the Greater Antilles. The United States had gained control over Cuba and Puerto Rico in 1898 after the Spanish-American War and in 1902 Cuba became an independent republic, although the US retained intervention rights until 1934 under the unilaterally imposed Platt Amendment. The Machado regime, in particular, was supported by the United States.

The 'Exhibition of New Art' that opened in Havana in May 1927, a few days after the publication of the Minorista manifesto, is usually cited as the Vanguardia's defining moment. This was the first group exhibition devoted to Cuban modernism and included the work of Abela, Gattorno, Carlos Enríquez (1900–1957) and his American wife Alice Neel (1900–1984), Víctor Manuel García (1897–1969) and Marcelo Pogolotti (1902–1988), among others. The major Vanguardia artists had distinct artistic personalities, but their thematic pursuits were closely related and document a search for iconic images of 'the Cuban'. In the first phase of the Cuban avant-garde, romanticized depictions of peasant life were most popular; the majority of Caribbean nationalist schools shared this interest which can be explained as a nostalgic reaction against urbanization. Other recurrent themes were the Afro-Cuban traditions, the urban proletariat, the Independence Wars and its heroes, and the physical environment. Portraits were also common and provided a source of income for many Vanguardia artists and their Caribbean contemporaries.

37 Víctor Manuel's *Gitana Tropical* (1929) is representative of the first phase of the Vanguardia. While technically a portrait, it represents a Creole archetype of femininity. The *gitana* does not belong to a specific racial or social group, but embodies Cuba's multi-racial, multi-cultural identity. The impact of the School of Paris is evident in the figure's simplified, rounded forms and the contrasting geometric grid structure of the background landscape. *Gitana Tropical* is the classic example of Víctor Manuel's extended series of related images of women, most of them in a more self-consciously primitivist style. He also painted various idyllic views of the parks and streets of Havana and nearby Matanzas.

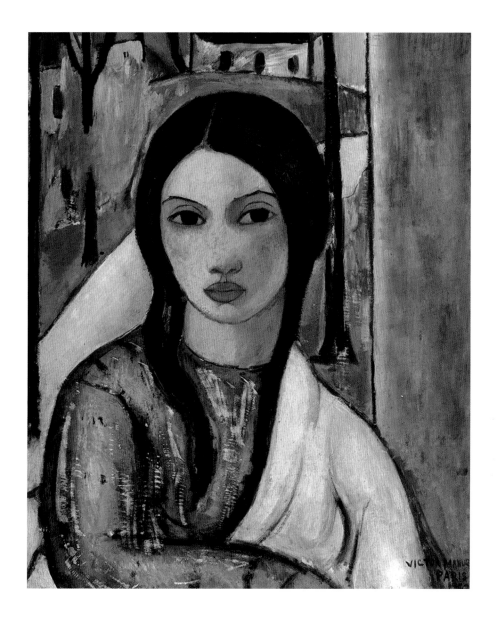

37 Víctor Manuel García, *Gitana Tropical* (*Tropical Gypsy*), 1929

Víctor Manuel's romantic *gitanas* and suburban landscapes seem oblivious to the harsh realities of the period. A similar idealization can be seen in the work of Antonio Gattorno, although there are hints of social criticism in his emaciated *guajiros* (Cuban peasants) of the 1930s. His best-known paintings represent a somewhat sentimental vision of vanishing Cuban country life in a style heavily influenced by Post-Impressionism and Art Deco. Gattorno's *Women by the River* (1927), an early painting, documents this search for iconic images. The stylized nude bathers or the bare, generic background landscape may hardly qualify as typical, but the Cubanness of the scene is inferred by such attributes as the bananas in the still life and the banana tree. The presence of the subservient, fully clothed black woman in the background fulfils the same function and recalls the work of *costumbrista* artists such as Brunias and Landaluze, who frequently juxtaposed seductive *mulatas* with black attendants. The banana tree is a recurrent, emblematic motif in nationalist Caribbean art along with the palm tree and sugar cane. With its crisp, elegantly curved lines, the banana tree also lends itself well to Art-Deco stylization.

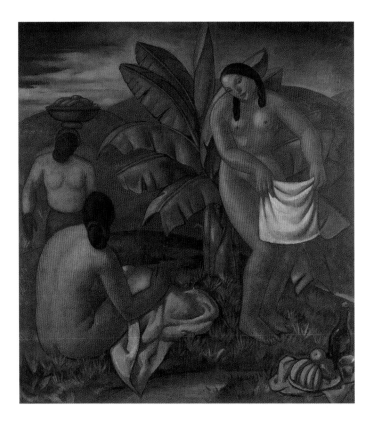

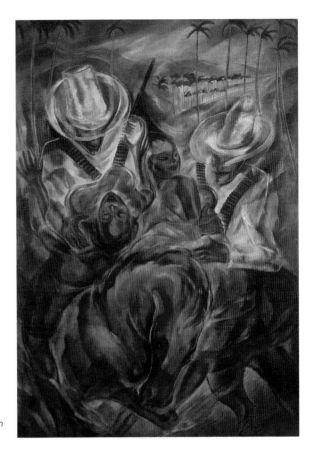

38 OPPOSITE Antonio
Gattorno, *Women by
the River*, 1927
39 RIGHT Carlos
Enríquez, *The Abduction
of the Mulatas*, 1938

The monumental clarity and stillness of Gattorno's style contrasts greatly with the frenzied expressionist language used by Carlos Enríquez. Although Enríquez also painted works that comment on the plight of the working class, he is best known for what he called his 'guajiro ballads', romantic and often frankly erotic fantasies of a Cuban countryside inhabited by voluptuous *mulatas* and macho *mambises*, the peasant outlaws of the Independence Wars. In his famous *The Abduction of the Mulatas* (1938) everything conspires to create an image of sensual rapture: the liquid, merging forms of the women, men and horses; the sweltering background landscape; and the luminous, multi-layered paint application. The image was obviously modelled after Peter Paul Rubens's *The Abduction of the Daughters of Leucippus* (c. 1618), although its ecstatic sexuality makes the Rubens seem almost puritanical. *The Abduction of the Mulatas* and related works by Enríquez

39

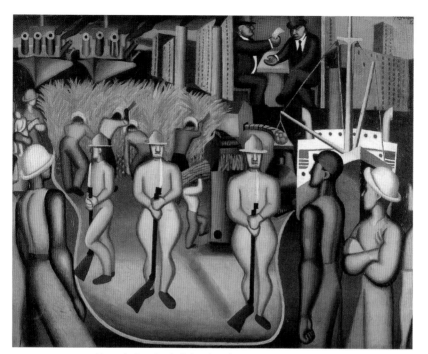

40 ABOVE Marcelo Pogolotti, *Cuban Landscape*, 1933
41 OPPOSITE Fidelio Ponce de León, *Tuberculosis*, 1934

perpetuate the myth of the sexual availability of the coloured woman. As *Women by the River* also illustrated, sexual, racial and social clichés abound in Vanguardia art, and colonial-era racial hierarchies persisted, showing that there is only a thin line between national icon and racial and cultural stereotype, a fundamental contradiction of Caribbean cultural nationalism.

Marcelo Pogolotti's paintings of the mid-1930s offer a very different perspective. Influenced by his involvement with the Turin Futurists and the Association des Ecrivains et Artistes Révolutionnaires in Paris, he sought to paint 'the Cuban', but was not interested in the picturesque or the nostalgic. His Cuba was emphatically modern and his 'types' were the worker, the cane-cutter, the guardsman, the clergyman, the bourgeois woman and the capitalist, whom he represented as anonymous actors in Cuba's social drama. Large American corporations had established a virtual monopoly over the Cuban sugar industry and invested heavily in other vital areas of the economy, such as banking and electricity generation, as they did in other parts of the region. Pogolotti's famous *Cuban Landscape* (1933) refers to this development and denounces

40

the capitalist exploitation of the Cuban sugar industry and its workers. The work is related to the machine aesthetics of Fernand Léger and the Purists, with whom Pogolotti was in close contact at the time.

The work of Fidelio Ponce de León (1895–1949) is equally devoid of the picturesque but, unlike Pogolotti, Ponce was not interested in socio-political statements. Instead, he portrayed a private world haunted by existential anguish, religious mysticism, poverty, alcoholism and disease. As the only major Vanguardia artist not to study abroad, Ponce's work was less visibly related to European modernism, although he listed Amedeo Modigliani among his influences, along with El Greco, Murillo and Rembrandt. His work inevitably also recalls the angst-ridden expressionism of Edvard Munch. His outlook is perhaps best expressed in *Tuberculosis* (1934), a haunting *memento mori* painted in bleak hospital colours. The painting represents a group of gaunt, elongated figures, almost lovingly gathered around a grimacing skull. Tragically, Ponce himself later contracted tuberculosis, then a common disease among the Cuban poor. Ponce may not have been interested in Indigenist subjects, but *Tuberculosis* reflects a Cuban reality.

Machado was overthrown in 1933 and was soon succeeded by the populist military strongman Fulgencio Batista, who controlled Cuba until 1944 and again from 1952 until the 1959 revolution. The turmoil of the early 1930s was followed by a period of national reconciliation; the Vanguardia, which had

41

started as a dissident movement, now received some official support. The first acknowledgment was the establishment in 1935 of a national salon, sponsored by the newly installed Directory of Culture. These salons included modernist and academic art, exhibited in separate rooms. Several Vanguardia masterpieces in the Cuban national collection were acquired from these exhibitions – *The Abduction of the Mulatas*, *Gitana Tropical* and Abela's *Los Guajiros* (The Cuban Peasants) from the 1938 salon. Another important initiative was the foundation of the Free Studio of Painting and Sculpture in 1937, whose main organizer and director was Abela. The school received a subsidy from the Directory of Culture and, as in the Mexican free schools, tuition was available free of charge to anyone interested. Teaching methods were innovative and encouraged the exploration of indigenous subjects. Although the Free Studio lasted less than a year, it was the first significant alternative to the elitist San Alejandro Academy.

The second generation of modernist Cuban artists was generally less interested in socio-political issues. While the Cuban avant-garde was from its onset closely allied with literary developments, this association intensified in the 1940s. Two literary figures were particularly influential: Alejo Carpentier, who was in Cuba during the early 1940s, and the poet and critic José Lezama Lima. Of particular interest in the writing of Lezama Lima and Carpentier is the notion of *barroquismo*, the eclectic, Baroque-style ornamentalism they identified as a fundamental characteristic of the Cuban and Latin American aesthetic.

While other Indigenist themes remained popular, artists such as Amelia Peláez (1896–1968) and René Portocarrero (1912–1985) found a new nationalist paradigm in the ornate, eclectic colonial architecture of the Cuban capital – a style of architecture which is more commonly associated with the Cuban elite than with the popular masses. This new direction in Cuban art is often referred to as the School of Havana. Chronologically, Peláez belongs to the Vanguardia generation, although her best-known work dates from the 1940s and 1950s and is closer in form and spirit to that of the younger painters. She brought a personal, feminine perspective to the search for 'the Cuban'. Her *Still Life* (1942) is typical of her mature style and reflects her main thematic pursuits: the still life, the interior and architectural ornamentation. The frontality of the image, its brilliant colours and heavy, interlocking black outlines recall the fan-shaped, stained-glass windows found over doorways in the colonial mansions of Havana. The work also reflects Peláez's interest in pictorial structure. This formalism separated her from her Cuban contemporaries and was

42

42　Amelia Peláez, *Still Life*, 1942

43 René Portocarrero, from the *Cerro-Interior* (*Interiors from El Cerro*) series, 1943

influenced by her studies with the Russian constructivist Alexandra Exter in Paris.

43 Portocarrero's sumptuous series of *Interiors from El Cerro* (1943) depict the same interiorized urban life that inspired Peláez, although his compositions have a more nervous, expressionist quality and sometimes include the human figure. In some of these works, the interiors and other elements are abstracted and formally integrated in a way that is almost abstract expressionist and emphasizes the act of painting itself. His themes also ranged wider and included what had by then become classic Indigenist subject matter: the rural and urban landscape, popular culture and religion. These thematic interests are summarized in *Homage to Trinidad* (1951), a fanciful view of the historical city of Trinidad, painted the year before he started his famous visionary, abstracted panoramas of Old Havana. The crowned female figures in the religious procession in the foreground herald the popular saints of his *Colour of Cuba* series on Cuban folklore of the early 1960s.

The Second World War brought together Caribbean intellectuals and exiled members of the European avant-garde, and provided a new impulse in the development of Caribbean art. It was during this period, for instance, that Wifredo Lam returned to Cuba. After fifteen years in Spain, during which he fought on the Republican side in the Civil War, in 1938 Lam had been accepted into the Paris avant-garde as a protégé of Pablo Picasso. At the start of the Second World War, Lam fled to Marseilles, where he joined the circle around André Breton and rapidly assimilated the language and methods of Surrealism. He made the long, nerve-racking passage to Martinique in 1941, in the company of Breton and his entourage.

While in Martinique, Lam and Breton met Aimé Césaire, who had returned to his 'native land' just before the start of the war. Césaire's Négritude aesthetics and politics deeply influenced Lam's mature work. After a brief stop in the Dominican Republic, Lam finally arrived in Cuba in the summer of 1941 and lived there, with some interruptions, until he moved back to Paris in 1952. In Havana, he befriended Carpentier and the folklorist Lydia Cabrera, who encouraged him to explore Afro-Cuban traditions. This reacquaintance with his heritage was a turning point in Lam's development –

2 it resulted in dramatic, powerful works such as *The Jungle* (1943) and *The Eternal Presence* (1945) that contrast greatly with his earlier, somewhat anaemic Cubist paintings.

The Jungle surely ranks with Picasso's *Guernica* (1937) as one of the most haunting images created in the twentieth century. The mask-like faces of the four figures are visibly indebted

to Picasso, although Lam brought an explicit anti-colonial agenda to Picasso's primitivism, arguably claiming back some of the latter's appropriations. Like most of Lam's mature work, *The Jungle* incorporates allusions to traditional Afro-Cuban practices, such the scissors – a motif associated with herbalism and the ritual control of spirit possession – which Lam said represented the need to break with colonial culture. With its hybrid, human-animal-plant imagery, the work also embodies the central pantheist notion of most African Caribbean religions that nature is humanity's point of contact with the spiritual. The backdrop of sugar cane and tobacco leaves, which Lam also used in other works of the period, links to Fernando Ortiz's allegorical study of Cuban culture, *Cuban Counterpoint of Tobacco and Sugar* (1940). The choice of vegetation is significant to the political meaning of the work: sugar cane and tobacco, Cuba's traditional crops of the plantation period, form the 'backdrop' of the island's colonial history and are heavily charged with connotations of slavery and exploitation, but also of resistance and revival. Because of this association, *The Jungle* is perhaps best understood as an allegory of Plantation America.

While the socio-political prevails in *The Jungle*, other Lam works of the period, such as *The Chair* (1943), are more directly associated with Afro-Cuban traditions and rituals. *The Chair* may seem like a casual garden still life, but the image recalls the altars to the *orishas* (divinities) that Santería practitioners keep in their homes or gardens. This interpretation is confirmed by the more anecdotal Santería altars Lam painted the following year and by the association of chairs or stools with the divine and the ancestral in several traditional West African religions. Significantly, the vase on the chair contains an offering of tobacco leaves, the crop Ortiz associated with the ritualistic, primarily Afro-Amerindian element in Cuban culture.

Although Lam's Cuban work reflects ideas that were current in the Caribbean, he remained an outsider to the Cuban School and was critical of the bourgeois outlook of contemporaries like Peláez. Lam's presence nonetheless affected the course of Cuban art and resulted in a renewed interest in Afro-Cuban subjects among the younger generation. Roberto Diago (1920–1957), himself of Afro-Cuban descent, was most visibly indebted to Lam, although he brought his own imagination and a strong sense of plasticity to the subject.

The Cuban Vanguardia was the first Caribbean school to receive attention in Europe and North America. In 1944 a major exhibition of modern Cuban painting was staged at the Museum of Modern Art in New York. Lam declined to

44 Wifredo Lam, *The Chair*, 1943

participate and instead had a solo exhibition at Pierre Matisse's gallery. The Museum of Modern Art acquired several Caribbean works, most notably Lam's *The Jungle* in 1945. These initiatives were part of a larger programme of Latin American exhibitions and acquisitions, in keeping with President Roosevelt's Good Neighbour policy. After the war, Cuban art also found its way to Europe. In 1951, for instance, there was a major exhibition of Cuban art at the Musée National d'Art Moderne in Paris.

Haitian art also began to receive international attention in the 1940s, especially after it was represented in two major UNESCO exhibitions of modern art in Paris, in 1946 and 1947. The spectacular upsurge of Haitian art in the mid-1940s is usually attributed to the establishment of the Centre d'Art in Port-au-Prince in May 1944, which served as a school and gallery. The organization was initially directed by the American watercolourist DeWitt Peters (1902–1966), who had come to Haiti in 1943 to teach English and who co-founded the Centre d'Art with several Haitian artists and intellectuals. While the Centre d'Art had a pivotal role in the development of Haitian art and its international promotion, the origin of modern Haitian art more correctly dates from the 1930s. As in Cuba, anti-American sentiments played a significant role in Haitian cultural nationalism, especially during the US occupation of Haiti from 1915 to 1934. The Haitian scholar Jean Price-Mars called for a revaluation of Afro-Haitian popular culture in his influential study *Ainsi parla l'oncle* (Thus Spoke the Uncle) (1928). It became the foundation text of Haitian Indigenism, mainly a literary movement, but it also influenced the visual arts.

Pétion Savain (1906–1973), who is usually regarded as Haiti's first modern artist, started painting local landscapes and scenes in the early 1930s in a modest, realist style. He was encouraged to explore indigenous subjects by the African American artist William E. Scott (1884–1964), who visited Haiti in 1930. In 1939 Savain published an illustrated novel, *La Case de Damballah* (Damballah's Shack). The novel reflects the ideas of Price-Mars, who had declared Vodou to be Haiti's national religion at a time when it was still illegal. Savain's illustrations, while formally crude, mark the first deliberate use of Vodou as a paradigm of 'the Haitian' in the visual arts. Savain later became famous for his much-copied geometrically stylized market scenes.

Indigenist Haitian art was nonetheless conventional and hesitant compared to the Cuban Vanguardia. The artistic climate became more energetic in the mid-1940s, galvanized by the activities of the Centre d'Art and by increased intra-regional contacts. Césaire came to Haiti in 1944, which established a

tangible link between Négritude and Indigenism. The Centre d'Art's programmes included exchanges with the Cuban avant-garde, like the showing of the MoMA exhibition of Cuban art in 1945 and other exhibitions. Several Cuban artists also visited, which reinforced their interest in African Caribbean culture – Lam came along with Breton in 1945 and stayed for four months as guests of Pierre Mabille, who was then French cultural attaché in Port-au-Prince; Enríquez visited in 1945 and Portocarrero in 1946.

These contacts with the Caribbean and European avant-garde were decisive in the development of Haitian artists such as Lucien Price (1915–1963). Price, whose small œuvre on paper is scarcely known, was the first Caribbean artist to venture into full abstraction in the mid-1940s, although he simultaneously produced drawings on indigenous and African themes. While Haiti's intelligentsia was absorbing modernism, the 'primitive' movement emerged with the 'discoveries' of Philomé Obin (1892–1986), Hector Hyppolite (1894–1948), Castera Bazile (1923–1966), Rigaud Benoit (1911–1986) and Wilson Bigaud (1931–2010), among others. The Centre d'Art soon became the main promoter of the 'Haitian Primitives', especially after the American writer Selden Rodman became co-director in 1947.

That the nationalist ideas of the Caribbean intelligentsia were, with some crucial variations, parallelled by those of the poor and working class is well illustrated by the early Haitian 'primitives'. Many of them openly produced Vodou-related work, for instance, reflecting changing attitudes towards the religion and also reasserting its historical association with decolonial liberation. Of the early 'primitives', the 'popular realist' Obin qualifies most readily as a nationalist artist. Apart from his depictions of life in his hometown of Cap-Haïtien and his autobiographic works, Obin applied his narrative and allegorical talents to patriotic subjects such as the Haitian Revolution and modern political events, including several emotionally charged paintings on the 1919 killing of Charlemagne Péralte, the leader of the *cacos* (peasant rebels) in northern Haiti, by the US occupation forces.

Obin's work illustrates that popular art is in a constant and mutual dialogue with the artistic mainstream, without clear boundaries between the two; his historical works, for instance, were painted in a formal style that can be traced to Haiti's creolized academic and popular traditions that had come out of the revolutionary period. He also produced paintings that verged on geometric abstraction. Obin had been painting for some thirty years before he joined the Centre d'Art, which shows that 'primitive' Haitian art did not appear suddenly

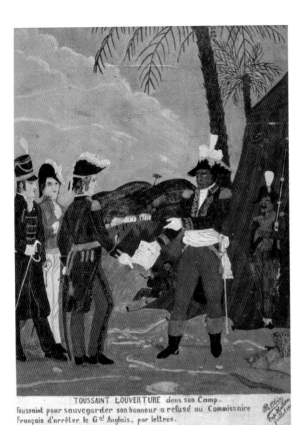

TOUSSAINT LOUVERTURE dans son Camp.
Toussaint pour sauvegarder son honneur a refusé au Commissaire
Français d'arrêter le Gal Anglais, par lettres.

45 Philomé Obin,
*Toussaint L'Ouverture
in his Camp*, c. 1945

or miraculously. He managed a branch of the Centre d'Art in
Cap-Haïtien and became the patriarch of what is now known
as the Cap-Haïtien School. The main exponents of this school
are his brother Sénèque Obin (1893–1977) and various younger
members of the Obin family.

Most patronage of the 'primitives' came from Europe and
North America where they were enthusiastically received as
the 'authentic', 'unspoiled' Haitian artists, while the work
of their modernist counterparts was criticized for being too
derivative. Rodman's popular book on Haitian art, *Renaissance
in Haiti* (1948), also championed the 'primitives', as did his later
publications on the subject. Predictably, this did not go down
well with the Haitian intelligentsia and a divisive polemic
developed. In 1950, a group of disgruntled artists left the
Centre d'Art and founded the Foyer des Arts Plastiques (Home
of the Visual Arts). The dissident group consisted mainly of
modernists, including Price, but also a few 'ex-primitives'

such as Dieudonné Cédor (1925–2010). While the Centre d'Art was trying to safeguard, and market, the 'purity' of the 'primitives', the artists at the Foyer sought to integrate them into the mainstream and aimed to translate modernism into something more relevant to the Haitian public. Most of the artists at the Foyer, however, espoused a gloomy naturalism that provided a lacklustre alternative to the thriving 'primitive' school at the Centre d'Art.

The Dominican Republic was also occupied by the US marines, from 1916 to 1924, and as in Haiti and Cuba, this resulted in a surge of nationalist sentiments that influenced cultural development. Celeste Woss y Gil (1890–1985), for instance, shocked the conservative, racially prejudiced Santo Domingo bourgeoisie with her candid nude pictures of coloured women, painted in a modernized academic style influenced by Gauguin. The Dominican nationalist school also includes Yoryi Morel (1901–1979), a regional artist who painted the people and views of his native city of Santiago and its environs. His *Peasant from Cibao* (1943) qualifies as a national icon and compares thematically with the *guajiro* paintings of the Cuban Vanguardia, be it in a more traditional, academic form.

Early Dominican modernism was shaped by two major influences: Mexican muralism and Spanish modernism. This is illustrated by the work of Jaime Colson (1901–1975). A restless traveller throughout his life, Colson studied in Spain and moved to Paris in the mid-1920s where he was accepted into the Cubist milieu. By the early 1930s, he had developed a distinctive style influenced by Purism, Picasso's classicism and Surrealism. Colson moved to Mexico in 1934 and taught at the Workers' Art School in Mexico City. His exposure to Mexican cultural nationalism led him to explore indigenous subject matter around the time of his return to the Dominican Republic in 1938, in works such as *Merengue* (1937), in which he infused an indigenous theme with the coolly dramatic, sexually ambiguous atmosphere of his surrealist work.

The US occupation of the Dominican Republic was followed by the dictatorship of Rafael Trujillo, who was in power from 1930 to 1961 with an increasingly corrupt and repressive regime. Eager to restore its public image after the 1937 'Parsley Massacre', a mass killing of Haitians living in the Dominican Republic, the Trujillo regime provided some artistic patronage during the early 1940s, establishing the National School of Fine Arts and the National Biennial in 1942. The Spanish influence in Dominican art was reinforced when Trujillo offered asylum to Spanish Civil War refugees, an act that was also part of a campaign to 'whiten' Dominican society

in keeping with Trujillo's anti-Haitian policies. Between 1939 and 1940, some five thousand Spaniards came, including several noted artists. Among those was the painter Eugenio Fernández Granell (1912–2001) and the painter and sculptor Angel Botello (1913–1986). Granell came to the Dominican Republic as a writer and musician and started painting there, influenced by the visits of Lam and Breton in 1941 and his subsequent contact with the Surrealists. This again shows how crucial the international exchanges of the early 1940s were for the development of Caribbean art and the later phase of Surrealism generally.

In Puerto Rico, nationalist resistance against the US occupation was led by the radical independence activist Pedro Albizu Campos, who came to prominence in the late 1920s – the artistic production of the time reflects this nationalist ferment. As in Cuba, traditional rural life was idealized and the Puerto Rican peasant, the *jíbaro*, was elevated to a national emblem. The painter Ramón Frade (1875–1954) is an early representative of this development, although in fact his work

is closer to late-nineteenth-century academism and the work of Francisco Oller than to Caribbean modernism. Frade said that 'since all that is Puerto Rican is being swept away by the wind...I seek to perpetuate it in paint.' His best-known painting, *Our Daily Bread* (c. 1905), is one of the earliest examples of nationalist art in the Caribbean. It presents a sober, monumental image of an elderly *jíbaro* holding a bunch of plantains, Puerto Rico's national food.

Frade is often mentioned alongside Miguel Pou (1880–1968), the first Puerto Rican artist to study in the United States. Pou lived in Ponce, Puerto Rico's prosperous second city, and, like Frade, he painted a nostalgic vision of Puerto Rico, although his work has a more informal, impressionist quality. Apart from his luminous landscapes and portraits of the Puerto Rican

46 OPPOSITE Jaime Colson, *Merengue*, 1937
47 RIGHT Ramón Frade, *El Pan Nuestro de Cada Día* (*Our Daily Bread*), c. 1905

48 Miguel Pou, *A Race of Dreamers: Portrait of Ciquí*, 1938

elite, Pou painted 'regional types'. His most famous work, *A Race of Dreamers: Portrait of Ciquí* (1938), a portrait of a popular baseball player, is, despite the title's benevolent racial stereotyping, a rare and sensitive portrait of a black person in a country that has struggled to come to terms with its African heritage.

Jamaica was the sole remaining European colony in the Greater Antilles, but artistic developments there were generally similar to those already discussed. The Jamaican School was dominated by the sculptor Edna Manley (1900–1987), who was born in England to a Jamaican mother and an English father. Her first Jamaican sculpture, *Beadseller* (1922), was probably the most radically modernist work created in the Caribbean at the time and reflects her interest in Vorticism. While the prayer-like work has autobiographical implications, it was inspired

by a market scene – a classic Indigenist theme. *Beadseller* is often cited as the start of the modern Jamaican School but it would take another decade before there was any sense of an emerging Jamaican artistic community. In the 1920s Manley exhibited in Britain, where she was acclaimed as a promising young modernist, and in 1930 she was accepted into the London Group along with Henry Moore and Barbara Hepworth.

West Indian independence was negotiated gradually and mainly on a political level. The cultural climate changed dramatically in the 1930s and a spirited nationalist, anti-colonial movement emerged throughout the British West Indies, fuelled by labour unionism and racial activism. Manley's husband Norman was a leader of the Jamaican nationalist movement and later became Premier. The West Indian labour movement emerged from a series of riots and strikes that racked the West Indies from 1935 to 1938 and gave the working class a political voice. Racial activism was particularly pronounced in Jamaica, which can be attributed to the influence of Garveyism and other emerging forms of black nationalism such as Rastafarianism. Marcus Garvey used Jamaica as his base from 1927 to 1935, when he left for Britain.

It was in this ideologically charged context that Manley created her *Negro Aroused* (1935), which has been consecrated in the national art-historical narrative as the icon of Jamaican cultural nationalism. It was the first of a series of explicitly political carvings that celebrated the black working class. While some are more anecdotal, such as *Market Women* (1936) or *Diggers* (1936), the carvings stand out among contemporary Caribbean art because of their emphatic 'blackness' and the heroic treatment of the figure – in Jamaica, where the majority of the population is of African descent, blackness was asserted as the default national identity, in contrast with the mixed racial identity that was, for instance, promoted in Cuban Vanguardia art. Although the graphic work of the English visionary artist William Blake was Manley's most consistent iconographic inspiration, her work of the 1930s also parallels that of the Harlem Renaissance in the United States. The silhouette quality and symbolism of *Negro Aroused*, in particular, recall the work of Aaron Douglas, which Manley may have known at the time.

Similarly, there is a striking resemblance between Manley's *Horse of the Morning* (1943) and the horse in the foreground of Carlos Enríquez's *The Abduction of the Mulatas*, although it is less likely that she was familiar with her Cuban counterparts. In both works, the quintessentially romantic image of the horse is associated with energy and male sexuality. While Manley and

49

50

Enríquez of course drew from the same sources, the similarity of their visual language reflects the conscious and unconscious crosscurrents within the Caribbean. *Horse of the Morning* belongs to Manley's *Dying God* series of the 1940s, in which she developed a romantic-surreal iconography with autobiographical overtones, based on the motifs of the sun, the moon and the horse. Although no longer explicitly political, the series was inspired by the spectacular Jamaican Blue Mountain landscape.

Alvin Marriott (1902–1992), like Manley, started his career in the 1920s, although at first independently from her. In 1929 he was cited by Marcus Garvey as the most outstanding West Indian sculptor, not surprisingly since his work embodied Garvey's academic preferences. Marriott was at his best in his exquisitely crafted woodcarvings, such as *Banana Man* (1955), that combine his academic approach to the figure with a slight Art-Deco stylization. These works reflect the influence of Manley and the avant-garde Jamaican furniture designer Burnett Webster, for whom Marriott did decorative carving.

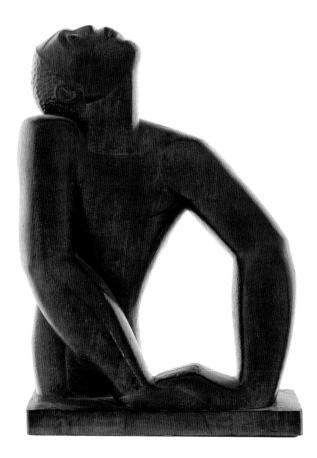

49 LEFT Edna Manley, *Negro Aroused*, 1935
50 OPPOSITE Edna Manley, *Horse of the Morning*, 1943

Like Manley's work of the late 1930s, *Banana Man* is an iconic image that heroicizes labour and the black race.

The changing cultural climate led to several initiatives that encouraged the development of Jamaican art. The Institute of Jamaica, which was founded in Kingston in 1879 for the promotion of art, science and literature, adjusted its colonial policies under pressure from the nationalist intelligentsia. In 1937 Manley's *Negro Aroused* was acquired through a public subscription campaign orchestrated by members of

51 Alvin Marriott,
Banana Man, 1955

the nationalist intelligentsia and became the first modern Jamaican work of art to enter the Institute's collection. Manley became an influential cultural organizer and in 1940 started free art classes at the Institute of Jamaica, which stimulated the development of a coherent artistic community and led to the establishment of the Jamaica School of Art in 1950.

The work of Albert Huie (1920–2010) exemplifies the interests of this Institute Group. Although he is now best known as a landscapist, many of his earlier images relate to labour; his *Crop Time* (1955), for instance, provides an anecdotal depiction of the cane harvest, with allusions to the dignity of labour and the positive role of sugar in the Jamaican economy – a nationalist repositioning of a subject that came with tremendous historical baggage as also occurred in the Cuban Vanguardia. It is a relatively small painting, but the epic quality of the composition suggests the influence of Mexican muralism, which reached Jamaica somewhat later than the Hispanic Caribbean. The moderate Post-Impressionist and Art-Deco stylization is also typical for the Institute Group. Another member of the group, David Pottinger (1911–2007), found his inspiration in the old working-class neighbourhoods of Kingston, where he has always lived. His *Nine Night* (1949) depicts a traditional African Jamaican wake in a sombre, awkward expressionist style reminiscent of the early work of Pétion Savain.

The painter and sculptor John Dunkley (1891–1947) belongs to the same generation, but he is usually classified as an 'intuitive' and discussed in isolation from the nationalist Jamaican School. It is part of Jamaica's art-historical lore that he was invited to join the Institute art classes but declined, stating that he saw things a little differently. His dark, brooding landscapes are indeed private visions that may seem far removed from the nation-building images of the Institute Group, yet his work also compares surprisingly well with that of his mainstream Caribbean contemporaries. The consciously or unconsciously sexualized character of Dunkley's imagery and its references to fertility and the cycles of life, for instance, bring to mind Wifredo Lam's notion of the spiritual 'murmur' of nature. On a more descriptive level, paintings such as *Banana Plantation* (*c*. 1945) compare with the iconic Caribbean landscapes of the nationalist schools. Dunkley's compositions were visibly influenced by Art Deco, which testifies to the popularity of the style in the Caribbean.

The sculptor Ronald Moody (1900–1984) was an outsider of the early Jamaican art movement, making his career in Britain and France. The hieratic monumentality, frontal emphasis and silent inwardness of early carvings like *Johanaan (Peace)* (1936)

52

53

54

55

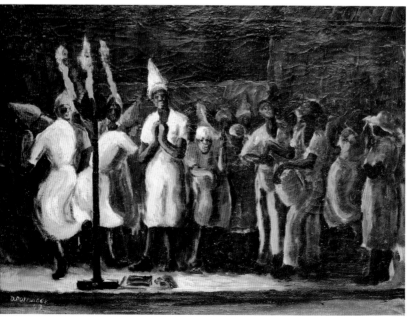

52 TOP Albert Huie, *Crop Time*, 1955
53 ABOVE David Pottinger, *Nine Night*, 1949

54 John Dunkley,
Banana Plantation,
c. 1945

reflect his interest in ancient Egyptian and Buddhist sculpture.
Although his brother, Harold Moody, was politically active in
Britain as the leader of the League of Coloured Peoples,
Moody's work was not guided by the nationalist agenda of his
Jamaican-based contemporaries. Instead, his sculptures
express a complex personal philosophy, influenced by his study
of Indian and Chinese metaphysics and, later, the experience
of the Second World War. With their simplified, monumental
forms, his early sculptures are nonetheless stylistically akin
to the contemporary carvings of Manley and Marriott – with
whom he shared his mastery of woodcarving – and his work
has also been situated in related, broader contexts such as the
Harlem Renaissance.

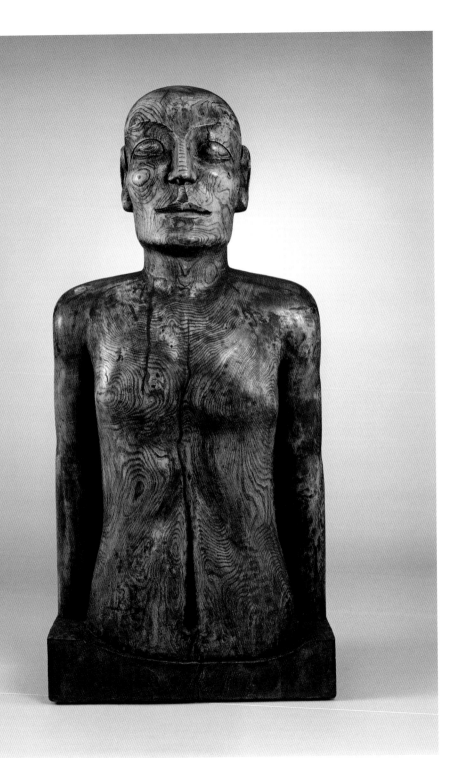

55 OPPOSITE Ronald Moody,
Johanaan (Peace), 1936
56 RIGHT Boscoe Holder,
Portrait of Louise de Frense Holder, 1938

The Eastern Caribbean produced some of the main literary, political and critical voices of the era, such as Aimé Césaire and the Trinidadian C.L.R. James, but there were also related artistic developments. In Trinidad, for instance, the first inkling of a modern, national art movement was the foundation of the Society of Independents (1929–38), a small group of young upper-class artists. The bohemian lifestyle of its main exponents, Amy Leong Pang (1908–1989) and Hugh Stollmeyer (1913–1981), scandalized the Port of Spain bourgeoisie. Artistically they were not of great consequence, although the references to *obeah* (African Caribbean spiritual practices) in Stollmeyer's work parallel developments elsewhere in the Caribbean, but they did influence others. The painter, dancer

56

and musician Boscoe Holder (1921–2007), for instance, was encouraged by Leong Pang as a young artist. While much of his later work suffers from facile exoticism, his 1938 portrait of his mother shows him as a sensitive portraitist.

The Trinidad Art Society, which was founded in 1943, was more specifically committed to the development of a national art movement. Among the founding members of the society,

57

Sybil Atteck (1911–1975), who was herself of Chinese descent, was most adventurous in reconciling abstraction and stylization with emblematic Trinidadian subjects such as the landscape and the popular festivals, paying attention to the distinctive

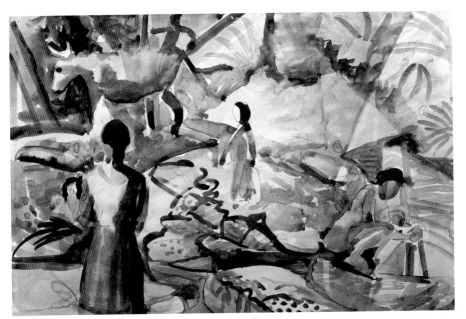

57 Sybil Atteck, a work, c. 1950s

multi-cultural and multi-racial nature of Trinidad society.
Her innovative work greatly influenced the following generation
of Trinidadian artists.

Cultural nationalism continues to be a major influence
on artistic production in the Caribbean, as can be seen in
the cultural policies and institutions of Caribbean nations.
Cultural nationalism has also been vigorously contested for
its artistic limitations and social contradictions, particularly
the tension between the co-option of popular culture and
its association with the establishment of a new, postcolonial
patron class. That Edna Manley – who defined herself as
coloured but who was regarded as white by many and who was
part of the new social and political elite – should have produced
one of the presumed icons of Jamaican black working-class
identity, *Negro Aroused*, and be consecrated as the 'mother of
Jamaican art' vividly illustrates these contradictions. These
tensions and the associated critical debates have, in effect,
been one of the driving forces in the development of art in
the region since the mid-twentieth century.

Chapter 4
Popular Culture, Religion and the Festival Arts

Caribbean popular religions such as Vodou, Santería and Rastafarianism have a strong visual emphasis and use an eclectic array of ritual and emblematic objects and images. Several well-known Caribbean artists started as makers of such sacred arts and crossed over into the domain of 'gallery art', usually after being encouraged by talent-scouting art patrons. Haiti makes for an instructive case study, as several of the most celebrated 'Haitian Primitives', such as Hector Hyppolite, Robert Saint-Brice (1898–1973) and André Pierre (1916–2005), were *houngans* (Vodou priests) and many others were associated with the religion.

Although Vodou is the religion of the Kreyol-speaking masses, it was only legalized in 1946. This helps to explain why Vodou-related art came to prominence in Haiti around that time, although its sacred arts have a much longer history. Ironically, it was not his involvement in Vodou that brought Hector Hyppolite, a third-generation *houngan*, to the attention of the Centre d'Art but his work as a decorative house-painter. He was approached by DeWitt Peters and the Haitian novelist Philippe Thoby-Marcelin because of the striking floral panels and name sign he had painted for a small bar in the village of Montrouis. Hyppolite moved to Port-au-Prince in 1945 and rose to international attention within months, aided by the enthusiastic endorsements of André Breton, Wifredo Lam and Pierre Mabille. His short but intense career ended abruptly when he died of a heart attack in 1948.

Hyppolite painted fanciful romantic scenes, still-life compositions, landscapes and even an occasional portrait, but his work was fundamentally linked to Vodou. He claimed to work in a state of possession by John the Baptist (although it should be remembered that he consciously produced for the

Centre d'Art, like many of his contemporaries). His most
memorable works depict major *loas* (divinities) of the Vodou
pantheon with considerable iconographical freedom. The
majestic, emblematic figure with a double nose and three eyes
in *The Great Master* (1946–48), for instance, is an image without
precedent in Haitian art and probably represents the elusive
chief god of the Vodou pantheon. With its symmetrical
frontality and lack of ornamental detail, the composition
is unusually stark for Hyppolite, although the bold, fiery
colours add to the visionary power of the image.

The candour of Hyppolite's paintings makes a striking contrast to the enigmatic, spectral images of Robert Saint-Brice, whose informal 'tachiste' painting style prefigures later developments in Haitian art such as the Saint-Soleil School. The singularity of Saint-Brice's style does not mean his work is unrelated to popular iconography – his early painting *The Queen Erzulie* (1957) represents the temperamental *loa* of love in her double identity as the black Virgin Mary.

Vodou was also essential to the work of Georges Liautaud (1899–1992), the master of the Haitian *ferroniers* (iron sculptors). He was a blacksmith by profession and started his career by making iron graveyard crosses in his hometown of Croix-des-Bouquets, today the centre of Haitian ironwork. Graveyard crosses are associated with Baron-la-Croix, the guardian of the graveyard in Vodou. Most of Liautaud's sculptures were made from recuperated metal – *Sirène Diamant* (Diamond Mermaid) was ingeniously forged from a long iron railway nail. It is an early representation of Liautaud's favourite *loa*, the mermaid La Sirène. The poetic title refers to the light effects created by the fish-tail pattern perforations of the figure. In the mid-1950s, Liautaud started cutting silhouette forms from sheet metal recycled from oil drums, the method also used by younger

59

60

58 OPPOSITE Hector Hyppolite, *The Great Master*, 1946–48
59 RIGHT Robert Saint-Brice, *The Queen Erzulie*, 1957

60 Georges Liautaud, *Sirène Diamant* (*Diamond Mermaid*), n.d.

ferroniers such as Murat Brierre (1938–1988) and Serge Jolimeau (b. 1952). The use of recycled and improvised materials is an important part of Haitian popular culture – Hyppolite, for instance, painted with a chicken feather – although most artists turned to more conventional art materials when they entered the gallery system.

Préfète Duffaut (1923–2012), another early member of the Centre d'Art, is best known for his fantastic cities, painted in a colourful, meticulous graphic style. Although they are formally inspired by the spectacular, mountainous landscape around his hometown of Jacmel in southern Haiti, Duffaut's cities evoke the supernatural rather than the natural. His *Heaven and Earth* (1959), for instance, juxtaposes a heavenly and an infernal realm, a recurrent theme in his work. The image embodies the dualist world view of Vodou and other African Caribbean religions, where good and evil are complementary, interconnected forces.

61

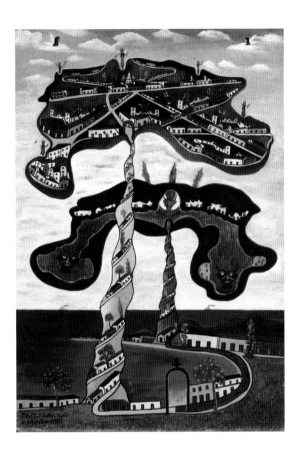

61 Préfète Duffaut,
Heaven and Earth, 1959

It is nonetheless reductive to define Haitian 'primitive' art as 'Vodou art', neither are all Haitian artists Vodou believers. Philomé Obin, for instance, was a devout Protestant and primarily a secular artist, but even his occasional religious paintings were unrelated to Vodou. Obin's best-known religious works are his contributions to the mural cycle at the episcopal Cathedral of the Holy Trinity (1950–51) in Port-au-Prince. The Holy Trinity mural project was executed by the most prominent artists attached to the Centre d'Art at the time. It was initiated and directed by Selden Rodman and enthusiastically supported by Bishop Alfred Voegeli, another early American patron of Haitian art. The first section to be completed was the apse, with three major murals, *The Nativity*, *The Crucifixion* and *The Ascension*, by Rigaud Benoit, Philomé Obin and Castera Bazile respectively. Despite the distinct painting styles of each, the apse murals form a surprisingly coherent whole, although the redundant, sugary angels and rosebuds by Gabriel Lévêque

62

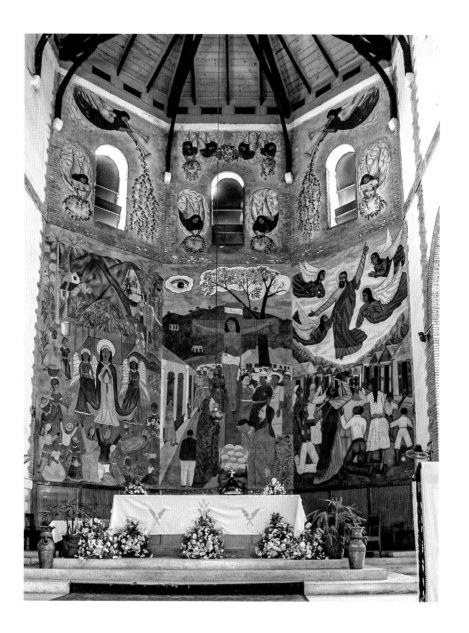

62 Rigaud Benoit, Philomé Obin and Castera Bazile, *The Nativity, The Crucifixion* and *The Ascension*, Cathedral of the Holy Trinity, Port-au-Prince, Haiti, 1950–51 (detail)

63 ABOVE RIGHT
Philomé Obin, *Last Supper*, Cathedral of the Holy Trinity, Port-au-Prince, Haiti, 1950–51 (detail)
64 BELOW RIGHT
Philomé Obin, *Last Supper*, Cathedral of the Holy Trinity, Port-au-Prince, Haiti, 1950–51 (detail)

63, 64 (1923–2013) in the upper section detract from the more formal compositions below. Obin also painted the *Last Supper* in the west transept chapel and Wilson Bigaud executed the *Wedding at Cana* in the east transept. The mural cycle also includes smaller paintings by Bazile and several other artists. In 1954 Bishop Voegeli commissioned a terracotta choir screen by Jasmin Joseph (1923–2005).

The biblical events represented in the Holy Trinity murals were placed in a modern Haitian context, a revolutionary departure at the time, and the biblical figures were 'Haitianized' by giving them a darker skin. Some murals include Vodou-related motifs, such as the drums and sacrificial animals in Bigaud's *Wedding at Cana*. This does not mean the murals are disguised Vodou art, since those references were included to depict Haitian life. Not all of this happened spontaneously, however, and contemporary accounts reveal

that Rodman encouraged the artists to include anecdotal Haitian details, to the point where some felt he was interfering and constructing an aesthetic, though the artists were clearly willing to go along with it.

Predictably, the project was at first controversial. Some felt the murals were sacrilegious and inappropriate for a mainstream Christian church. The Holy Trinity murals were also executed during the conflict about the promotion of Haitian art by the Centre d'Art and, in fact, contributed to the crisis. The murals are now well-recognized as part of Haiti's artistic heritage, but the church was destroyed in the earthquake that struck the country in 2010. There are plans for its restoration, as part of a post-earthquake art and architecture conservation project for which Haiti is receiving assistance from organizations such as the Smithsonian Institution in Washington, DC.

Vodou is not the sole explanation for Haitian art, but it has also been an important source for mainstream Haitian artists. This took a more actively lived turn with the foundation of the Poto Mitan School in 1968 by the artists Tiga (Jean Claude Garoute, 1935–2006), Patrick Vilaire (b. 1941) and Frido (Wilfrid Austin, b. 1942). The term 'poto mitan' refers to the central pole in the main room of the *hounfort* (Vodou temple), which symbolizes the link between the spiritual and the earthly realm. The artists associated with Poto Mitan turned to Vodou cosmology as well as Taíno culture as the basis of their aesthetic investigations.

Tiga is best known as the initiator of the Saint-Soleil experiment in the early 1970s. The project started as an application of his theories about spirituality, spontaneity and collaborative, inter-disciplinary art. Art materials were given to peasants who had never painted before in Soisson-la-Montagne, a village in the mountains above Port-au-Prince. Several well-known artists emerged from the experience, including Prospère Pierre-Louis (1947–1996), Dieuseul Paul (1953–2006), Levoy Exil (b. 1944) and one of very few recognized female 'Haitian Primitives', Louisiane Saint-Fleurant (1924–2005). Like Saint-Brice, they portray the spirit world of Vodou in amorphous, intuitive forms and only occasionally represent identifiable *loas*. There is no realism in their paintings, which separates them from most other popular artists in Haiti. Although each member maintained a distinct style, the group developed a recognizable idiom, characterized by intricately patterned psychedelic colours and two-dimensional, frontal compositions defined by heavy black outlines.

65

65 Prospère Pierre-Louis, *Spirit*, 1996

66 Myrlande Constant, *Baron la Kwa*, 2008–18

The Saint-Soleil group came to international attention after
the visit of André Malraux to Haiti in 1975, another example
of the role of western endorsements in the development and
conceptualization of 'Haitian Primitive' art. Malraux was
particularly impressed by the tomb paintings members of
the group had made at the local cemetery. He discussed their
work in his study of religious iconography, *L'Intemporel* (1976),
and described Saint-Soleil as 'the most arresting and the only
controllable experience of magic painting in our century',
adding to the perception that Haitians are a people of natural
painters. Saint-Soleil was also conceived as an alternative to the
commercialization of Haitian art, but the group's work soon
found its way into local and overseas galleries and collections.
The community fell apart in the late 1970s, but Saint-Soleil

revitalized Haitian art with strong new voices. It inspired several younger artists such as Stevenson Magloire (1963–1994), Saint-Fleurant's son, who combined motifs that relate to Haiti's modern realities – such as armed militiamen – with elements of the Saint-Soleil idiom.

The dictator François Duvalier ('Papa Doc'), who was Haiti's president from 1957 to 1971, ruthlessly exploited Vodou beliefs to reinforce his corrupt and violent regime. His personal appearance was modelled after Baron Samedi, the fearsome *loa* of death. Unavoidably, there was a backlash against Vodou when his son and successor Jean-Claude Duvalier ('Baby Doc') was deposed in 1986. One of the casualties was the *hounfort* and murals of André Pierre in Croix-des-Bouquets, which were destroyed in the uprising. More recently, there has been renewed pressure against Vodou from the missionary activities of American fundamentalist Christian churches, who contribute social services and attract many traditional Vodou believers. Vodou remains as a defining cultural force in Haiti although the ideological terrain of the art world has changed significantly since the foundational generation of 'Haitian Primitives'.

Spurred by general critiques of western primitivism, questions have been raised about the patronage dynamics that not only helped to uncover legitimate talent but also created 'Haitian Primitive' art, as a construct of a selective, external gaze rather than as the spontaneous upwelling of popular creativity it has been made out to be. This has included the imposition of western notions about what constitutes 'art' – and, alongside, what constitutes 'authentic' black, Caribbean and Haitian art – on popular cultural expressions that resist such categorizations, and the exclusion of cultural forms that could not be recuperated in this manner.

There is now more recognition for the sacred arts, such as the eclectic Vodou altar installations and the Paket Kongo spirit containers. This is thanks in part to exhibitions such as the splendorous 'Sacred Arts of Vodou' at the Fowler Museum in Los Angeles in 2001, although issues of externally mediated representation and aestheticization also arose there. This shift in attention furthermore parallels developments in mainstream western art, such as the advent of contemporary installation and performance art, and concurrent, expanded definitions of 'art', so it does not necessarily amount to recognizing Haitian culture on its own terms.

The *drapos Vodou* (Vodou flags), which are often elaborately beaded and sequinned, collaged and embroidered, hold an ambiguous place in this context. In their original, sacred form,

such flags serve as icons associated with specific *loas* that are paraded in rituals, but the format lends itself well to commodification. The *drapos* had already entered the Haitian art market in the 1960s and over time became a thriving enterprise, alongside Haitian painting and metalwork. Most 'art flags' incorporate Vodou imagery but they have no consecrated status or ritual use. Some artists have added technical and iconographic innovations to the tradition –

66 the large, elaborately designed *drapos* by Myrlande Constant (b. 1968) are a good example and combine Vodou iconography with narratives on issues and events in Haitian society, such as the 2010 earthquake.

Street art and graffiti have appeared in the urbanized parts of the Caribbean since the 1960s and have evolved in dialogue with similar developments in the metropolitan areas of the west. They are now a common presence in Jamaica, Trinidad, Puerto Rico, Haiti and Guadeloupe, which has a particularly strong graffiti culture, as well as in Cuba, although there they are usually related to state propaganda. In Haiti the street murals that appeared in the period following the deposition of the Duvalier regime in 1986 are a good example. Although most of these murals were sponsored by political organizers, they depict the political ferment among the wider population. Some served an educational function, as with the anonymous,

67 undated mural captioned 'Don't Burn Them, Judge Them' in Port-au-Prince – an appeal to calm outbursts of popular anger against the Tonton Macoute militia and other Duvalier collaborators. These Haitian street murals combine realist depictions of contemporary events with traditional Vodou iconography and Vodou-inspired interpretations of North American pop icons, such as Rambo, another example of the Caribbean ability to absorb and transform foreign influences.

There has been significant dependence on external agents in the conceptualization and promotion of Haitian popular art but that does not mean that the artists have not been actively involved. Many have organized themselves into community-based collectives, which gives them greater agency in terms of how their work is represented and sold. The Atis Rezistans, a collective based in the inner-city area along the Grand Rue in Port-au-Prince, for instance, was founded in 1998 by André

68 Eugène (b. 1959), Jean-Hérard Céleur (b. 1966) and Guyodo (Frantz Jacques) (b. 1973), although Céleur and Guyodo later left the group. While some of them also paint, the Atis Rezistans are best known for their three-dimensional, sometimes large-scale assemblages made from recuperated metal and wood, and other found objects (which controversially

67 'Don't Burn Them, Judge Them', street mural, Port-au-Prince, Haiti, undated

sometimes includes human skulls) along with carved elements. Theirs is a deliberately provocative, disquieting urban aesthetic that is informed by Vodou, particularly the rowdy Ghede family of *loas* of death and fertility, and confronts the viewer directly with the pressures of Haitian inner-city life. Céleur has said: 'My work... represents the people's demands for change. I live in the reality that deals with poverty everyday which informs my work all the time.'

In 2009 Atis Rezistans established the Ghetto Biennale, for which they host artists from Haiti and all over the world to present site-specific, collaborative work in the Grand Rue community. This event also challenges the conventional boundaries between the worlds of the popular artists and the artistic mainstream, pointedly reversing the usual power dynamics of the art world, while asserting the status of the Atis Rezistans as contemporary artists. The collective has received significant international attention and was the focus of a travelling exhibition, 'Pòtoprens' (2018), which was co-curated by Haitian American artist and curator Edouard Duval-Carrié (b. 1954) and the British artist and curator Leah Gordon (b. 1959). The role of Leah Gordon, a close associate of Eugène, and international organizations in the international exposure of the collective, however, illustrates that it is difficult to step

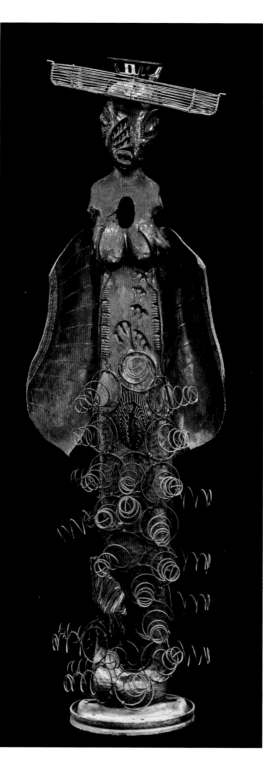

68 Jean-Hérard Céleur,
La Sirèn, 2020

away from externally mediated representation in a global art world which still maintains many of its old hierarchies.

Yet it is just as important to move away from the reductive, artificial binaries that have shaped the critical debate about Haitian art, between self-taught and trained, popular and mainstream, and represented and lived reality. Trained contemporary Haitian artists have also challenged these binaries by using Vodou iconography and the idioms of the popular artists, and often do so to make poignant critical statements. Duval-Carrié is a leading exponent of this development and his paintings and installations evoke the magic, mystery and visual splendour of the Vodou universe and comment on Haiti's history and socio-political realities with sharp, surreal wit. A more personal engagement with these issues is evident in the work of Tessa Mars (b. 1985), whose work, among other things, asks questions about the invisibility of women in Haiti's intellectual, cultural and political history and in her own ancestry, as a great-grand-daughter of Jean Price-Mars.

192

Jamaican Revival religions, a generic term used to describe the traditional Afro-Jamaican religions, also combine Christian and African-derived beliefs and practices, on a spectrum from the more Christian-influenced Zion Revival to the fully African-derived Kumina. The Christian elements stem, however, from inspirational Protestantism rather than Roman Catholicism, since the evangelization of the Jamaican masses was primarily the work of Baptist, Methodist and Moravian Abolitionists.

69

Mallica 'Kapo' Reynolds (1911–1989) was a Zion Revival bishop and, like most other Caribbean artist-priests, he claimed to have received divine instruction to start carving and painting. His subjects vary from biblical figures and Revival rituals to landscape and market scenes, as well as portraits and erotica, yet even his secular works portray the social and physical environment of Revivalism as he lived it. Many of his paintings and sculptures are autobiographical and include self-images of Kapo in his capacity as the leader of his flock. Some of his most outstanding works are about women and reflect the prominence of women in the religion. His sculpture *Revival Goddess Dina* (1968) is an homage to the spiritual power of a matriarchal, possibly ancestral figure and to women in general. The figure's horn-shaped hair signifies her spiritual involvement and her pose captures the typical swirling motion of Revival dancing.

Kapo produced ritual items for his church, which was initially located in Trench Town, but his paintings and sculptures were from early on consciously created as 'art' and sold via Kingston dealers, such as the Hills Galleries in the

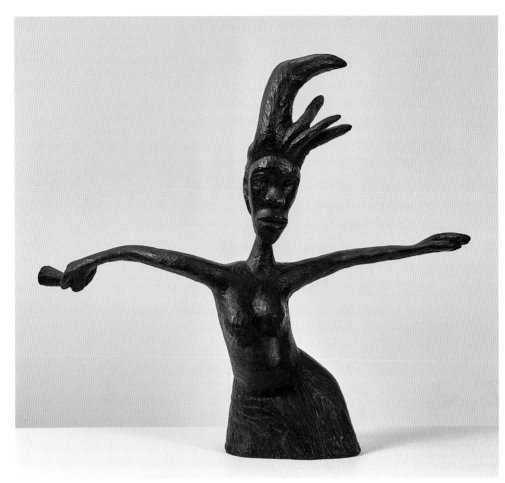

69 Mallica 'Kapo' Reynolds, *Revival Goddess Dina*, 1968

1950s and 1960s, or directly to visiting patrons. He suffered persecution and was even jailed on suspicion of practising Obeah, which remains illegal in Jamaica, but he also received significant support. His most prominent Jamaican patron was Edward Seaga, a sociologist and politician who became prime minister of Jamaica in the 1980s.

Jamaican Revival religions are declining because of the competition from Pentecostalism, the new North American evangelical churches and Rastafarianism. The latter emerged in the 1930s as a counterculture in the economically depressed urban and rural areas. The pioneers of the movement identified Haile Selassie, the young emperor of Ethiopia, as the black

Messiah, influenced by Marcus Garvey and his metaphorical references to Ethiopia as the African Zion. African Zionism is not unique to Garveyism and Rastafarianism but is rooted in the popular resistance to New World slavery. Vodou practitioners, for instance, believe they will return to Guinée after death, the ancestral place 'across the waters' where the *loas* reside.

Of all African Caribbean religions, Rastafarianism most explicitly unites the religious and the political, and developed as a conscious African nationalist alternative to Christianity and mainstream Jamaican nationalism. Early Rastafarians were defiant of government authority and the social establishment. Their anti-establishment stance was reinforced by the long, matted 'dreadlocks' and the ritual use of ganja (marijuana). Most African Caribbean religions use emblems and symbolic colours but in Rastafarian culture this takes on a nationalist character, deriving from an eclectic array of sources such as the red, gold and green Ethiopian flag, the Lion of Judah and the star of David.

Predictably, Rastafarianism was initially repressed by the colonial and Jamaican authorities, but by the late 1960s there was greater public and official acceptance. Haile Selassie's state visit to Jamaica in 1966 was a turning point in that regard. It is during this period that Everald Brown (1917–2003) came to national attention with the wall paintings, ritual objects and decorated musical instruments he had made for his small church in Kingston, a self-appointed mission of the Ethiopian Orthodox church. Many early Rastafarians embraced the Ethiopian Orthodox church as an authentically African form of Christianity, although their beliefs were only partly compatible, especially where the divinity of Haile Selassie is concerned.

The images in Brother Brown's paintings and sculptures came to him in dreams and meditations – he combined elements of Rastafarian, Ethiopian Orthodox, Revival, Judaic, Masonic and East Indian iconography with his own unique visions, a good illustration of the eclecticism and individualism of Rastafarianism. Brown frequently used polymorphic images, which he reinforced with verbal punning – the title of the painting *Ethiopian Apple* (1970) is a pun on the Otaheite apple, a common fruit in Jamaica. The central figure in the composition is at once an Otaheite apple tree and a hieratic figure, and symbolizes humanity's sacred oneness with nature, a central notion of Rastafarianism and other African Caribbean religions. The colours of the tree and its backdrop also form the Rastafarian tricolour. Verbal and visual punning are common in Caribbean popular culture, particularly in

70

Rastafarian circles where such punning is usually based on mystical association. In Brown's work, it became a powerful visionary tool that took his imagery far beyond the conventional Rastafarian iconography.

While Brown professed to be apolitical, the militant side of Rastafarianism is represented by the early work of Albert Artwell (1942–2018), who used the apocalyptic 'fire and brimstone' rhetoric of the movement to express an African nationalist world view. This is illustrated by *Judgement Day* (1979), where the only white persons are among the damned in hell. The frontal, hieratic quality of the composition and the vertical stacking of the figures reflect the popularization of Ethiopian religious painting in Rastafarian circles. The Rastafarian colours are again used in the rainbow motif over the head of the Christ figure. It is interesting to compare Artwell's *Judgement Day* with a work on a similar theme, *The Judge of Nations* (1989) by Gladwyn Bush ('Miss Lassie', 1914–2003) from the nearby Cayman Islands, where the Christ figure is white and the congregation multi-racial. Although Bush was of part African descent, her representation of race and religion reflects the more Eurocentric outlook of the Cayman Islands, where racial activism has been limited.

71

72

70 Everald Brown, *Ethiopian Apple*, 1970

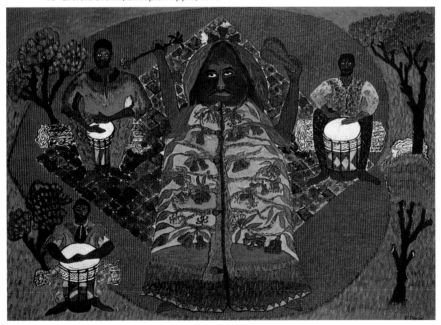

71 TOP Albert Artwell, *Judgement Day*, 1979
72 ABOVE Gladwyn Bush, *The Judge of Nations*, 1989

73 Osmond Watson, *Peace and Love*, 1969

Revivalism appears as a subject in mainstream Jamaican art, but Rastafarianism has been a more visible influence, especially since the late 1960s when black nationalism entered Jamaican mainstream ideology. This is illustrated by the work of the painter and sculptor Osmond Watson (1934–2005). While not a Rastafarian himself, Watson used the movement (and occasionally Revivalism) as a paradigm of black nationalism. His painting *Peace and Love* (1969), for instance, is at once a self-portrait and a 'Rastafarianized' Christ image, and also reflects the influence of Ethiopian Orthodox icon painting.

73

Rastafarianism has spread throughout the African diaspora and even to Africa itself. Two of Barbados's leading contemporary artists, Ras Akyem Ramsay (b. 1953) and Ras Ishi Butcher (b. 1960), are Rastafarians and use Rastafarian imagery in their work. The international familiarity with Rastafarian imagery also stems from its association with reggae and the work of graphic designers such as Neville Garrick (b. 1950), a Jamaican Rastafarian who was Bob Marley's art director and designed most of his record covers. Aspects of Rastafarian imagery have been co-opted by the Jamaican and Caribbean tourist industry and product merchandizing, to the point where the colours are used on anything from beach towels and souvenir T-shirts to beer and rum bottles and, of course, fashion, with little consideration for their original religious and political meaning.

As with Vodou, there is a tendency to overuse the label 'Rastafarian art'. Leonard Daley (1930–2006) is often described as a Rastafarian artist, although his work is only indirectly related to the movement. Daley had been painting on all sorts of surfaces in his living environment for many years and came to the attention of the Jamaican art establishment in the early 1980s. While his personal philosophy was loosely associated with Rastafarianism, his cryptic, hallucinatory paintings are in essence autobiographic parables of good and evil, which he, too, saw as necessarily intertwined parts of human nature.

74

In contrast to Haiti, the art-historical representation of the Jamaican popular artists was mainly articulated locally. It was spearheaded by the National Gallery of Jamaica, which had opened in 1974, and its long-serving Director/Curator, the artist and art historian David Boxer (1945–2017), who was also a major collector of the genre. Boxer's 'Intuitive Eye' exhibition in 1979 launched the term 'Intuitive' as an alternative to more obviously problematic 'primitive' and 'naïve'. He defined the Intuitives as follows:

74 Leonard Daley, *The Pickpocket*, 1984

These artists paint, or sculpt, intuitively. They are not guided by fashion. Their vision is pure and sincere, untarnished by art theories and philosophies, principles and movements... Their visions (and many are true visionaries), as released through paint or wood, are unmediated expressions of the world around them – and the worlds within. Some of them...reveal as well a capacity for reaching into the depths of the subconscious to rekindle century old traditions, and to pluck out images as elemental and vital as those of their African fathers.

Boxer intimated that mainstream Jamaican artists were somehow culturally compromised and therefore inferior to the supposedly 'pure' and unmediated Intuitives – a revolutionary and inevitably controversial counter-canonical move which not only granted recognition to those previously marginalized self-taught artists he sanctioned, in a way which was even more selective than the 'Haitian Primitive' canon, but also placed

them at the epicentre of Jamaica's national canons. In doing so, however, Boxer privileged individual psychological impulses over cultural context – or, as some of his critics have argued, at the expense of cultural context – and his Intuitives concept is more consistent with the concept of Outsider art than with how popular art from the Caribbean has been typically represented.

Boxer, however, made another important implied point, namely that interpreting the work of self-taught, popular artists should not be over-determined by the cultural labels attached to that work, but that it should also be considered on its own terms, as the artistic expression of the individuals who created it. Leonard Daley's visionary images are indeed too individual to accommodate any reductive religious or ideological labels. The same can be said of the work of the Guyanese painter and sculptor Philip Moore (1921–2012). Moore was associated with the Jordanites, an inspirational Guyanese church, but his work expresses a very personal, utopian vision of Guyana, an ideal of community in a country that has a history of racial and political divisiveness. Like Everald Brown in Jamaica, Moore frequently used polymorphic imagery. *The Cultural Centre* (1996) is a personification of the National Cultural Centre in Georgetown and an allegory of multi-cultural Guyana. The figure-building is crowned with symbols of Guyana's five national religions and supported by Greenheart – Guyana's national tree – caryatid pylons, an example of Moore's unique interpretation of national symbols. Moore's work was, however, also consecrated, particularly by the artist and archaeologist Denis Williams

75

75 Philip Moore, *The Cultural Centre*, 1996

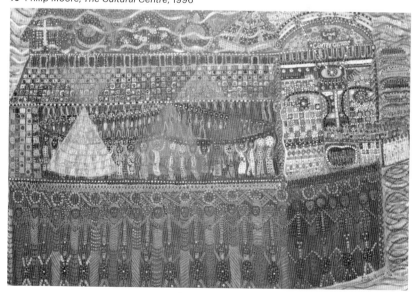

(1923–1998) – Guyana's 'culture czar' during the Burnham period – as part of the remedy to Eurocentric cultural contamination, a positioning of popular art which repeats itself throughout modern Caribbean art history.

The Cuban painter and woodcut maker Gilberto de la Nuez (1913–1993) often referred to Afro-Cuban traditions, such as the *bembé* dance ritual of Santería, but his work stemmed from a broader interest in documenting the history and customs of Cuba. De la Nuez was, however, a marginal figure in Cuban art, in part because the cultural policies of revolutionary Cuba have focused on formal arts training and state control of the cultural sector, which has left little room for the recognition of independent, untrained artists.

Afro-Cuban traditions are nevertheless unusually well preserved, largely because local colonial policies allowed the various African ethnic groups to maintain their cultural identity. The Santería religion (*regla de ocha*), for instance, is primarily of Yoruba origin, and its main counterpart, Palo Monte (*regla de Congo*), is derived from Kongolese traditions. Policies of revolutionary Cuba towards Afro-Cuban religions have been ambivalent, but they are more popular than ever and Afrocubanismo has remained an important current in Cuban art.

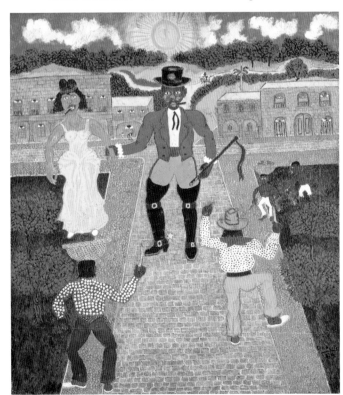

76 LEFT Gilberto de la Nuez, *Memory of the Colonial Past*, 1989
77 OPPOSITE Manuel Mendive, *Barco Negrero (Slave Ship)*, 1976

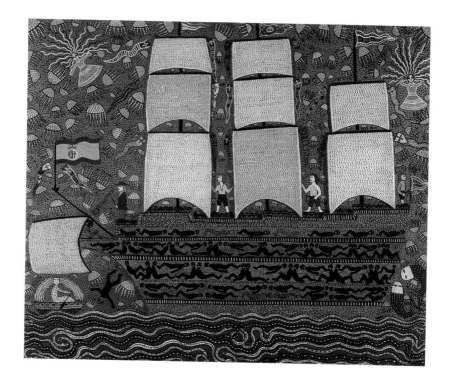

77 Manuel Mendive (b. 1944), a major exponent of contemporary Afrocubanismo, was born in a Santería-practising family. He received a conventional artistic schooling at the San Alejandro Academy but turned to popular culture as his main formal and conceptual source. Mendive is an initiate in Santería and Palo Monte, but his work has no ceremonial function; instead, he uses Afro-Cuban imagery to examine the questions of history and contemporary life. His travels to Africa in the early 1980s gave new energy and depth to his work and he adopted a more informal idiom that expresses a vision of nature, humanity and spirituality acted out by hybrid, amorphous figures similar to those of Saint-Brice and the Saint-Soleil School in Haiti. Mendive has also been involved in performance art. His performances are loosely choreographed pieces acted out by a troupe of performers and involve body painting, dance, music, sculpted and ready-made objects, and even the artist himself in the act of painting. The performances allude to Afro-Cuban rituals, but again without being literal or descriptive.

There is indeed strong resonance between the ritual performances and assemblages of African Caribbean religions and the performances and installations of contemporary art.

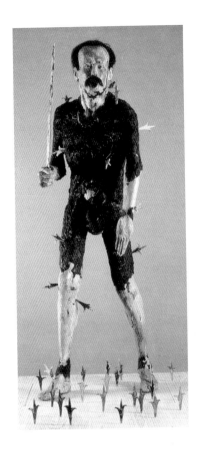

78 LEFT Juan Francisco Elso,
For América (José Martí), 1986
79 OPPOSITE José Bedia, *Isla jugando a
la guerra (Island Playing at War)*, 1992

One of the first artists to tap this potential was Ana Mendieta (1948–1985), who had been sent to the United States as an adolescent in 1961. For Mendieta, Afro-Cuban rituals provided insight into her identity as a Cuban exile and a woman. Her first major work on this subject was *The Burial of the Nañigo* (1976), one of her *Silueta* installations, which refers to burial rites of the all-male Abakuá secret society of Western Cuba. (Nañigo is the general term for an Abakuá member.) The identification with an exclusively male ritual addressed the issue of male domination and its relationship to cultural and personal identity.

The Cuban generation of the 1980s also turned towards Afro-Cuban rituals to explore issues of identity, although most had no traditional involvement in these religions. In these works, the spiritual, the personal and the political powerfully meet. The installation *For América (José Martí)* (1986) by Juan Francisco Elso (1956–1988), for instance, was a ritualized

78

representation of José Martí, the 'sacred warrior' of Cuban independence. The carved image of Martí was covered with mud mixed with blood and items significant to him and his wife, the Mexican artist Magali Lara. The dart-like objects that are sprouting from the body can be read as arrows, blood or flowers and are reminiscent of the St Sebastian iconography, Kongolese power objects and Mesoamerican regeneration rituals. Like Mendieta, Elso became a mythical figure in the Latin American art world after his early death from leukaemia, an illness on which his work reflected.

79 Another major Cuban artist of that generation, José Bedia (b. 1959), became an initiate of Palo Monte in 1984. His interest in non-western, aboriginal cultures led to a residency with the Dakota Sioux in 1985. His paintings, drawings and installations are reminiscent of Kongo cosmograms, Afro-Cuban altars, Abakuá ideographic writing and Sioux pictographs. As a true heir of Wifredo Lam, Bedia uses Afro-Cuban and Native

American culture in a poetic, yet critical, dialogue between the Third World and the west.

The Abakuá society was also the inspiration of the large, grisaille mixed-media prints by Belkis Ayón (1967–1999). Her mysterious multifigure scenes were based on her research into the sole female figure in the society's mythology, Princess Sikán, who was put to death after divulging an accidentally uncovered magical secret – a figure with which Ayón personally identified. The ghostly, mouthless figures in her prints allude to the imposed silences and cultural constraints that affect women in particular.

Puerto Rico has been slower to embrace its African heritage, but this has changed in recent years. The national and international attention that has recently been paid to the mixed-media assemblages by Daniel Lind-Ramos (b. 1953), whose hieratic *María María* (2019) created a sensation in the 2019 Whitney Biennial, exemplifies this repositioning. Lind-Ramos, who is Afro-Puerto Rican, produces his work from found and gifted objects that range from Federal Emergency Management Agency tarps to coconuts and tools, all collected from his hometown of Loíza. Like many of his counterparts in Cuba, he associates the spiritual and the political, commenting among other things on the disproportionate impact of the catastrophic 2017 Hurricane Maria on this poor, predominantly Afro-Puerto Rican community.

The African Caribbean components in Caribbean popular culture have received most art-historical attention, and have most visibly influenced the visual arts, but the contributions of other ethnic groups are nonetheless significant and are increasingly being asserted. Wendy Nanan (b. 1955), for instance, used

80 BELOW Belkis Ayón, *The Supper*, 1991
81 OPPOSITE Daniel Lind-Ramos, *María María*, 2019

popular religion as an ironic token of hope in the troubled 'marriage' of multi-racial, multi-cultural Trinidad in her relief construction *Idyllic Marriage No. 4* (1989). It represents 'La Divina Pastora' in a wedding scene with Lord Krishna. La Divina, as she is popularly known, is a wooden statue of a black Virgin Mary in the town of Siparia in southern Trinidad that is venerated by Hindus and Roman Catholics alike for its purported miraculous powers. As a sacred sculpture of uncertain, probably Venezuelan origin, the figure of La Divina embodies the syncretism of creole Caribbean culture. Her 'marriage' to Lord Krishna challenges the perception that the East Indian population does not participate in Trinidadian culture.

The Caribbean has many festival traditions, mainly pre-Lenten carnivals and Christmas season masquerades that originated

82

82 Wendy Nanan, *Idyllic Marriage No. 4* from the *Idyllic Marriage* series, 1989

during the plantation period. While these festivals are primarily Afro-European, other ethnic groups have contributed traditions such as the East Indian Hosay festival and the Chinese New Year celebrations. These festivals are, as such, beyond the scope of this book, although the costumes and other constructions are often of considerable artistic merit. Where there are dominant festival traditions, as in Trinidad and the Bahamas, the festival arts have contributed to the development of a vernacular aesthetic that influences the entire cultural spectrum, including the visual arts. As events that are rooted in popular culture but traditionally attract mass-participation across class boundaries, the Caribbean masquerades are less subject to the class and external patronage dynamics that have affected the representation of popular religions in art, but this does not mean that those processional arts are apolitical or devoid of internal tensions.

Traditional carnivals are found in countries with a Roman Catholic heritage, such as Cuba, Puerto Rico, Haiti, the Dominican Republic and Trinidad. In these carnivals, the sacred and the secular meet. Cuban carnival, for instance, incorporates Afro-Cuban ritual practices such as the *ireme* masqueraders of the Abakuá. In revolutionary Cuba, the *ireme* figure has become a national symbol and carnival was moved to the last two weeks of July to coincide with the anniversary of the revolution. The *ireme* masqueraders are the subject of

83 René Portocarrero's *Little Devil No.3* (1962), part of his *Colour of Cuba* series, a celebration of Cuban popular culture, but their national consecration also signals the gender biases in the conceptions of national cultural identity, which Ana Mendieta and Belkis Ayón have both challenged.

The origins of Trinidad carnival or 'mas', as Trinidadians prefer to call it, are primarily French Creole and West African. Mas has grown into the premier pre-Lenten carnival of the Caribbean and is the focal point of modern and contemporary Trinidadian culture. Peter Minshall (b. 1941), a theatre designer by training, revolutionized mas in the early 1980s and became one of Trinidad's most influential contemporary artists. Describing mas as a 'living art that we make fresh every year', he challenged the stereotypes of sequins, lamé and feathers that had overtaken mas, and brought a renewed social consciousness

83 René Portocarrero,
Little Devil No.3 from
the *Colour of Cuba*
series, 1962

to the festival. Minshall's bands are unusually large, sometimes involving more than two thousand people, and act out complex morality plays on the fundamental existential issues of modern life. Not surprisingly, Minshall cites Cecil B. DeMille as an influence, although more recent film sagas such as the *Star Wars* trilogies also come to mind. Minshall's epic performances have also appeared outside of mas, for instance at the opening ceremonies of the 1992 Barcelona and 1996 Atlanta Olympics.

Minshall's spectacular 'king' and 'queen' costumes are elaborate kinetic constructions, animated by the wearer and sometimes also by mechanical devices such as the electric compressor in the king costume *ManCrab* (1983) that pumped 'blood' over a canopy of white silk. *ManCrab* was the king of the 1983 carnival band *The River*, an allegory of the destructive nature of modern life. The band acted out a battle between good and evil – between ManCrab, a Lucifer-like creature that represented the evils of modern technology, and the queen Washerwoman, the embodiment of purity and harmony.

84

84 LEFT Peter Minshall, *ManCrab* from the Trinidad Carnival *The River*, 1983
85 OPPOSITE Gaston Tabois, *John Canoe in Guanaboa Vale*, 1962

Washerwoman was 'killed' at the end of the 1983 carnival, a surprising and unconventional victory of evil. While the East Indian and Chinese contributions to Trinidad mas have not always been acknowledged, Minshall's bands are emphatically multi-cultural (to the point of glossing over the very real race, ethnicity and class divisions in that country). In *The River*, for instance, he appropriated East Indian elements such as the small, portable *tassa* drums and the East Indian *phagua* (holi) festival in which coloured dyes are thrown on participants.

In predominantly Protestant countries like Jamaica, other traditional festivals exist such as the Christmas season Jonkonnu masquerade. Like the *ireme* masqueraders in Cuban art, Jonkonnu has fascinated artists since the nineteenth century when Isaac Mendes Belisario first documented the tradition. In the twentieth century, Jonkonnu appears in the work of artists who are concerned with 'the Jamaican', such as Osmond Watson and Gaston Tabois (1924–2012). The latter was a keen observer of Jamaican life and the surreal overtones of his precisely crafted Jonkonnu paintings remind us that reality and the fantastic intersect in masquerade. Although there have been several attempts to revive Jonkonnu, among others through Jamaica's midsummer Independence Festival, it is a waning tradition.

85

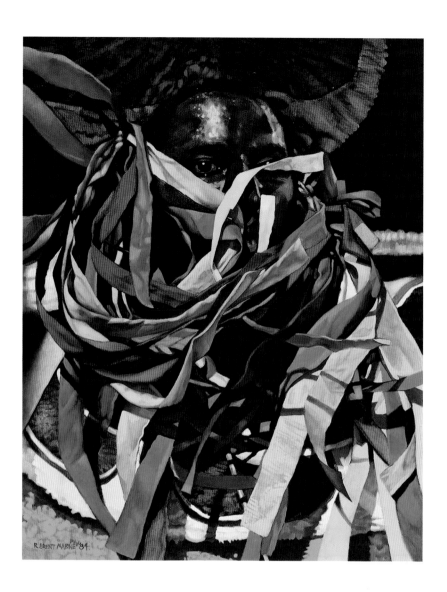

86 ABOVE Brent Malone, *Junkanoo Ribbons*, 1984
87 OPPOSITE John Beadle, *Cuffed: Held in Check*, 2018

Unlike its related, Jamaican near-namesake, the Bahamas Junkanoo has evolved into a major street parade in which various organized themed bands compete with floats and masqueraders. The modern Junkanoo attire consists of a body costume and headdress, both elaborately decorated with brightly coloured crêpe-paper strips, that are clearly related to Belisario's *Actor Boys*. As in Trinidad, several contemporary Bahamian artists are involved in Junkanoo design – Stan Burnside (b. 1947), John Beadle (b. 1964) and Jackson Burnside (1949–2011) are associated with the 'One Family' Junkanoo Organization.

Junkanoo frequently appears as a subject in modern Bahamian art and has generated a recognizable aesthetic. One such example is *Junkanoo Ribbons* (1984) by Brent Malone (1941–2004), which is part of a larger series of part photorealist, part surrealist portrayals of the festival. Junkanoo was also an important theme for Amos Ferguson (1920–2009), and even his paintings that are not directly related to the masquerade reveal its formal influence. While he does not use the brilliant colours and patterns associated with Junkanoo in his art, John Beadle uses materials and techniques from its costume construction in his mixed-media installations and employs the masquerade's theatrical strategies to interrogate politicized subjects such as illegal migration and the social and historical constructs about black athletes.

The Caribbean festivals have travelled with Caribbean migration to North America and Europe. The larger Caribbean

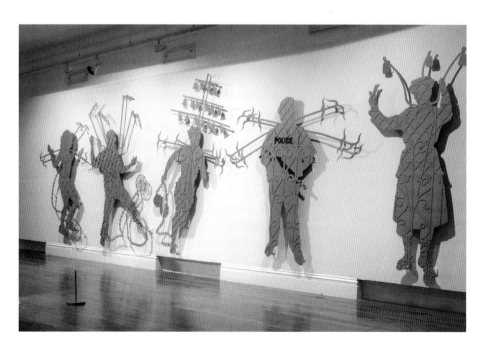

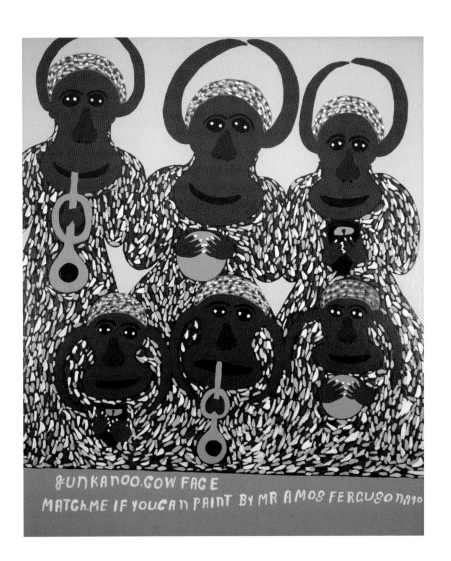

88 ABOVE Amos Ferguson, *Junkanoo Cow Face: Match Me If You Can*, 1990
89 OPPOSITE Tam Joseph, *Spirit of the Carnival*, 1983

carnivals in cities such as Brooklyn, Toronto and London were modelled after Trinidad mas, although they attained broader significance as celebrations of Caribbean heritage, black solidarity and multi-cultural goodwill. Unavoidably, and as in the Caribbean itself, these festivals have also been vehicles for resistance and political dissent. The Notting Hill Carnival in London, for instance, erupted into race riots in 1976, one of the first major episodes of unrest among the black population in Britain.

Tam Joseph (b. 1947), a London-based artist who was born in Dominica, started his career during this turbulent period and has devoted his work to exploring the cultural and racial stereotypes that prevail in multi-cultural Britain. He commented on the politicized nature of carnival as resistance in his *Spirit of the Carnival* (1983). The work appropriates the stereotypical media images of black rioters in confrontation with the police to satirize the typical overreaction of the British security services to matters involving the black population.

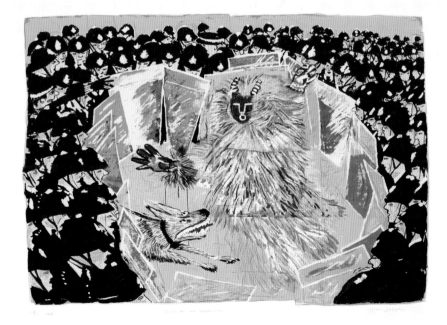

Chapter 5
'Dangerously Close to Tourist Art'

Tourism has a long history in the Caribbean and started during the plantation era. The first hotel, in the modern sense, was the Bath Hotel, which opened on the volcanic island of Nevis in 1778 and attracted wealthy colonial tourists who came to make use of the curative hot water springs. The introduction of the steamship and the emergence of a capitalist leisure class with the resources and time to travel to exotic locations turned tourism into a viable economic activity in the nineteenth century. The Caribbean, with its year-round salubrious climate, natural beauty and proximity to the US mainland, was well-positioned, geographically, to become a major tourist destination.

The colonial governments recognized the economic potential of tourism to the Caribbean and facilitated the development of the needed infrastructure. This was one of the objectives of the Jamaica International Exhibition in Kingston in 1891, a joint initiative of local businesspersons and the colonial government that sought to promote Jamaica's economic potential and invite investments to replace the island's declining sugar industry. The exhibition itself was not profitable, unlike the 1851 Great Exhibition in London's Crystal Palace after which it was modelled, but it set the stage for the island's tourist industry. The paintings and photographs of Jamaican sights in the exhibition helped to codify the island's tropical beauty as a major selling point for tourism, while the displays of 'native craft' identified potential cottage industries that could produce items for sale to tourists. Kingston's original grand hotels, the Constant Spring and Myrtle Bank, were built to accommodate the anticipated visitors. The Jamaica Hotels Law of 1890, the first tourism-related legislation in Jamaica, offered government assistance for hotel construction.

90 A. Duperly and Sons, *Castleton Gardens*, 1901

Jamaican tourism took off when the Boston-based United Fruit Company, which dominated the emerging banana industry throughout the Caribbean and Central America, started using the passenger capacity on its banana boats to transport tourists to Jamaica, building or acquiring several grand hotels, such as the Titchfield Hotel in the banana port of Port Antonio, which opened in 1897. Consequently, most early tourists in Jamaica were wealthy Americans from the cities along the Atlantic seaboard, but they also came from England, mainly with Elder, Dempster & Co., a Bristol-based shipping company, and soon also from continental Europe.

By the 1920s, the Caribbean tourist industry was well-established and a growing economic, social and cultural influence in most of the region. The cultural impact of tourism has, however, received only scant attention in the art histories of the region. Tourism created a large new market for images and objects that represented the Caribbean in ways that would appeal to tourists, and that have also helped to shape those tastes. This, in turn, created significant, if unevenly distributed,

economic opportunities in the Caribbean, from grassroots level to big business.

As we have seen in Chapter 1, the advent of photography helped to set the stage for the development of tourism which, in turn, provided a lucrative market for locally based and visiting photographers. Tourism-related photography played a major role in the creation of the image of the tropical Caribbean that was offered as tourism's main attraction – an extravagantly lush, picturesque and partially fabricated vision of tropicality which, as the Bahamian art historian Krista Thompson has demonstrated, also involved modifications to the not always compliant Caribbean landscape itself.

90

A 1901 photograph of Castleton Gardens by A. Duperly and Sons provides a revealing example. Castleton Gardens is a famous botanical garden, located inland north of Kingston, Jamaica, which was established in 1862 and which was a popular tourist attraction during the early years of tourism. The Gardens received more than four thousand plant species from London's Kew Gardens, which illustrates the extent to which tropical landscapes were being transformed for tourist consumption and agro-economic purposes alike. The photograph features two suited black men, whose dress and posing suggests a self-confidence, status and modernity usually denied to 'natives' in such images, but the two men are dwarfed by the overwhelming, gigantesque tropical vegetation of the gardens. What could, at first sight, be construed as an image of black middle-class respectability, masculinity and personhood is presented in uneven juxtaposition with the presumed hyper-fertility of tropical nature, which sends mixed messages about the men's status as 'natives', colonial subjects or citizens – a perfect image of the contradictory social dynamics of that moment.

The advent of tourism indeed sat uneasily with the concurrently emerging anti-colonial, nationalist ideologies. The Jamaican journalist Ken Hill, in a 1938 feature on tourism in the nationalist weekly *Public Opinion*, cautioned: 'Develop the tourist trade and perhaps you may have a "nation" of waiters.' Tourism was perceived, and with good reason, as a threat to the nationalist efforts at fostering social progress and a dignified sense of personhood, and as a perpetuation of the 'native' servitude of the colonial era. Caribbean tourism, most of which was also racially segregated until the mid-twentieth century, was thus from early on regarded as a neo-colonial venture, which furthermore only benefited a privileged minority of the local population. Caribbean tourism also emerged while the United States were becoming a major economic and political influence in the region, and American interests were crucially

91 A tourism brochure for Cuba, 1951

involved, which added to the social, cultural and political tensions that surrounded the nascent industry.

The 1920 to 1933 Prohibition in the US further positioned nearby Caribbean locations, such as Cuba and the Bahamas, as playgrounds for the rich and famous, as alcohol could be freely consumed there. The US Mafia took advantage of the accommodating, corrupt Cuban governments of that period and brought their gambling, prostitution and narcotics activities to Havana. Artists such as Wifredo Lam were making great efforts to challenge the typecasting of Havana as 'a land of pleasure, of sugary music, rumbas, mambos and so forth' but Cuban tourism posters of the same period, some of which were designed locally and others in the US, make it abundantly clear that this was exactly what was being sold to the tourists. Designed in cheerful colours and patterns, and often with a coy cartoonesque style, such posters also made it clear that exotic Cuban women, who are almost always featured, were part of what was on offer – modern-day versions of Landaluze's seductive *mulatas*.

91

21

The socio-economic inequities and exploitation involved in this phase of Cuban tourism were significant and, in fact, helped to set the stage for the Cuban Revolution.

Mural commissions for hotels were common in the Caribbean at that time and involved the production of elegant, alluring background images. The prestigious Tower Hill Hotel in St Mary, Jamaica, was opened in 1949 by the Lebanese Jamaican Issa family, which has played a pioneering role in the local tourism industry. It featured murals by three of the main tourism-oriented artists active in Jamaica at that time: the American John Pike (1911–1979), the Englishman Hector Whistler (1905–1978) and the Jamaican Rhoda Jackson (1913–1971), who also had exhibitions at the hotel during the 1950s. Whistler was also active in Barbados, which was another pioneering tourist destination in the Caribbean. The Polish painter Michael Lester (né Michal Leszczynski, 1906–1972) settled in Jamaica's Montego Bay in 1950 and produced majestic panoramas of the Bay and its environs, as well as picturesque genre scenes. Many of Lester's works can still be seen at the upscale hotels and resorts that opened in the area around that time, which were his best customers.

Although these expatriate artists also interacted with local audiences – Pike was the architect of the 1938 Carib movie theatre for MGM in Kingston, a major Art Deco landmark in the Caribbean – their work was primarily geared towards the tourism industry and reflects the specialization that was taking place in that arena. The dominance of expatriates suggests reluctance on the part of Jamaican artists to work for the industry and, conversely, reluctance on the part of tourism interests to place such representations in the hands of Jamaicans. Many hotel murals were, however, destroyed when hotels were redecorated or demolished and very few were even documented, which suggests that they were regarded as décor and not as art works of great aesthetic or cultural significance.

Rhoda Jackson, a white Jamaican, had returned to the island in 1936, after studies at the Reading University art school in England, and was one of the island's first formally trained modern artists. Jackson executed hotel murals but also designed advertisements, postcards, textiles, embroidery patterns and book covers, such as the dustjacket of Esther Chapman's *Pleasure Island* (1952), a guidebook that had a rather instructive title although it purported to provide a more 'informed' perspective on Jamaica as a tourist destination.

Jackson was an undeniably talented and innovative painter and designer. Her work represents Jamaica by means of a repertory of colourful, iconic images consisting of picturesque

92

92 Rhoda Jackson, jacket design for *Pleasure Island: The Book of Jamaica*, 1952

gingerbread cottages, idyllic fishing beaches and waterfalls, and rollicking cane-fields and mountainscapes, all peopled with pretty ladies, dandyish men and cute children involved in various, apparently very pleasant work activities, most of them black and all dressed in colourful, frilly 'native' costumes. Forms are simplified and stylized into patterned compositions that often have a tapestry-like quality. This made her designs very versatile, suitable for large panoramic paintings and small embroidery motifs alike.

While the type of subjects Jackson depicted are, as such, not substantially different from those of the Jamaican nationalist school, the tone and politics of her work could not be more different. Her style is modern but the cheerful vision of rural Jamaica she presents is located in an idyllic, quasi-timeless colonial past and subliminally conveys to tourists that 'this is yours to enjoy, and available on your terms'. This, of course, stands in sharp contrast with the earnest, nation-building modernism of, for instance, Albert Huie's *Crop Time* (1955) and the assertions of national belonging, ownership and identity that predominated in nationalist art.

Rhoda Jackson is best known for tourism-related work, but she was also involved in Jamaica's mainstream art world and she participated in the Institute of Jamaica's art exhibitions, along with artists such as Huie and Edna Manley.

93 Hotel Oloffson, Port-au-Prince, Haiti

It is nonetheless telling that, despite being one of the most accomplished Jamaican artists of her generation, there was no substantive critical response to her exhibitions in the local press. She is also unmentioned in later art-historical narratives such as David Boxer's *Jamaican Art 1922–1982* (1983), the standard text on Jamaican art history.

The question arises as to why there is greater recognition for the artistic worth of Lester and Whistler. Lester was granted a retrospective at the National Gallery of Jamaica in 2006 and Whistler was the subject of a retrospective at the Barbados Museum and Historical Society in 1988. It may be that Jackson was primarily seen as a designer and not a 'fine artist', but the work of Lester and Whistler is also less explicitly addressed to the tourist trade, and closer in subject, tone and execution to the artists of the nationalist school and post-independence generation. This illustrates that the boundaries between tourist and 'legitimate' Caribbean art are in effect quite tenuous and flexible, and sometimes even arbitrary.

This uneasy proximity was also evident in the specialized art tourism that developed when the 'Haitian Primitives' captured the international, western imagination. Haiti's tourism industry had emerged during the American occupation of that country, from 1915–34, and while Haiti's political instability has

prevented it from becoming a major tourist destination, tourism has been a major factor in the development of Haitian art. 'Primitive' art of widely varying quality and originality could be bought, and often very cheaply, at places such as the Marché en Fer (Iron Market), the iconic Hotel Oloffson (which is also a prime example of the Haiti's famed gingerbread style of architecture), the Centre d'Art itself and a wide array of formal galleries and roadside stalls. Much of it was exported wholesale, and standardized Haitian scenes are still on sale today at galleries and craft markets throughout the Caribbean. While this mass-production provided an income to many, at different socio-economic levels in Haitian society and beyond, there were widespread critical concerns that the integrity of Haitian art had been compromised in the process.

The Jamaican critic Norman Rae wrote in *Ian Fleming Introduces Jamaica* (1965): 'Jamaican painters generally do not aim at the titillatingly decorative "native" object or art/craft, the stylish decorations designed for the tourist market that one finds proliferating in many other Caribbean and tropical countries. The ever-present determination not to let the glittering island vistas lead them astray makes them avoid this.' That such a statement, which obviously sought to position Jamaican art against its Haitian counterparts, could have appeared in a celebrity-edited tourist guidebook, and in a chapter that furthermore sought to introduce Jamaican art to 'knowing' tourists, is indicative of the contradictions in the local art world's engagement with tourism. It illustrates what Ruth Phillips and Christopher Steiner, in their 1999 book *Unpacking Culture: Art and Commodity in Colonial and Post-colonial Worlds*, have labelled as the 'commercial appeal of anti-commercialism', whereby the perception, or illusion, that certain cultural products and destinations are not 'tainted' by tourism is what turns them into sought-after, high-end tourist products – the contradictory staging of 'authenticity' that is a characteristic part of how culture is packaged for tourism consumption.

Many 'serious' artists throughout the Caribbean have indeed sold their work in the tourist market and have even made clear accommodations in the form and content of their creations. Several of Jamaica's 'Intuitive' artists, the presumed pinnacle of 'purity' in Jamaica's artistic hierarchies, for instance, started out by producing for the tourist market and even the religious leader and artist Mallica 'Kapo' Reynolds (see Chapter 4) operated a roadside stall near Kingston's Constant Spring Hotel for a while. Jamaica's first modern art gallery, the Hills Gallery, was located within walking distance of the Myrtle Bank Hotel in Kingston and exhibited artists such as Gaston Tabois

and Kapo. At the Gallery's tenth anniversary, in 1963, it was announced that forty per cent of sales were to local buyers, a major achievement in the development of local art patronage, but there was no acknowledgment that this also meant that sixty per cent of sales were still to visitors.

Photographs of Kapo and his work were also used in Jamaica Tourist Board advertisements in the 1960s, as part of efforts to give Jamaica greater cultural distinction in the increasingly generic 'sun, sea and sand' tourism of the Caribbean and, no doubt, to compete with Haiti's promotion of its 'primitives'. Selden Rodman, the champion of the 'Haitian Primitives', visited Jamaica in the mid-1960s for his book *The Caribbean* (1968) and enthusiastically compared Kapo's paintings to those of Hector Hyppolite. With perhaps a hint of retaliation, he however dismissed Kapo's sculptures as 'grotesque and inelegant, influenced perhaps by what passes for "African" in the tourist shops'. The tourist market has provided a much-needed outlet for many Caribbean artists but overtly catering to its demands, or even being accused of moving 'dangerously close to tourist art', to use a common phrase in such discussions, has been a line artists cross at their own peril.

Far fewer anxieties have surrounded the production of craft for the tourist market, such as baskets, straw hats or carved calabashes, since it is more generally accepted that craft is made to sell and therefore should be adjusted to the needs and expectations of the buyer. Craft items are usually customized for the tourist market with decorative elements and references to the location, as well as changes in scale, to facilitate their new function as souvenirs, but most are based on traditional, utilitarian craft forms and skills. The transition to the tourist market has, in fact, often aided the survival of traditional skills and creates opportunities for innovation in craft designs and techniques.

The traditional markets of the Caribbean were, from early on, positioned as tourist attractions and the sale of art and craft items to tourists started early there – the Marché en Fer in Port-au-Prince is one such example. Those general markets did not meet tourism's desire for comfortable, managed environments, however, and specialized tourist craft markets were soon established. The Straw Market in Nassau, in the Bahamas, originated as a general market but became a specialized tourist craft market in the 1940s, aided by its proximity to the passenger terminal of Nassau harbour. The Bahamas had a tradition of utilitarian straw-weaving, making use of various local natural fibres, and the Straw Market soon became famous for its high-quality straw work and as a must-

94

94 Straw Market, Nassau, Bahamas, 1960s

see attraction. The original, open-air market building was destroyed by fire in 2001 and a new, air-conditioned building has since been constructed. While locally produced straw work and other craft items are still being sold there, such products are increasingly displaced by cheaper, imported souvenirs that are mass-produced in East Asia and only tenuously customized for the local markets, which jeopardizes the sustainability of local crafts aimed at the tourist market.

Despite being represented as a picturesque character in tourist art, the vendor – 'Madan Sara', as she is called in Haiti (since most vendors are female) – is a traditional figure of resistance and resilience in the Caribbean against an oppressive and deeply unequal socio-economic system through small, independent entrepreneurship. That the formal and informal markets became a prime space for unmediated encounters between tourists and vendors explains why these were, from early on, laced with conflict, as different social worlds, values and interests collided there. Tourist complaints about harassment appeared from the early days of Caribbean tourism – especially in the context of informal, ambulant craft-vending – along with complaints about rudeness and poor service in the hotels. These frictions are, however, best

95 Fernando Rodríguez, *At la Bodeguita* from the *Nuptial Dream* series, 1994

understood as the passive and active resistance of those
who were in a position of disadvantage in an industry in
which the real benefits and profits – then as now – go to
the local business elite and foreign interests.

The advent of jetliners and paid vacation after the
Second World War ushered in the era of mass tourism,
with rapidly growing numbers of visitors and shorter stays,
and an even more genericizing approach to Caribbean
tourism. These developments, however, also coincided
with political radicalization in the region and more intense
criticism of the social and cultural implications of the tourist
industry. When Jamaica's democratic socialist Prime Minister
Michael Manley (Edna Manley's son) declared in 1975 that
'Jamaica was not for sale', he was not exclusively referring
to tourism, but it was certainly on his mind; and a 1970
Time magazine article about Caribbean Black Power was
provocatively titled 'Tourism is Whorism', leaving no doubt
about the critical position taken in the interviews for
that article.

In Cuba, tourism was nationalized after the revolution
and, after the 1961 US embargo, tourism became a marginal
part of the Cuban economy. During the so-called Special
Period – the severe economic crisis after the dissolution of

the Soviet Union – the decision was made to reopen Cuba to tourism. A Ministry of Tourism was established in 1994 and there was rapid investment in tourist facilities, and the country is now once more one of the Caribbean's main destinations. This has inevitably resulted in major tensions, between the Cuban revolutionary ethos, the daily lived realities and how the country and its culture are staged for the tourists. Ironically, the Revolution itself has become part of Cuba's tourist attractions, along with Old Havana which has, critics have argued, become a colonial 'theme park'. Havana is not the sole example of the uncritical promotion of the colonial past in contemporary Caribbean tourism, as colonial districts serve as signature attractions in Santo Domingo and San Juan, and the dominant architectural style of Caribbean resorts is Plantation Modern.

Fernando Rodríguez (b. 1970) is one of several contemporary Cuban artists who have satirized these issues. He works through his fictional alter ego of Fernando de la Cal, a blind charcoal-maker and popular artist, and a 'good revolutionary'. De la Cal/Rodríguez's series of polychromed relief carvings *Nuptial Dream* (1994) chronicles the imaginary 'wedding' of Fidel Castro and the Cuban patron saint El Virgen del Cobre (Our Lady of Charity). As part of their honeymoon, the 'newlyweds' visit the tourist attractions of what some have called 'Havanaland'. In one panel, the couple is seen feasting at the famous café La Bodeguita del Medio, which is far too expensive for most Cubans, and their 'chronicler' de la Cal is signing the wall, as celebrity visitors are traditionally asked to do. With its mock naïve 'craft' style, the series also comments on the new wave of Cuban tourist art that provides hard-currency income for artisans and street vendors who often have tertiary qualifications in fields such as economics or law.

The ideological contradictions in Cuban tourism are extreme, but similar developments have taken place throughout the Caribbean and tourism is regarded as an economic necessity by Caribbean governments. Although there are efforts at more culturally sensitive and socially equitable tourism, such as smaller scale, community and eco-tourism, mass tourism reigns supreme throughout most of the region. Almost identical all-inclusive resorts can be found on practically every island, and cruise ship tourism – whereby tourists spend only hours at each destination, being bussed to popular attractions and duty-free shopping havens – accounts for a significant part of the tourist arrivals, which run in the millions per year in most major Caribbean tourist destinations. Local distinctiveness is significantly eroded in the process and direct contact with the local people is often deliberately limited. An extreme example

95

96 Blue Curry, *PARADISE.jpg* (2014), East Street, Kingston,
Jamaica Biennial, National Gallery of Jamaica, 2014

'Dangerously Close to Tourist Art'

is the cruise-ship port of Labadee (originally named Labadie), which is located on a peninsula on the northern coast of Haiti and leased and operated by Royal Caribbean cruises. Tourists are not allowed to leave the securely fenced property and Haitians, other than workers and licensed vendors, are not allowed in – Labadee is a self-contained, stage-managed beach paradise.

Blue Curry (b. 1974), a London-based contemporary artist from the Bahamas, has explored the dissonance between the generic fictions of mass tourism and the lived realities of the Caribbean in his work. His *PARADISE.jpg* (2014), as it was shown in the 2014 Jamaica Biennial of the National Gallery of Jamaica, was based on a stock image of the Caribbean reduced to its barest, almost abstract 'essentials': a bright blue sea and sky separated by an endless horizon line. Large wallpaper-size prints of the photograph were mounted on the walls of three derelict buildings in downtown Kingston, a grungy urban environment that is far removed from the sanitized, generic imaginary that prevails in the tourist industry. The clash between these two worlds had a surreal, poetic effect that added unexpected beauty to a powerful social and cultural critique.

The tourist industry's capacity to co-opt even that which challenges and resists it is remarkable. Aspects of Rastafarian culture have been commodified and trivialized by the Caribbean tourist industry, to the point where the colours and other symbols are used on anything from beach towels and souvenir T-shirts to beer and rum bottles, with little consideration for their original religious and political meaning. Bob Marley's 'One Love' is now the anthem of Jamaican tourism. But this does not mean that social inequities and contestation have disappeared from the field, and craft vending has, for instance, been a major arena for such conflicts in Jamaica.

Fern Gully, a delicate rainforest ecosystem near Ocho Rios in Jamaica, was until the recent construction of an alternative highway also a busy thoroughfare to the touristic North Coast, a tourist attraction in itself and a major illegal craft vending site. In the 1980s and 1990s, there were regular conflicts between the authorities and the craft producers and vendors who had established themselves there, with multiple, unsuccessful attempts at removing them. Most of the crafts sold there were stereotypical 'Rasta' woodcarvings, which have become commonplace in Caribbean tourist art. However, the site also featured life-size male Rastafarian figure carvings with an enormous, erect penis which made uncomfortable reference to the rarely acknowledged fact that black male sexuality is part of what is being transacted in Caribbean tourism. There were many public calls, including from Jamaica's first female Prime

97 Labadee Craft Market, Haiti

Minister, Portia Simpson-Miller, to have them removed or at least displayed less prominently, but to no avail. That those phallic carvings would have appeared in the highly contested space of Fern Gully can, however, also be read as a carnivalesque gesture that provocatively claimed space and visibility in a tourism industry that has consistently marginalized and disempowered the producers and vendors of such carvings.

Chapter 6
Political Radicalism, Abstraction and Experimental Art

Caribbean art entered a new phase in the 1950s and 1960s, characterized by a radicalization and polarization of artistic views. Some artists rebelled against the Indigenist canons of the nationalist schools and sought a more universal artistic expression in formalist modernism. Almost simultaneously, social and political subjects became more prominent and several distinctive schools of political art emerged. This chapter examines the ideologically motivated art forms of this era and their relationship with abstract and experimental art.

The Cuban Revolution of 1959 was a watershed event in Caribbean history and gave the entire region unprecedented international attention. It placed Cuba in opposition to the United States in the midst of the Cold War and influenced the course of politics throughout the Americas. The assassination of the dictator Rafael Trujillo in the Dominican Republic in 1961 marked the start of several years of social and political unrest that culminated in civil war in 1965. Anxious to avoid 'another Cuba', the United States sent an intervention force of 20,000 marines and restored the status quo. The following year, the former Trujillo aide Joaquín Balaguer was elected president. It was during this period, also, that François 'Papa Doc' Duvalier came to power in Haiti and established one of the most repressive regimes in modern Caribbean history.

There were fundamental changes in the political status of most Caribbean countries. In 1958 the British territories were united into the West Indies Federation, but this fell apart when Jamaica and Trinidad seceded to become independent from Britain on their own in 1962. Barbados and Guyana followed in 1966 and most other islands have since then also become independent. The failure of this federation shows that the region was not ready for a pan-Caribbean state, but the

establishment of the Caribbean Community and Common Market (CARICOM, with the 1973 Treaty of Chaguaramas) has provided a formal avenue for economic and cultural cooperation and has also served as a shared political platform for its members. While this organization has been dominated by the Anglophone Caribbean, Surinam joined in 1995 and Haiti in 2002. Puerto Rico, in contrast, became a Commonwealth or 'Associated Free State' of the US in 1952, a controversial compromise between integration and independence. The French Antilles and French Guiana opted for full assimilation with France as Overseas Departments in 1946 and, similarly, the Dutch territories became part of the Netherlands in 1955, with internal self-government, although Surinam opted for independence in 1975.

Whereas local conditions varied, there was a general increase in political activity throughout the region. Anti-imperialist sentiments ran high and several Caribbean nations asserted themselves as a part of the Third World, in the political sense of the Non-Aligned Nations movement. In many instances, the nationalist leaders and intellectuals of the previous decades became the governing politicians, which allowed them to turn anti-imperialist nationalism into official policy. There was a pervasive, undeniably utopian belief that a more equitable socio-political order had finally become possible. This view was perhaps best summarized by the Trinidadian historian and politician Eric Williams, who said in a 1961 public speech on Woodford Square in Port of Spain: 'Massa day done' – the slave-master's time is over.

This new breed of politicians was acutely aware of the social and political importance of culture in postcolonial society and this led to an unprecedented level of government involvement in the arts and, occasionally, incidents of interference. New art schools, museums and other supporting facilities were established in the larger Caribbean countries, most of them with government funding, which helped to broaden the scope of Caribbean art. The Cuban government, in particular, has devoted considerable resources to artistic and cultural promotion, more so than most Caribbean nations. There is a comprehensive art education system that is offered free of charge – the flagship of this system is the Higher Institute of Art (ISA) in Havana, the influential national postgraduate art school, which opened in 1976.

Caribbean cultural exchanges also increased. The establishment of the roving cultural festival CARIFESTA was a galvanizing force in the Caribbean art world during the 1970s, as it was the first time Caribbean creative practitioners

98 Rafael Tufiño, *Temporal* (*Storm*) from *Portafolio de Plenas*, 1953–55

encountered each other in a shared regional forum. Perhaps inevitably, as a government-controlled initiative, the festival later became associated with the more prescriptive and routine 'official' expressions of Caribbean culture. Its first edition was held in Guyana in 1972, followed by Jamaica in 1976 and Cuba in 1979.

Despite the initial optimism, internal tensions emerged in several Caribbean countries and the new political establishment was soon challenged by dissident, usually more radical factions. Marxism was important, but race was a central issue in this radicalization process, especially in Jamaica, Trinidad and Guyana, where black nationalism gained widespread support and became an important political force. Other ethnic groups asserted themselves, especially the fast-growing East Indian populations of Trinidad and Guyana, who frequently found themselves at odds with radical black nationalism. Caribbean migrants and their descendants also participated in racial activism in North America and Europe, as they had done earlier in the century. Malcolm X, for instance, was of part West Indian descent (his mother was from Grenada) and the Black Panther leader Stokely Carmichael was born in Trinidad.

It may seem contradictory that Caribbean artists became interested in abstract art during this era of ideological radicalization. The two were not mutually exclusive, however, if only because the Caribbean ventures into abstraction often

amounted to a refusal to be typecast, whether by the western or the Caribbean cultural establishment. The Guyanese-born painter Frank Bowling (b. 1936) vocally defended his place as a black artist in the modernist mainstream of New York and London, and the Trinidadian Kynaston McShine became one of the most influential curators at the Museum of Modern Art in New York City, responsible for major exhibitions on artists such as Andy Warhol, Robert Rauschenberg, Richard Serra and Marcel Duchamp. These developments were reinforced by the shift from Paris to New York as the focal point of the metropolitan avant-garde, as well as the increased Caribbean engagement with what was brewing there through overseas study, travel, migration and international art journals.

Predictably, however, abstract art has been highly controversial in the Caribbean and has been rejected by many as a concession to North American cultural imperialism. It is too simplistic to attribute these developments to the influence of the New York School, however, since abstraction and formalism are firmly rooted in twentieth-century Latin American art. Starting with the Uruguayan Joaquín Torres-García (1874–1949), Latin American artists have been among the pioneers of Constructivism and Concrete art and its offshoots into Kinetic art and Op art. The critique of Indigenism also started early in Latin America, especially in Argentina where cultural nationalism was already rejected in the 1920s by the artists and intellectuals associated with the 'art for art's sake' *Martín Fierro* journal. It is therefore no coincidence that abstraction emerged in Caribbean art at a time of intensifying intellectual and artistic contacts with Latin America and that it flourished mainly in the Hispanic Caribbean.

Cuba and Puerto Rico represent two political extremes in the Caribbean and have produced the most distinctive schools of political and abstract art. It is therefore useful to examine the developments in these two countries in some detail and to compare them with related trends elsewhere in the Caribbean. Cuba had a well-established national art movement, but in the first half of the twentieth century Puerto Rican art had been comparatively dormant. A cohesive, assertively nationalist Puerto Rican school appeared in the 1950s, at a time when Indigenism was being challenged throughout the Caribbean and Latin America, and this initially left limited room for abstract art. This coincided with the country's change in political status from colony to commonwealth of the United States and the launching of Operation Bootstrap, an ambitious social and economic reform programme based on industrialization and US investment. These reforms took place during the administration of Luis Muñoz Marín, the first

locally born governor and the 'architect of the Puerto Rico Commonwealth'.

The Puerto Rican movement was more radically populist in orientation than the earlier nationalist schools in the Caribbean and found its most distinctive expression in the graphic arts, which can be distributed widely and at low cost. Although the Mexican workshop, Taller de Gráfica Popular, was clearly an inspiration, Puerto Rican printmaking was directly influenced by the social reform programmes of Operation Bootstrap. The Division of Community Education (DIVEDCO) of the Department of Health, a rural education agency established in 1949, used film, photography, posters and other graphic media in its educational campaigns, which reinforced the notion of art as a social mobilization tool and encouraged the development of printmaking. Most emerging Puerto Rican artists of that era were at some point associated with the DIVEDCO screenprinting workshop.

The decisive event in the evolution of modern Puerto Rican art was the establishment of the Centre of Puerto Rican Art (CAP) in 1950 by Lorenzo Homar (1913–2004), Rafael Tufiño (1922–2008), José Torres Martinó (1916–2011) and Julio Rosado del Valle (1922–2008). CAP served as a training centre, print workshop and exhibition venue. Its first collaborative print portfolio, entitled *The Puerto Rican Print* (1951), was accompanied by a statement that outlined the organization's objectives and can be read as a manifesto of nationalist Puerto Rican art. It stated that:

This portfolio...is the fruit of the collective labour of a group of artists interested in the development of Puerto Rican art. They are of the view that the print permits the artist to reach a broader public; that in Puerto Rico art should spring from a complete identification of the artist with the people; and that only by working together and engaging in collective discussion of their work and problems, with views to self-improvement, will artists be able to bring new life to Puerto Rican art.

CAP was short-lived and closed in 1952, but it had galvanized the energies of young Puerto Rican artists, many of whom had recently returned from studies in Europe, North America and Mexico. The early graphic work of Tufiño and Homar is characteristic of this period – they collaborated on the *Portafolio de Plenas* (1953–55), a portfolio of linocuts inspired by the Puerto Rican *plenas*, popular songs on topical subjects. One of Tufiño's prints in the portfolio, *Temporal* (Storm), was inspired by a song about the San Felipe hurricane that

98

99 Julio
Rosado
del Valle,
Vejigantes
(*Carnival
Devils*) 1955

devastated the island in 1927. Tufiño represented the storm as
a malevolent giant sweeping away the defenceless people and
ramshackle houses of the poor neighbourhoods of San Juan.
Temporal has a poignant counterpoint in a contemporaneous
print by Carlos Raquel Rivera (1923–1999), *Hurricane from the
North* (1955), in which the storm became a metaphor for the
destructive influence of North American materialism on
Puerto Rican society, one of the first openly anti-American
statements in Puerto Rican art.

 Abstraction also appeared in the mid-1950s, most notably
in the paintings of Julio Rosado del Valle. At first, Rosado
del Valle used indigenous subjects as his point of departure –
99 his painting *Vejigantes* (Carnival Devils) (1955), for example,
captured the shapes, colours and patterns of the horned
masqueraders of the Ponce carnival in a composition
reminiscent of Synthetic Cubism. His work became more
radically abstract in the late 1950s, although he returned
to representation in the 1970s.

 As the Argentinean-born critic Marta Traba later observed,
the resistance against cultural assimilation with the United
States has been a fundamental characteristic of modern

Puerto Rican art. Not surprisingly, therefore, early abstractionists were criticized for adopting a North American artistic concept. Migration and overseas studies meant that the influence of the New York School was inevitable, although New York had also become a meeting place for Caribbean and Latin American artists, as Paris had been in the 1920s and 1930s. Rosado del Valle had studied under the Cuban Mario Carreño (1913–1999), a pioneer of Cuban abstraction, at the New School for Social Research in New York in the mid-1940s.

Except for the isolated case of Lucien Price in Haiti in the previous decade, Cuban artists took the lead in Caribbean abstraction. Alongside this, political events were leading up to the Cuban Revolution. Fulgencio Batista had seized power in 1952 and resistance against his dictatorship started the following year, when Fidel Castro's rebels attacked the Moncada Barracks in Santiago de Cuba. Artistically, 1953 was also an important year that saw the establishment of, among others, *Noticias de Arte*, a journal favouring geometric abstraction, and of Los Once (The Eleven) (1953–55), an informal group of artists with Abstract Expressionist leanings.

The editorial council of *Noticias de Arte* included Mario Carreño, Luis Martínez Pedro (1910–?1990) and Sandú Darié (1908–1991). Carreño and Martínez Pedro had been involved in the second phase of the Indigenist avant-garde which contained the rudiments of abstraction, particularly in the surreal stylizations of Lam, the pattern structures of Portocarrero and the decorative formalism of Peláez (see Chapter 3). Afrocubanismo was an important influence on geometric abstraction in Cuba. This is not surprising, since Afro-Cuban ideographic writing, cosmograms and colour symbolism provided ready-made models for the reconciliation of abstract form with indigenous content, the 'creolized' approach to abstraction that many Caribbean artists have taken. The

100 Dominican painter Paul Giudicelli (1921–1965), for instance, also used symbols derived from Taíno and African Caribbean sources in his highly abstracted, linear compositions. In Cuba, this was also evident in Portocarrero's geometric abstractions of the early 1950s, which were still recognizably linked to Cuban folklore and the architecture of Old Havana.

Darié, on the other hand, represented the radical, experimental side of Cuban abstraction. He was born in Romania but moved to Cuba in 1941 to escape the Second World War, and started producing abstract art in 1950. Paintings such
101 as *Spatial Multivision* (1955) reflect his concern with pictorial structure, space and movement, and his lack of interest in indigenous content. Darié befriended Gyula Košice of the

100 Paul Giudicelli, *Untitled*, 1963

101 Sandú Darié, *Spatial Multivision*, 1955

Argentinean avant-garde group Madí, sharing the group's emphasis on construction and invention, which could be seen in works such as his participatory *Transformable Structures* (1956). Whereas most Cuban abstractionists later returned to representation, Darié remained faithful to Concretism throughout his career. The radical formalism of his work was unusual for the Caribbean, although there have been a few other artists with comparable interests, such as the Dominican artist Soucy de Pellerano (Jesusa Castillo Sánchez de Pellerano-Soucy, b. 1928), who started making her whimsical kinetic sculptures in the late 1970s.

The Los Once artists were also committed to modernism and were particularly critical of the regionalism and exoticism of the School of Havana. Raúl Martínez (1927–1995),

102

who joined the group shortly after its establishment, deliberately restricted colour in his gestural abstracts of that period. In spite of their formalist interests, the Los Once members were politically active. Martínez explained the group's position to the American art historian Shifra Goldman in 1982: 'We believe[d] that art is for art's sake, but what one does with the art is a problem of individual conscience, and that is already political.' The group's main political act was the organization of the so-called Antibiennial at the University of Havana in 1954 to protest against the Hispano-American Biennial, a joint project of the Batista and Franco regimes, of which three editions were held in Barcelona between 1951 and 1956.

103 Castro and his rebels came to power in 1959 and officially embraced Communism in 1961. Although the Cuban Revolution caused a shift towards representational political art, abstraction did not suddenly disappear. Martínez Pedro's *Territorial Waters* paintings of the mid-1960s, for instance, present a highly abstracted, 'hard-edge' evocation of the wave movement and optical effects of the sea, although the title inevitably evoked Cuba's uncertain territorial status during those eventful years.

104 While abstract art was on the wane in Cuba, it gained greater credibility in Puerto Rico with initiatives like the exhibition 'The New Abstraction' (1967) at the University of Puerto Rico in San Juan. Noemí Ruiz (b. 1931) and Luis Hernández Cruz

102 Soucy de Pellerano, *Machine Lever Structure*, 1990

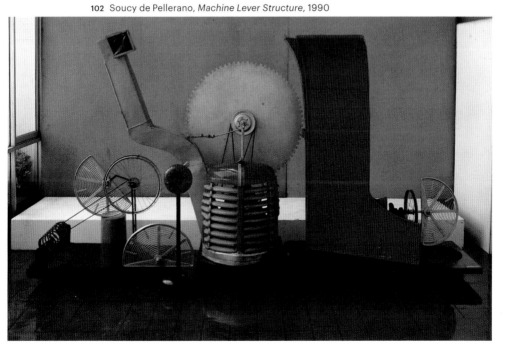

(b. 1936) were among the Puerto Rican artists who adopted Minimalism and geometric abstraction in the 1960s, a more fundamental 'universalist' departure from the nationalist norm than their predecessors. The work of Hernández Cruz is a good example of the eclecticism of Caribbean abstraction, however, and usually combines organic forms with elements that relate to Constructivism and Op art. Many of his paintings and sculptures also include references to the figure or the Puerto Rican landscape.

Hernández Cruz has been important as an advocate of experimentation and greater openness for Puerto Rican art. He was influential as art professor at the University of Puerto Rico (1968–93) and was a founder of the Puerto Rican Frente group

103 Luis Martínez Pedro, *Territorial Waters No. 14*, 1964

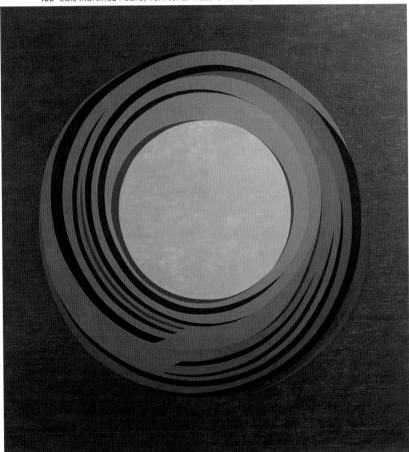

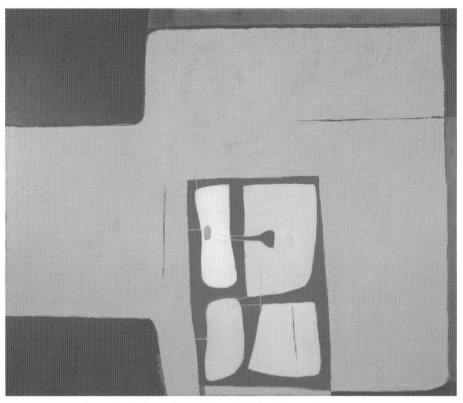

104 Luis Hernández Cruz, *Composition with Ochre Shape*, 1976

105 in 1977, with Lope Max Díaz (b. 1943), Paul Camacho (1929–1989) and Antonio Navia (b. 1945). Max Díaz stands out among this group with his immaculately crafted mixed-media reliefs, based on the square and rectangle, that reflect a more orthodox Constructivist vision. Frente was one of many artists' associations that were formed in the Caribbean during this period – other influential groups were Proyecta (1968) and Nuevo Imagen (1972) in the Dominican Republic and the Contemporary Jamaican Artists' Association (1964–74) in Jamaica. Whereas local conditions varied, the general objectives of these groups were very similar: they challenged the established artistic order and promoted the development of contemporary art in their respective countries.

 Although Operation Bootstrap had generated some prosperity, it did not fulfil expectations, and by the late 1950s there was a growing disenchantment with the political situation, fuelled by the Cuban Revolution and the struggles of Puerto

Rican migrants in the US. This led to an intensification of nationalism and pro-independence activism, especially among the intelligentsia, but also to growing pro-statehood sentiments.

The artistic impact of this political radicalization is evident in the screenprint portfolio *The Alacrán Cards Deck* (1968) by Antonio Martorell (b. 1939), which satirized the elections of that year. This portfolio took the form of an oversized cards deck, with Lyndon B. Johnson as the joker. It was produced at the Taller Alacrán (1967–71), a print and poster workshop established by Martorell in an economically depressed area of San Juan. The name of the workshop, which means scorpion, refers to a gang-related scarification pattern. It was the first of several independent, community-based workshops with a more radical political orientation.

Posters became a major art form in Puerto Rico and Cuba in the 1960s. Some of the most beautiful Puerto Rican posters were made for the Institute of Puerto Rican Culture, an institution established in 1955 for the study and advancement of Puerto Rican culture. Lorenzo Homar directed the Institute's graphics workshop from its inception in 1957 until 1973. While there, he produced several classic Puerto Rican posters

105 BELOW Lope Max Díaz, *Ancestral Penetrations*, 1982
106 OPPOSITE Antonio Martorell, *Joker* from *The Alacrán Cards Deck*, 1968

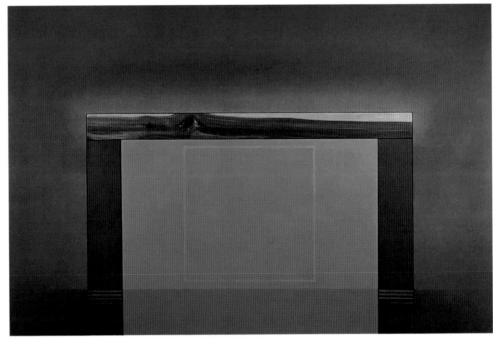

JOKER

107 Lorenzo Homar, poster for the 5ta Feria de Artesanías de Barranquitas, 1966

such as the one for the 5ta Feria de Artesanías de Barranquitas (1966), an annual craft fair. This poster stands out because of its colourful abstract design and the dominant, playful lettering, one of Homar's special interests. It is also an early example of the use of motifs derived from Taíno art and the *santos* carvings in modern Puerto Rican art.

In Cuba, the appearance of poster art was directly linked to the Revolution and the need of the Cuban government and its agencies to communicate political ideas and information to a large audience. Cuba's new alliances in Eastern Europe reinforced this development and Polish poster design was a notable influence. Cuban poster design was spearheaded by artists such as Raúl Martínez, who had worked in advertising

108

108 Raúl
Martinez, poster
for *Lucía*, 1968

before, and Alfredo Rostgaard (1943–2004). The posters were
primarily produced for educational initiatives such as the
nationwide literacy campaign of 1961 and for cultural
organizations such as the Cuban Cinema Art and Industry
Institute (ICAIC), the Cuban Artists and Writers Union (UNEAC)
and the Casa de las Américas. As in Puerto Rico, screenprinting
was the medium of choice, although in Cuba this was caused in
part by the lack of functional lithographic presses after the US
imposed its economic blockade in 1961.

The designs for ICAIC included Martínez's famous poster for
Lucía (1968), a film by Humberto Solás. With its brilliant colours
and compartmentalized composition, the *Lucía* poster reflects
the legacy of Amelia Peláez and, therefore, the continuities in

CANCION PROTESTA

encuentro agosto 1967 casa de las américas/cuba

109 Alfredo Rostgaard, poster for Canción Protesta, 1967

Cuban art, despite Martínez's earlier criticisms of the School of Havana. In fact, Portocarrero designed the official poster for *Soy Cuba* (I Am Cuba), a 1964 Cuban-Soviet film directed by Mikhail Kalatozov and written by the Cuban writer and film director Enrique Pineda Barnett and the Russian writer and director Yevgeny Yevtushenko. A propaganda film that outlines how the Revolution was the necessary response to the hardship experienced by the Cuban people in the 1950s, *Soy Cuba*'s stunning cinematography has made it a classic in film history. Film and photography played a crucial role in generating the iconic images of the revolutionary years – Alberto Korda's 1960 photograph of Che Guevara is the most famous example and its many reproductions,

in posters and other formats, greatly helped to define Guevara's global romantic-revolutionary appeal.

A poster-making workshop was also established at the Casa de las Américas in Havana, an organization established to foster cultural exchanges with the Caribbean and Latin America – its best-known poster was Rostgaard's for Canción Protesta (1967), concert of protest songs. This poster became an international icon of the period when it appeared on the cover of the 1970 book *The Art of Revolution, Castro's Cuba: 1959–1970* by Dugald Stermer and Susan Sontag. The emblematic simplicity of Rostgaard's design – a stylized rose with a bloodied thorn – contrasts with the more complex designs by Martínez and Portocarrero, showing that there was no official style for Cuban poster art.

The Canción Protesta poster illustrates that the political and the cultural were not separated in Cuban poster art. This was less apparent in Puerto Rico, although the cultural posters had strong nationalist overtones. While most Puerto Rican designs were elaborate, occasionally involving as many as twenty colours, the Cuban designs were simpler, in part because of the shortage of printing ink that forced artists to use less colours and more open space. Cuban and Puerto Rican poster-makers both used abstraction in their designs – which again shows that abstraction and political content are not mutually exclusive – although the Cuban posters were more distinctly modernist, in keeping with the revolutionary ethos of modernity. Because of the considerable artistic value of these handmade posters, they became collectibles and inevitably lost some of their public function, especially in Puerto Rico. The Institute of Puerto Rican Culture posters, for instance, were printed in small editions and given only limited public exposure. Some smaller private workshops, such as the Taller Alacrán, also resorted to selling their posters to recover costs.

Apart from his work as a graphic designer, Martínez was also the prime exponent of Cuban revolutionary painting. After a series of works on political subjects in a style influenced by the American artist Robert Rauschenberg, he produced *Martí and the Star* in 1966. It was the first painting in which he used his trademark graphic stylization and repetition of the image – techniques borrowed from his screenprinting experience. Similar paintings followed, primarily iconic images of Cuban revolutionary heroes such as José Martí, Che Guevara and Fidel Castro, although he portrayed anonymous Cuban types as well. Martínez's work of this period is often compared with Andy Warhol's multiple screenprinted images but, although he was visibly aware of US Pop art, his work

was rooted in the ideology and visual culture of the Cuban Revolution rather than in western consumerism and its upbeat, purposefully political character was far removed from Warhol's dispassionate, mechanical approach.

110 Martínez's mural-size triptych *Island 70* (1970) is in essence a summary of his work of the late 1960s and recalls the propaganda billboards that have proliferated in revolutionary Cuba. It was painted during the year of the Cuban Government's ill-fated campaign to produce ten million tons of sugar on its state-run plantations and is a subtly ironic image of a utopian world in which various Cuban types (and a cat and a gorilla) mingle with the heroes of the Revolution as one happy, smiling

110 Raúl Martínez, *Island 70*, 1970

'Cuban family'. The sugar cane and factory in the background refer to what had become the official doctrine of *la zafra* (the sugar crop) as the engine of the Revolution rather than an agent of oppression. The political significance of *Island 70* is reinforced by the prominence of reds and oranges in the colour scheme and the inclusion of the logo of the Committee for the Defense of the Revolution (CDR), a stylized image of a cane harvester.

Cuban art of the 1960s was far more imaginative than the Socialist Realism of the Soviet Union or China, but most of it was propaganda art. Anti-government protest art was not tolerated and artists with 'bourgeois' interests were

systematically castigated by orthodox critics. This led to the alienation of the neo-figurative painter Antonia Eiriz (1929–1995), one of the most interesting Cuban artists of the era. She stopped painting in 1969 and dedicated the rest of her active life to community craft work for the CDR. By the mid-1970s Cuban art had lost much of its early revolutionary enthusiasm and photorealism had become the dominant style. In 1976 the Cuban constitution incorporated the following statement: 'Artistic creation is free as long as its content does not oppose the Revolution. Forms of expression are free.' However, what 'opposing the Revolution' means is a matter of interpretation, which helps to explain the inconsistency of Cuban artistic policies that have wavered between liberalism and dogmatism.

The Cuban revolutionary school was unique in the Caribbean, and elsewhere 'propaganda' art was usually limited to official portraits and public monuments. While these works document the development of official iconography in these postcolonial societies, which is historically and culturally significant, most are of limited artistic interest. In comparison, social and political protest art flourished throughout the region, not surprisingly, given the political turbulence of the era. Artists actively participated in the events surrounding the Dominican Civil War of 1965, for instance, and represented their political views in their work – this can be seen most notably in the early work of Ramón Oviedo (1927–2015). Although most artists refrained from direct political comments during the succeeding Balaguer administration, the civil war period left a legacy of social and political involvement in Dominican art that is still evident today.

Overt political protest art can, of course, only exist when there is a reasonable degree of freedom of expression. The conditions in Haiti under the Duvaliers did not allow for overt political dissent and most artists therefore turned to general existential, social and cultural issues, often from a black nationalist perspective. It is no coincidence that there was a revival of Vodou-related art, as we saw in Chapter 4. There are notable exceptions, however, such as the work of the 'primitive' artist Jasmin Joseph (1923–2005), who had abandoned sculpture for painting in the late 1950s. His fable-like animal scenes often alluded to socio-political events and personalities, although references are often so subtle that they can only be understood by those who are intimately familiar with Haiti's current affairs. Edouard Duval-Carrié (b. 1954) also uses quasi-naive, surreal imagery, but has been more candid with his comments on Haitian politics, perhaps because he has spent most of his life outside Haiti. His early painting *J.C. Duvalier en Folle de Marié*

111

112

111 Jasmin Joseph, *Le Roi Lion* (*The Lion King*), 1983

112 Edouard Duval-Carrié,
J.C. Duvalier en Folle de Marié
(*J.C. Duvalier as Mad Bride*), 1979

(J.C. Duvalier as Mad Bride) (1979), for instance, is a daring satirical reference to rumours about Baby Doc's sexual preferences and unstable character.

As these Haitian examples illustrate, allusions and metaphors are powerful tools in political art, especially when overt political commentary is restricted. The seemingly conventional idyllic landscapes painted by the Guyanese artist Bernadette Persaud (b. 1946) from the mid-1980s to the early 1990s quietly decried the militarization of Guyana by the inclusion of barely visible, but heavily armed, soldiers in camouflage outfits. The series was inspired by the botanical gardens, near the official residence of Forbes Burnham, who

113

113 Bernadette Persaud,
A Gentleman at the Gate, 1987

was president of Guyana from 1966 until he died in 1985, as well
as by the famous final lines in the Guyanese poet Martin
Carter's 'This is the Dark Time, My Love' (1954):

Whose boot of steel tramps down the slender grass
It is the man of death, my love, the strange invader
Watching you sleep and aiming at your dream.

The policies of the Burnham administration, which instituted
an idiosyncratic form of socialism, were isolationist and
intolerant of opposition – it is widely believed that the 1980
assassination of the radical Guyanese historian and politician

Walter Rodney was set up by his administration. While there were a few exceptions, such as Errol Ross Brewster's political art of that period, most Guyanese artists therefore avoided the overtly political, like their Haitian and Dominican counterparts.

In comparison, freedom of expression was maintained in the English-speaking islands, for instance in Jamaica, where artists commented freely on the political crisis of the late 1970s. Michael Manley had become prime minister in 1972 and under his administration Jamaica espoused democratic socialism and became a vocal exponent of the Third World movement. Culturally, it was a particularly fertile era, during which the visual arts flourished and reggae music, another form of protest art, came to international attention. The Jamaican feature film *The Harder they Come* (1972), which was directed by Perry Henzell and starred the reggae singer Jimmy Cliff, was groundbreaking in this context. In the film's famous photoshoot scene, the lead character, the notorious but elusive rebel-gunman Ivanhoe Martin, had himself photographed, cowboy-style and with guns in both hands, and sent the photos to the press to taunt the authorities. The photograph

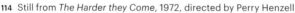

114 Still from *The Harder they Come*, 1972, directed by Perry Henzell

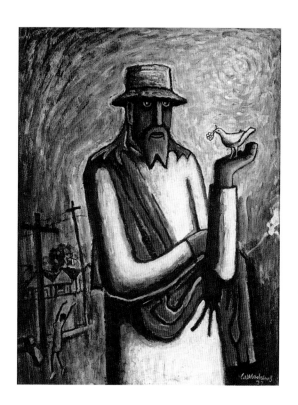

115 Carl Abrahams,
Christ in Rema, 1977

series is also a period icon of the so-called Rude Boy style,
and the association between dress, personal style and
anti-establishment resistance.

By the mid-1970s, the atmosphere in Jamaica had become
increasingly tense, however, with rapid economic decline,
outbursts of partisan violence in Kingston's inner-city areas
and rumours of destabilization plots and CIA interference.
The unrest culminated in the violent 1980 elections that
brought the Manley era to an end (he returned as prime
minister, on a moderate political platform, from 1989 to 1992).
One of the many artists who responded to the events of the late
1970s was Carl Abrahams (1911–2005), a contemporary of the
Institute Group, who presented a moving image of hope and
115 reconciliation with his *Christ in Rema* (1977). (Rema is one of
Kingston's most volatile inner-city neighbourhoods.)

Others presented a more critical and pessimistic view – such
as Eugene Hyde (1931–1980) in his *Casualties* series (1978). The
abstracted, bandaged figures that dominate these paintings
refer to the street people of Kingston, whom Hyde used as a
metaphor of the deteriorating socio-economic conditions.

116 LEFT Eugene Hyde, *Behind the Red Fence* from the *Casualties* series, 1978
117 OPPOSITE Isaiah James Boodhoo, *Breakdown in Communications*, 1970

116 As is typical for political art, the series relies heavily on colour symbolism – in his *Behind the Red Fence* (1978), the red refers to the violence of the period and to Communism, which Hyde perceived as an imminent threat to Jamaica. The *Casualties* series also reveals his indebtedness to the American artist Rico Lebrun, particularly Lebrun's *Casualties* series of 1959. Hyde was a pioneer of abstraction in Jamaican art in the early 1960s and a founder of the Contemporary Jamaican Artists' Association.

Trinidad had one of the strongest economies in the Caribbean, due to its oil reserves, but its political life was far from stable. The so-called Black Power Rebellion of 1970 was a major uprising against the persistent social inequalities during the administration of Eric Williams, who served as

prime minister of Trinidad from independence in 1962 until he died in 1981. Black Power activists were joined by striking East Indian sugar workers and even members of the army, which resulted in a seven-month long state of emergency in 1970–71. This atmosphere of crisis was graphically represented by Isaiah James Boodhoo (1932–2004) – who is better known for his lyrical, semi-abstract landscapes and evocations of East Indian life – in *Breakdown in Communications* (1970). It represents Williams as a skull-faced demon, with his trademark sunglasses, hearing aid and tie with the logo of his political party. The flag next to him is the 'stars and stripes', not the Trinidadian flag, an expression of the growing anti-American sentiments in the Caribbean and a reference to the geopolitical context of the uprising.

117

Boodhoo's portrayal of Williams contrasts sharply with Martínez's cheerfully propagandist images of Castro, although both depict the stock image of the Caribbean political patriarch as public speaker, a tantalizing subject for political satire.

118 *There is a Meeting Here Tonight* (1993) is a suite of three paintings

by the Guyanese artist Stanley Greaves (b. 1934) – who has also lived in Barbados – which, without being specific, satirizes the demagogic tendencies in Caribbean politics and reflects the recent disenchantment with Caribbean political culture. In the first panel, *The Annunciation*, the literally double-talking political activist seems unaware that he is standing in a garbage can, ready to be carted away. Political subjects are only one aspect of Greaves's work, although his precise 'metaphysical' paintings usually contain references to his Guyanese background.

Many black nationalist artists refrained from direct references to the racial tensions of the 1960s and 1970s and, instead, emphasized the philosophical and cultural aspects of race. This is evident in the work of the Trinidadian painter and poet LeRoy Clarke (1938–2021), whose visionary paintings explore the existential dimensions of race and postcolonial identity. For more than forty years, Clarke has worked on an extended series called *The Poet*, in which he has developed a complex iconographical programme on the black experience in the New World, from oppression to transcendence. The central symbols of *The Poet* derive from the geography of Trinidad: the island's second highest mountain, El Tucuche, represents the pinnacle

118 LEFT Stanley Greaves, *The Annunciation* from *There is a Meeting Here Tonight* series, 1993
119 OPPOSITE LeRoy Clarke, *Now*, 1970

120

of human achievement, while the highest mountain, El Cerro del Aripo, is used as a symbol of the divine. His imagery draws heavily from Afro-Trinidadian religion and folklore, reflecting the growing appreciation of popular African Caribbean culture among black nationalist artists.

Compared with the rest of the Caribbean, there was little political activity in the French Overseas Departments of the French Antilles and French Guiana, although there were some separatist rumblings, especially in Guadeloupe. However, the changed relationship with the 'metropolis' did cause new social, racial and cultural dilemmas and led to a renewed need for cultural definition in art. This is illustrated by the work of the Martiniquans Louis Laouchez (b. 1934) and Serge Hélénon (b. 1934), who joined forces in 1970 as the Ecole Négro-Caraïbe (Negro-Caribbean School) and defined their work as African Caribbean art with universalist aspirations. Hélénon has been explicitly critical of social conditions in his *Expressions-Bidonvilles* (Ghetto-Expressions), a series of painted wood assemblages inspired by the slums that still exist in the French Antilles, despite the artificial prosperity generated by the Overseas Department status.

Caribbean migration to Europe and North America peaked in the post-war era. Mass migration to the colonial and neo-colonial 'mother countries' caused fundamental cultural changes in the Caribbean and the destination countries alike. The political and cultural sensibilities of these migrants and their descendants

were sharpened by the marginalization they faced in these new environments. Predictably, many identified with the struggle of local 'minorities' for social and political justice, especially in the United States during the Civil Rights campaign. This was epitomized by the Young Lords party, the Puerto Rican equivalent to the Black Panthers, who coupled radical Puerto Rican nationalism with Hispanic and Black Power activism.

Artists of Caribbean descent were closely involved in these developments and joined with other 'minority' artists in questioning the exclusion of black, Hispanic and women artists from the metropolitan mainstream. One particularly influential pressure group was the Art Workers' Coalition in the US, which included among its members Raphael Montañez Ortiz (b. 1934), an artist of Mexican and Puerto Rican parentage. Ralph Ortiz, as he was known then, gained notoriety in the 1960s with his *Theatre of Destruction* performances in which he demolished pianos and sacrificed chickens – artistic 'guerrilla' acts that challenged the social and cultural stereotypes of Latinos. Around the same time, Rafael Ferrer attacked the exclusivity of the New York art world with interventions in prime exhibition spaces, such as the Museum of Modern Art, which consisted of impromptu installations made from messy, ephemeral materials such as ice, autumn leaves and grease.

This cultural activism led to the establishment of specialized cultural facilities and organizations, usually with a strong community orientation. In New York, El Museo del Barrio (1969) and the Studio Museum in Harlem (1967) were set up to promote Hispanic and African diasporal art, respectively. Both museums have Caribbean art in their collections and have employed art professionals of Caribbean origin – Ralph Ortiz, for example, was the founding director of El Museo del Barrio and the Trinidadian artist LeRoy Clarke was attached to the Studio Museum as programme coordinator and artist-in-residence from 1971 until 1974, when he returned to Trinidad.

The Puerto Rican collaborative workshop model was transplanted to New York with the Taller Alma Boricua, founded in 1969 by a group of 'Nuyorican' artists, including Armando Soto (b. 1945), Marcos Dimas (b. 1943) and Adrián García (b. 1948). The Taller Boricua, as it is more commonly known, became a meeting place for Puerto Rican artists in New York. The collaborative's nationalist orientation was reflected in its name, which is derived from the Taíno word for Puerto Rico, and the frequent use of Taíno symbols by the participating artists. The workshop was initially housed in a building across from the East Harlem headquarters of the Young Lords and produced several posters for the party. An early workshop member,

120 Serge Hélénon,
Le cherche lumière
(*The Light-Seeker*), 2016

121 OPPOSITE Martín
'Tito' Pérez, *Untitled*,
1972–74
122 RIGHT Namba
Roy, *Jesus and his
Mammie*, 1956

Martín 'Tito' Pérez (1943–1974), was arrested for playing
music in the New York subway and died under controversial
circumstances while in police custody. His tragic death
gives special poignancy to the crucifixion-like self-image
121 of his *Untitled* (1972–74).

122 Cultural and racial awareness was also growing among
the West Indian migrants in Britain. Namba Roy (Roy Atkins,
1910–1961), who was born in the Jamaican Maroon village
of Accompong but lived in Britain for most of his adult life,
produced consciously neo-African ivory carvings. He came
from a family of traditional storytellers and used his Maroon
heritage as a source for his sculptures, novels and storytelling
projects. Although he is now recognized as an important
name in Jamaican art history, he worked on the margin of
the British art world, as was the fate of most black artists
of his generation.

Political Radicalism, Abstraction and Experimental Art

West Indian artists and writers became more visible in Britain with the establishment of the Caribbean Artists' Movement (CAM) (1966–72). CAM helped to articulate the debates on race and multi-culturalism that dominate black British art today, and influenced developments in the Caribbean as well, since several members later returned to the region. The group was dominated by writers and philosophers such as Edward Kamau Brathwaite, Stuart Hall and Andrew Salkey, but also included notable visual artists such as Ronald Moody and Aubrey Williams (1926–1990) from Guyana and Errol Lloyd (b. 1943) from Jamaica. While the first two dealt with broader existential and cultural issues in their work, Lloyd was one of the first West Indian artists to represent the black experience in Britain, although his expressionist paintings lack the militancy of black British art of the 1980s.

Most Caribbean migrants were attracted to the United States by the economic opportunities, but many Cubans went there for political reasons after the Revolution. In spite of this, the work of Cuban exile artists such as Ana Mendieta and Luis Cruz Azaceta (b. 1942), who both left Cuba in their teens, deals with the general existential issues of exile and identity instead of the political questions that surround their experience.

While Mendieta's work implied that redemption is possible, Azaceta's tormented neo-expressionist paintings present a more pessimistic view of post-modern urban life. During the 1970s he used grotesque cartoon images to represent the urban violence of New York City. His subsequent work is more distinctly autobiographical and often refers to his Cuban background, although he continues to comment on broader social problems such as the AIDS epidemic – self-images appear in many of Azaceta's paintings, usually as a gaunt, naked figure with hybrid, insect-like limbs. In *Ark* (1994), which was made during the Cuban boat-people crisis, he presented himself as a Cuban rafter, with an oar-shaped arm, surrounded by Polaroids of attacking sharks. Like his New York paintings, it is a gripping image of an archetypal individual in a hostile, alien environment.

123 Luis Cruz Azaceta, *Ark*, 1994

Chapter 7
The Land, the Sea and the Environment

The natural beauty of the Caribbean region has been a source of inspiration to artists, local and foreign, since Prehispanic times, and a major source of metaphorical and formal possibilities for many modern and contemporary Caribbean artists. As the most predictable subject matter of Caribbean art, however, run-of-the-mill depictions of the natural environment tend often to be conventional in style and format and usually present an idealized, even stereotypical view of the Caribbean.

The German playwright and poet Bertolt Brecht wrote in his poem 'To Those Who Follow in Our Wake' (*c.* 1939):

What kind of times are these, when
To talk about trees is almost a crime
Because it implies silence about so many misdeeds.

While Brecht was writing in the context of Nazi Germany, his lines were adopted by the Jamaican contemporary artist David Boxer (1946–2017) to speak about the dilemmas facing Jamaican artists in the politically turbulent late 1970s, which he was confronting in his own artistic work at that time. Caribbean landscape and nature art indeed often presents an aestheticized and even escapist representation of the realities of the region, which has its own artistic legitimacy. As we will see in this chapter, however, the engagement with nature and the landscape in Caribbean art is often deeply political, as the sea, the land and living nature offer rich metaphors for the histories, identities and present-day issues facing the Caribbean.

Derek Walcott (1930–2017), the St Lucian 1992 Nobel Laureate for literature, powerfully reminded us in one of

his most famous poems that 'the Sea is History'. The sea, which both unites and divides the Caribbean and separates the archipelago from its peoples' diasporic origins, is a site of transition, regeneration and transformation, but also of tremendous devastation and human and cultural loss, forever associated in the Caribbean imaginary with the history of the Middle Passage, migration and diaspora. As Walcott knew well (and he was also a visual artist, whose work was focused on the landscape), the land has memory too, and is, likewise, associated with histories of conquest and ownership and questions of belonging and alienation, as could be seen in the topographical art and maps of the colonial period and the iconic landscapes of the nationalist art movement alike. The region's tropical vegetation is, as we have seen in Chapters 1 and 5, in part the creation of colonialism but also has other and longer indigenous histories and associations, for instance with traditional healing practices and survival strategies.

As Bernadette Persaud's 'militarized' landscapes of the 1980s illustrate, even the most idyllic scenes sometimes address political issues. This also applies to the work of Colin Garland (1935–2007), an Australian-born artist who moved to Jamaica in 1962. While the figure usually dominates his fanciful, intricately painted fairytale-like images, nature and the landscape are also important elements. The content of his paintings and sculptures is often personal, with ambiguous erotic overtones, although his images are laced with ironic allusions to social and political issues. His triptych *In the Beautiful Caribbean* (1974), for instance, presents a dazzling panorama of an imaginary Caribbean landscape filled with tokens of the local flora and fauna (including the scarlet ibis and the hibiscus flower) and references to spiritual practices such as Vodou and Rastafarianism. These are combined with surreal reminders of foreign invasions, economic poverty and modern development, and the police and the military – all highly visible components of the historical and modern Caribbean socio-political 'landscape'. Garland's epic triptych has, in fact, been described as a metaphor for the precarious position of the Caribbean during the Cold War.

Such tensions are also evident in the contemporary Jamaican media artist Ebony G. Patterson's (b. 1981) concept of 'beauty as a trap' (as a way to draw in audiences and to confront them with the unseen and disregarded) and of the garden as a site of metaphorical convergence for the plantation, the cemetery and the provision grounds. In Patterson's work, the garden is a place for hidden and overlooked past and present acts of violence on brown and black bodies, where the murdered,

124

190

124 Colin Garland, *In the Beautiful Caribbean*, 1974

125 ABOVE Aubrey Williams, *Olmec Maya – Night and the Olmec*, 1983
126 OPPOSITE Frank Bowling, *Night Journey*, 1969–70

violated and disappeared may be found, but also a place of revival, freedom and transcendence. Interestingly, it is often in such nature metaphors that the art and literature of the Caribbean most poignantly meet. Patterson's garden concept, for instance, deeply resonates with the Jamaican poet Olive Senior's *Gardening in the Tropics* cycle (1994) and particularly the poem 'Brief Lives', which starts with the words:

*Gardening in the Tropics, you never know
what you'll turn up. Quite often, bones.*

125 The Guyanese abstract painter Aubrey Williams is better known for his use of Mesoamerican and Guyanese Amerindian symbols and his leading role in the 'Amerindian revival' in Guyanese art, but the lyrical, atmospheric quality of his abstracted images evokes the opulent vegetation of the Guyanese rain forests. As the Guyanese poet Wilson Harris has pointed out: 'Aubrey Williams is not a painter of landscapes, but his brush dips into landscapes to become a filter of associations into abstract reverie and moods.' And these abstract reveries, along with the ancestral cultural

memories that are evoked in his work, allude to notions of
belonging and ownership that predate and transcend the
disruptions of colonialism. Williams lived in England for
most of his adult life and his work also reflects a nostalgia
for the Caribbean environment shared by other expatriate
Caribbean artists.

While Williams maintained strong links with Guyana and
the English-speaking Caribbean, his compatriot Frank Bowling
has exhibited only once in Guyana since he left to settle in
Britain in 1950 and has made his career in near isolation from
the Caribbean art world. As we saw in Chapter 6, Bowling has
been militant about his self-definition as a formalist modernist
although his paintings are haunted by his childhood memories
of Guyana, especially the shimmering light of the rivers and
the tidal flats of the Atlantic coast. Rivers and water still play
an important role in Bowling's everyday life: his London studio
is near the Thames and the Brooklyn studio he maintained

for many years overlooked the East River. After a neo-figurative phase, he produced his well-known series of map paintings in the late 1960s – contour maps of South America and the western hemisphere are covered with thinly poured, aqueous layers of paint that are perhaps reminiscent of the plant- and mineral-stained waters of the Guyanese rivers. In his more recent work, he has been using pigment and objects embedded in thick layers of acrylic gel, a medium that brings to mind a sense of solidified water. Although Bowling is not, in any narrow sense, a political painter, his images and titles are often charged with the 'flotsam and jetsam' of history. The map paintings, for instance, inevitably evoke the Middle Passage, migration and Guyana's complicated socio-political position within the western hemisphere.

127 Marc Latamie (b. 1952), a New York-based Martiniquan artist, uses sugar as a metaphor – powerfully associated with the Caribbean – as a product of the land, its people and colonial history. Since the start of European colonization, sugar has been the local product and vehicle of exchange between the Caribbean and the rest of the world. It is now traded electronically on the metropolitan commodity markets. Sugar is thus associated with transatlantic trade, the plantation experience and the continued economic dependency of the Caribbean in the globalized sphere. Latamie's sugar installations are deceptively simple but teeming with allusions. *Caldera* (1995), for instance, is a conical mound of refined sugar, surrounded by the neon words 'sky', 'terre' (earth) and 'indigo', which evokes the volcanic nature of the island of Martinique. Indigo is itself an Antillean commodity, but also alludes to the sea, another vehicle of exchange. And since the accompanying text is in English and French, *Caldera* refers to the linguistic and identity shifts that accompany such exchanges. Latamie's *Caldera* therefore hints at the Caribbean condition of always being in transit, but also at the complexity, as well as the continuity, of its experience.

Latamie's volcanic image also reminds us that Caribbean nature is unpredictable and uncontrollable. The region is prone to natural disasters – hurricanes, floods, volcanic eruptions and earthquakes – and this unpredictability has been used by artists and writers alike to evoke the volatility of the Caribbean experience, most poignantly by the poet Aimé Césaire, who employed the volcano as a metaphor of a convulsive, explosive decolonial identity. The related theme of humanity's powerlessness against nature often appears in Caribbean art, for instance, in the American Winslow Homer's
24, 98 *The Gulf Stream* (1899) and Rafael Tufiño's *Temporal* (Storm)

127　Marc Latamie, *Caldera*, 1995

(1953–55) and is, symbolically, also a central tenet in the visionary
work of John Dunkley.

54

　　As an archipelago, with significant low-lying areas, the
Caribbean is particularly vulnerable to climate change, although
the region's contributions to its environmental causes are
comparatively minor – in light of several recent, catastrophic
hurricanes, the concept of 'climate justice' is now part of the
critical discourse about the Caribbean and an emerging geo-
political issue. As the almost unimaginable human losses
caused by the 2010 Port-au-Prince earthquake illustrate, the
Caribbean is also disproportionally affected by natural disasters
because of poverty and socio-economic marginalization.

　　The unique but fragile natural ecology of the Caribbean has
been a major subject in the work of the St Lucian painter and
128　printmaker Llewellyn Xavier (b. 1945). He gained exposure on the
London art scene in the early 1970s with a series of mail-art
exchanges with the activist George Jackson, one of the
imprisoned Soledad Brothers, with contributions by celebrities
such as James Baldwin, Jean Genet, the British politician Peter
Hain, John Lennon and Yoko Ono, and is considered one of the
pioneers of mail art. Xavier now lives in St Lucia again and has
applied this contributory approach to the environmental

The Land, the Sea and the Environment

128 LEFT Llewellyn Xavier, *Red Vermillion* from the *Global Council for the Restoration of the Earth's Environment* series, 1992
129 OPPOSITE Tomás Sánchez, *Relations*, 1986

movement in a series of collages, *Global Council for the Restoration of the Earth's Environment*, first exhibited in 1992. These collages were made entirely from recycled materials such as brightly coloured handmade paper and nineteenth-century zoological prints. Although there is a very active environmental movement in St Lucia, the images Xavier appropriated are not necessarily specifically related to the Caribbean but reflect a more global interest in the environment. Each collage is endorsed with stamps and signatures from environmental activists, including his compatriot Derek Walcott, and environmental organizations such as the World Wildlife Fund.

Environmental concerns have become more common in Caribbean art recently and a large but uneven body of work now exists on the subject, and has indeed become fashionable. It is often difficult for artists to find a balance between

attention-seeking opportunism and genuine activism, and between work that is merely justified by its environmental intentions and truly compelling art on the subject. The theme, however, appears to different degrees in the work of many contemporary artists from the region, in ways that are often intertwined with other thematic concerns or subtly alluded to.

129 The Cuban photorealist painter Tomás Sánchez (b. 1948), for instance, is best known for his serene, crepuscular vistas of Cuba's coastal wetlands. His emphasis on the formal relationships within these landscapes recalls the work of René Magritte, who has been a significant influence on surrealist and magic realist trends in Caribbean and Latin American art. Sánchez joined the exodus of Cuban artists to the United States in 1990 and now lives in Costa Rica. He has become one of the 'best-selling' Cubans, no doubt because of his remarkable technical mastery and the sleek, meditative 'tropical' quality of his images. His work has also moved in more explicit environmental directions, however, and includes ominous representations of environmental issues such as solid-waste pollution.

Unless an artist's intentions are purely documentary, landscape painting often stems from a deeply personal identification with nature and the land. The English-born painter Alison Chapman-Andrews (b. 1942) has been painting the landscape of Barbados since she moved there in 1971 and, while her early works were in essence realist, with a slight degree of stylization, her depiction of the landscape gradually became more abstracted and internalized. The patchwork-like quality of her compositions derives from a process of abstraction, but also

captures the fragmented quality of the Barbadian landscape that consists of windswept, heavily cultivated rolling hills intersected by steep, densely overgrown gullies with tall royal palm trees. The Barbadian gully groves are the remnants of the primeval forest that covered the entire island before the sugar plantations were established, which imparts an environmental and historical subtext to Chapman-Andrews's work. As her work evolved, these gullies have been transformed into surreal cosmic visions.

Nature is the primary inspiration for the 'minimalist' paintings of Hope Brooks (b. 1944), a Jamaican artist who in the 1970s pursued her right to 'talk about trees' while many of her contemporaries felt compelled to turn to the political. In spite of her formalist emphasis on texture, pattern and structure, she is a subjective observer of nature and her paintings are ultimately autobiographical and rooted in introspection. Her extended *Garden* series (1986–89) was inspired by a small interior garden in her house, a controlled, self-contained environment for interaction with nature. Although some paintings in the series contain vestigial images, they are in essence highly abstracted evocations of fleeting moments of light and atmosphere. The multi-panel format of most works in the *Garden* series suggests not only a window structure, but also a sequential, almost filmic development. The *Garden* series evolved into the *Nocturne* series

131

130 Alison Chapman-Andrews, *A Last Day in the Country*, 1987

131 Hope Brooks, *Nightfall – The City* from the *Nocturne No. II* series, 1991

in the early 1990s, in which she explored the overwhelming sensory experience of the tropical night and the use of black as a colour. In the early 2000s, however, Brooks's work has taken a surprising political turn, with references to slavery and the Middle Passage, although there is strong continuity with the formal qualities of her earlier work.

The autobiographical is also implied in the work of Bendel Hydes (b. 1953), a New York-based painter from the Cayman Islands whose work explores the marine character of the Caribbean environment. His best-known paintings are informal, abstract evocations of light, water and atmosphere, superimposed on nautical map images that evoke the seafaring history of his home country. Before the Cayman Islands became a tourist and offshore banking paradise, its main source of income was fishery, and shipping is still an important industry today. Paintings such as *Roncador Cay* (1995) refer more specifically to the cays off the coast of central America where Cayman fishermen used to journey.

Nature has also been the point of departure for many Caribbean abstractionists. This is well illustrated by the semi-abstract, biomorphic carvings by the Jamaican sculptor Winston Patrick (b. 1946), which are made from local hardwoods. His tactile, almost fluid *Mahogany Form* (1974)

132

133

is a technical marvel of illusionist woodcarving inspired by the suggestive shapes of banana leaves. While formalist in intent, Patrick's erotically suggestive carving also alludes to the human body and its association with nature, a subject several Caribbean artists have explored.

Perhaps none has taken the identification with nature as far as Ana Mendieta, who sought to become part of nature and the earth itself in her quest for personal identity as a Cuban exile. Her extended *Silueta* series of the 1970s, in particular, consists of ritualistic performances and interventions in the landscape for which she used her own body, or a symbolic silhouette outline, in a quasi-sacrificial manner. She explained these works as follows:

I have been carrying on a dialogue between the landscape and the female body (based on my own silhouette). I believe this has been a direct result of my having been torn from my homeland (Cuba) during my adolescence. I am overwhelmed by the feeling of having been cast from the womb (nature). My art is the way I reestablish the bonds that unite me to the universe. It is a return to the maternal source. Through my earth/body sculptures I become one with the earth.

Interestingly, this statement was written in 1981, the year Mendieta made her *Esculturas Rupestres* (Rupestrian Sculptures) in Cuba. She was the first, and one of very few, Cuban exile artists to receive permission to work there by the Cuban

134

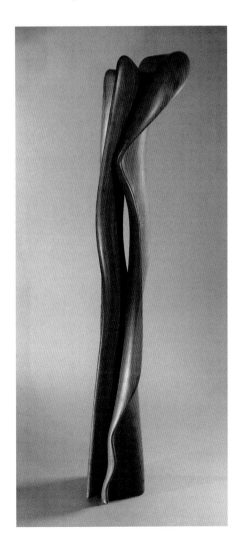

132 OPPOSITE Bendel Hydes, *Roncador Cay*, 1995
133 RIGHT Winston Patrick, *Mahogany Form*, 1974

authorities. The *Rupestrian Sculptures* are a series of carvings made into the rock walls and caverns of the Jaruco forest near Havana, which had also been used by Prehispanic Amerindian artists. The carvings consist of stylized, slightly smaller than life-size female figures that can also be seen as vaginal forms, consistent with Mendieta's metaphor of the earth as womb. To create these images, she used existing bumps and cavities in the rock surfaces, as the prehistoric artists would have done; some forms were also enhanced with paint. These carvings were named after female figures from Taíno mythology such as Guanaroca, the first woman, and Guabancex, the goddess of the wind, another reference Mendieta makes to Cuba as her 'maternal source'. In their ephemeral character and dependence on nature, Mendieta's earth works allude to the cycle of life and the transience of the human experience.

Such themes also dominate the work of the Puerto Rican ceramicist and installation artist Jaime Suárez (b. 1946), who has taken the use of clay well beyond the traditional confines of ceramics. In his work, clay is used as earth, as a token of the land, and his methods have strong ritualistic overtones.

134 BELOW Ana Mendieta, *Guabancex* (*Goddess of the Wind*) from the series *Esculturas Rupestres* (*Rupestrian Sculptures*), 1981, printed 1993
135 OPPOSITE Ana Mendieta, *Guanaroca* (*First Woman*) from the series *Esculturas Rupestres* (*Rupestrian Sculptures*), 1981, printed 1993

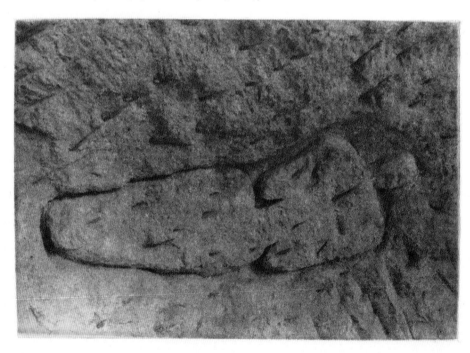

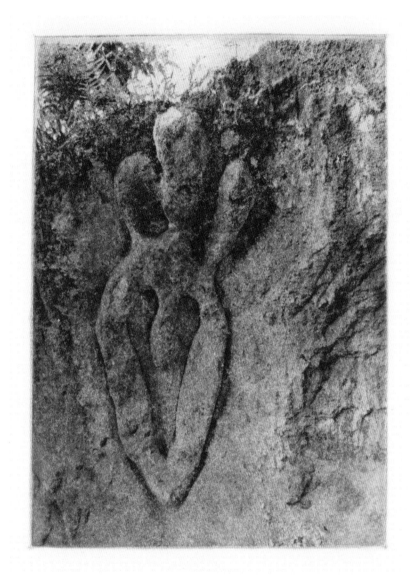

Basic ceramic forms are broken and reassembled, deliberately eroded with water or vinegar, rubbed with oxides and combined with other materials such as wood or stones. He also uses clay as a printmaking medium in his so-called *barrografías*, made by pressing clay surfaces onto paper.

Suárez's ceramic reliefs, totemic structures, vessels and installations explore the closely related themes of architecture, the land and ritual. He was trained as an architect and his weathered architectural relief structures are representations of a man-made environment. On a broader metaphorical level, they also allude to civilization and its decline. Nature is represented by his highly abstracted 'earthscapes' or 'topographies', as he calls them, that are reminiscent of the parched, fissured soils of the arid mangrove swamps that exist on most Caribbean islands. They also refer to the degradation of the natural environment. The ritualistic character of his work comes to the fore in his sober, unadorned vessel forms and carefully staged installations. Most of these works evoke funerary rituals – death as the ultimate surrender to the earth.

Mendieta's work in the Cuban landscape represented a powerful act of identification, as does Suárez's engagement with the earth, but the individual's relationship with the land and landscape can also signal alienation and exclusion, and this is a subject a number of artists in the Caribbean diaspora have explored. The Jamaican-born British artist Eugene Palmer (b. 1955), for instance, in a series of paintings of the early 1990s, represented black persons in poses reminiscent of formal studio photographs, set in English landscapes or interiors and painted in an anachronistic, romantic style. The dark, haunted moodiness of works such as *Duppy Shadow* (1993), with the uneasy tilts and angles of the composition, the awkward posing of the uniformed black schoolgirl and the distorted sense of space, adds to the surreal atmosphere of alienation and displacement.

Similar themes are evident in the photographic work of Ingrid Pollard (b. 1953), who was born in Guyana but has lived in Britain since she was four years old. Her *Wordsworth's Heritage* (1992) was presented on billboards in major urban centres in the UK and took the format of a tourist postcard which featured four photographs showing a group of Pollard's friends walking in the Lake District – a region that is historically associated with the Romantic English poet William Wordsworth. The photographs are accompanied by the poet's profile and an ironic text that reads: 'After reaching several peaks, Ms Pollard's party stops to ponder on matters of History and Heritage.'

137

138

137 Eugene Palmer, *Duppy Shadow*, 1993

'After reaching several peaks, Ms Pollard's party stops to ponder on matters of History and Heritage.'

138 Ingrid Pollard, *Wordsworth's Heritage*, 1992

Wordsworth's Heritage, and related works such as *Pastoral Interlude* (1988), explore how the 'familiar', Romantic conceptions of the British landscape appear to be disrupted by the presence of this particular group of walkers. Pollard has stated that 'it's as if the Black experience is only lived within an urban environment: I thought I liked the Lake District where I wandered lonely as a Black face in a sea of white. A visit to the countryside is always accompanied by a feeling of unease, dread.' By foregrounding the presence of the black walkers in the landscape, such works by Pollard not only challenge questions of belonging, ownership, enjoyment, beauty and Britishness, but also reveal the historical silences and blind spots in the British landscape and heritage, such as the deep-rooted association with colonialism and slavery. They also highlight the historical absence of black persons in representations of the British landscape including tourist postcards.

The work of Palmer and Pollard reminds us that the history of the Caribbean is not only present in the Caribbean landscape itself, but also, in ways that are often still unacknowledged, in the physical environment of the former colonial 'mother countries' and the still-contested place of persons of Caribbean descent on those soils.

Chapter 8
The Personal and the Political

As this book amply illustrates, identity is a cardinal issue in modern and contemporary Caribbean art. Artists have been exploring this question across the spectrum, from a personal and existential level to the explicitly political. Race activism, feminism and related recent debates about gender, sexuality and the body have furthermore driven home that 'the personal is the political', so the two are not necessarily separate or opposed. This chapter takes a closer look at how these themes and issues have been dealt with in Caribbean art, in what has been one of several alternative and diverse trajectories artists from the Caribbean have pursued since the 1960s. The portrait and the human body are an important area of focus in this context, with more conventional as well as experimental approaches.

Barrington Watson (1931–2016) was one of the founders of the Contemporary Jamaican Artists Association, along with Eugene Hyde and Karl Parboosingh (1923–1975), but his work represents the more conservative, academic realist side of Independence-era art in Jamaica. He is best known for his deliberately classicized portraits and figure paintings, but his early works have an appealing, unaffected immediacy. One such example is his iconic, subtly humorous *Mother and Child* (1958), which portrays his wife and one of his young children. The work was painted while Watson was a student at the Royal College of Art in London (where he was one of the first black students). Such intimate representations of black motherhood were and still are rare in the Caribbean and its diaspora, and speak about black identity and pride in a way that is subtle and highly relatable. Not surprisingly, *Mother and Child* is today one of the most popular paintings in the collection of the National Gallery of Jamaica.

139

139 Barrington Watson, *Mother and Child*, 1958

The female figure also dominates the work of the Puerto Rican painter and printmaker Myrna Báez (1931–2018), but from a female perspective that departs from and implicitly challenges the dominant male gaze. Her still, contemplative images of female nudes in interior settings, painted in dream-like transparent colours, defy convention with their emphasis on older women, who are represented with great serenity but without idealization. An exception is her *Nude in Front of Mirror* (1980), which depicts a younger, more conventionally beautiful woman in front of a mirror that evokes an abstracted landscape. Whereas the personal prevails over the ideological in her figure scenes, Báez's nationalist convictions are more obviously expressed in her depictions of the Puerto Rican landscape and flora – *Nude in Front of Mirror* thus brings the two into dialogue. The formal characteristics of Báez's paintings, such as the use of transparency and large, simplified colour areas, clearly relate to her experience in printmaking, a common feature of modern Puerto Rican painting.

140

In Haiti, the female figure was, from yet another perspective, also the focus of the School of Beauty, whose main representatives were Bernard Sejourné (1947–1994), Emilcar Similien (known as 'Simil', b. 1944) and Jean-René Jérôme (1942–1991). The elegant, serene 'dream surrealism' of the School of Beauty can be regarded as an escapist reaction to the socio-political conditions in Haiti during the Duvalier era, but was also presented as a celebration of black female beauty. The School of Beauty was the first mainstream Haitian school to challenge the commercial supremacy of the 'primitives' with some success. Sejourné, Jérôme and Simil were eagerly patronized by the Haitian elite and their work was in demand on the international market as well. Perhaps because of this commercialization, their depictions deteriorated into beautifully crafted, ornamental luxury objects that lacked conceptual depth or emotional authenticity. There were

140 OPPOSITE Myrna
Báez, *Nude in Front
of Mirror*, 1980
141 RIGHT Jean-René
Jérôme, *Woman
with Pigeon*, 1973

141 exceptions, however, such as Jérôme's *Woman with Pigeon*
(1973), a more thoughtful image painted after the death of his
teenage daughter.

 The shift in focus on subjectivity in Caribbean art was
influenced by existentialist philosophy and related to Latin
American neo-figuration of the 1960s, and this resulted in
disquieting, psychologically probing works of art. The dark,
macabre paintings and drawings of the Cuban Antonia Eiriz
are an early example and are formally and thematically akin
to the work of continental artists such as the Mexican José
Luis Cuevas and the Venezuelan Jacobo Borges. Like these
artists, Eiriz was evidently indebted to Goya and Ensor. Her
preoccupation with the macabre, however, also relates to the
Cuban caricature tradition and the work of certain Vanguardia
figures such as Fidelio Ponce de León.

142 ABOVE Antonia Eiriz, *La Muerte en Peloto (Death at the Ball Game)*, 1966
143 OPPOSITE Angel Acosta León, *Metamorphosis*, 1960

Eiriz's short artistic career was contemporaneous with the early years of the Cuban Revolution and she occasionally alluded to political rhetoric and events. One such example is the pen and ink drawing *My Comrade* (1962) in which her 'comrade' is death, in the form of a grinning skeleton. While she takes no clear political position in this work, its sarcastic tone contrasts greatly with the declarative propaganda art of the period, which surely contributed to the negative critical response she received. Most of Eiriz's works are, in fact, recognizably linked to contemporary Cuban life, unlike
142 those of her continental counterparts – *La Muerte en Peloto* (Death at the Ball Game) (1966) was inspired by baseball that is, ironically, as popular in Cuba as in the United States. It is hardly a nationalist image, however, and Eiriz used formal analogy to transform the protective headgear of the players into skull-like masks and the audience into an accumulation of grimacing skulls reminiscent of the Mesoamerican skull racks.

Whereas Eiriz is best understood in her cultural and
143 historical context, the work of her compatriot Angel Acosta León (1930–1964) is entirely idiosyncratic and depicts the hermetic, private world of a tormented man (he committed suicide at the age of thirty-four). His surreal, hybrid imagery, which combines mechanical, animal and human forms, may

The Personal and the Political

at first seem like a delightful fantasy but it also expresses alienation and pain, even if in a highly aestheticized form. One of Acosta León's fantasies was to be a bus driver and wheel motifs appear throughout his work – in some instances they suggest escape, not unlike the ladder motifs of the German artist Wols, while in other works, particularly those that involve his cruelly stretched humanoid figures, the wheel is an instrument of torture and restraint.

Personal anguish is also evident in the work of Ramón Oviedo (1924–2015), who was from the Dominican Republic. He began his career as a painter of social and political subjects but turned towards existential issues in the mid-1970s in a period of personal crisis. His work of this era was figurative with surrealist overtones, as can be seen in *Sterile Echo* (1975), one of a series of paintings in which he explored questions of birth, life, sexuality and death. Much of the emotional tension of his work derives from the contrast between the self-

144 BELOW Ramón Oviedo, *Sterile Echo*, 1975
145 OPPOSITE Milton George, *The Ascension*, 1993

contained plasticity of the tumbling figures, which include
an anguished self-image, and the spatially ambiguous but
ominous blood-red background. Oviedo's work of this period
lacks specific references to his Dominican background, but his
later, more abstracted works often include motifs derived from
Taíno art.

Autobiography became increasingly important in Caribbean
art in the wave of figurative expressionist painting that
appeared in the 1980s. The Jamaican painter Milton George
(1939–2008) was a key representative of this new autobiographic
expressionism – his sensually painted, instinctive images are
directly linked to his personal life, especially his turbulent
relationships with women, although he occasionally refers to
social and political issues as well. Milton George insisted that
all his paintings are self-portraits and many of them include
self-images, usually as a tiny naked figure, with recognizable
features or disguised with a horned mask, a tragi-comical

145

146 David Boxer, *Havana Postscript*, 1997–2002

counterpart to the tormented self-images of the Cuban
American artist Luis Cruz Azaceta. While Milton George's
work is often humorous and sometimes frankly carnal, it is
also deeply anguished and death is always lurking, as in *The
Ascension* (1993), which was painted during a period of illness
and personal turmoil.

The self-portrait was also central to the paintings and
mixed-media works of David Boxer that document, as he put
it, 'the thoughts and memories, the fears and drives, of one
twentieth-century man who lives through a life on one small,
complex, disturbing Caribbean island'. Boxer introduced the
autobiographical in his work with his 'assaulted self-portraits'
of the early 1970s that were visibly influenced by his doctoral
research, at Johns Hopkins University in Baltimore, on the early
work of the twentieth-century English painter Francis Bacon.

146

Boxer's later work was more political, with strong critical, anti-imperialist overtones, although the autobiographical element always remained. His practice is unified by his interest in the general themes of oppression and conflict, whether personal or political – the annihilation of the Jamaican Taíno, the cultural conflicts caused by colonization and the threat of a nuclear holocaust during the Cold War were particularly important recurrent themes within this context.

Boxer's artistic work developed in close dialogue with his art-historical and curatorial practice and he explored his thematic interests by means of complex, open-ended iconographical programmes, often through the appropriation of existing images from a variety of historical and contemporary sources, such as traditional African art, Italian Renaissance painting and the modern electronic media. He was a pioneer of assemblage, installation and video in Jamaican art, media that are particularly suitable for his appropriation techniques. His paintings were, however, more directly autobiographical and often include recognizable self-images.

Self-image also dominated in the mesmerizing, visionary paintings of the Puerto Rican Arnaldo Roche Rabell (1955– 2018) – one of his many disguised self-portraits, *You Have to Dream in Blue* (1986), is a provocative statement on racial identity. In addition to being a general indictment of racial prejudice, it more specifically challenges the common denial of the 'blackness' of the Puerto Rican population, although the incongruous blue eyes of the black figure also remind of its hybridity. *You Have to Dream in Blue* was produced with Roche's trademark *frottage* technique of rubbing and carving into thick, wet layers of paint, often with his bare hands. In other works, he placed the canvas on top of a model, often his mother or other close associates, and traced their body into the wet paint. He also made imprints of decorative surfaces, such as plant leaves and paper lace-mats, into the wet paint, another example of the impact of printmaking on Puerto Rican painting. The intense physical involvement in the process of painting gave Roche a strong presence in his work, even when there is no recognizable self-image.

As these last few examples illustrate, there are no certainties in the more recent explorations of identity in Caribbean art, in contrast with the search for affirmative, stable collective icons in the first half of the twentieth century. Similarly, the Dominican painter José García Cordero (b. 1951), who has described his work as 'images for times of crisis', uses grotesque metaphorical imagery, such as his alarmingly humanoid dogs, to comment on social and political issues

147 ABOVE Arnaldo Roche Rabell, *You Have to Dream in Blue*, 1986
148 OPPOSITE José García Cordero, *Bilingual Dog*, 1993

relevant to the Dominican Republic and neighbouring Haiti.
The dog metaphor is disturbingly open-ended and even in his
famous images of 'boat dogs', it is not certain whether the dogs
are the victims or aggressors. The dog image also appears in
148 *Bilingual Dog* (1993), a pun on hybridity, double entendre and
duplicity, although the issue of bilinguality can also be taken
more literally, as an autobiographical 'in joke', since García
Cordero lives in both Santo Domingo and Paris.

The seductive but shallow conformism of Haiti's School of
Beauty and the restrictive labels that are often attached to
Caribbean artists are provocatively challenged by the paintings
149 and mixed-media installations of Mario Benjamin (b. 1964), who
has been influential as a contemporary artist based in Haiti.
His searingly anguished (self-)portraits are deconstructed to the
point where they become biomorphic forms that appear to burn
and disintegrate from within, and explore existential questions

of race and identity in the context of the general upheavals of the contemporary world, without resorting to the usual specificities.

The AIDS epidemic has taken its toll in the Caribbean, which has surely contributed to the thematic emphasis on mortality and the transience of life that appeared in art of the 1980s. This is evident in the work of the Puerto Rican artist Carlos Collazo-Mattei (1956–1990), whose earlier, photorealist work was somewhat facile, but his art took on new urgency when he was confronted with disease and death, first of a close friend and then his own. His later paintings examine the questions raised by his terminal illness in a sober but emotionally gripping manner. The most poignant of these works are the monumental self-portraits, true confrontations with the self in which Collazo-Mattei appears bald-headed and naked, an existential nakedness intensified by the otherworldly, electric colours.

The Caribbean can be very homophobic and most Caribbean countries still have prohibitive laws and religious and social strictures that make it hard for LGBTQ individuals to lead their lives freely and openly. LGBTQ issues are still today rarely addressed openly by artists who live and work in the Caribbean itself, but the conversation has broadened, in part because of the impact of artists in the Caribbean diaspora who operate

150

149 BELOW Mario Benjamin, *Untitled*, c. 1997
150 OPPOSITE Carlos Collazo-Mattei, *Self-Portrait I*, 1989

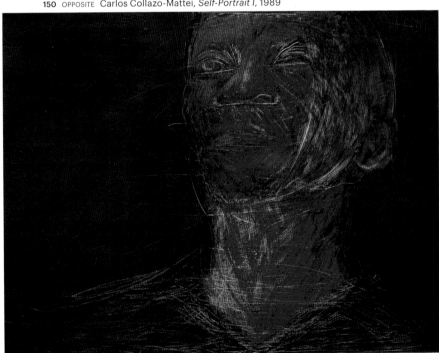

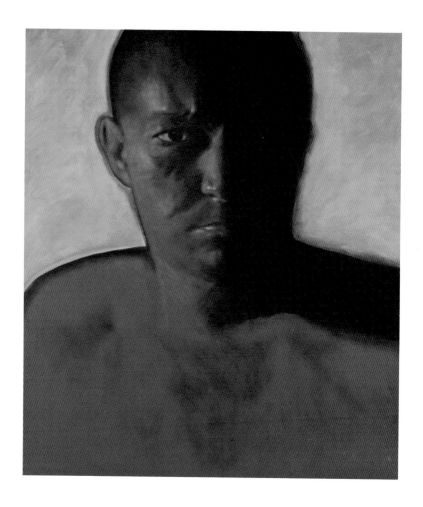

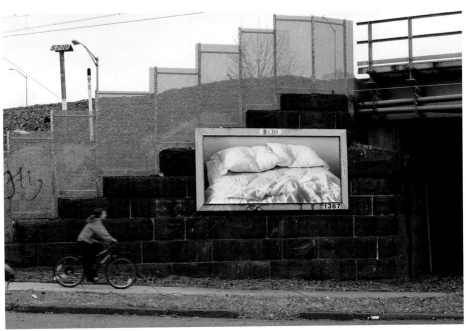

151 Felix Gonzalez-Torres, *"Untitled"*, 1991

in less intolerant environments. Perhaps the most influential artist in that regard was the American Felix Gonzalez-Torres (1957–1996) who was born in Cuba but moved to the United States as a young man, via Spain and Puerto Rico, where he did part of his art studies at the University of Puerto Rico in San Juan. From 1989 to around 1991 he was active in Group Material (1979–96), a New York City-based group of conceptual artists that included Jenny Holzer, Barbara Kruger and Hans Haacke, and engaged in cultural activism, public and participatory projects and community education.

Gonzalez-Torres is best known for his ephemeral but carefully strategized installations that consist of cultural artefacts such as wrapped candies, paper stacks, strings of light and minimalist billboards – simple interventions open to multiple interpretive possibilities that do not provide any direct, explanatory representation of the themes he explored, but powerfully engage the viewer on a physical, emotional and intellectual level, often inviting them to interact in an equally simple, almost mundane manner. About this, he said in a 1995 interview with fellow artist Ross Bleckner: 'I want some distance. We need our own space to think and digest what we see. And we also have to trust the viewer and trust the power

of the object. And the power is in simple things. I like the kind of clarity that that brings to thought. It keeps thought from being opaque.'

A number of Gonzalez-Torres's works can be interpreted as a response to the illness and death, of AIDS, of his partner Ross Laycock. The best known of these works is the billboard *"Untitled"* (1991), which was originally displayed at different locations in the streets of New York and presented a black and white photograph of an empty, unmade bed – the artist's own bed – with the imprints of the two persons who had slept in it still visible on the pillows. A common interpretation was to regard the work as a meditation on love and loss, and on presence and absence, and it became one of the signal images of the fight against AIDS and for gay rights. Another work, *"Untitled" (Portrait of Ross in L.A.)* (1991), consists of an installation of heaped, colourfully wrapped candies, which can be shown in a variety of configurations and ideally comprises 175 pounds of candies, an 'ideal weight' that can be interpreted as that of a healthy, adult male. Viewers have the opportunity to take some of the candies and the exhibitors the option to replenish them, a process which may allude to the wasting nature of the illness but also to symbolic survival.

Gonzalez-Torres, who also died of AIDS in 1996, has been one of the most internationally influential contemporary artists of Caribbean heritage. He too lives on in his work, much of which can be recreated by following his basic instructions, in what has been a truly remarkable posthumous exhibition record which has included the 52nd Venice Biennale in 2007, when his work was selected to represent the United States. While his art does not as such allude to his Caribbean origins, he had his earliest exhibitions in Puerto Rico and his work has also been included in various editions of the San Juan Poly/Graphic Triennial, since 2003 the successor of the San Juan Printmaking Biennial, which accommodates more expansive, contemporary definitions of printmaking, multiples and graphic art.

In May 2020, during the near-global Covid-19 pandemic lockdown, there was an unexpected but poignant symbolic homecoming to Cuba when a mound of fortune cookies – an installation of Gonzalez-Torres's well-known *"Untitled" (Fortune Cookie Corner)* (1991) – appeared on a rooftop in Havana, with visitors partaking in the cookies and reading their fortunes. This was the result of an invitation for a collective Gonzalez-Torres installation presented by Andrea Rosen and David Zwirner galleries in New York, in which some 320 persons in different parts of the world took part.

This participatory project provided a powerful signal of global connection and solidarity in a moment of shared fragility and uncertainty, with which Gonzalez-Torres would surely have identified.

If the body was present by its absence in the work of Gonzalez-Torres, it is more actively suggested in the work of the Jamaican media artist Petrona Morrison (b. 1954), which addresses questions of fragility and resilience as autobiographic and socio-cultural issues. Her earlier work explored her historic and symbolic connections as a member of the African diaspora. Her monumental assemblages and installations of that period, which were made from found and recuperated material, had the verticality and frontality of Dogon art and a strong ritualistic, altar-like quality, which alluded to healing and reconnection. Her later work has taken a more conceptual, dematerialized and technological turn in which she explores the dynamics of representation regarding the black body, including her own, and the tensions between mapping, surveillance and official identifications on the one hand, and the fertile poetic and political implications of self-fashioning and the choice of opacity on the other.

152 The gallery-sized installation *Reality/Representation* (2004) was an important turning point, in which she addressed her history and identity as a person with a congenital condition. The darkened room was dominated by a vertically elongated,

152 Petrona Morrison, *Reality/Representation*, 2004

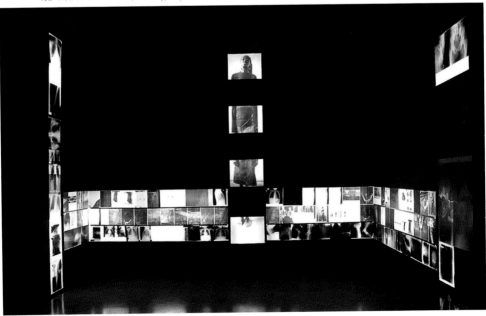

153 Ernest Breleur,
Untitled from the
Suture series, 1995

segmented self-image, in which she became an abstracted
totemic form herself, juxtaposed with X-rays and topographical
images and ghostly white wooden chairs of different heights
that challenged conventions of normality and viewpoint.

The Martiniquan Ernest Breleur (b. 1945) has approached the
subject of the fragility of the body with emotional detachment,
as a broader philosophical issue. Breleur was a founder of the
Indigenist group Fwomajé in Martinique, but left the group in
1989 and rejected Indigenism in favour of formal experimentation
and universal subject matter, such as the significance of religion
and myth and the futility of human pursuits. After several series
of paintings on death and the decomposition of the body, he
turned in the mid-1990s to the symbolic reconstruction of the
153 body in his *Suture* series of X-ray collages. While these works
contain no anecdotal references to Martinique or the Caribbean,
they are related to the intellectual and literary traditions of the
Francophone Caribbean. The *Suture* series, more specifically,
recalls Aimé Césaire's collection of poems *Corps perdu* (Lost

Body) (1950). In the last poem in that collection, 'Dit d'errance' (Song of Wandering), Césaire evoked the ancient Egyptian myth of Osiris, whose scattered body was reassembled by Isis.

Breleur's working method on his X-ray collages mimicked that of a surgeon: the radiographies were carefully arranged on a horizontal surface reminiscent of an operating table and he wore a surgical mask and gloves to avoid infection, since some of the X-rays had been used during actual medical procedures. In spite of this clinical method, there is a singular poetry to the nocturnal, incorporeal X-ray images that appear to be 'sutured' together with white correction strips. These strips are also combined with red paper dots to form elaborate, abstract patterns that are sometimes cruciform, suggestive of tombs or the body.

Other artists have, in contrast, embraced materiality to address similar issues. Patrick Vilaire, the Haitian sculptor and ceramist, creates monumental sculptures for which he uses various, meticulous processes, including the cut-metal techniques of the Haitian *ferroniers*. His work explores broad existential questions, such as power, death and the subject of memory, all relevant to Haiti and based on his research into the cosmogony and iconography of Vodou. The latter includes *Le Carcan* (The Stocks) (1996), a wood and metal sculpture of a shackled figure imprisoned in the solid block form of the wood. While the sculpture evokes the physical realities of slavery, particularly the iron collars, shackles and stocks that were routinely used to restrain rebellious slaves, it also refers to slavery as an existential state, a pessimistic image that seems to rule out the 'emancipation from mental slavery' the Jamaican reggae artist Bob Marley sang about in his 'Redemption Song'.

Vilaire is an important representative of a revival in Caribbean sculpture in the 1980s and 1990s, which is characterized by a shift of scale towards sober, monumental, mixed-media installations, often on subjects of identity and existential questions. The work of the Jamaican sculptor Margaret Chen (b. 1951) is another exponent. Her *Steppe* series, a group of mural-size, mixed-media reliefs she produced in the early 1980s while living in Canada, represents an exploration of her ancestral subconscious as a Jamaican of Chinese descent. She described her work on the series as:

Assembling and gluing, building layer upon layer, scraping, scoring, carving to an inner compulsion that propelled me to work now furiously and spontaneously, at other times slowly and repetitively. That whole process became not only an exploration of the passage of time, but of my roots – an imaginary subterranean

journey beneath the Steppes of Asia, of life that was no more and of what remained, accumulating, layer upon layer – vague shadows, nebulous shapes.

In spite of the word play on the stepped shape of the reliefs and the calligraphic quality of the surfaces, her approach to this exploration of identity is entirely instinctive, but without anecdotal references to China or Chinese art.

155
156

If Margaret Chen's explorations of race and identity are subtle and understated, those by the Barbadian painter Ras Akyem Ramsay are deliberately provocative. His *Blakk King Ascending* (1994), a self-image as the black Christ, embodies the patriarchal, individualist philosophy of Rastafarianism and its politicized interpretations of biblical and historical imagery. With its enormous, erect penis, it is also an image of sexual and racial defiance. Ras Akyem's work has been heavily dependent on Jean-Michel Basquiat's, but he has recontextualized Basquiat's quintessentially urban, boldly expressionist imagery into one of the most orderly societies in the Caribbean where

155 BELOW Margaret Chen, *Steppe VII*, 1982
156 OPPOSITE Ras Akyem Ramsay, *Blakk King Ascending*, 1994

graffiti is virtually unknown. His work therefore also constitutes a deliberate challenge to Barbados's conservative social and cultural establishment, a concern he shares with several contemporary Barbadian artists.

The politics of race, sexuality, postcoloniality and power are also interwoven in the work of his Jamaican contemporary Omari S. Ra 'Afrikan' (Robert Cookhorne, b. 1960), who attended the Jamaica School of Art (now the Edna Manley College of the Visual and Performing Arts) around the same

time as Ras Akyem. As his complex, metaphorical imagery and theatrical titles suggest, Ra samples a wide and disparate array of historical and cultural sources, ranging from Garveyism and the symbolic implication of the Haitian Revolution and Vodou to Herman Melville's *Moby Dick* (1851) and modern comic strips. He interprets these in heavily worked, visceral material forms that include painting, collage and constructions. Arguably the most consistent, central theme in his work is the defiant, subversive and revolutionary power of the subaltern masses – the 'Wretched of Earth', as Frantz Fanon called them – which found one of its most potent early expressions in the series of ambiguous, scowling and menacing 'beggar-king' figures he produced in the late 1980s, of which *Figure with Mask* (1987) is the best-known example.

157

Defiance is also evident in the early linocuts of Annalee Davis (b. 1963) from Barbados but, in contrast, as an angry examination of her identity as a light-skinned Barbadian woman of privilege with family roots in the plantocracy, a difficult subject very few Caribbean artists have tackled.

158

157 Omari S. Ra, *Figure with Mask*, 1987

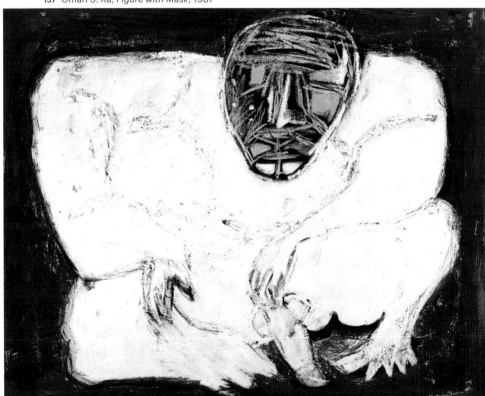

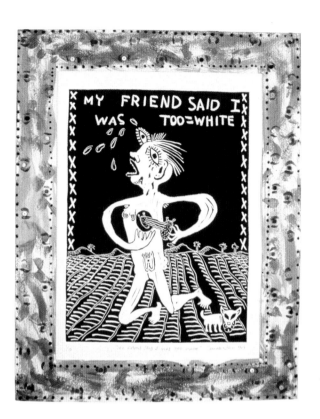

158 Annalee Davis,
*My Friend Said I Was
Too White*, 1989

Most of Davis's early works contain a recognizable self-image, with provocative details such as ripped-out hearts and stylized genitalia combined with schematic representations of the Barbados landscape, the national flag, the home, aeroplanes, snarling dogs and, often, text. These works also interrogated her connection to the land of Barbados, that was once transformed from forest to sugar-cane fields and, more recently, to tourist resorts and golf courses – her deep identification with the land and its symbolic potential continues to be an important focus in her later work.

As a major aspect of the modern Caribbean experience, migration raises additional, new existential questions, primarily of belonging, displacement, and cultural and racial otherness. The Jamaican-born artist, writer and curator Keith Morrison (b. 1942) left to study art in Chicago in the early 1960s and settled in the US. In his paintings, Morrison explores his multi-cultural identity by means of eclectic, often satirical references to his childhood memories of Caribbean folklore,

modern African American life and mainstream western culture. He also frequently comments on social issues – his *Crabs in a Pot* (1994), for instance, summarizes the African diasporal experience with references to ancient Africa, slavery and African Caribbean popular culture, but also refers to the self-destructive 'crab barrel' mentality of placing individual over communal progress. As a grotesque *memento mori*, the scene is surmounted by a urinating skeleton.

These themes also appear in the installations of Antonio Martorell who, like many Puerto Rican artists, lives in Puerto Rico and in New York. The title of his installation *Pasaporte Portacasa* (1993) is a pun on the Spanish words for home and passport. With its playful allusions to official documents, the home, popular culture, colonization, racial prejudice

159

160

159 BELOW Keith Morrison, *Crabs in a Pot*, 1994
160 OPPOSITE Antonio Martorell, *Pasaporte Portacasa*, 1993

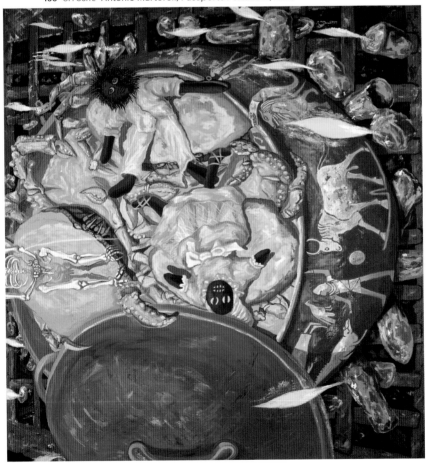

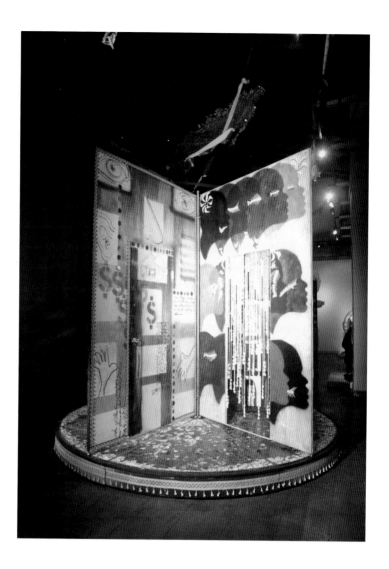

and economic need, the installation refers to the realities and
historical context of Caribbean migration and celebrates the
'portable', ever-changing but ultimately irrepressible cultural
identities of the Caribbean and its diaspora.

Chapter 9
The Caribbean Contemporary

The 1980s and 1990s marked the start of a crucial period of change in the Caribbean art world. A strong new cohort of artists emerged, whose work differed significantly from those of their predecessors and set the course for major developments since then. For instance, although painting remained as an important medium, installation, performative, and photography-based and mixed-media art became prevalent. These contemporary artists embarked on a reevaluation of art in the Caribbean, in the rapidly changing social, political, technological and cultural environment of the late twentieth and early twenty-first century. While a critical perspective is implied, or explicit, in most of the art that has been discussed in this book thus far, this new contemporary art is characterized by an unprecedented level of self-reflexivity and criticality, which is more explicitly present in the work itself. This new generation has deeply challenged the art-historical narratives, reductive labels and conventions that were imposed in the previous decades – particularly the expectation that legitimate Caribbean art has to represent particular aspects of Caribbean culture in prescribed ways.

The Trinidadian artist and critic Christopher Cozier (b. 1959) has argued that the main difference between Trinidadian art of the 1960s and 1970s and that of his generation is the shift from 'representing culture' to 'creating culture', a polemical statement that is nonetheless applicable to contemporary Caribbean art as a whole. While Cozier may underestimate the contribution of the previous generation to the articulation of postcolonial culture, many established artists had lapsed into making highly marketable, formulaic representations of accepted 'culturally relevant' subjects, a tendency which was reinforced by the development of vigorous internal markets in

161 María de Mater O'Neill, *Self-Portrait VIII*, 1988

countries such as Jamaica, Trinidad, the Dominican Republic and Puerto Rico. The work of the younger generation, therefore, also represents a challenge to what had become official postcolonial or revolutionary culture. In spite of this often contentious generation gap, several older artists have actively contributed to the recent developments. They include Ana Mendieta, Luis Cruz Azaceta, David Boxer, Milton George, Keith Morrison, Antonio Martorell and Ernest Breleur, who are discussed in the previous chapters.

Such an interrogation of the representation of national identity is, for instance, evident in the early work of the Puerto Rican painter and designer María de Mater O'Neill (b. 1960), where it is infused with a disconcerting combination of humour, anguish and stridency. One major example is her
161 *Self-Portrait VIII* (1988), a riotous, iconoclastic interpretation of the placid, contemplative *Nude in Front of Mirror* (1980) by Myrna Báez, an iconic work by an equally iconic artist in the Puerto Rican context – a pointed dialogue, also, between two generations of female artists and feminists.

162 Christopher Cozier, *The Attack of the Sandwich Men*, installation from the 'Being an Island' exhibition, daadgalerie, Berlin, 2014

Cozier has been particularly influential in these new, critical conversations. As he states: 'My work aims to transform conventional readings of where I am from – or about what I am supposed to be concerned.' He resists labels such as 'Caribbean artist' and has turned his critical, deadpan satirical eye on the mundane, conformist trappings of national bureaucracies and education in the postcolonial Caribbean – some of the same forces that helped to produce such labels in the first place.

162 Cozier's *Attack of the Sandwich Men* (2004–13) takes the form of hundreds of identically sized and wrapped white-bread sandwiches – the bland standard lunch of the petty civil servant – each topped with a tiny Trinidadian flag and laid out in grid formation on the floor like a miniature armada or marching army in the service of the 'greater good' of the postcolonial nation. When the installation was shown for the second time in 2013 in Berlin, it was accompanied by a vintage Blaupunkt radio – an obligatory presence in many independence-era West Indian homes – playing a 1960s school broadcast that instructed on the 'proper' way to sing the Trinidadian national anthem.

163 Another signal work in this context is *A Cultural Object* (1985) by the Jamaican artist and designer Dawn Scott (1951–2010).

It was commissioned for the National Gallery of Jamaica's 1985 exhibition 'Six Options: Gallery Spaces Transformed', for which six artists were invited to produce installations, the first of its kind in Jamaica. *A Cultural Object* effectively forced the physical and cultural environment of Kingston's inner cities into the genteel 'high culture' space of the National Gallery of Jamaica, a powerful, if not always recognized form of institutional critique. It consists of a spiral-shaped structure, constructed from recuperated corrugated metal and lumber – the typical building materials in the squatter settlements of the poor. The surfaces of these materials bear the sort of shop signs, dancehall posters and graffiti that are common in Kingston's inner cities. The installation may appear unplanned, much like a squatter settlement, but it is carefully orchestrated: the claustrophobic, trap-like spiral corridor ushers the visitor from amusement to dismay when the shockingly realistic sculpture of a rag-clad street person in the middle is seen.

A Cultural Object presents a critique of the forces that, according to Scott, trap the poor in their marginalized position, including the escapist nature of much popular

163 Dawn Scott, *A Cultural Object*, 1985

music, self-deprecating beauty practices such as skin-bleaching, socially counterproductive attitudes towards women and sexuality, disempowering religious beliefs, partisan political violence, and, ultimately, mental illness and social alienation. Much of its effect derives from its extreme realism and the way the images, textures and materials are used to capture the sensory experiences of inner-city life, resulting in an immersive experience of a reality most typical museum visitors avoid in their daily lives. Conservative art patrons objected that the work represented Jamaica in a negative light, but the installation was nevertheless acquired by the National Gallery of Jamaica where it became one of the most popular exhibits. Its influence is
still evident today in the work of younger Jamaican artists.

As Dawn Scott's installation illustrates, the concept of 'art', the art object and its institutions are part of what has been interrogated by contemporary artists in the Caribbean, consistent with developments in contemporary art globally. Interestingly, several artists who have notably contributed to these challenges in the metropolitan west, with innovative and poignant institutional critiques, are of Caribbean descent. In addition to Felix Gonzalez-Torres, whose work was discussed in Chapter 8, they include Fred Wilson (b. 1961), whose maternal grandparents were from St Vincent, Andrea Fraser (b. 1965), whose mother is from Puerto Rico, and Coco Fusco (b. 1960), who is Cuban on her mother's side – an instructive reflection of the role of the Caribbean experience in the questioning of the western cultural status quo.

The start of new developments in Caribbean art occurred in an era characterized by disillusionment with the social and political ideals of the previous generation: the violence-ridden 1980 general elections in Jamaica, which ended the country's democratic socialist era; the 1980 assassination of Walter Rodney in Guyana; the deaths of the long-serving post-independence leaders of Trinidad and Guyana, respectively Eric Williams in 1981 and Forbes Burnham in 1985; the Grenada Invasion in 1983; and, although it should be seen in a different ideological context, the end of the Duvalier dictatorship in Haiti in 1986 all marked the end of an era in Caribbean politics and were related to epochal changes on a global scale. This crucially included the end of the Cold War, with the 1989 fall of the Berlin Wall and the dissolution of the Soviet Union in 1991, and a general turn towards political and economic neo-liberalism. While Cuba has stayed the Communist course, it was severely affected by the end of the Soviet Union, resulting in the Special Period, during which even the most basic supplies became scarce.

The Cuban art critic and curator Gerardo Mosquera, who has been closely associated with the development of contemporary Cuban art, has aptly termed the atmosphere in late twentieth-century Cuba as 'post-utopian', a description that can be extended to much of the region. This new uncertainty has been heightened by the effects of political instability, neo-colonial economic dependency, urbanization, deepening socio-economic inequality, new technologies, global communications, travel and mass tourism, as well as migration and exile, all of which have, in turn, fundamentally changed Caribbean culture and its relationship to the rest of the world. This globalized cultural climate has generated a new awareness of the political significance of culture, as well as of the implications of the history and modern-day dynamics of the Caribbean, and an even greater urgency to interrogate questions of identity but with more recognition of the complexities and contradictions involved.

Stuart Hall, who lived in Britain, wrote about his Caribbean background: 'What I have thought of as dispersed and fragmented comes, paradoxically, to be the representative modern experience!' The late-twentieth century zeitgeist indeed seemed to vindicate ideas that have been central to Caribbean intellectual life. Writers such as Fernando Ortiz and Frantz Fanon have been rediscovered and several influential contemporary cultural critics and theoreticians, like Hall, Edouard Glissant, Kamau Brathwaite, Antonio Benítez-Rojo, Audre Lorde and Michelle Cliff, are from the Caribbean or have Caribbean roots. Much contemporary Caribbean art is created and, even more so, curated with awareness of these theoretical and critical frameworks – a remarkable number of recent exhibitions have been conceived around such themes.

What is now often called New Cuban Art emerged in the early 1980s and the 1981 'Volumen I' exhibition at the International Art Centre in Havana is often cited as its symbolic start. This exhibition featured artists such as José Bedia, Juan Francisco Elso, José Manuel Fors (b. 1956), Ricardo Brey (b. 1956), Leandro Soto (b. 1956) and Rubén Torres Llorca (b. 1957) and the photorealists Tomás Sánchez and Flavio Garciandía. Most of these artists were recent graduates of the Instituto Superior de Arte (ISA), which had opened in Havana in 1976 and introduced advanced, postgraduate studies to Cuba's art school system.

'Volumen I' helped to establish the main trends in contemporary Cuban art. Garciandía, for example, was already moving from photorealism towards conceptualism and has contributed greatly to the critical, self-referential character of New Cuban Art. Elso and Bedia have been influential with their

164 Tomás Esson, *My Homage to Ché*, 1987

highly individual syntheses of the personal, the mythical,
the spiritual and the political.

The Havana Biennial was another significant factor in
the ascent of contemporary Cuban art. The Biennial was
established in 1984 as an exhibition of Latin American art,
but in 1986 it was expanded to the entire Global South. The
biennial has encouraged the development of process-oriented
art forms such as installation and performance art, a trend
reinforced by the scarcity of conventional art materials in
Cuba. It has also created a forum for artists and observers
from all over the globe, and Cuba and the Caribbean itself.
The Havana Biennial quickly became a much-noted event on
the international art calendar, making the international
exposure of Cuban art less dependent than before on the
power structures of the western art world.

New Cuban Art emerged during a period of greater
openness in the country and, for the first time since the
Revolution, Cuban artists overtly challenged political and
artistic dogma, often in a satirical manner. Inevitably, they

also targeted the Fidel Castro government. Perhaps the most provocative example of this was Tomás Esson's (b. 1963) *My Homage to Ché* (1987), a painting in which he portrayed Che Guevara as a black man and combined images of Che and Fidel with grotesque sexual and scatological imagery.

Predictably, such work was not readily tolerated by the Cuban authorities, whose reactions ranged from unease to outright censorship. Even Elso's mystical portrayal of José Martí in *Por América* (1986) had caused some concern and Esson's 1988 solo exhibition at a major Havana gallery, which included *My Homage to Ché*, was closed down. In the debates that followed, the Cuban Minister of Culture, Armando Hart, declared any disrespectful use of national symbols out of bounds. This crisis took place during the so-called 'rectification' process of the late 1980s, which marked the end of a brief but culturally productive period of liberalization.

While this ideological crisis was unfolding, the international fame of contemporary Cuban art was rapidly growing. The influential German collector Peter Ludwig acquired most of the 1990 'Kuba O.K.' exhibition (shown at the Stadtische Kunsthalle, Düsseldorf), for instance, and in 1995 established a branch of his foundation in Havana, providing support for innovative and alternative artistic expressions. Many exhibitions on contemporary Cuban art were held in various parts of the world and a remarkable number of catalogues and books on the subject were published.

With the growing commercial success of Cuban art, the sale of art became an important part of the system of 'state capitalism' that has been in effect in Cuba since the fall of the Soviet Union. International sales are handled through the Fondo Cubano de Bienes Culturales (Cultural Property Fund) which initially paid the artists in Cuban pesos, at the unrealistic official exchange rate. Since Cuba was rapidly becoming a 'dollar economy', where many essential items could only be bought with US dollars, this added to the mounting feeling of dissatisfaction among artists. After much controversy, artists were eventually given access to their share of the hard currency earned by the sale of their work.

Prompted by these conflicts with the authorities and the economic crisis, many artists left the country in the early 1990s and, predictably, several of these 'defections' took place during overseas exhibitions. A few went to Europe and some, like Esson, applied for political asylum in the United States, although most moved to Mexico, where Cubans can live in semi-exile without severing ties with Cuba. Following economic difficulties in Mexico, after the devaluation of the Mexican peso in 1994, several moved on to the US, however, including José Bedia.

The response of the 'refugee' artists to their new environment has varied. Although Bedia's work is closely linked to his Cubanness, living in Mexico and the US has allowed him to deepen his knowledge of Native American culture. His outlook has not changed dramatically, although some of his work speaks of his migrant status and of being on the other side of the 'divide'. It was not always easy, however, for the artistic 'refugees' to adjust to the market-driven art system of the US and, more so, the dilemmas caused by Cuban-American politics. Controversy arose, for instance, when three of them – Arturo Cuenca (b. 1955), Florencio Gelabert (b. 1961) and Esson – participated in the 1992 Absolut Freedom advertising campaign for Absolut vodka, which sought to capitalize on their 'defector' status. However, most have refused to be typecast as dissidents.

Conflicts with the Cuban government were less overt in the 1990s but a subversive spirit remained, as could be seen in the installations of Kcho (Alexis Leyva Machado, b. 1970). He caused controversy at the Fifth Havana Biennial with his

165 LEFT Kcho, *Regatta*, 1994
166 OPPOSITE Los Carpinteros, *Havana Country Club*, 1994

165 installation *Regatta* (1994), a work that referred to the rafters'
crisis – then at its peak – but also to the flight of Cuban artists.
The installation consisted of a flotilla of miniature wooden and
paper boats, egg trays and old shoes, tragi-comical reminders
of the improbable raft constructions many Cubans have used
in their attempts to flee to the US. Kcho's use of improvised,
transitory materials also reflects the legacy of Elso, a
persistent influence on Cuban art, years after his death.

 Similar shifts were evident in the work of Los Carpinteros
(The Carpenters), a collective initially consisting of the
sculptors Alexandre Arrechea (b. 1970) and Dagoberto
Rodríguez (b. 1969), and the painter Marco Castillo (b. 1971),
one of several such Cuban artists' collectives in recent
decades – Arrechea left the group in 2003 to pursue a solo
career and now lives in Miami. Los Carpinteros have examined
the ambivalent relationship with Cuba's pre-revolutionary
past and revolutionary utopianism, with deadpan formality
in imagery and execution, and with careful attention to the
conceptual and critical possibilities of craftmanship.

166 In *Havana Country Club* (1994), the three artists are
represented playing golf at the ISA campus, their alma mater,
which was built on the grounds of the Havana Country Club,

167 ABOVE Carlos Garaicoa, installation view of *Rivoli, About the Place from Where the Blood Flows – Cruel Project*, 1993–95
168 LEFT Carlos Garaicoa, installation view of *Rivoli, About the Place from Where the Blood Flows – Cruel Project*, 1993–95
169 OPPOSITE Marta María Pérez Bravo, *Parallel Cults*, 1990

once a gathering place of the local and expatriate elite. While the knee-high grass is realistic (and a reflection of the neglect of the compound), other details, such as the 'home-made' golf clubs, are absurd reminders of the Cuban culture of 'bricolage', an amusing contrast with the artists' own meticulous traditional craftsmanship. The painting is mounted in an elaborately carved wooden picture frame like those often used for members' club memorabilia.

The city of Havana has been an important inspiration to Cuban artists. While René Portocarrero's 'cities' celebrated the baroque splendour of Old Havana, the conceptual artist Carlos Garaicoa (b. 1967) has chronicled its slow decay. Garaicoa's Havana is a mythical, living place, where buildings bleed and invisible giants support the collapsing walls. His most striking installations juxtapose elevation drawings of bizarre utopian structures with nostalgic photographs of the disintegrating buildings, perhaps the most poignant illustration in Cuban art of Mosquera's notion of 'post-utopia'.

Garaicoa's work also illustrates the growing importance of photography in Cuban art. Marta María Pérez Bravo (b. 1959) is best known for her performative photographic self-portraits that allude to rituals and self-sacrifice. It comes as no surprise that she cites Ana Mendieta (see Chapter 7) as a major influence. Pérez Bravo's work draws from Santería beliefs and mythology, to which she initially turned to address anxieties about her pregnancy and the birth of her twins, which are of special

167

168

169

170 LEFT Juan Carlos Alom, *Untitled* from the *Libro Oscuro* (*Dark Book*) series, 1995
171 OPPOSITE Víctor Vásquez, *Prelude*, 1994

significance in the Yoruba religion. Constructed photography lends itself well to represent the complex, syncretic nature of Caribbean identity because of the possibilities it offers to transform images.

A similar preoccupation with the body and the ritualistic could be seen in the photographic work of Juan Carlos Alom (b. 1964), particularly his *Libro Oscuro* (Dark Book) series (1995). The series resists literal association with Afro-Cuban religious practices, but the cathartic effect of ritualized violence is however a theme in these works, as are the references to blackness and Afro-Cuban history.

Cuba was dominant in the contemporary Caribbean artworld of the 1980s and 1990s, certainly in terms of international visibility, but similar developments took place throughout the region – some of the artists who took the lead in these developments, such as Petrona Morrison from Jamaica, Edouard Duval-Carrié from Haiti and Marc Latamie from Martinique,

170

are discussed elsewhere in this book. In some instances, the parallels with developments with Cuba are obvious, and illustrate the crosscurrents of ideas, interests and cultural sources that have shaped contemporary Caribbean art.

171 One such example is the work of the Puerto Rican Víctor Vásquez (b. 1950), who incorporates photographs of anonymous bodies and body parts in assemblages and installations that are often reminiscent of votive offerings. His images, which are akin to those of Alom and Pérez Bravo, reflect his interest in the iconography of Roman Catholicism and Santería and allude to autobiographical issues and subjects such as AIDS, a recurrent theme in contemporary Puerto Rican art.

As a result of the debates around the 1992 Columbus Quincentennial (see Introduction), there were several major international art exhibitions and conferences with a critical focus on the Caribbean, and these provided new meeting opportunities for artists, curators and writers from across the Caribbean, many of whom met for the first time. The short-lived Santo Domingo Biennial of Caribbean and Central American painting, which was established in 1992 as part of the Quincentennial observations in the Dominican Republic, was one such meeting place in the Caribbean itself, in addition to the Havana Biennial. These initiatives resulted in an increasingly networked contemporary art scene in the Caribbean and new creative developments based on artistic and ideological dialogues that transcended the customary national situations.

161 Tony Capellán (1955–2017), Belkis Ramírez (1957–2019) and Marcos Lora Read (b. 1965) are among the artists who spearheaded these conversations in the Dominican Republic.

172 The parallels of their formal and thematic pursuits with those of their Cuban contemporaries are clear, although they gave voice to social and cultural issues that had until then remained unaddressed in Dominican art, such as the strained racial politics with Haiti, the exploitation of the poor, illegal and legal migration, and attitudes towards women.

Capellán exposed rarely recognized Dominican problems, such as the boat people who try to cross the dangerous Mona Passage to Puerto Rico, child prostitution in the tourism sector, or the rumours of kidnappings of children for the illicit human-organ trade. His installations are deceptively simple and typically rely on the repetition of a single component, often articles of clothing or shoes, suspended in space or arranged on the wall or floor. These generic, empty clothes symbolize the anonymous, absent victims and their predicament is graphically represented by such attributes as plastic bags filled with animal organs or the barbed wire thongs he attached to damaged and discarded plastic 'flip-flops', the footwear of the poor in the Caribbean.

While Capellán gave voice to the perspective of the victim, Ramírez pursued the perpetrators of a corrupt political and civic system with biting satire. This is apparent from her titles

172 Tony Capellán, *Organ Theft*, 1994

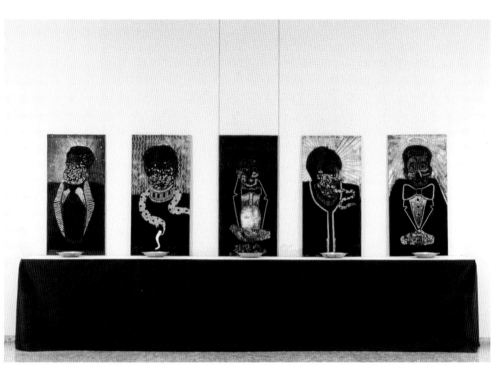

173 Belkis Ramírez, *In a Plate of Salad*, 1993

173 alone – *If Anything Happens, I Was Not Here* (1995) or, more
subtly, *In a Plate of Salad* (1993). The public figures to which she
alludes are often recognizably represented in her installations
and are surrounded by menacing objects such as giant sling
shots and heavy stones. Not all her work was satirical, however,
and later on in her career she focused on the role of women in
Dominican society. Ramírez was also an accomplished
printmaker and often incorporated carved woodblocks in her
installations, which adds to their strong materiality.

 Lora Read, who has also lived in the Netherlands, refers on a
broader philosophical level to the history and present situation
of the Caribbean. Like Capellán, however, he exploits the
evocative power of the commonplace in his installations, which
often include large, found and constructed objects that have
174 a surreal poetic quality. His *40 Metres of Schengen Space* (1995),
a site-specific installation consisting of suspended oil barrels,
alludes to the geo-political dimensions of travel, migration
and trade, and the issues surrounding the visa regime in the
European Union, which is internally borderless (known as the
Schengen Area) but imposes strong boundaries for migrants.

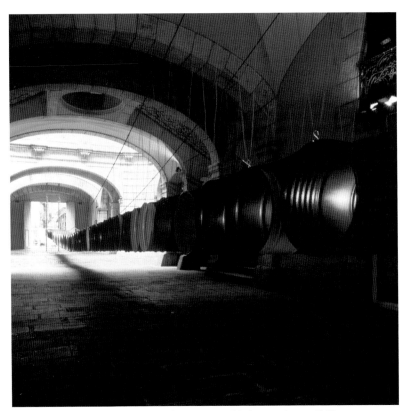

174 ABOVE Marcos Lora Read, *40 Metres of Schengen Space*, 1995
175 OPPOSITE Marcel Pinas, *Kibii Wi Koni*, 2009

A strong concern with social issues is also evident in the work of Marcel Pinas (b. 1971) from Surinam, who combines art activism with community activism. Pinas is an Ndjuka Maroon from the district of Marowijne in Surinam, who studied art in Jamaica and the Netherlands. He grew up during the Surinamese Interior War (1986–89), a bloody civil war between the military dictatorship of Dési Bouterse and the Jungle Commando led by Ronnie Brunswijk. One of Pinas's best-known works is the Moiwana monument (2007), which is dedicated to the thirty-six villagers, most of them women and children, who were massacred by Bouterse's troops in the village of Moiwana in 1986. The monument is one of several works in which Pinas refers to and seeks to redress the human and cultural losses of the civil war.

As Christopher Cozier puts it:

Pinas's work does not 'represent' Maroon culture in any reductive way. Rather, he is in the process of reconstructing its presence and meaning. It is a personal concern that takes on wider political commitments. As a contemporary artist, Pinas does not see himself in conflict with tradition. His work is not iconoclastic in any way. His idea of tradition is perpetually in the present tense, already adapting, always anticipating the next step.

Pinas's commitment to preserving, adapting and rebuilding community is evident throughout his work. His *Kibii Wi Koni* installation, a powerfully celebratory evocation of community, tradition and resilience, involves hundreds of bottles wrapped in the traditional *pangi* cloth of the Ndjuka Maroons, placed against an ominous black backdrop with cut-out, upside-down figures that appear to allude to slavery, torture and the Middle Passage.

Artist-led initiatives have been a transformative force in the contemporary Caribbean art world and several other artists have dedicated themselves to such endeavours. Elvis López (b. 1957) from Aruba is one such and he is today best known as a curator and cultural organizer. He is the founder of Ateliers '89, where pre-college art programmes, workshops and exhibitions are offered, and which, since 2012, hosts the regionally influential Caribbean Linked artist residency and exhibition programme. López's own work fits in the same socially engaged context as the artists already discussed in this chapter. His *Social Critic* series (1993), for instance, uses humour

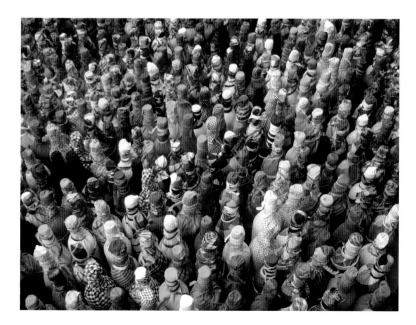

and formal punning in to allude to serious socio-political and gender issues, from AIDS to modern warfare.

Such a strong activist spirit has also been evident the work of Caribbean diaspora artists of the same generation. The US-born artist Juan Sánchez (b. 1954), for instance, in his *Rican/Structions*, a title borrowed from the Salsa musician Ray Barretto, deals with the need of the Puerto Rican diaspora in the US for personal, cultural and ideological self-definition. Sánchez's images are composed from symbols of identity, such as the Puerto Rican flag, Taíno pictographs, palm trees, photographs and laser copies of Ramón Frade's famous Jíbaro painting *Our Daily Bread* (c. 1905). Sánchez also often uses text, adding a narrative element to his otherwise emblematic work.

177 Sánchez's collage diptych *Nueva Bandera* (New Flag) (1994) was made for the twenty-fifth anniversary of New York City's El Museo del Barrio. The composition of this work was inspired by the cover of an issue of *Pa'lante*, the newsletter of the

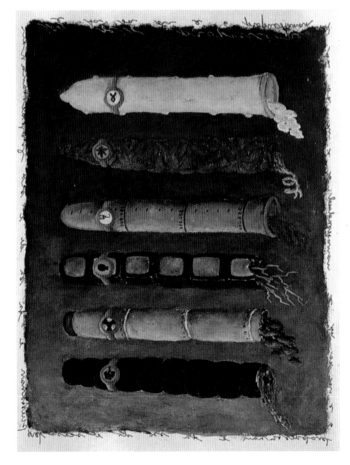

176 LEFT Elvis López, *The Six Proposals* from the *Social Critic* series, 1993
177 OPPOSITE Juan Sánchez, installation view of *Nueva Bandera* (New Flag) from the *Rican/Structions* series, 1994

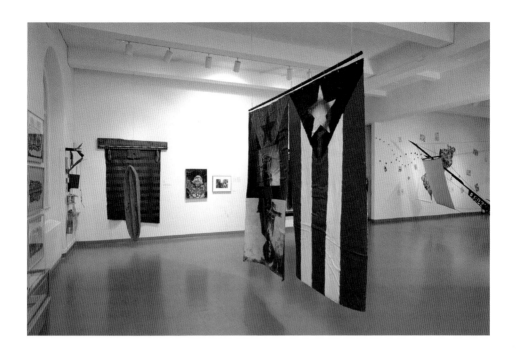

Young Lords Party, from the year the museum was founded, which featured a group of activists in front of the Puerto Rican flag. Sánchez therefore decided to design a new 'flag', composed of references to the political struggles of the past that are an integral part of contemporary Puerto Rican identity.

This urge to reconcile history and the social and political 'here and now' is also present in the work of Nari Ward (b. 1963), who left Jamaica at an early age and lives in New York's Harlem district. His monumental installations typically consist of 'urban debris', such as abandoned children's strollers, shopping carts, old cars, electric fans or car tyres, which are methodically stacked, covered with grimy layers of caramelized sugar or 'tropical' soda – references to the African diaspora's complex histories with sugar – or neatly tied into package forms with fire hoses. While Ward's accumulations recall the work of western artists like Arman or Christo, their main sources are the assortments of odd belongings many metropolitan street people carry with them and the yard exhibitions of the African diaspora – associations that, along with the inclusion of gospel music in some of these works, add to the spiritually moving quality of his work.

Harlem is Ward's principal inspiration but some of his works refer to his Jamaican background, as in *The Happy Smilers: Duty*

179

178 LEFT Felix de Rooy,
Cry Surinam, 1992
179 BELOW Nari Ward,
*The Happy Smilers: Duty
Free Shopping*, 1996

Free Shopping (1996), which was named after an album his uncle made when he sang with the band in a high-class Jamaican hotel. This installation refers to cultural and racial stereotypes, and the tensions between the socio-cultural impact of tourism and the alienating effect of migration – but it also speaks of the resilience of the migrant, alluded to by the almost incidental detail of the potted aloe vera plant sitting on the fire escape ladder within the installation.

Similar questions arise in the work of Felix de Rooy (b. 1952), a filmmaker, theatre director and visual artist from Curaçao who has lived in Amsterdam since the mid-1970s. He is the curator of the Negrophilia Collection in Amsterdam, which contains artefacts and images of black persons in popular western culture that document racism and racial stereotyping. Such 'negrophilia' elements are included in surreal

178

assemblages such as *Cry Surinam* (1992), which refers to the dilemma of the Surinamese migrants who have to endure the 'artificial' heat and racism of the Netherlands in order to get away from the troubling political environment at home.

Renee Cox (b. 1960), who was born in Jamaica and lives in New York, is known for her performative photographs in which she uses her own image, and that of friends, to 'flip the script' on art-historical and pop culture representations, in terms of the politics of race and gender. She is best known for her controversial *Yo Mama's Last Supper* (1996), which re-interprets the traditionally white and male imagery of the Last Supper, casting black, dreadlocked men as the Apostles and Cox herself as Christ, photographed frontally nude. The work was met with official censorship attempts when it was exhibited at New York's Brooklyn Museum in their 2001 exhibition of contemporary black photography, 'Committed to the Image'.

Cox's 2004 series *Nanny of the Maroons* was produced in Jamaica and several of her earlier works contain references to her Jamaican background. In the *Rajé* (1998) series, she adopted the glamorous persona of a black female superhero – Rajé, a play on the word rage – with the Jamaican flag emblazoned across her chest, who intervenes in historical and present-day injustices, for instance by liberating Aunt Jemima and Uncle Ben

180

from their food packaging boxes. In *Chillin' with Liberty*, she takes a rest on the crown of the Statue of Liberty reflecting, by implication, on the conflicted relationship of the United States with notions of freedom, given its history of slavery and racism.

Such an impulse to reconnect and reconstruct can also be seen in the work of Albert Chong (b. 1958), another Jamaican-

181

born photographer who lives in the US. His *Ancestral Thrones*, most of which were originally created in 1990, explore his

180 ABOVE Renee Cox, *Chillin' with Liberty* from the *Rajé* series, 1998
181 OPPOSITE Albert Chong, *Throne for the Justice* from the *Ancestral Thrones* series, 1990

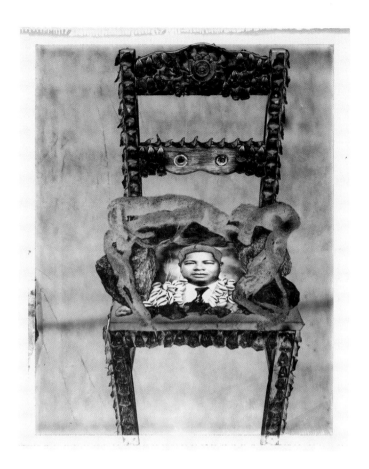

identity as a Jamaican migrant of African Chinese descent.
To create this series, he transformed common chairs into
ancestral shrines by covering them with family photographs,
personal documents – such as passports – and ritualistic items,
such as bones, his cut-off dreadlocks and cowrie shells. These
'thrones' have been used as installations in their own right
or as the basis of photographic images that are enhanced by
overprinting, solarization, tinting and other manipulations.
The chair or throne is a recurrent motif in Caribbean art, as
in Wifredo Lam's *The Chair* (1943), and Chong's interpretation
clearly relates to its ritual, ancestral significance. The chair is
of course also a proxy for the body, which is the main subject
of Chong's other photographic work.

 In contrast, there are few direct references to the Bahamas in
the work of Janine Antoni (b. 1964), a sculptor, photographer and
performance artist who was born in Grand Bahama but lives in

the US. Her work is preoccupied with the female body, the autobiographical, the relationships between people and things, and with audience participation. For *Lick and Lather* (1999) she exhibited two sets of seven female sculpture busts, one set made from chocolate and the other from white soap, which she then reshaped by eating from the chocolate and washing herself with the soap. The sculptures are rich with bodily metaphorical allusions to issues such as menstrual cravings, eating disorders and notions of cleanliness, but also assert self-love.

182

Artists of Caribbean descent have been prominent in the new waves of black British art that emerged from the racial unrest in Britain of the late 1970s and early 1980s. They include Keith Piper (b. 1960), Eddie Chambers and Sonia Boyce (b. 1962), all born in Britain to parents from the Caribbean, and who all defined themselves as black British artists first although they have since then also explored their relationship with the Caribbean.

183

Chambers's early work is most directly linked to its political context. What started out as angry rebuttals of the racist propaganda of the right-wing National Front, however, led to a more thoughtful exploration of the rhetoric and visual language of racism and black nationalism, including the iconography of Garveyism and Rastafarianism which relates indirectly to Chambers's Jamaican background. He is also one of several artists in Britain to take matters into their own hands in

182 Janine Antoni, *Lick and Lather*, 1999

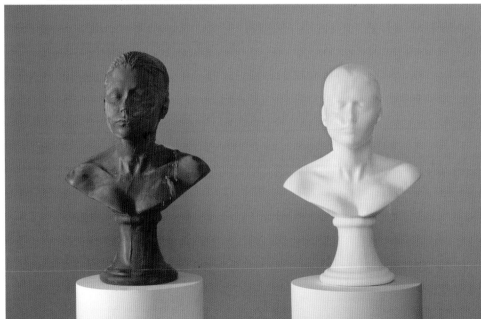

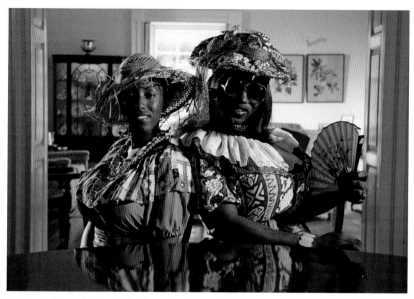

183 Sonia Boyce, *Mother Sallys* from *Crop Over*, 2007

response to the lack of representational opportunities for black artists, and is an influential curator, critic, art historian and publisher of black British art.

Boyce drew attention in the mid-1980s with her powerful, autobiographical pastel drawings that commented candidly on the social and personal issues facing black British women. These were followed by surreal collages that juxtaposed photographic self-portraits with caricatural racial images and also addressed the politics of black hair. More recently, she has focused on collaborative, critical projects that bring to the fore untold histories. Her *Crop Over* (2007) video installation, for instance, delved into the cultural, racial and gender politics of the sugar-cane harvest Crop Over festival in Barbados, mixing the documentary and the staged. It was shown as part of a one-year, extended installation at Harewood House, a large historic mansion and estate in West Yorkshire, which was built in 1738 with profits from the West Indian sugar trade, thus bringing the defiant popular culture practices of the plantation into the space of its absentee historical beneficiaries.

Like Chambers, Piper's early work commented directly on the British political situation of the early 1980s, particularly the racial policies of Margaret Thatcher's Conservative government. He then turned towards the closely linked subjects of black masculinity and the relationship between the transatlantic

184 Keith Piper, *Ghosting the Archive*, 2005

passage and twentieth-century migration. Piper's interest in technology also led him to video and interactive computer graphics. His *Ghosting the Archive* (2005) is based on his research in the Birmingham City Central Library. For this project, he focused on the archives of a Birmingham photographer who had specialized in portraits of members of the various migrant groups that had come to the city. The end-product was a video, |a quasi-slideshow, in which Piper used glass negatives of some of the portraits, with their ghostly images held against the rigidly structured backdrop of the archival racks of the library. Before switching to the next image, each glass negative becomes positive and the library background negative, which gives the persons in the portrait the presence they previously lacked, while the dehumanizing classificatory environment of the archive recedes in the background.

Most of the artists who have been discussed thus far in this chapter, who represent but a small sample of a wide and diverse field, are now well-established and they have been joined by many younger artists. Digital, online and time-based media have further expanded the range and diversity of artistic practices in and from the Caribbean. Further aided by the new international biennial, art fair and artists' residency circuits, and the advent of social media, the Caribbean art world has become even more intensely networked, with real-time regional and global conversations helping to steer new directions and critical responses.

The proliferation of artist-run spaces is another recent development and has helped to galvanize the development of contemporary art in the region. Along with the earlier-mentioned Ateliers '89 in Aruba, some of the most influential are Espacio Aglutinador, an independent space in Havana which was established in 1994; Alice Yard, which was established in 2006 in Port of Spain, Trinidad, by Christopher Cozier, the writer Nicholas Laughlin and the architect Sean Leonard; Fresh Milk in Barbados, which was founded in 2011 by Annalee Davis; as well as Popop Studios in Nassau, Instituto Buena Bista in Curaçao, Beta Local in San Juan, Puerto Rico, L'Artocarpe in Guadeloupe, and New Local Space (NLS) in Kingston, Jamaica. In addition to providing exhibition and studio space and workshops for local artists and art students, most of these initiatives host international residencies.

The conferences which have been held by the Southern Caribbean chapter of the International Association of Art Critics (AICA-SC) in Barbados and Martinique since 1998 have also provided important opportunities for critical exchange, as have the Tilting Axis meetings, an annual think-tank of artists, critics and curators which has convened at various Caribbean locations since 2014. Tilting Axis is a joint initiative of Fresh Milk and *ARC Magazine* and these two are also collaborating on the previously mentioned Caribbean Linked events at Ateliers '89. *ARC Magazine*, which was founded in 2011 as a combined print and online art magazine by the artists Holly Bynoe (b. 1980) and Nadia Huggins (b. 1984), who both lived in St Vincent at that time, is probably the most ambitious art publishing initiative to date in the Caribbean, although it is now dormant.

While many new conversations have thus become possible, others have been threatened. The Cuban artist Tania Bruguera (b. 1968), who lives between Havana and New York, explores issues of power, control and resistance in her provocative performances. In an instance where artistic practice, activism and lived reality have become inevitably intertwined, Bruguera has increasingly positioned her work as a call to collective action for greater artistic independence and freedom of speech in Cuba. This has included attempts at organizing unauthorized 'open mike' events in public spaces in Havana, to which the Cuban authorities have responded with heavy-handed interventions – she has been detained and arrested on multiple occasions.

The key issue against which recent Cuban artist-activists, such as Bruguera and the performance artist Luis Manuel Otero Alcántara (b. 1987), have protested is the controversial Decree

349, which was signed by the new Cuban president, Miguel Díaz-Canel, in 2018. This decree reinforces state control of the cultural sector by requiring Ministry of Culture authorization for any independent initiatives, and outlaws the use of patriotic symbols and sexist, vulgar or obscene content. This resulted in the outlawing, for instance, of the transgressive performances of Alcántara, who is also an LGBTQ activist, and placed him in personal jeopardy. Alcántara is one of the leading figures in the San Isidro Movement, a group of artists, journalist and academics who have engaged in peaceful protest actions against the cultural policies of the Cuban government that have ranged from an alternative biennial in 2018, as a challenge to the official Havana Biennial, to sit-in demonstrations and, more recently, lawsuits against the Ministry of Culture.

The response of the Cuban government to what it regards as counter-revolutionary pressures and artists looking for international publicity, has been to prohibit independent cultural activities altogether and to harass the artists-activists with multiple detentions, arrests and even prison time – Alcántara has been arrested on dozens of occasions, sometimes disappearing for extended periods. He is emphatic that his protest actions are not performances, but acts of non-violent resistance, however, they have a strong performative quality that adds to their poignancy. Other than the human-rights issues involved, which have been condemned by organizations such as Amnesty International, the story of art in revolutionary Cuba illustrates that there needs to be a measure of freedom for the art world to thrive and the future of contemporary art in Cuba may well depend on whether a resolution is found to the present impasse.

In the rest of the Caribbean, artists can tackle difficult subjects such as race, class, gender and sexuality without major official repercussions, although there are still few open conversations on matters of sexuality and gender because of conservative social pressures. Much of the work that has been recently produced is, however, committed to telling the untold stories of the Caribbean experience and is consequently richly allusive, technically and conceptually sophisticated, and open to multiple readings and interpretations.

Raquel Paiewonsky (b. 1976), from the Dominican Republic, is focused on women's rights and the politics of the female body and its representation. Her *Guardarropía* (Wardrobe) (2010) series, for instance, explores, as she puts it, 'the highly questionable circumstances surrounding the personal freedoms of women in the Dominican Republic, where different forms of violence, the denial of basic rights and an absurdly biased

186

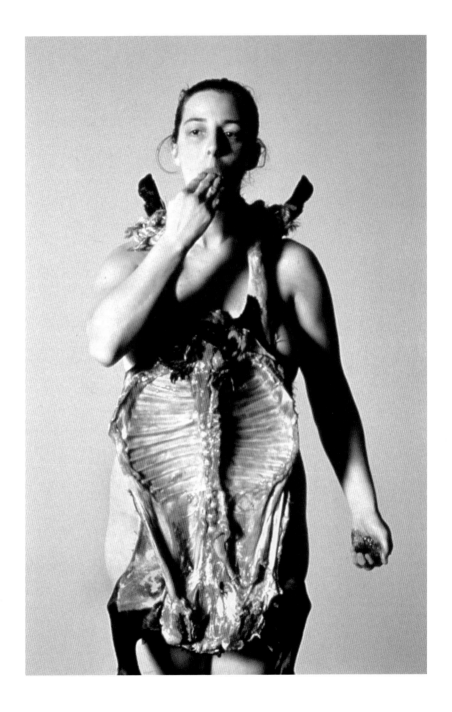

185 Tania Bruguera, *The Burden of Guilt*, 1999

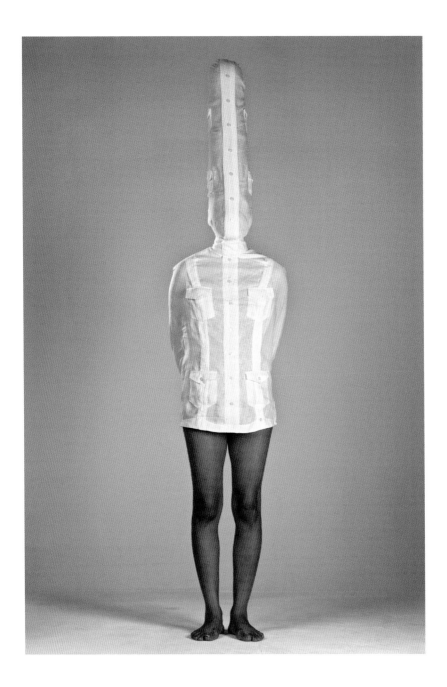

186 ABOVE Raquel Paiewonsky, *Contenedor de ideas* (*Ideas Container*) from the series *Guardarropía* (*Wardrobe*), 2010
187 OPPOSITE Ewan Atkinson, *Posters 3 and 6* from the *Only in Our Imagination* series, 2015, part of *The Neighbourhood Project*

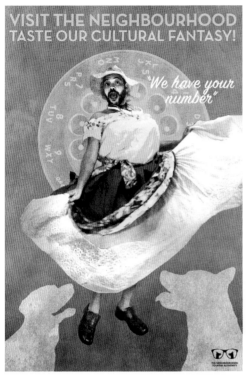

legislation perpetuate negative gender attitudes'. The series
consists of a series of sculptural dresses that embody these
issues and are photographed as 'performed' by various
models – the dresses themselves and the photographs are
both part of the project.

187 *The Neighbourhood Project* (2006–ongoing) by the Barbadian
artist Ewan Atkinson (b. 1975) maps out a fictional community
with its own website, promotional posters, news broadcasts
and even its own visa application system. Atkinson studies
this community, and his place therein, as a quasi-ethnographer
and auditor, unearthing significant personages, strange
sightings, artefacts, locations and histories in the process.
As he puts it, 'The Neighbourhood is a strangely comfortable
place, frustratingly cryptic and yet delightfully transparent
all at once.' There are indeed clear allusions to the artist's
identity, as a light-skinned, queer, middle-class man, in
small, socially conservative but tourism-oriented Barbados,
with its contradictory dynamics of ownership, belonging,
welcoming and exclusion.

The paintings, drawings, animations and performance work of Sheena Rose (b. 1986), who is also from Barbados, are similarly preoccupied with community and autobiography, and her own place in the class, racial and gender constructs that shape contemporary Barbados society. Her ongoing *Sweet Gossip* (2013) series, for instance, draws from the local pop culture and modern black visual culture to speak about social prejudices and peer pressures, as well as personal insecurities and trauma, in a frank but subtly humorous manner and relatable 'Pop art' style.

188

The Jamaican painter Phillip Thomas (b. 1980) also tackles the vexing connection between race and class in the postcolonial Caribbean, its intersections with sexual politics, colonial histories and, for that matter, fashion and style. His large triptych *Pimper's Paradise – The Terra Nova Nights Edition* (2019) offers a multi-layered, ironic panorama of the foibles of a social world that is inhabited by the very same Caribbean patron class that supports the sort of art he produces. Thomas's work also illustrates that representational, figure-based painting remains a major medium in the contemporary art of the Caribbean.

189

Ebony G. Patterson, who lives between Jamaica and Chicago, explores the politics of social and cultural visibility and invisibility, tapping into the over-the-top 'bling' culture of Jamaican dancehall, exploring how those who are socially marginalized have claimed a powerful but controversial cultural visibility that defies class-driven notions of good taste as well as gender norms. While she is better known for her mixed-media installations and embellished tapestries, her *Three King's Weep* (2018) video installation is particularly instructive. It shows three young black men who are solemnly putting on extravagant dancehall style clothes and jewellery, as if preparing for a funeral, with Claude McKay's famous poem 'If We Must Die' (1919) read at the end. Shown in reverse and slowed-down, projected to superhuman size in a chapel-like enclosure, with the men appearing to undress to the point of naked vulnerability, the work movingly foregrounds the humanity behind the spectacle of fashion and style, as well as the untold human losses arising from the various types of violence that affect black communities.

190

The question of human vulnerability and resilience is also central to the work of Kishan Munroe (b. 1980), a painter, photographer and cultural researcher from the Bahamas. His more recent work is presented under the collective title of *The Universal Human Experience* (2008–ongoing), a series of actual and metaphorical expeditions and research projects into the border disputes, illegal migrations and climate disasters that

188 Sheena Rose, *Too Much Makeup II*, from *The Sweet Gossip* series, 2013

189 Phillip Thomas, *Pimper's Paradise – The Terra Nova Nights Edition*, 2019

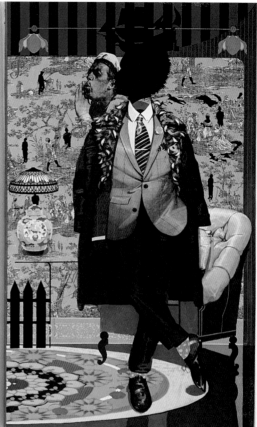

characterize the modern Caribbean experience. For his
Drifter in Residence (2018–ongoing), a project for which he has
constructed a sea-worthy raft, christened *The Diaspora*, he
plans to throw himself at the mercy of the sea in the waters
around the Bahamas that have, in recent history, been traversed
by thousands of illegal migrants from Haiti and Cuba, often
disastrously, thus experiencing first-hand what is barely
acknowledged in the news reports of such instances.

Finally, the Haitian artist Tessa Mars, the youngest artist
discussed in this book, challenges the gender biases and
exclusions of the official narratives on the Haitian Revolution
and more recent developments in Haitian society and culture.
She subversively inserts herself into these narratives through
her personal avatar Tessalines – a play on her own name and
the revolutionary leader Jean-Jacques Dessalines – to examine
what are ultimately questions of collective and individual
identity. Her deliberately open-ended approach to this quest
reminds us that the new identity politics of the Caribbean
are not about definitive answers but about probing and
acknowledging the elusive, and in many ways unanswerable,
questions that shape Caribbean life.

While these examples illustrate the health and maturity
of the contemporary Caribbean art scene, new problems and
critical questions are arising. Despite their anti-canonical
aspirations, the most successful contemporary artists
have rapidly become the new, internationally supported
establishment and power brokers of the Caribbean art

190 Ebony G. Patterson, still from *Three Kings Weep*, 2018

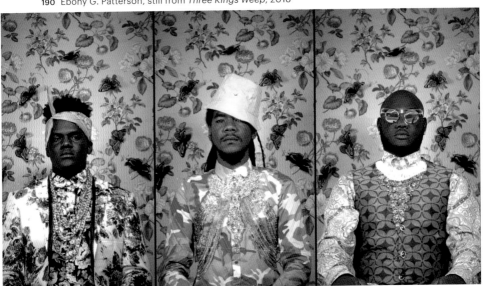

191 Kishan Munroe, photograph from *Drifter in Residence*, 2018–ongoing

world, leading to fresh areas of exclusion where creative and intellectual dialogues and solidarity across generations and genres could have been more productive – there is bitterness on that count among some of the older artists and others who have pursued different directions. A lot of the contemporary art furthermore operates in disconnect from the societies in and about which it is created and, at its worst, the contemporary Caribbean art world is one which primarily talks to itself and to receptive foreign curators, writers, collectors and audiences. This sometimes involves performing new kinds of Caribbeanness that are just as reductive as the cultural stereotypes and labels that have been challenged by the contemporary artists.

The present global cultural moment, with its demands for racial and social justice and decolonizing of the cultural sector, is however indebted to conversations in which artists from the Caribbean have often played pioneering roles. This is, for instance, illustrated by the globally influential work in film of the Haitian director Raoul Peck (b. 1953) and the British director Steve McQueen (b. 1969), who is of Trinidadian and Grenadian parentage. It is also remarkable that three black women of Caribbean heritage have been selected to represent western metropolitan countries in the 59th Venice Biennale in 2022 – Simone Leigh (b. 1967), who is of Jamaican parentage,

will represent the United States; Sonia Boyce, whose family is from Barbados and Guyana, will represent Britain; and Alberta Whittle (b. 1980), who was born in Barbados, will represent Scotland.

It begins to appear that, at least where art is concerned, the Caribbean is no longer seen – and, more importantly, no longer sees itself – as a grudging cultural dependency or exotic other but as a fully fledged part of the current global cultural conversations, with voices that are increasingly heard on their own terms. It therefore seems appropriate to end the second edition of this book with a work by Richard Mark Rawlins (b. 1967), an artist and graphic designer from Trinidad who explores the visual and social histories that have led to the present cultural moment. In his *Empowerment*, from the *I Am Sugar* Series (2018) – a digitally manipulated photograph – a Black Power fist rises from a delicate antique English teacup, an eloquent visual representation of the momentous, if contested, cultural changes that are taking place globally.

192 BELOW Tessa Mars, *Dreaming the Ancestors – Sa m konnen, sa m pa konnen*, 2017
193 OPPOSITE Richard Mark Rawlins, *Empowerment*, from the *I Am Sugar* series, 2018

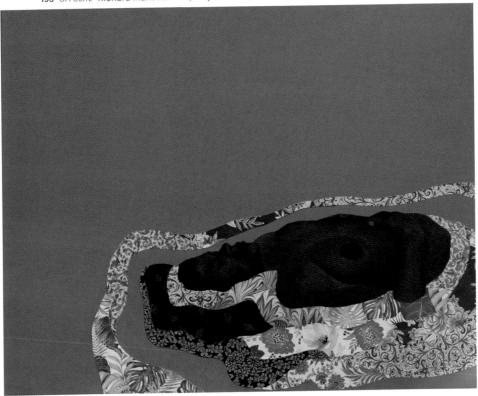

Bibliography

General: Art

Acha, Juan, et al., *Plastica del Caribe*, Havana: Letras Cubanas, 1989

Ades, Dawn, ed., *Art in Latin America: The Modern Era, 1820–1980*, exh. cat., London: Hayward Gallery, 1989

Anderson, Kat and Evelyn, Graeme, *Jamaican Pulse: Art and Politics from Jamaica and the Diaspora*, Bristol: Royal West of England Academy, 2016

Angel, Felix, *Three Moments in Jamaican Art*, Washington, DC: Inter-American Development Bank Cultural Center, 1997

Archer, Melanie, and Mariel Brown, eds, *A to Z of Caribbean Art*, Port of Spain: Robert and Christopher, 2019

Archer-Straw, Petrine, et al., *New World Imagery: Contemporary Jamaican Art*, exh. cat., London: The South Bank Centre, 1995

Archer-Straw, Petrine, and Kim Robinson, *Jamaican Art*, Kingston: Kingston Publishers, 1989

Barson, Tanya, et al., *Afro-Modern: Journeys Through the Black Atlantic*, London: Tate, 2010

Binnendijk, Chandra van, and Peter Faber, *Twintig jaar beeldende kunst in Suriname/ Twenty Years of Visual Art in Suriname*, exh. cat., Paramaribo: Stichting Surinaams Instituut, 1995

Blackwood, Lisa, and Liliana Gómez, *Liquid Ecologies in Latin American and Caribban Art*, London: Routledge, 2020

Boxer, David, *Jamaican Art 1922–1982*, exh. cat., Washington: S.I.T.E.S. and National Gallery of Jamaica, 1983

Boxer, David, and Veerle Poupeye, *Modern Jamaican Art*, Kingston: Ian Randle and UWI Development and Endowment Fund, 1998

Cancel, Luis, et al., *The Latin American Spirit: Art and Artists in the United States 1920–1970*, exh. cat., New York: The Bronx Museum of the Arts and Harry N. Abrams, 1988

Caribart: Contemporary Art of the Caribbean, exh. cat., Curaçao: UNESCO, 1993

Caribbean Art Now, exh. cat., London: Commonwealth Institute, 1986

Cervantes, Miguel, ed., *Myth and Magic in America: The Eighties*, exh. cat., Monterrey, Mexico: Museo de Arte Contempóranea de Monterrey, 1991

Chang, Alexandra, *Circles and Circuits: Chinese Caribbean Art*, Durham: Duke University Press, 2018

Christensen, Eleanor Ingalls, *The Art of Haiti*, New York: S. A. Barnes, 1971

Cullen, Deborah, and Elvis Fuentes, eds, *Caribbean: Art at the Crossroads of the World*, exh. cat., New Haven: Yale University Press, 2012

Cummins, Alissandra, et al., *Art in Barbados: What Kind of Mirror Image*, Kingston: Ian Randle, 1999

Damian, Carol, *Contemporary Expressions of Haitian Art*, exh. cat., Miami: Haitian Cultural Arts Alliance, 1995

Dávila, Arlene, *Latinx Art: Artists, Markets, and Politics*, Durham: Duke University Press, 2020

Delgado Mercado, Osiris, 'Artes plasticas: Historia de la Pintura in Puerto Rico', in *La Gran Enciclopedia de Puerto Rico*, vol. 8, Madrid: Forma Gráfica, 1976

Fraunhar, Alison, *Mulata Nation: Visualizing Race and Gender in Cuba*, Jackson: University of Mississippi Press, 2018

Frohnapfel, David, *Alleviative Objects: Intersectional Entanglement and Progressive Racism in Caribbean Art*, New Rockford: Transcript, 2021 (in publication)

Glinton, Patricia, et al., *Bahamian Art 1492–1992*, Nassau: The Counsellors, 1992

Juan, Adelaida de, *Pintura Cubana: Temas y Variaciones*, Havana: Letras Cubanas, 1978

Juan, Adelaida de, *Mas Alla de la Pintura*, Havana: Letras Cubanas, 1993

La Habana: Salas del Museo Nacional de Cuba – Palacio de Bellas Artes, catalogue, Havana: Letras Cubanas, 1990

Lawrence, Wayne, *A Celebration of Jamaican Art*, Kingston: Jamaican Artists and Craftsmen Guild, 2002

Lawrence, Wayne, *Art of Jamaica: A Prelude*, Bloomington and Kingston: Trafford and Jamaica Guild of Artists, 2010

Lerebours, Michel Philippe, *Haiti et Ses Peintres – de 1804 à 1980*, 2 vols, Port-au-Prince, Haiti: L'Imprimeur II, 1989

Lewis, Samella, et al., *Caribbean Visions*, exh. cat., Alexandria, Virginia: Art Services International, 1995

Lucie-Smith, Edward, *Latin American Art of the 20th Century*, London and New York: Thames & Hudson, 1993

MacLean, Geoffrey, *Contemporary Painting – Trinidad and Tobago: Leroy Clarke, Isaiah James Boodhoo, Kenwyn Crichlow, Emheyo Bahabba*, exh. cat., London: October Gallery, 1992

Miller, Jeannette, *Historia de la Pintura Dominicana*, Santo Domingo: Amigos del Hogar, 1979

Mosquera, Gerardo, *Exploraciones en la Plástica Cubana*, Havana: Letras Cubanas, 1983

Mosquera, Gerardo, 'Africa in the Art of Latin America', *Art Journal*, no. 51, Winter 1992, pp. 30–38

Nadal-Gardère, Marie-José, and Gérald Bloncourt, *La Peinture Haïtienne/Haitian Arts*, Paris: Editions Nathan, 1986

Nunley, John, and Judith Bettelheim, *Caribbean Festival Arts*, Seattle: University of Washington Press, 1988

Ové, Zak, et al., *Get Up, Stand Up Now*, exh. cat., London: Somerset House, 1991

Poupeye, Veerle, *Contemporary Jamaican Art, circa 1962/circa 2012*, exh. cat., Mississauga: Art Gallery of Mississauga, 2012

Powell, Richard, *Black Art and Culture of the 20th Century*, London and New York: Thames & Hudson, 2003, first published 1997

Ramírez, Mari Carmen, *Puerto Rican Painting Between Past and Present*, exh. cat., Princeton: The Squibb Gallery, 1987

Rasmussen, Waldo, ed., *Latin American Artists of the Twentieth Century*, exh. cat., New York: The Museum of Modern Art, 1993

Rozelle, Robert, ed., et al., *Black Art: Ancestral Legacy. The African Impulse in African-American Art*, exh. cat., Dallas: Dallas Museum of Art, 1989

Santos, Danilo de los, *La Pintura en la Sociedad Dominicana*, Santiago, Dominican Republic: Universidad Católica Madre y Maestra, 1978

Stratton, Suzanne, ed., Elizabeth Ferrer and Edward Sullivan, *Modern and Contemporary Art of the Dominican Republic*, exh. cat., New York: Americas Society and The Spanish Institute, 1996

Sullivan, Edward, ed., *Latin American Art of the Twentieth Century*, London: Phaidon, 1997

Tancons, Claire and Krista Thompson, eds, *EN MAS': Carnival and Performance Art of the Caribbean*, New Orleans: Independent Curators International and Contemporary Art Center, 2016

Taylor, René, et al., *Colección de Arte Latinoamericano/Latinamerican Art Collection*, Museo de Arte de Ponce, Fundación Luis A. Ferré, 1994

Urquhart, Natalie, *The Art of the Cayman Islands: A Journey through the National Gallery Collection*, National Gallery of the Cayman Islands, 2016

Walmsley, Anne and Stanley Greaves, *Art in the Caribbean: An Introduction*, London: New Beacon, 2010

Wood, Yolanda, *De la Plastica Cubana y Caribeña*, Havana: Letras Cubanas, 1990

The following specialized journals frequently contain articles on Caribbean art and related subjects: *ARC Magazine: Contemporary Caribbean Visual Art* (St Vincent, 2011–15, continued publication online at arcthemagazine.com which is now maintained as an archive), *Anales del Caribe* (Cuba), *Art Nexus* (Colombia, published in Spanish and English), *Caribbean Quarterly* (Jamaica), *Conjonction* (Haiti), *Jamaica Journal* (Jamaica), *Interviewing the Caribbean* (Jamaica), *Small Axe* (USA, the journal's online platforms SX Salon and SX Visualities can be accessed on its website, smallaxe.net), *Representing Artists* (1993–95, digital copies are available at: https://freshmilkbarbados.com/projects/ra-representing-artists/), *Revolución y Cultura* (Cuba), *Revue Noire* (France, 1991–2001), *Ten.8* (Britain), *Third Text* (Britain). Several online magazines and blogs also published on Caribbean art: *Aica-SC* (Martinique, aica-sc.net), *Faire Mondes* (Martinique, fairemondes.com), *PREE* (Jamaica, preelit.com), *Repeating Islands* (USA, repeatingislands.com) and *'El Cuarto del Quenepón'* (Puerto Rico, 1994–2005). The in-flight magazine of the Trinidadian airline BWIA, *Caribbean Beat*, frequently contains useful articles on art from the English-speaking

Caribbean. Many Caribbean artists, artists' estates and cultural organizations have their own websites and blogs.

General: History, Culture, Ideas

Barrett, Leonard, *The Rastafarians: The Dreadlocks of Jamaica*, Kingston: Sangster's and Heinemann, 1977

Benítez-Rojo, Antonio, *The Repeating Island: The Caribbean and the Postmodern Perspective*, Durham and London: Duke University, 1992

Bernabé, Jean, Patrick Chamoiseau, and Raphaël Confiant, *Eloge de la Créolité*, Paris: Gallimard/ Presses Universitaires Créoles, 1989

Brathwaite, Kamau, Contradictory Omens: *Cultural Diversity and Integration in the Caribbean*, Mona, Jamaica: Savacou Publications, 1974

Césaire, Aimé, *Discourse on Colonialism*, New York: Monthly Review Press, 1972, first published 1955

Césaire, Suzanne, *The Great Camouflage: Writings of Dissent (1941–1945)*, Middletown: Wesleyan University Press, 2012

Chevannes, Barry, *Rastafari: Roots and Ideology*, Syracuse: Syracuse University Press, 1995

Clarke, John Henrik, ed., *Marcus Garvey and the Vision of Africa*, New York: Vintage Books, 1974

Cliff, Michelle, *If I Could Write This in Fire*, Minneapolis: University of Minnesota Press, 2008

Dabydeen, David, and B. Samaroo, eds, *India in the Caribbean*, London: Hansib, 1987

Dash, J. Michael, *The Other America: Caribbean Literature in a New World Context*, Charlottesville: University of Virginia Press, 1998

Fanon, Frantz, *Black Skin, White Masks*, New York: Grove Weidenfeld, 1967, first published 1952

Fanon, Frantz, *The Wretched of the Earth*, Harmondsworth: Penguin, 1970, first published 1961

Gilroy, Paul, *'There Ain't No Black in the Union Jack': The Cultural Politics of Race and Nation*, Chicago: University of Chicago Press, 1991

Glissant, Edouard, *Caribbean Discourse*, Charlottesville: University of Virginia Press, 1989, first published 1981

Glissant, Edouard, *Poetics of Relation*, Ann Arbor: University of Michigan Press, 1997

Hall, Stuart, *Selected Writings on Race and Difference*, Paul Gilroy & Ruth Wilson, eds, Durham: Duke University Press, 2021 (in publication)

Harris, Wilson, *History, Fable & Myth in the Caribbean and Guianas*, Wellesley, Massachusetts: Calaloux Publications, 1995, first published 1970

Horowitz, Michael, ed., *Peoples and Cultures of the Caribbean: An Anthropological Reader*, Garden City, New York: Natural History Press, 1971

James, C.L.R., *The Future in the Present: Selected Writings*, London: Allison & Busby, 1977

James, C.L.R., *Beyond a Boundary*, London: Hutchinson, 1963

James, C.L.R., *The Black Jacobins: Toussaint L'Ouverture and the San Domingo Revolution*, London: Allison & Busby, 1980, first published 1938

Knight, Franklin, *The Caribbean: The Genesis of a Fragmented Nationalism*, Oxford: Oxford University Press, 1978

Lewis, Gordon, *Main Currents in Caribbean Thought*, Baltimore: Johns Hopkins University Press, 1983

Lorde, Audre and Roxanne Gay, *The Selected Works of Audre Lorde*, New York: W.W. Norton & Co, 2020

Métraux, Alfred, *Le Vaudou Haïtien*, Paris: Gallimard, 1958

Naipaul, V.S., *The Middle Passage*, London: Macmillan, 1963

Nettleford, Rex, *Mirror, Mirror: Indentity, Race and Protest in Jamaica*, New York: William Morrow, 1972, first published 1970

Nettleford, Rex, *Caribbean Cultural Identity – The Case of Jamaica: An Essay in Cultural Dynamics*, Kingston: Institute of Jamaica Publications, 1978

Nettleford, Rex, *Inward Stretch, Outward Reach: A Voice from the Caribbean*, Basingstoke: Macmillan, 1993

Seaga, Edward, 'Revival Cults in Jamaica', *Jamaica Journal*, 3/2, June 1969

Simpson, George Eaton, *Religions, Cults of the Caribbean: Trinidad, Jamaica and Haiti*, San Juan: Institute of Caribbean Studies, University of Puerto Rico, 1970

Smith, M.G., *Plural Society in the British West Indies*, Berkeley: University of California Press, 1965

Thompson, Robert Farris, *Flash of the Spirit: African & Afro-American Art & Philosophy*, New York: Vintage Books, 1983

Walcott, Derek, 'The Antilles: Fragments of Epic Memory' (1992), in *The Birth of Caribbean Civilisation: A Century of Ideas About Culture and Identity, Nation and Society*, Nigel Bolland, ed., Kingston: Ian Randle, 2004, pp. 593–606

Williams, Eric, *Capitalism and Slavery*, London: André Deutsch, 1964

Williams, Eric, *From Columbus to Castro: The History of the Caribbean 1492–1969*, New York: Vintage Books, 1984, first published 1970

Introduction

Alvarez, Lupe, *Flavio Garciandía: Una visita al museo de Arte Tropical*, exh. cat., Havana: Museo Nacional, Palacio de Bellas Artes, 1995

Barringer, Tim, Gillian Forrester, and Barbaro Martinez-Ruiz, eds, *Art and Emancipation in Jamaica: Isaac Mendes Belisario and His Worlds*, New Haven: Yale Centre for British Art & Yale University Press, 2007

Boxer, David, and Rex Nettleford, *The Intuitive Eye*, exh. cat., Kingston: National Gallery of Jamaica, 1979

Briend, Christian, *Hervé Télémaque*, exh. cat., Martinique: Fondation Clément, 2016

Fouchet, Max-Pol, *Wifredo Lam*, Barcelona: Polígrafa, 1976

'Hervé Télémaque', in the catalogue of the permanent collection of the Fonds Régional d'Art Contemporain de Martinique, Fort de France

Marshall, Richard, *Jean-Michel Basquiat*, exh. cat., New York: Whitney Museum of American Art, 1993

Nairne, Eleanor, and Hans Werner Holzwarth, *Jean-Michel Basquiat, 40th Anniversary Edition*, Cologne: Taschen, 2020

Ortiz, Fernando, 'La Cubanidad y los Negros', *Estudios Afrocubanos*, no. 3, 1939, pp. 3–15

Poupeye, Veerle, 'Intuitive Art as a Canon', *Small Axe*, no. 24, 2007, pp. 73–82

Thompson, Robert Farris, 'Royalty, Heroism and the Streets: the Art of Jean-Michel Basquiat', in *XXIII Bienal Internacional de São Paulo*, exh. cat., Bienal Internacional de São Paulo, Brazil, 1997

Walcott, Derek, 'The Caribbean: Culture or Mimicry?', *Journal of Interamerican Studies and World Affairs*, vol. 16, no. 1, February 1974

Yau, John, 'Please Wait by the Coatroom: Wifredo Lam in the Museum of Modern Art', *Arts Magazine*, vol. 63, no. 4, 1988, pp. 56–61

Chapter 1
Prehispanic and Colonial Art

Archer-Straw, Petrine, et al., *Photos and Phantasms: Harry Johnston's Photographs of the Caribbean*, exh. cat., Royal Geographic Society and British Council, 1998

Ayre, Michael, *The Caribbean in Sepia: A History in Photographs, 1840–1900*, Kingston: Ian Randle, 2013

Bagneris, Mia, *Colouring the Caribbean: Race and the Art of Agostino Brunias*, Manchester: Manchester University Press, 2017

Barrenechea, Francisco, et al., *Campeche – Oller – Rodón: Tres Siglos de Pintura Puertorriqueña*, exh. cat., San Juan: Instituto de Cultura Puertorriqueña, 1992

Boxer, David, *Duperly*, exh. cat., Kingston: National Gallery of Jamaica, 2001

Boxer, David, *Five Centuries of Jamaican Art*, exh. cat., Kingston: National Gallery of Jamaica, 1976

Brathwaite, Kamau, 'The Development of Creole Society in Jamaica 1770–1820', *Kingston*, vol. 9, 1972; Kingston: Ian Randle, 2005

Ebanks, Roderick, 'Ma Lou and the Afro-Jamaican Pottery Tradition', *Jamaica Journal*, vol. 17, no. 3, 1984

Fagg, William, *The Tribal Image,* London: Trustees of the British Museum, 1970

Kerchache, Jacques, ed., *L'Art Taïno*, exh. cat., Paris: Musée du Petit Palais, 1994

Haslip-Viera, Gabriel, *Taino Revival: Critical Perspectives on Puerto Rican Identity and Cultural Politics*, Princeton: Markus Wiener, 2001

Lucie-Smith, Edward, and David Boxer, *Jamaica in Black and White: Photography in Jamaica c.1845–c.1920, the David Boxer Collection*, London: Macmillan Caribbean, 2013

MacLean, Geoffrey, *Cazabon: An Illustrated Biography of Trinidad's Nineteenth Century Painter*, Port-of-Spain: Aquarela Galleries, 1986

Paintings and Prints of Barbados in the Barbados Museum, St Ann: The Barbados Museum and Historical Society, 1981

Ranston, Jackie, *Belisario – Sketches of Character: A Historical Biography of a Jamaican Artist*, Kingston: Mill Press, 2008

Rouse, Irving, *The Taínos: The Rise and Decline of the People Who Greeted Columbus*, New Haven and London: Yale University Press, 1992

Sullivan, Edward, *From San Juan to Paris and Back: Francisco Oller and Caribbean Art in the Era of Impressionism*, New Haven: Yale University Press, 2014

Thompson, Krista, *An Eye for the Tropics: Tourism, Photography, and Framing the Caribbean Picturesque*, Durham: Duke University Press, 2006

Waldron, Lawrence, *Pre-Columbian Art of the Caribbean*, Gainesville: University of Florida Press, 2019

Chapter 2
Decolonization and Creative Iconoclasm

Burch III, Lonnie, *A Fool's Errand: Creating the National Museum of African American History and Culture in the Age of Bush, Obama, and Trump*, Washington, DC: Smithsonian, 2019

Dacres, Petrina, 'An Interview with Laura Facey Cooper', *Small Axe*, no. 16, 2004, pp. 125–36

Dacres, Petrina, 'Monument and Meaning', *Small Axe*, no. 16, 2004, pp. 137–54

González, Robert, 'El concurso del Faro de Colón: Un reencuentro con el monumento olvidado de la arquitectura panamericana', *ARQ*, no. 67, December 2007, pp. 80–87

Lewis, Lesley, 'English Commemorative Sculpture in Jamaica', monograph edition of *Jamaica Historical Review*, Kingston, vol. 9, 1972

Mitchell, W.J.T., ed., *Art and the Public Sphere*, Chicago: University of Chicago Press, 1993

Poupeye, Veerle, 'Creative Iconoclasm: What To Do With Those Colonial Monuments', *Perspectives blog, Part 1*, 10 June 2020, https://veerlepoupeye.wordpress.com/2020/06/10/creative-iconoclasm-what-to-do-with-those-colonial-monuments-part-1/; *Part 2*, 10 June 2020: https://veerlepoupeye.wordpress.com/2020/06/10/creative-iconoclasm-what-to-do-with-those-colonial-monuments-part-2/

Poupeye, Veerle, 'Notes on the Columbus statues of the Caribbean', *Perspectives blog*, 19 August 2020: https://veerlepoupeye.wordpress.com/2020/08/19/notes-on-the-columbus-statues-of-the-caribbean/

Poupeye, Veerle, 'A Monument in the Public Sphere: The Controversy about Laura Facey's Redemption Song', *Jamaica Journal*, vol. 28, nos 2 & 3, 2004, pp. 36–48

Ramírez, Dixa, *Colonial Phantoms: Belonging and Refusal in the Dominican Americas, from the 19th Century to the Present*, New York: NYU Press, 2018

Sculpture and Ceremonial: Monuments to Queen Victoria, Yale Center for British Art, https://interactive.britishart.yale.edu/victoria-monuments

Statues of Christopher Columbus, Wikipedia: https://en.wikipedia.org/wiki/Category:Statues_of_Christopher_Columbus

Chapter 3
Modernism and Cultural Nationalism

Alexis, Gerald, et al., *50 Années de peinture en Haiti 1930–1950, Tome I: 1930–1959*, Port-au-Prince: Fondation culture création, 1995

Boxer, David, *Edna Manley: Sculptor*, Kingston: Edna Manley Foundation and National Gallery of Jamaica, 1990

Carpentier, Alejo, 'La Ciudad de las Columnas', *Tientos y Diferencias*, Montevideo: ARCA, 1967

Césaire, Aimé, *Return to My Native Land*, Paris: Presence Africaine, 1968, first published 1939

Colson, Jaime, *Memorias de un Pintor Trashumante: Paris 1924 – Santo Domingo 1968*, Santo Domingo: Fundación Colson, 1978

Dunkley, Cassie, 'Life of John Dunkley', *Memorial Anniversary Exhibition of the Late John Dunkley, Artist and Sculptor*, Kingston: Institute of Jamaica, 1948

Hurston, Zora Neale, *Tell My Horse: Voodoo and Life in Haiti and Jamaica*, New York: Harper and Row, 1990, first published 1938

Lucie-Smith, Edward, *Albert Huie: Father of Jamaican Painting*, Kingston: Ian Randle, 2001

MacLean, Geoffrey, *Boscoe Holder*, Port of Spain: MacLean Publishing, 1994

Manley, Norman, 'National Culture and the Artist, 1939', *Manley and the New Jamaica*, in Rex Nettleford, ed., London: Longman Caribbean, 1971, pp. 108–09

Martínez, Juan, *Cuban Art and National Identity*, Gainesville: University of Florida Press, 1994

Moody, Cynthia, 'Ronald Moody: A Man True to His Vision', *Third Text*, nos 8/9, 1989

Nawi, Diana, Nicole Smythe-Johnson and David Boxer, *John Dunkley: Neither Day Nor Night*, Munich: Delmonico Books-Prestel and Perez Art Museum Miami, 2017

Poupeye-Rammelaere, Veerle, 'Garveyism and Garvey Iconography in the Visual Arts of Jamaica', *Jamaica Journal*, Part I: 24/1, 1991, pp. 9–21; Part II: 24/2, 1992, pp. 24–33

Powell, Richard, and David A. Bailey, *Rhapsodies in Black: Art of the Harlem Renaissance*, Oakland: University of California Press, 1997

Price-Mars, Jean, *Ainsi Parla l'Oncle*, New York: Parapsychology Foundation, 1954, first published 1928

Rigol, Jorge, *Víctor Manuel*, Havana: Letras Cubanas, 1990

Rodman, Selden, *Renaissance in Haiti: Popular Painters in the Black Republic*, New York: Pellegrini and Cudahy, 1948

Sánchez, Juan, *Fidelio Ponce*, Havana: Letras Cubanas, 1985

Stokes Sims, Lowery, *Wifredo Lam and the International Avant-Garde, 1923–1982*, Austin: University of Texas Press, 2002

Thompson, Krista, '"Black Skin, Blue Eyes": Visualizing Blackness in Jamaican Art, 1922–1944', *Small Axe*, no. 16, 2004, pp. 1–31

Chapter 4
Popular Culture, Religion and the Festival Arts

Bender, Wolfgang, ed., *Rastafarian Art*, Kingston: Ian Randle, 2005

Boxer, David, ed., *Kapo: The Larry Wirth Collection*, Kingston: National Gallery of Jamaica, 1982

Boxer, David, *Fifteen Intuitives*, exh. cat., Kingston: National Gallery of Jamaica, 1989

Boxer, David, et al., *Intuitives III*, exh. cat., Kingston: National Gallery of Jamaica, 2007

Brathwaite, Edward, 'Art and Society: Kapo, a Context', in *Jamaican Folk Art*, Kingston: Institute of Jamaica, c. 1971, pp. 4–6

Browne, Kevin Adonis, *High Mass: Carnival and the Poetics of Caribbean Culture*, Jackson: University of Mississippi Press, 2018

Butcher, Pablo, *Invoking the Spirits: Haiti's Charged Murals*, exh. cat., Miami: The Haitian Cultural Arts Alliance, 1996

Celeur Jean Hérard, *Afrikanah*, 16 September 2016, https://africanah.org/celeur-jean-herard/

Chambers, Eddie, et al., *The Artpack: A History of Black Artists in Britain*, Bristol: Eddie Chambers and Tam Joseph, 1988

Cosentino, Donald, ed., *The Sacred Arts of Haitian Vodou*, exh. cat., Los Angeles: Fowler Museum of Cultural History, 1995

Duval-Carrie, Edouard, et al., *Pòtoprens: The Urban Artists of Port-au-Prince*, Brooklyn: Pioneer Works, 2021 (in publication)

Fareharson, Alex and Leah Gordon, *Kafou – Haiti, Art and Vodou*, exh. cat., Nottingham: Nottingham Contemporary, 2012

Feldman, Melissa, and Gustavo Pérez Firmat, *José Bedia: De donde Vengo*, exh. cat., Philadelphia: Institute of Contemporary Art, University of Pennsylvania, 1994

Ghetto Biennale official website, http://ghettobiennale.org/

Hernandez, Orlando, et al., *José Bedia, Carlos Capelan, Saint Clair Cemin*, Bogotà: Galeria; Fernando Quintana, 1995

Hill, Errol, *Trinidad Carnival: Mandate for a National Theatre*, Austin: University of Texas Press, 1972

Malraux, André, *La Métamorphose des Dieux: L'Intemporel*, Paris: Gallimard, 1976

Mason, Kara, ed., *From Revolution in the Tropics to Imagined Landscapes by Edouard Duval-Carrié*, Miami: Perez Art Museum, 2014

Morris, Randall, *Redemption Songs: the Self-Taught Artists of Jamaica*, exh. cat., Winston-Salem: Diggs Gallery, 1997

Morrow, Chris, *Stir It Up: Reggae Album Cover Art*, London: Thames & Hudson, 1999

Poupeye, Veerle, 'Intuitive Art as a Canon', *Small Axe*, no. 24, 2007, pp. 73–82

Poupeye, Veerle, and Wayne Cox, *Spiritual Yards: Home Ground of Jamaica's Intuitives – Selections from the Wayne and Myrene Cox Collection*, Kingston: National Gallery of Jamaica, 2016

Poupeye-Rammelaere, Veerle, 'The Rainbow Valley: The Life and Work of Brother Everald Brown', *Jamaica Journal*, vol. 21, no. 1, 1988, pp. 2–14

Poupeye, Veerle, ed., *The Rainbow Valley: Everald Brown, a Retrospective*, exh.cat., Kingston: National Gallery of Jamaica, 2004

Prézeau-Stephenson, Barbara, et al., *Tessa Mars: Ile modèle, Manman zile, Island Template*, Berlin; NAIMA and Le Centre d'Art, 2020 (also available as e-book)

Rodman, Selden, *Where Art is Joy, Haitain Art: The First Forty Years*, New York: Ruggles de Latour, 1988

Smith, M.G., Roy Augier, and Rex Nettleford, *The Rastafari Movement in Kingston, Jamaica*, Kingston: Institute of Social and Economic Research, 1960

Stebich, Ute, *Haitian Art*, exh. cat., New York: Brooklyn Museum and Harry N. Abrams, 1978

Vandenbroeck, Paul, et al., *America: Bride of the Sun*, exh. cat., Antwerpen: Koninklijk Museum voor Schone Kunsten, 1992

Williams, Sheldon, *Voodoo and the Art of Haiti*, Nottingham: Morland Lee, 1969

Chapter 5
'Dangerously Close to Tourist Art'

Graburn, Nelson, *Ethnic and Tourist Arts*, Berkeley: University of California Press, 1976

Kempadoo, Kamala, ed., *Sun, Sex and Gold*, Lanham: Rowman & Littlefield, 1999

Kincaid, Jamaica, *A Small Place*, New York: Penguin, 1988

Pattullo, Polly, *Last Resorts: The Cost of Tourism in the Caribbean*, Kingston: Ian Randle, 1996

Phillips, Ruth, and Christopher Steiner, eds, *Unpacking Culture: Art and Commodity in Colonial and Post-colonial Worlds*, Berkeley: University of California Press, 1999

Poupeye, Veerle, 'From the Archives: Dangerously Close to Tourist Art', *Perspectives blog*, 16 February 2019, https://veerlepoupeye.wordpress.com/2019/02/16/dangerously-close-to-tourist-art/

Poupeye, Veerle, 'From the Archives: 'Big Bamboo' and the Politics of Space in Fern Gully', *Perspectives blog*, 18 February 2019, https://veerlepoupeye.wordpress.com/2019/02/18/big-bamboo-and-the-politics-of-space-in-fern-gully/

Rae, Norman, 'Contemporary Jamaican Art', in *Ian Fleming Introduces Jamaica*, London: Andre Deutsch, 1965

Rodman, Selden, *The Caribbean* , New York, E.P. Dutton, 1968

Chapter 6
Political Radicalism, Abstraction and Experimental Art

Barreros del Rio, Petra, et al., *Taller Alma Boricua: Reflecting on Twenty Years of the Puerto Rican Workshop 1969–1989*, exh. cat., New York: El Museo del Barrio, 1990

Bowling, Frank, *Postscript, in The Dub Factor*, exh. cat., Bristol: Eddie Chambers, 1992

Castillo, Efraim, *Oviedo 25 Años: Trascendencia Visual de Una Historia*, Santo Domingo: Galería de Arte Moderno, 1988

Congreso de Artistas Abstractos de Puerto Rico, exh. cat., San Juan: Instituto de Cultura Puertorriqueña, 1984

Dabydeen, David, ed., *Martin Carter: Selected Poems*, Leeds: Peepal Tree Press, 1999

Darié, Sandú, *El Mundo Nuevo de los Cuadros de Carreño*, exh. cat., Havana: Instituto Nacional de Cultura, Palacio de Bellas Artes, 1957

Fernández Retamar, Roberto, *Raúl Martínez: El Desafío de los Sesenta*, exh. cat., Havana: Museo Nacional, Palacio de Bellas Artes, 1995

Frente: Movimiento de Renovación Social de Arte, exh. cat., San Juan: Instituto de Cultura Puertorriqueña, 1978

Goldman, Shifra, *Dimensions of the Americas: Art and Social Change in Latin America and the United States*, Chicago: University of Chicago Press, 1994

Juan, Adelaida de, *Pintura Cubana: Temas y Variaciones*, Havana: Letras Cubanas, 1978

Lee, Simon, 'Warrior Art', *Caribbean Beat*, Autumn 1995, pp. 50–56

López Oliva, Manuel, et al., *Luis Martínez Pedro: Exposicion Retrospectiva*, exh. cat., Havana: Museo Nacional, Palacio de Bellas Artes, 1987

Mennekes, Friedhelm, *Luis Cruz Azaceta*, exh. cat., Köln: Kunst-Station Sankt Peter, 1988

Merewether, Charles, *Edouard Duval-Carrié*, exh. cat., Monterrey, Mexico: Ediciones MARCO, 1992

Mosquera, Gerardo, et al., *Nosotros: Exposición Antológica Raúl Martínez*, exh. cat., Havana: Museo Nacional, Palacio de Bellas Artes, 1988

Poupeye, Veerle, 'What Times Are These? Visual Art and Social Crisis in Postcolonial Jamaica', *Small Axe*, no. 29, 2009, pp. 164–84

Rivera Rosario, Nelson, et al., *Antonio Martorell: Obra Gráfica 1963–1986*, exh. cat., San Juan: Museo de Arte de Puerto Rico, La Casa del Libro and Instituto de Cultura Puertorriqueña, 1986

Roopnaraine, Rupert, et al., *Caribbean Metaphysic: Another Reality. An Exhibition of Mini Paintings of Stanley Greaves*, exh. cat., Bridgetown: Queen's Park Gallery, 1993

Smith-McCrea, Rosalie, *Eugene Hyde: A Retrospective*, exh. cat., Kingston: National Gallery of Jamaica, 1984

Stermer, Dugald, and Susan Sontag, *The Art of Revolution: Castro's Cuba: 1959–1970*, New York: McGraw-Hill, 1970

Tió, Teresa*, El cartel en Puerto Rico: 1946–1985*, exh. cat., Río Piedras: Museo de la Universidad de Puerto Rico, 1985

Tió, Teresa, *El Portafolios en la Gráfica Puertorriqueña*, exh. cat., San Juan: Museo de las Américas, 1995

Tolentino, Marianne de, *Luis Hernandez Cruz: Tiempos y Formas de un Itinerario Artistico*, San Juan: Publicaciones Puertorriqueñas, 1989

Traba, Marta, *Propuesta Polémica sobre Arte Puertorriqueño*, San Juan: Ediciones Librería Internacional, 1971

Walmsley, Anne, *The Caribbean Artists Movement 1966–1972: A Literary and Cultural History*, London and Port of Spain: New Beacon Books, 1992

Williams, Eric, *Inward Hunger: the Education of a Prime Minister*, London: André Deutsch, 1969

Chapter 7
The Land, the Sea and the Environment

Brebion, Dominique, and Octavio Zaya, *XXIIIè Biennale de Sao Paulo Bresil: Marc Latamie*, exh. cat., Fort-de-France: DRAC, 1996

Constantine, David, ed., *The Collected Poems of Bertolt Brecht*, New York: Liveright, 2018

Crippa, Elena, *Frank Bowling*, London: Tate, 2019

Enwezor, Okwui, et al., *Frank Bowling: Mappa Mundi*, Munich: Prestel, 2017

Gayford, Martin, et al., *Frank Bowling on through the Century*, exh. cat., Bristol: Eddie Chambers, 1996

Gattani, Francesco, *Swamping the Country: Ingrid Pollard's Cartography of Englishness*, papers of the Black Arts in Contemporary Britain conference at the Università degli Studi di Padova, 14–16 January 2010

Gooding, Mel, 'Grace Abounding: Bowling's Progress', *Third Text*, no. 31, Summer 1995, pp. 37–46

Gooding Mel, and Frank Bowling, *Frank Bowling*, London: Royal Academy of Arts, 2021 (in publication)

Moreno, Maria Luisa, and Marimar Benítez, *Jaime Suarez: Ceramica 1975–1985*, exh. cat., Ponce: Museo de Arte de Ponce, 1985

Norrie, Jean, and Petrine Archer Straw, *Eugene Palmer*, exh. cat., Bristol: Eddie Chambers, 1993

Ostrander, Tobias, *Ebony G. Patterson:...while the dew is still on the roses...*, Munich: Prestel, 2019

Perreault, John, and Petra Barreras del Rio, *Ana Mendieta Sculpture*, exh. cat., New York: New Museum of Contemporary Art, 1987

Poupeye, Veerle, 'Trading Across the Black Atlantic: Globalization and the Work of Marc Latamie', *Australian and New Zealand Journal of Art*, vol. 3, no. 2, 2003, pp. 77–102

Poupeye, Veerle, et al., *We Have Met Before: Graham Fagen, Leasho Johnson, Joscelyn Gardner, Ingrid Pollard*, exh. cat., Kingston: British Council and National Gallery of Jamaica, 2017, e-publication: https://caribbean.britishcouncil.org/programmes/arts/visualarts/we-have-met-art-exhibition-national-gallery-jamaica.

Senior, Olive, *Gardening in the Tropics*, Toronto: Insomniac, 2009

Urquhart, Natalie, et al., *Bendel Hydes – A Retrospective*, exh. cat., Grand Cayman: National Gallery of the Cayman Islands, 2019

Walcott, Derek, *The Star-Apple Kingdom*, New York: Farrar, Straus, and Giroux, 1979

Walmsley, Anne, ed., *Guyana Dreaming: The Art of Aubrey Williams*, Aarhus, Denmark: Dangaroo Press, 1990

Chapter 8
The Personal and the Political

Benítez, Marimar, et al., *Carlos Collazo Mattei: Whatever*, exh. cat., San Juan: Liga de Arte de San Juan

Bleckner, Ross, 'Interview with Felix Gonzalez-Torres', *Bomb Magazine*, no. 51, April 1, 1995, e-publication: https://bombmagazine.org/articles/felix-gonzalez-torres/

Césaire, Aimé, 'Corps Perdu', in *Œuvres Completes, vol. 1 Poèmes,* Fort-de-France: Désormeaux, 1976, p. 278, first published 1950

Césaire, Aimé, 'Dit d'Errance', in *Œuvres complètes, vol. 1 Poèmes*, Fort-de-France, Martinique: Désormeaux, 1976, p. 278, first published 1950

Daguillard, Fritz, et al., *Patrick Vilaire: Réflexion sur la Mort*, Port-au-Prince: Fondation Afrique en Créations, 1994

Frerot, Christine, *José Garcia Cordero: Gardens of Delírium*, exh. cat., Coral Gables: Lumbreras-Fisher Fine Art, 1994

García Gutiérrez, Enrique, *Arnaldo Roche Rabell: Fuegos*, exh. cat., Santurce, Puerto Rico: Museo de Arte Contemporáneo, 1993

Perodin Jérôme, Mireille, et al., *Jean-René Jérôme Rétrospective II*, exh. cat., Port-au-Prince: Musée d'Art Haitien, 1992

Pogolotti, Graziella, *Angel Acosta León*, exh. cat., Havana: Museo Nacional, Palacio de Bellas Artes, 1991

Powell, Richard, et al., *Keith Morrison: Recent Paintings*, exh. cat., New York: Alternative Museum, 1990

Poupeye, Veerle, ed., *Barrington: A Retrospective*, exh. cat., Kingston: National Gallery of Jamaica, 2012

Roopnaraine, Rupert, and Alison Thompson, *Retentions and Redemptions: Recent Paintings of Ras Akyem-I Ramsay*, exh. cat., Bridgetown: Mervyn Awon, 1995

Traba, Marta, and Marimar Benítez, *Myrna Báez: Diez Años de Gráfica y Pintura 1971–1981*, exh. cat., New York: El Museo del Barrio, 1982

Tibol, Raquel, et al., *Tres Decadas Gráficas de Myrna Báez 1958–1988*, exh. cat., San Juan: Museo de Arte de Puerto Rico and Instituto de Cultura Puertorriqueña, 1988

Chapter 9
The Caribbean Contemporary

Araeen, Rasheed, *The Other Story: Afro-Asian Artists in Post-War Britain*, exh. cat., London: South Bank Centre, 1989

Bailey, David A., et al., *Mirage: Enigmas of Race, Difference and Desire*, exh. cat., London: Institute of Contemporary Arts and Institute of International Visual Arts, 1995

Bienal de la Habana catalogues, Havana: Centro Wifredo Lam, 1984, 1986, 1989, 1991, 1994, 1997, 2000, 2003, 2006, 2009, 2012, 2015, 2019

Block, Holly, *Art Cuba: The New Generation*, New York: Harry N. Abrams, 2001

Bocquet, Pierre, ed., *1492/1992 Un Nouveau regard sur les Caraïbes*, exh. cat., Paris: Creolarts, 1992

Borras, Maria Lluïsa, et al., *Cuba Siglo XX: Modernidad y Sincretismo*, exh. cat., Las Palmas de Gran Canaria: Centro atlántico de arte moderno, 1996

Camnitzer, Luis, *New Art of Cuba*, Austin Texas University Press, 2003 (2nd revised edition, first published 1994)

Carrion-Murayari, Gary and Massimiliano Gioni, eds, *Nari Ward: We the People*, London: Phaidon, 2019

Chambers, Eddie, *Black Artists in British Art: A History Since the 1950s*, London: I.B. Tauris, 2014

Chambers, Eddie, *Roots & Culture: Cultural Politics in the Making of Black Britain*, London I.B. Tauris, 2017

Cozier, Christopher, and Tatiana Flores, *Wrestling with the Image: Caribbean Interventions*, exh. cat., Washington, DC: Art Museum of the Americas, 2011

Enright, Robert, 'The Beautiful Trap: Janine Antoni's Body Art', *Border Crossings*, vol. 3, no. 113, March 2010, https://bordercrossingsmag.com/article/the-beautiful-trap-janine-antonis-body-art

Fernandez, Antonio Eligio, et al., *New Art from Cuba*, exh. cat., London: Whitechapel Gallery, 1995

Flores, Tatiana, and Michelle Ann Stephens, eds, *Relational Undercurrents: Contemporary Art of the Caribbean Archipelago*, Durham: Duke University Press, 2017

Ford-Smith, Honor, 'Chewing on the Mix: Creolization, power and art', lecture, in *The Mix: Conversations on Creolization and Artist-Community Collaboration*, Toronto: A Space Gallery, 2003

Fusco, Coco, *Artists in Cuba Spearhead First Major Protest in Decades*, NACLA, 14 December 2020

Fusco, Coco, *The Right to Have Rights: A New "Artivist" Movement Demands Freedom of Expression in Cuba*, 23 December 2020

Garrido Castellano, Carlos, *Beyond Representation in Contemporary Caribbean Art: Space, Politics, and the Public Sphere*, New Brunswick NJ: Rutgers University Press, 2019

Gibbons, Sean, *Renee Cox: Raje, A Superhero, The Beginning of a Bold New Era*, exh. cat., New York: Christine Rose Gallery, 1998

Hall, Stuart, 'Reconstruction Work', *Ten*, vol. 8, nos 2/3, Spring 1992, pp. 106–13

Jimenez-Muñoz, Gladys, *Rican/Structed Realities: Confronted Evidence. New Paintings and Prints by Juan Sanchez*, exh. cat., Binghamton, New York: University Art Museum, 1991

Karaibische Kunst Heute, exh. cat., Kassel: Projektgruppe Stoffwechsel, 1994

Kaspersen-Hachity, Therese, *The Making of a Caribbean Avant-Garde: Postmodernism as Postnationalism*, West Lafayette: Purdue University Press, 2020

Kréyol Factory: Des artistes Interrogent les indentités créoles, exh. cat., Paris: Gallimard, 2009

Lenz, Iris, *Marcos Lora Read*, exh. cat., Bonn: Institut für Auslandsbeziehungen, 1995

Malbert, Roger, et al., *In Fusion: New European Art*, exh. cat., London: The South Bank Centre, 1993

Marcel Pinas: Artist, More Than an Artist, exh. cat., Paramaribo, Jap Sam, 2011

Mercer, Valerie, *From the Studio: Artists-in-Residence 1992–1993, Bob Rivera, Michelle Talibah, Nari Ward*, exh. cat., New York: The Studio Museum in Harlem, 1993

Mosaka, Tumelo, et al., *Infinite Island: Contemporary Caribbean Art*, exh. cat., London: Phillip Wilson and Brooklyn Museum, 2007

Mosquera, Gerardo, *Los Hijos de Guillermo Tell*, exh. cat., Caracas: Museo de Artes Visuales Alejandro Otero, 1991

Mosquera, Gerardo, et al., *Kuba OK*, exh. cat., Düsseldorf, Germany: Städtische Kunsthalle, 1990

Mosquera, Gerardo, 'Marta María Perez: Autoretratos del Cosmos', *Art Nexus*, Bogota, no. 17, July–September 1995, pp. 84–87

Monograph issue on contemporary Cuban photography of Aperture, USA, no. 141, Fall 1995

Nawi, Diana, *Nari Ward: Sun Splashed*, exh. cat., Munich: Prestel, 2015

Njami, Simon, et al., *Otro país: Escalas Africanas*, exh. cat., Centro Atlantico de Arte Moderno, Las Palmas de Gran Canaria, 1994

Noceda Fernández, José, *Elvis Lopez*, exh. cat., Oranjestad: Instituto di Cultura Aruba, 1994

Paul, Annie, 'Interview with Christopher Cozier', *Bomb*, 1 January 2003, https://bombmagazine.org/articles/christopher-cozier/

Pellegrini, Elena, *Tony Capellan: Campo Minado*, exh. cat., Santo Domingo: Casa de Francia, 1996

Poupeye, Veerle, 'Dawn Scott – A Cultural Object (1985)', *Perspectives blog*, 3 September 2016, https://veerlepoupeye.wordpress. com/2016/09/03/dawn-scott-a-cultural- object-1985/

Reid, Michael, ed., *Ancestral Dialogues: The Photographs of Albert Chong*, San Francisco: The Friends of Photography, 1994

Ríos Avila, Rubén, *Victor Vasquez: El Cuerpo y El Autoretrato Extendido*, exh. cat., San Juan: Galería Botello, 1994

David, et al., *Caribbean Queer Visualities, A Small Axe Project*, exh. cat., e-publication http:// smallaxe.net/cqv/issue-01/, 2015.

Solomon, Tessa, 'Tania Bruguera's Most Famous Works: How the Artist Has Challenged Oppressive Forces with Incisive Performances', *Art News*, 16 July 2020, https://www.artnews. com/feature/tania-bruguera-most-famous- works-performances-1202694439/

Sullivan, Edward, *Tomás Esson: Chá-Chá-Chá*, exh. cat., Monterrey, Mexico: Galería Ramis Barquet, 1993

Tawadros, Gilane, 'Black Women in Britain: A Personal and Intellectual Journey', *Third Text*, no. 15, Summer 1991, pp. 71–76

Weiss, Rachel, et al., *The Nearest Edge of the World: Art and Cuba Now*, exh. cat., Brookline, Massachusetts: Polarities Inc., 1990

Weiss, Rachel, *To and from Utopia in the New Cuban Art*, Minneapolis: University of Minnesota Press, 2011

List of Illustrations

Dimensions are in centimetres, followed by inches, height before width before depth

1 Colin Garland, *In the Beautiful Caribbean*, 1974 (detail). Oil on canvas, 122 × 76 (48 × 29⅞). National Gallery of Jamaica, Kingston. © Colin Garland
2 Wifredo Lam, *The Jungle*, 1943. Gouache on paper mounted on canvas, 239.4 × 229.9 (94¼ × 90½). Museum of Modern Art, New York. © ADAGP, Paris and DACS, London 2021
3 Bismarck Victoria, *Avis Rara*, 1981. Tone-coated aluminium, multi-electrode flow unit with neon and mercury, electrified, height 168 (66⅛). Private Collection. © Bismarck Victoria
4 Rafael Ferrer, a lithograph from the *Istoria de la isla (Island's Tale)* series, 1974. Lithograph, 50.8 × 68.6 (20 × 27). El Museo del Barrio, New York. Photo Ken Showell. © Rafael Ferrer
5 Isaac M. Belisario, *Koo-Koo* or *Actor Boy* from the *Sketches of Character* series, 1837. Hand-coloured lithograph, 29.5 × 20.7 (11⅝ × 8¼). Yale Centre for British Art, New Haven
6 Eddie Chambers, *Untitled*, 1994. Courtesy the artist
7 Jean-Michel Basquiat, *Self Portrait as a Heel*, 1982. Acrylic and oilstick on canvas, 127 × 102 (50 × 40¼). Private Collection. Photo Christie's Images/Bridgeman Images. © The Estate of Jean-Michel Basquiat/ADAGP, Paris and DACS, London 2021
8 Hervé Télémaque, *Currents No. 2*, 1987. Acrylic on canvas, 200 × 310 (78¾ × 122⅛). Collection du FRAC, Martinique. © ADAGP, Paris and DACS, London 2021
9 Flavio Garciandía, a work from *A Visit to the Tropical Art Museum* series, 1994. Installation of various paintings and objects. Photo Galeria Ramis Barquet, Mexico. © Flavio Garciandía
10 Pedro Alvarez, *Ron & Coca-Cola*, 1995. Paper, 70 × 50 (27⅝ × 19¾). Private Collection. © Pedro Alvarez

11 'Bird Man', *c.* 1000–1500. Wood, 87 × 70 (34⅜ × 27⅝). Photo Trustees of the British Museum, London
12 Cotton reliquary *zemi*, *c.* 1400–1500. Cotton, shell and human skull, height 75 (29½). Museo di Antropologia ed Etnografia, Turin
13 José Campeche, *Portrait of Governor Ustariz*, *c.* 1792. Oil on canvas, 62 × 43 (24⅜ × 16⅞). Instituto de Cultura Puertorriqueña, Puerto Rico
14 Agostino Brunias, *Chatoyer, The Chief of the Black Charaibes, in St Vincent with his Five Wives*, *c.* 1770–80. Oil on canvas, 30.5 × 24 (12 × 9.4). Private Collection
15 George Robertson, *Rio Cobre*, *c.* 1773. Oil on canvas, 45.7 × 61 (18 × 24). National Gallery of Jamaica, Kingston
16 William Clarke, *Cutting the sugar-cane*, from *Ten Views in the Island of Antigua*, 1823. John Carter Brown Library, Brown University, Providence
17 William Blake, *A Negro hung alive by the Ribs to a Gallows*, 1792. Engraving, 25.8 × 18.3 (10¾ × 7¼). Princeton University Art Museum, Gift of Frank Jeweett Mather Jr.
18 Nicolas Eustache Maurin, *Toussaint L'Ouverture*, early nineteenth century. Lithograph, 27.3 × 17.8 (10¾ × 7). Musée des Beaux-Arts, Chartres. Photo Josse/Scala, Florence
19 Sir Harry Johnston, Photograph of a 'voodoo shrine', Haiti, 1908–9. Photo Harry Johnston/Royal Geographic Society via Getty Images
20 Caban group, *La Mano Poderosa*, *c.* 1875–1925. Carved and painted wood with string and metal, 26.1 × 12.8 × 3.7 (10¼ × 5 × 1½). Smithsonian American Art Museum, Teodoro Vidal Collection, Washington, DC.
21 Víctor Patricio de Landaluze, *Día de Reyes en la Habana (Epiphany Day in Havana)*, second half of nineteenth century. Oil on canvas, 51 × 61 (20⅛ × 24). Museo Nacional de Bellas Artes, Havana
22 James Valentine and Sons, *A Young Jamaican*, 1912. Scomburg Center for Research in Black Culture, Jean Blackwell Hutson Research and Reference Division, New York Public Library
23 Paul Gauguin, *La Cueillette des Fruits, ou Aux Mangos (The Mango Trees, Martinique)*, 1887. Oil on canvas, 89 × 116 (33⅞ × 45⅜). Van Gogh Museum, Amsterdam
24 Winslow Homer, *The Gulf Stream*, 1899. Oil on canvas, 71.5 × 125 (28⅛ × 49¼). Metropolitan Museum of Art, New York. Catherine Lorillard Wolfe Collection, Wolfe Fund, 1906
25 Michel-Jean Cazabon, *Bamboo Arch*, *c.* 1840–50. Watercolour and bodycolour with stretching out on paper, 30 × 45 (11⅞ × 17¾). Private Collection
26 Guillermo Collazo, *The Siesta*, 1886. Oil on

canvas, 65.5 × 83.5 (25¾ × 32⅞). Museo Nacional de Bellas Artes, Havana. VTR/Alamy Stock Photo
27 Juana Borrero, *Pilluelos* (*The Little Rascals*), 1896. Oil on canvas, 76 × 52.5 (30 × 20¾). Museo Nacional de Bellas Artes, Havana
28 Francisco Oller, *El velorio* (*The Wake*), 1893. Oil on canvas, 243.8 × 397.5 (96 × 156½). Museo de Historia, Antropología y Arte, Universidad de Puerto Rico, San Juan. Artiz/Alamy Stock Photo
29 Removal of Edward Colston Statue, Bristol, England, 2020. PA Images/Alamy Stock Photo
30 Hew Locke, *Nelson*, 2018. Barbados Museum and Historical Society. Photo Veerle Poupeye
31 Errol Ross Brewster, *Discarded Statue of Queen Victoria Mounted by Children of Empire*, 1981. Botanical Gardens, Georgetown, Guyana. Photo Errol Ross Brewster
32 Gabriel-Vital Dubray, *Joséphine de Beauharnais* (beheaded), La Savane Park, Fort de France, Martinique, photograph taken in 2012. Photo Veerle Poupeye
33 Faro a Colón (Columbus Lighthouse), Santo Domingo, Dominican Republic. M. Timothy O'Keefe/Alamy Stock Photo
34 Laura Facey, *Redemption Song* (*Emancipation Monument*), 2003. Emancipation Park, Kingston, Jamaica. Photo Franz Marzonca
35 Jeannette Ehlers and La Vaughn Belle, *I Am Queen Mary*, 2017, public sculpture, Copenhagen. Bjanka Kadic/Alamy Stock Photo
36 Eduardo Abela, *El triunfo de la rumba* (*The Triumph of the Rumba*), c. 1928. Oil on canvas, 65 × 54 (25⅝ × 21¼). Museo Nacional de Bellas Artes, Havana
37 Víctor Manuel García, *Gitana Tropical* (*Tropical Gypsy*), 1929. Oil on wood, 46 × 38 (18⅛ × 15). Museo Nacional de Bellas Artes, Havana
38 Antonio Gattorno, *Women by the River*, 1927. Oil on canvas, 193 × 117 (76 × 46⅛). Museo Nacional de Bellas Artes, Havana
39 Carlos Enríquez, *The Abduction of the Mulatas*, 1938. Oil on canvas, 162.5 × 114.5 (64 × 45). Museo Nacional de Bellas Artes, Havana
40 Marcelo Pogolotti, *Cuban Landscape*, 1933. Oil on canvas, 73 × 92.5 (28¾ × 36½). Museo Nacional de Bellas Artes, Havana
41 Fidelio Ponce de León, *Tuberculosis*, 1934. Oil on canvas, 91 × 122 (35⅞ × 48). Museo Nacional de Bellas Artes, Havana
42 Amelia Peláez, *Still Life*, 1942. Gouache and watercolour on paper, 75.7 × 72 (29⅞ × 28⅜). Private Collection. © Amelia Peláez Foundation
43 René Portocarrero, a work from the *Cerro-Interior* (*Interiors from El Cerro*) series, 1943. Oil on canvas, 71 × 57 (28 × 22½). Museo Nacional de Bellas Artes, Havana. akg-images

44 Wifredo Lam, *The Chair*, 1943. Oil on canvas, 115 × 81 (45¼ × 31⅞). Museo Nacional de Bellas Artes, Havana. akg-images. © ADAGP, Paris and DACS, London 2021
45 Philomé Obin, *Toussaint L'Ouverture in his Camp*, c. 1945. Musée d'Art Haitien, Port-au-Prince
46 Jaime Colson, *Merengue*, 1937. Tempera on board, 51 × 67 (20⅛ × 26⅜). Museo Juan José Bellapart, Santo Domingo
47 Ramón Frade, *El Pan Nuestro de Cada Día* (*Our Daily Bread*), c. 1905. Oil on canvas, 127 × 81.5 (50 × 32). Instituto de Cultura Puertorriqueña, Puerto Rico
48 Miguel Pou, *A Race of Dreamers: Portrait of Ciquí*, 1938. Oil on canvas, 87 × 71 (34¼ × 28). Museo de Arte de Ponce, Fundación Luis A. Ferre, Ponce. Photo John Betancourt. Courtesy Galería Botello
49 Edna Manley, *Negro Aroused*, 1935. Guatemalan redwood, height 51 (20⅛). National Gallery of Jamaica, Kingston. Image courtesy of the Edna Manley Foundation
50 Edna Manley, *Horse of the Morning*, 1943. Guatemalan redwood, 129.5 (51). National Gallery of Jamaica, Kingston. Image courtesy of the Edna Manley Foundation
51 Alvin Marriott, *Banana Man*, 1955. Acrylic on board, 81 × 113 (31⅞ × 44½). Photo National Gallery of Jamaica, Kingston. © Alvin Marriott Estate
52 Albert Huie, *Crop Time*, 1955. Acrylic on board, 81 × 113 (31⅞ × 44½). National Gallery of Jamaica, Kingston. © Albert Huie Estate
53 David Pottinger, *Nine Night*, 1949. Oil on canvas, 75 × 94 (29½ × 37). National Gallery of Jamaica, Kingston
54 John Dunkley, *Banana Plantation*, c. 1945. Mixed media on board, 89 × 60 (35 × 23⅝). National Gallery of Jamaica, Kingston
55 Ronald Moody, *Johanaan* (*Peace*), 1936. Elm, h 155 (61). Photo Tate, London. © The Ronald Moody Trust
56 Boscoe Holder, *Portrait of Louise de Frense Holder*, 1938. Oil on board, 35.5 × 28 (14 × 11). © Boscoe Holder
57 Sybil Atteck, *a work*, c. 1950s. Watercolour. National Museum and Art Gallery of Trinidad, Port-of-Spain. © Sybil Atteck
58 Hector Hyppolite, *The Great Master*, 1946–48. Oil on cardboard, 96 × 65 (37¾ × 25⅜). Musée d'Art Haitien, Port-au-Prince. Photo Pablo Butcher
59 Robert Saint-Brice, *The Queen Erzulie*, 1957. Oil on masonite, 76.5 × 61 (30⅛ × 24). Musée d'Art Haitien, Port-au-Prince. Photo Pablo Butcher
60 Georges Liautaud, *Sirène Diamant* (*Diamond Mermaid*), n.d. Height 45.5 (18). Musée d'Art Haitien, Port-au-Prince. Photo Pablo Butcher
61 Préfète Duffaut, *Heaven and Earth*, 1959. Oil on masonite, 90 × 61 (35⅜ × 24). Musée d'Art Haitien, Port-au-Prince

62 Rigaud Benoit, Philomé Obin and Castera Bazile, *The Nativity, The Crucifixion* and *The Ascension*, Cathedral of the Holy Trinity, Port-au-Prince, 1950–51. Photo Ron Mayhew
63 Philomé Obin, *Last Supper*, Cathedral of the Holy Trinity, Port-au-Prince, 1950–51 (detail). Photo Pablo Butcher
64 Philomé Obin, *Last Supper*, Cathedral of the Holy Trinity, Port-au-Prince, 1950–51 (details). Photos Pablo Butcher
65 Prospère Pierre-Louis, *Spirit*, 1996. Oil on canvas, 40.6 × 30.5 (16 × 12). Musée d'Art Haitien, Port-au-Prince
66 Myrlande Constant, *Baron la Kwa*, 2008–18. Courtesy of the artist and CENTRAL FINE, Miami
67 'Don't Burn Them, Judge Them', street mural, Port-au-Prince, Haiti, undated. Photo Pablo Butcher
68 Jean-Hérard Céleur, *La Sirèn*, 2020. Wood, cycling tyres, metal pieces, 182.9 × 53.3 × 38.1 (72 × 21 × 15). Le Centre d'Art, Haiti. Photo Valérie Baeriswyl. © Jean Hérard Céleur
69 Mallica 'Kapo' Reynolds, *Revival Goddess Dina*, 1968. Lignumvitae wood, height 86.5 (34½). National Gallery of Jamaica, Kingston. © Mallica 'Kapo' Reynolds Estate
70 Everald Brown, *Ethiopian Apple*, 1970. Oil on canvas, 65 × 90 (25⅝ × 35⅜). National Gallery of Jamaica, Kingston
71 Albert Artwell, *Judgement Day*, 1979. Oil on board, 63.5 × 119.5 (25 × 47). National Gallery of Jamaica, Kingston
72 Gladwyn Bush, *The Judge of Nations*, 1989. Oil on canvas, 89 × 120 (35 × 47¼). Photo Carib Art Management, Curaçao. Courtesy the artist and the Cayman National Cultural Foundation
73 Osmond Watson, *Peace and Love*, 1969. Oil on hardboard, 43.2 × 29.2 (17 × 11½). National Gallery of Jamaica, Kingston
74 Leonard Daley, *The Pickpocket*, 1984. Mixed media on plywood, 99 × 118 (39 × 46½). Private Collection
75 Philip Moore, *The Cultural Centre*, 1996. Acrylic on canvas, 117 × 175 (46⅛ × 68⅞). Mervyn Awon Collection, St Michael, Barbados. Courtesy the artist
76 Gilberto de la Nuez, *Memory of the Colonial Past*, 1989. Mixed media on linen, 40 × 36 (15¾ × 14⅛). Mervyn Awon Collection, St Michael, Barbados. Courtesy the artist
77 Manuel Mendive, *Barco Negrero (Slave Ship)*, 1976. Casein and carving on wood, 102.5 × 126 (40⅜ × 49⅝). Museo Nacional de Bellas Artes, Havana
78 Juan Francisco Elso, *Por América (José Martí)*, 1986. Mixed media, 150 × 100 × 100 (59 × 39⅜ × 39⅜). Private Collection
79 José Bedia, *Isla jugando a la guerra (Island Playing at War)*, 1992. Acrylic on canvas with found objects, diameter 300 (118⅛). Phoenix Art Museum, Arizona. Courtesy the artist
80 Belkis Ayón, *The Supper*, 1991. Collagraph, 138.1 × 300 (54⅜ × 118⅛). © Collection of the Belkis Ayón Estate
81 Daniel Lind-Ramos, *María María*, 2019. Metal basin, wooden seat, lamp, tarp, coconuts, palm-tree trunk, steel sheet, beads, fabric, tacks, wood, plastic tubing, steel bars, scissors and wooden box, 226.1 × 99.7 × 109.2 (89 × 39¼ × 43). Whitney Museum of American Art, New York. Purchase with funds from the Painting and Sculpture Committee 2019.417. © Daniel Lind-Ramos 2019
82 Wendy Nanan, *Idyllic Marriage No. 4* from the *Idyllic Marriage* series, 1989. National Museum and Art Gallery of Trinidad, Port-of-Spain. Courtesy the artist
83 René Portocarrero, *Little Devil No.3* from the *Colour of Cuba* series, 1962. Oil on canvas, 51 × 41 (20⅛ × 16⅛). Museo Nacional de Bellas Artes, Havana
84 Peter Minshall, *ManCrab* from the Trinidad Carnival *The River*, 1983. Mobile mixed-media sculpture animated by Peter Samuel and an electric compressor. Photo Noel Norton
85 Gaston Tabois, *John Canoe in Guanaboa Vale*, 1962. Oil on hardboard, 61 × 76 (24 × 29⅞). National Gallery of Jamaica, Kingston
86 Brent Malone, *Junkanoo Ribbons*, 1984. Oil on canvas, 84 × 76 (33⅛ × 29⅞). National Gallery of Jamaica, Kingston. Reproduced with permission of the estate of Brent Malone
87 John Beadle, *Cuffed: Held in Check*, 2018. Photo National Gallery of Art, Bahamas/Jackson Petit. © John Beadle
88 Amos Ferguson, *Junkanoo Cow Face: Match Me If You Can*, 1990. Enamel paint on card, 96.3 × 81.8 (38 × 32¼). Photo National Gallery of Art, Bahamas/Jackson Petit. © Amos Ferguson
89 Tam Joseph, *Spirit of the Carnival*, 1983. Acrylic, gouache and glue on brown paper, 182.9 × 162.6 (72 × 64). Arts Council Collection, Southbank Centre, London. © Tam Joseph
90 A. Duperly and Sons, *Castleton Gardens*, 1901. Silver gelatin print. National Gallery of Jamaica, Kingston
91 A tourism brochure for Cuba, 1951. Jim Heimann Collection/Getty Images
92 Rhoda Jackson, jacket design for *Pleasure Island: The Book of Jamaica*, 1952
93 Hotel Oloffson, Port-au-Prince, Haiti. Photo Don Bartletti/Los Angeles Times via Getty Images
94 Straw Market, Nassau, Bahamas, 1960s. Pictures Now/Alamy Stock Photo

95 Fernando Rodríguez, *At la Bodeguita* from the *Nuptial Dream* series, 1994. Mixed media, 85 × 135 × 15 (33½ × 53⅛ × 5⅞). Private Collection

96 Blue Curry, *PARADISE.jpg* (2014), East Street, Kingston, Jamaica Biennial, National Gallery of Jamaica. © Blue Curry

97 Labadee Craft Market, Haiti. All Canada Photos/Alamy Stock Photo

98 Rafael Tufiño, *Temporal* (*Storm*) from *Portafolio de Plenas*, 1953–55. Linocut, 27 × 45.7 (11 × 18). Museo de Arte de Ponce

99 Julio Rosado del Valle, *Vejigantes* (*Carnival Devils*), 1955. Oil on masonite, 80.5 × 81 (31¾ × 32). Courtesy Galeria Botello, Puerto Rico

100 Paul Giudicelli, *Untitled*, 1963. Oil on canvas, 98 × 67.5 (38½ × 26½). Museo Juan José Bellapart, Santo Domingo

101 Sandú Darié, *Spatial Multivision*, 1955. Oil on canvas, 136 × 102 (53½ × 40⅛). Museo Nacional de Bellas Artes, Havana

102 Soucy de Pellerano, *Machine Lever Structure*, 1990. Iron, aluminium and rubber, 225 × 450 × 200 (88⅝ × 177⅛ × 78¾). Museo del Hombre Dominicano, Santo Domingo

103 Luis Martínez Pedro, *Territorial Waters No. 4*, 1964. Oil on canvas, 206 × 190.5 (81 × 75). Museo Nacional de Bellas Artes, Havana

104 Luis Hernández Cruz, *Composition with Ochre Shape*, 1976. Acrylic on canvas, 127 × 152.5 (50 × 60). Collection the artist

105 Lope Max Díaz, *Penetraciones Ancestrales* (*Ancestral Penetrations*), 1982. Acrylic on canvas and wood, 122 × 183 (48 × 72). Photo Ricardo Rojas. Courtesy the artist

106 Antonio Martorell, *Joker* from *The Alacrán Cards Deck*, 1968. Silkscreen, 6.5 × 8.8 (2½ × 3½). Courtesy the artist

107 Lorenzo Homar, poster for the 5ta Feria de Artesanías de Barranquitas, 1966. Silkscreen, 71 × 47 (28 × 18½). Courtesy Galeria Botello, Puerto Rico

108 Raúl Martinez, poster for *Lucia*, 1968. Silkscreen, 45.5 × 30.5 (18 × 12).

109 Alfredo Gonzalez Rostgaard, poster for Canción Protesta, 1967. Silkscreen, 112 × 75.5 (44⅛ × 29¾). Ackland Art Museum, The University of North Carolina at Chapel Hill/Art Resource, New York/Scala, Florence

110 Raúl Martinez, *Island 70*, 1970. Oil on canvas, 200 × 451.5 (78¾ × 177½). Museo Nacional de Bellas Artes, Havana. akg-images

111 Jasmin Joseph, *Le Roi Lion* (*The Lion King*), 1983. Oil on canvas, 22 × 28 (8¾ × 11⅛). Le Centre d'Art, Haiti

112 Edouard Duval-Carrié, *J.C. Duvalier en Folle de Marié* (*J.C. Duvalier as Mad Bride*), 1979. Oil on

canvas, 244 × 107 (96⅛ × 42⅛). Private Collection. © ADAGP, Paris and DACS, London 2021

113 Bernadette Persaud, *A Gentleman at the Gate*, 1987. Oil on canvas, 165 × 76.2 (65 × 30). Courtesy the artist

114 Still from *The Harder they Come*, 1972 directed by Perry Henzell. Perry Henzell Estate

115 Carl Abrahams, *Christ in Rema*, 1977. Acrylic on canvas, 50 × 37.5 (19⅝ × 14¾). Private Collection

116 Eugene Hyde, *Behind the Red Fence* from the *Casualties* series, 1978. Private Collection. © Eugene Hyde Estate

117 Isaiah James Boodhoo, *Breakdown in Communications*, 1970. Oil on canvas, 112 × 102 (44⅛ × 40⅛). Mervyn Awon Collection, St Michael, Barbados. Courtesy the artist

118 Stanley Greaves, *The Annunciation* from *There is a Meeting Here Tonight* series, 1993. Oil on canvas, 122 × 108 (48 × 42½). © Stanley Greaves

119 LeRoy Clarke, *Now*, 1970. Oil on canvas, 122.6 × 183.8 (48¼ × 72⅜). The Studio Museum, Harlem. © LeRoy Clarke

120 Serge Hélénon, *Le cherche lumiere* (*The Light-Seeker*), 2016. Mixed media, reclaimed wood assemblies, textiles, canvas materials, electric bulb, 238 × 40 (93¾ × 15¾). © ADAGP, Paris and DACS, London 2021

121 Martín 'Tito' Pérez, *Untitled*, 1972–74. Acrylic on canvas, 91.4 × 61 (36 × 24). Museo del Barrio, New York

122 Namba Roy, *Jesus and his Mammie*, 1956. Ivory, height 35.5 (14). Private Collection

123 Luis Cruz Azaceta, *Ark*, 1994. Acrylic, polaroids, charcoal, shellac on canvas, 280.7 × 303.5 (110½ × 119½). Courtesy of the artist and George Adams Gallery, New York

124 Colin Garland, *In the Beautiful Caribbean*, 1974. Oil on canvas, triptych, each panel 122 × 76 (48 × 29⅞). National Gallery of Jamaica, Kingston. © Colin Garland

125 Aubrey Williams, *Olmec Maya - Night and the Olmec*, 1983. Oil on canvas, 119 × 178 (46⅞ × 70⅛). Private Collection. © Aubrey Williams

126 Frank Bowling, *Night Journey*, 1969–70. Acrylic on canvas, 212.7 × 183.2 (83¾ × 72⅛). Metropolitan Museum of Art, New York. © Frank Bowling. Courtesy Hauser & Wirth. All Rights Reserved, DACS 2021

127 Marc Latamie, *Caldera*, 1995. Installation sugar and neon, dimensions variable. Courtesy the artist

128 Llewellyn Xavier, *Red Vermillion* from *Global Council for the Restoration of the Earth's Environment* series, 1992. Handmade paper, nineteenth-century original print, silkscreen printing, collectible card, postage stamp, marbling, ribbons and embossing

on paper, 76.2 × 56.5 (30 × 22¼). Private Collection. Courtesy the artist

129 Tomás Sánchez, *Relations*, 1986. Acrylic on canvas, 200 × 350 (78¾ × 137¾). Museo Nacional de Bellas Artes, Havana. © Tomás Sánchez

130 Alison Chapman-Andrews, *A Last Day in the Country*, 1987. Acrylic on canvas, 122 × 160 (48 × 63). Barbados Gallery of Art. Courtesy the artist

131 Hope Brooks, *Nightfall - The City* from the *Nocturne No. II* series, 1991. Gouache and modelling paste on canvas, 20 panels, each 40.5 × 45.5 (16 × 18). Collection Bank of Jamaica, Kingston

132 Bendel Hydes, *Roncador Cay*, 1995. Oil on canvas, 188 × 167.6 (74 × 66). Clive and Elaine Harris Collection, Cayman Islands

133 Winston Patrick, *Mahogany Form*, 1974. Mahogany, height 137 (53⅞). National Gallery of Jamaica, Kingston

134 Ana Mendieta, *Guabancex* (*Goddess of the Wind*), from the series *Esculturas Rupestres* (*Rupestrian Sculptures*) 1981, printed 1993. Photo etching and chine collé, 25.4 × 18.1 (10 × 7⅛). Yale University Art Gallery, Leonard C. Hanna, Jr., Class of 1913, Fund. © ARS, NY and DACS, London 2021

135 Ana Mendieta, *Guanaroca* (*First Woman*), from the series *Esculturas Rupestres* (*Rupestrian Sculptures*) 1981, printed 1993. Photo etching and chine collé, 25.4 × 18.1 (10 × 7⅛). Yale University Art Gallery, Leonard C. Hanna, Jr., Class of 1913, Fund. © ARS, NY and DACS, London 2021

136 Jaime Suárez, *Totem Telurico*, 1992. Glyn Genin/Alamy Stock Photo

137 Eugene Palmer, *Duppy Shadow*, 1993. Oil on canvas, 213 × 152 (83⅞ × 59⅞). Wolverhampton Museum and Art Gallery. Courtesy the artist

138 Ingrid Pollard, *Wordsworth's Heritage*, 1992. © Ingrid Pollard. All rights reserved, DACS/Artimage 2021.

139 Barrington Watson, *Mother and Child*, 1958. Oil on canvas, 100.5 × 127 (39½ × 50). National Gallery of Jamaica, Kingston

140 Myrna Báez, *Nude in Front of Mirror*, 1980. Acrylic on canvas, 83 × 163 (32⅝ × 64⅛). Private Collection

141 Jean-René Jérôme, *Woman with Pigeon*, 1973. Oil on canvas. Musée d'Art Haitien, Port-au-Prince

142 Antonia Eiriz, *La Muerte en Peloto* (*Death at the Ball Game*), 1966. Oil on canvas, 206 × 342.5 (81⅛ × 134⅞). Museo Nacional de Bellas Artes, Havana. akg-images. © Antonia Eiriz

143 Angel Acosta León, *Metamorphosis*, 1960. Oil on masonite, 193 × 118.7 (76 × 46¾). Private Collection

144 Ramón Oviedo, *Sterile Echo*, 1975. Oil on canvas, 147.3 × 147.3 (58 × 58). Art Museum of the Americas Collection, © Fundación Ramon Oviedo

145 Milton George, *The Ascension*, 1993. Oil on canvas, 178 × 180 (70⅛ × 70⅞). Private Collection

146 David Boxer, *Havana Postscript*, 1997–2002. Mixed media on wood, 213.4 × 243.8 (84 × 96). © David Boxer

147 Arnaldo Roche Rabell, *You Have to Dream in Blue*, 1986. Oil on canvas, 213 × 152 (83⅞ × 59⅞). Courtesy Galeria Botello, Puerto Rico

148 José García Cordero, *Bilingual Dog*, 1993. Acrylic on canvas, 80 × 80 (31½ × 31½). Courtesy the artist

149 Mario Benjamin, *Untitled*, c. 1997. Oil on canvas. Musée d'Art Haitien, Port-au-Prince. Photo Pablo Butcher

150 Carlos Collazo-Mattel, *Self-Portrait I*, 1989. Oil and acrylic on linen, 127 × 117 (50 × 46⅛). Courtesy Galeria Botello, Puerto Rico

151 Felix Gonzalez-Torres, *"Untitled"*, 1991 Installed at Bridge Street in Trenton, New Jersey, 1 of 12 outdoor billboard locations around the greater Princeton area, as part of a special installation by Princeton University Art Museum, Princeton, NJ. 21 Oct – 16 Dec. 2013. Billboard, dimensions vary with installation. Photo James Ewing. Courtesy of the Felix Gonzalez-Torres Foundation. © Felix Gonzalez-Torres

152 Petrona Morrison, *Reality/Representation*, 2004. Courtesy the artist

153 Ernest Breleur, *Untitled* from the *Suture* series, 1995. Radiography collage, 237 × 190 (93¼ × 74¾). © ADAGP, Paris and DACS, London 2021

154 Patrick Vilaire, *Le Carcan* (*The Stocks*), 1996. Wood, iron and bronze. Photo Jean Guèry. Collection the artist

155 Margaret Chen, *Steppe VII*, 1982. Mixed media on plywood, 213.5 × 305 (84 × 120). Wallace Campbell Collection, Jamaica

156 Ras Akyem Ramsay, *Blakk King Ascending*, 1994. Acrylic on canvas, 213 × 137 (84 × 54). Mervyn Awon Collection, St Michael, Barbados. Courtesy the artist

157 Omari S. Ra, *Figure with Mask*, 1987. Acrylic on paper, 58 × 73 (22⅞ × 28¾). National Gallery of Jamaica, Kingston. © Omari S. Ra

158 Annalee Davis, *My Friend Said I Was Too White*, 1989. Linoleum print, 71 × 48.5 (29 × 19). Reproduced with the permission of the artist

159 Keith Morrison, *Crabs in a Pot*, 1994. Oil on canvas, 152.4 × 162.6 (60 × 64). Courtesy the artist

160 Antonio Martorell, *Pasaporte Portacasa*, 1993. Mixed-media installation. Exhibited at the 5th Havana Biennial. Courtesy the artist

161 María de Mater O'Neill, *Self-Portrait VIII*, 1988. Mixed media, 76 × 62 (30 × 24½). Museo de Arte Contemporaneo de Puerto Rico, Santurce

162 Christopher Cozier, *The Attack of the Sandwich Men*, installation from 'Being an Island', 2013. © Christopher Cozier

163 Dawn Scott, *A Cultural Object*, 1985. Installation. © Dawn Scott Foundation

164 Tomás Esson, *My Homage to Ché*, 1987. Oil on canvas, 160 × 198 (63 × 78). Collection the artist

165 Kcho, *Regatta*, 1994. Mixed media, dimensions variable. Courtesy Barbara Gladstone Gallery, New York

166 Los Carpinteros, *Havana Country Club*, 1994. Oil on canvas on wooden frame, 140 × 140 (55⅛ × 55⅛). Courtesy Sean Kelly Gallery, New York. © Los Carpinteros

167, 168 Carlos Garaicoa, installation view of *Rivoli, About the Place from Where the Blood Flows – Cruel Project*, 1993–95. Installation consisting of cibachrome colour photograph, 48 × 48 (19 × 19) and acrylic watercolour and ink drawing, 200 × 154 (78¾ × 60⅝). © DACS 2021

169 Marta María Pérez Bravo, *Parallel Cults*, 1990. Silver gelatin print. Courtesy the artist and Alida Anderson Art Projects

170 Juan Carlos Alom, *Untitled* from the *Libro Oscuro (Dark Book)* series, 1995. Silver gelatin print. Courtesy the artist

171 Víctor Vásquez, *Prelude*, 1994. Photograph and mixed media, 122 × 244 (48 × 96⅛). Courtesy the artist

172 Tony Capellán, *Organ Theft*, 1994. Mixed-media installation, 400 × 400 (157½ × 157½). Courtesy the artist

173 Belkis Ramírez, *In a Plate of Salad*, 1993. Mixed-media installation, dimensions variable. Courtesy the artist

174 Marcos Lora Read, *40 Metres of Schengen Space*, 1995. Oil drums and salt, 0.5 × 1 × 40 metres (1 ft 8 in. × 3 ft 3 in. × 131 ft 3 in.). Photo Carlos Rodés. Courtesy the artist

175 Marcel Pinas, *Kibli Wi Koni*, 2009. Bottles, wood, acrylic, plastic, fabric, dimensions variable. © Marcel Pinas

176 Elvis López, *The Six Proposals* from the *Social Critic* series, 1993. Acrylic and conté on paper, 25 × 30 (9⅞ × 11¾). Courtesy the artist

177 Juan Sánchez, installation view of *Nueva Bandera (New Flag)* from the *Rican/Structions* series, 1994. Photo laser print with collage diptych, 231 × 272 (91 × 107⅛). El Museo del Barrio, New York. Photo Charles Erikson. Courtesy the artist

178 Felix de Rooy, *Cry Surinam*, 1992. Mixed media sculpture, H 110 (43¼). Courtesy the artist

179 Nari Ward, *The Happy Smilers: Duty Free Shopping*, 1996. Mixed-media installation including firescape, firehouse, household objects, salt, speakers, audio recording, aloe vera plant, variable dimensions.Courtesy the artist

180 Renee Cox, *Chillin' with Liberty* from the *Rajé* series, 1998. Cibachrome print (40 × 60). Courtesy the artist

181 Albert Chong, *Throne for the Justice* from the *Ancestral Thrones* series, 1990. Photograph, 94 × 61 (37 × 24). Courtesy the artist

182 Janine Antoni, *Lick and Lather*, 1999. One licked chocolate self-portrait bust and one washed soap self-portrait bust on pedestals, bust, 61 × 40.6 × 33 (24 × 16 × 13). Pedestal 116 × 40.6 (45⅞ × 16). Collection of Carl Emil and Rich Silverstein and the San Francisco Museum of Modern Art (John Caldwell, Curator of Painting and Sculpture, 1989–93, Fund for Contemporary Art Purchase). Photo Ben Blackwell. Courtesy of the artist and Luhring Augustine, New York. © Janine Antoni

183 Sonia Boyce, still from *Mother Sallys* from *Crop Over*, 2007. Photo William Cummins. © Sonia Boyce. All Rights Reserved, DACS/Artimage 2021

184 Keith Piper, still from *Ghosting the Archive*, 2005. Courtesy the artist

185 Tania Bruguera, *The Burden of Guilt*, 1999. Re-enactment of a historical event, decapitated lamb, rope, water, salt, Cuban soil, dimensions variable. © ARS, NY and DACS, London 2021

186 Raquel Paiewonsky, *Contenedor de ideas (Ideas Container)* from the series *Guardarropía (Wardrobe)*, 2010. Photographic print, 81.3 × 121.9 (32 × 48). Courtesy the artist

187 Ewan Atkinson, *Posters 3 and 6* from the *Only in Our Imagination* series, 2015, part of *The Neighbourhood Project*. Courtesy the artist

188 Sheena Rose, *Too Much Makeup II*, from *The Sweet Gossip*, 2013. Acrylic on plywood, 86.4 × 73.7 (34 × 29). Courtesy the artist

189 Phillip Thomas, *Pimper's Paradise – The Terra Nova Nights Edition*, 2019. Mixed media on canvas, 213.4 × 487.7 (84 × 192). On loan by Phillip Thomas & The RJD Gallery.com

190 Ebony G. Patterson, still from *Three Kings Weep*, 2018. Three-channel digital colour video with sound, 8:34 minutes. Image courtesy the artist and Monique Meloche Gallery, Chicago

191 Kishan Munroe, photo from *Drifter in Residence*, 2018–present. Photo courtesy of the artist

192 Tessa Mars, *Dreaming the Ancestors – Sa m konnen, sa m pa konnen*, 2017. Acrylic on canvas, 61 × 76.2 (24 × 30). © Tessa Mars 2017

193 Richard Mark Rawlins, *Empowerment* from the series *I Am Sugar*, 2018. Digital photographic print, 83.1 × 61.2 (32¾ × 24⅛). Courtesy the artist

Index

References in italics indicate
illustration figure numbers

A

Abakuá society 128, 130, 133
The Abduction of the Mulatas
(Enríquez) 77–8, 80, 93–4; *39*
Abela, Eduardo 70, 74, 80; *36*
abolition 38, 60
Abrahams, Carl 181; *115*
abstraction 11, 87, 101, 158–60,
162–7, 173, 182, 201, 203–4
Acosta León, Angel 216–18; *143*
African American culture 72
African American Flag
(Hammons) 19
African Zionism 119
Afrocubanismo 72, 126–9, 162
AIDS 224, 227, 251
Ainsi parla l'oncle (Price-Mars)
86
ajiaco 17
The Alacrán Cards Deck
(Martorell) 168; *106*
Albizu Campos, Pedro 90
Alcántara, Luis Manuel Otero
265
Alom, Juan Carlos 250; *170*
Alvarez, Pedro 24–5; *10*
Amerindian revival 196–7
Amerindians 28–30
Anacaona 63
Ancestral Penetrations (Díaz)
105
Ancestral Thrones series (Chong)
259–61; *181*
anti-colonialism 70, 93
anti-imperialism 157
Antoni, Janine 261–2; *182*
appropriation 221

ARC Magazine 265
Ark (Azaceta) 190; *123*
Arrechea, Alexandre 247
Art-Deco 94, 97, 144
*The Art of Revolution, Castro's
Cuba* (Stermer & Sontag) 173
art schools 48, 80, 86–7, 88–9,
97, 110, 157, 160, 243
Art Workers' Coalition 186
artist-run spaces 265
artists' associations 167
Artwell, Albert 120; *71*
Aruba 16, 17, 255
The Ascension (Bazile) 107–9; *62*
The Ascension (George) 220
The Ascension (Milton) *145*
assemblage 221, 228, 251, 259
Ateliers '89 255, 265
Atis Rezistans 114–15
Atkinson, Ewan 269; *187*
The Attack of the Sandwich Men
(Cozier) 240; *162*
Atteck, Sybil 101–2; *57*
authenticity 12, 147
autobiographic expressionism
219–21
Avis Rara (Victoria) 9–10; *3*
Ayón, Belkis 130, 133; *80*
Azaceta, Luis Cruz 190, 220,
239; *123*

B

Bacon, Francis 220
Báez, Myrna 213, 239; *140*
Bahamas
 Junkanoo 137; *86*, *88*
 landscape art 46
 markets 148–9; *94*
 Taíno 27
Balaguer, Joaquín 63, 156, 176
Bamboo Arch (Cazabon) 25
Banana Man (Marriott) 94–5; *51*
Banana Plantation (Dunkley)
97; *54*
Banksy 56
Barbados
 Crop Over festival 263
 independence 156
 landscape art 201–2, 235
 Rastafarianism 123
 statue removal 56–9
 tourism 144
Barco Negrero (Mendive) 77
Baron la Kwa (Constant) 66
Baron Samedi 113

Barretto, Ray 256
barroquismo 80
Basquiat, Jean-Michel 20–2,
232–3; *7*
Batista, Fulgencio 79, 162
Bazile, Castera 87, 109; *62*
Beadle, John 137–9; *87*
Beadseller (Manley) 92–3
In the Beautiful Caribbean
(Garland) 193; *1*, *124*
Beckford, William 36, 54
Bedia, José 129–30, 243–4,
245–6; *79*
Belisario, Isaac Mendes 17, 34,
43, 44, 135; *5*
Belize 13, 30
Belle, La Vaughn 69; *35*
Benítez-Rojo, Antonio 14, 17,
243
Benjamin, Mario 223–4; *149*
Benoit, Rigaud 87, 109; *62*
Bigaud, Wilson 87, 109–10
Bilingual Dog (García Cordero)
223; *148*
'Bird Man' 28–9; *11*
The Birth of the New World
(Tsereteli) 65–6
Black Lives Matter 53–4
black nationalism 123, 158, 262
Black Panthers 69, 158, 186
Black Power 150, 182–3; *276*
Blake, William 37, 93; *17*
Blakk King Ascending (Ras
Akyem) 232; *156*
Bleckner, Ross 226–7
Blue Curry 154; *96*
Boodhoo, Isaiah James 183; *117*
Borrero, Juana 49; *27*
Botello, Angel 90
Bouterse, Dési 254
Bowling, Frank 159, 197–8; *126*
Boxer, David 25, 123–5, 146,
192, 220–1, 239; *146*
Boyce, Sonia 262, 263, 275; *183*
Brathwaite, Kamau 14, 190, 243
Breakdown in Communications
(Boodhoo) 183; *117*
Brecht, Bertolt 192
Breleur, Ernest 229–30, 239; *153*
Breton, André 83, 87, 103
Brewster, Errol Ross 59, 180; *31*
Brey, Ricardo 243
Brierre, Murat 106
Britain 53–4, 189–90, 209–11,
262–4

Brooks, Hope 202–3; *131*
Brown, Everald 119–20; *70*
Bruguera, Tania 265; *185*
Brunias, Agostino 35; *14*
Brunswijk, Ronnie 254
The Burden of Guilt (Bruguera) *185*
The Burial of the Nañigo (Mendieta) 128
Burnham, Forbes 179–80, 242
Burnside, Jackson 137
Burnside, Stan 137
Bush, Gladwyn 120–3; *72*
Bynoe, Hollie 265

C

Caban group *20*
Cabrera, Lydia 83
Cahier d'un retour au pays natal (Césaire) 70
Caldera (Latamie) 198; *127*
Camacho, Paul 167
Campeche, José 33, 34; *13*
Canción Protesta poster 173; *109*
Cap-Haïtien School 88
Capellán, Tony 251–2; *172*
Carbonell, Teófilo 65
Caribbean Artists' Movement (CAM) 190
Caribbean Community and Common Market (CARICOM) 157
The Caribbean (Rodman) 148
CARIFESTA 157–8
Carmichael, Stokely 158
carnivals 43, 131–9, 161; *84*
Carpentier, Alejo 74, 80, 83
Carreño, Mario 162
Carter, Martin 179
Casa de las Américas 173
Cass, John 53–4
Cassidy, John 54
Castillo, Marco 247
Castleton Gardens (Duperly and Sons) 142; *90*
Castro, Fidel 14, 151, 162, 165, 173, 183, 245
Casualties series (Hyde) 181–2; *116*
Cayman Islands 120–3, 203
Cazabon, Michel-Jean 46; *25*
Cédor, Dieudonné 89
Céleur, Jean-Hérard 114, 115; *68*

Centre d'Art, Port-au-Prince 86–7, 88–9, 110, 147
Centre of Puerto Rican Art (CAP) 160
Cerro-Interior series (Portocarrero) 83; *43*
Césaire, Aimé 60, 70, 83, 86–7, 101, 198, 230
The Chair (Lam) 84, 261; *44*
Chambers, Eddie 18–19, 262–3; *6*
Chapman-Andrews, Alison 201–2; *130*
Chapman, Esther 144
Chartrand, Esteban 46
Chassériau, Théodore 46
Chatoyer, The Chief of the Black Charaibes (Brunias) *14*
Chen, Margaret 230–2; *155*
Chong, Albert 259–61; *181*
Christ in Rema (Abrahams) 181; *115*
Church, Frederic Edwin 45–6
cities *20*
Clarke, LeRoy 184–5, 186; *119*
Clarke, William 36; *16*
Cleenewerck, Henri 46
Cliff, Jimmy 180
Cliff, Michelle 243
climate change 199
Collazo, Guillermo 48; *26*
Collazo-Mattei, Carlos 224; *150*
collectives 114–17, 160, 186–9, 227–8, 247
Colón Camacho, Doreen 42
colonial art 31, 33–6, 60–3
colonialism 11, 15–16, 41, 54, 56, 62, 63, 193
Colour of Cuba series (Portocarrero) 83, 133; *83*
Colson, Jaime 89; *46*
Colston, Edward 54, 55–6; *29*
Columbus, Christopher 60–6, 251
Columbus Lighthouse, Santo Domingo 56, 63–5; *33*
Committee for the Defense of the Revolution (CDR) 175–6
commodification 25
Composition with Ochre Shape (Hernández Cruz) *104*
conferences 265
Constant, Myrlande 114; *66*
Constructivism 159, 166, 167

Contemporary Jamaican Artists' Association 167, 182, 212
Corps Perdu (Césaire) 230
costumbrismo 43–4, 73, 76
cotton 29–30
Courbet, Gustave 49
Cox, Renee 259; *180*
Cozier, Christopher 238, 240, 254–5, 265; *162*
Crabs in a Pot (Morrison) 236; *159*
crafts, tourism 148–9, 154–5; *97*
Creole 16, 17, 32–3
creolization 17, 31, 162
Crop Over (Boyce) 263
Crop Time (Huie) 97, 145; *52*
The Crucifixion (Obin) 107–9; *62*
Cry Surinam (de Rooy) 259; *178*
Cuba
 abolition 38
 abstraction 159, 162–5, 173
 Afrocubanismo 72, 126–9, 162
 art schools and salons 80, 157, 243
 carnival 133
 censorship 245, 265–6
 costumbrismo 43–4
 creolization 31
 exhibitions 84–6, 87
 geography 14
 graphic art 170–3
 landscape art 46
 New Cuban Art 243–50
 nineteenth century school 46–8
 revolutionary art 174–6
 School of Havana 80
 tourism 25, 143–4, 150–1
 Vanguardia 73–80
Cuban Art and National Identity (Martínez) 73
Cuban Counterpoint of Tobacco and Sugar (Ortiz) 84
Cuban Landscape (Pogolotti) 78–9; *40*
Cuban Revolution 156, 162, 165, 170, 172
Cuenca, Arturo 246
Cuffed: Held in Check (Beadle) *87*
The Cultural Centre (Moore) 125–6; *75*
cultural imperialism 12

cultural nationalism 70–2, 87, 93, 102, 145, 159
A Cultural Object (Scott) 240–2; *163*
Curaçao 16, 17
Currents No. 2 (Télémaque) *8*

D

Daley, Leonard 123, 125; *74*
Darié, Sandú 162–4; *101*
Davis, Annalee 234–5, 265; *158*
De la Cal, Fernando 151
de la Nuez, Gilberto 126; *76*
de Rooy, Felix 259; *178*
Decolonial movement 53
decolonization 11, 12, 15, 58, 275
Dessalines, Jean-Jacques 38, 41, 274
Día de Reyes en la Habana (Landaluze) 44; *21*
Diago, Roberto 84
diaspora 13, 186–90, 209–11, 224–8, 235–7, 242, 256–64, 275–6
Díaz-Canel, Miguel 266
Diggers (Manley) 93
Dimas, Marcos 186
Discarded Statue of Queen Victoria Mounted by Children of Empire (Brewster) 59; *31*
DIVEDCO screenprinting workshop 160
diversity 54
Dominican Republic
 artists' associations 167
 civil war 156, 176
 Columbus 62–3, 66
 contemporary art 251–3
 Faro a Colón (Columbus Lighthouse) 63–5
 independence 38
 migration and ethnic groups 30
 nationalism 89
 Prehispanic art 28, 29
 Spanish Civil War refugees 89–90
'Don't Burn Them, Judge Them' (street mural) 114; *67*
Douglas, Aaron 93
drapos 114
Dreaming the Ancestors – Sa m konnen, sa m pa konnen (Mars) *192*

Drifter in Residence (Munroe) 274; *191*
Dubray, Gabriel-Vital 59–60; *32*
Duffaut, Préfète 106; *61*
Dunkley, John 97, 198; *54*
Duperly and Sons 44, 45, 142; *90*
Duppy Shadow (Palmer) 209; *137*
Duval-Carrié, Edouard 13, 115, 117, 176–8, 250; *112*
Duvalier, François ('Papa Doc') 113, 156
Duvalier, Jean-Claude ('Baby Doc') 62, 113, 178, 242; *112*
Dying God series (Manley) 94

E

earthquakes 199
Ecole Négro-Caraïbe 185
Edwards, Bryan 35
Ehlers, Jeannette 69; *35*
Eiriz, Antonia 176, 215–16; *142*
El Museo del Barrio, New York 186
El Pan Nuestro de Cada Día (Frade) 91, 256; *47*
El triunfo de la rumba (Abela) 70; *36*
El velorio (Oller) 49–52; *28*
Elso, Juan Francisco 128–9, 243–4, 245, 247; *78*
emancipation monuments 66–9
Enríquez, Carlos 74, 77–8, 87, 93–4; *39*
enslavement 14, 16, 31, 36–7, 41, 60, 230
environmental movement 199–201
Esculturas Rupestres (Mendieta) 205–6; *134, 135*
Esson, Tomás 245, 246; *164*
The Eternal Presence (Lam) 83
Ethiopian Apple (Brown) 119–20; *70*
Eugène, André 114, 117
Evans, Richard 38
exhibitions
 'Caribbean: Crossroads of the World' 26
 Cuba 84–6, 87, 243–4, 245
 Ghetto Biennale 115
 Gonzalez-Torres 227
 Haiti 86, 87

'Intuitives' 124
Jamaica 145–6, 154
Prehispanic art 27
Puerto Rico 251
retrospectives 146
sacred art 113
tourism 140
Exil, Levoy 110
exile 190
Expressions-Bidonvilles (Hélénon) 185

F

Facey, Laura 66–9; *34*
Fanon, Frantz 73, 234, 243
Faro a Colón (Columbus Lighthouse) 56, 63–5; *33*
Ferguson, Amos 137; *88*
Fern Gully, Jamaica 154–5
Ferrer, Rafael 14, 186; *4*
ferroniers 105–6, 230
festival arts 43, 131–9, 161; *5, 84*
figure painting 212–15, 218–19
Figure with Mask (Ra) 234; *157*
5ta Feria de Artesanías de Barranquitas 170; *107*
flags 114
For América (José Martí) (Elso) 128–9, 245; *78*
formalism 159, 164
Fors, José Manuel 243
40 Metres of Schengen Space (Lora Read) 253; *174*
Fouchet, Max-Pol 73
Foyer des Arts Plastiques 88–9
Frade, Ramón 90–1, 256; *47*
Fraser, Andrea 242
French Antilles 16–17, 157, 185
French Guiana 13, 16–17, 157, 185
Frente group 167
Fresh Milk 265
Frido (Wilfrid Austin) 110
Fusco, Coco 242
Futurists 78
Fwomajé group 229

G

Garaicoa, Carlos 249; *167, 168*
García, Adrián 186
García Cordero, José 221–3; *148*
Garciandía, Flavio 23, 243; *9*
Garden series (Brooks) 202
Gardening in the Tropics cycle (Senior) 196

Garifuna 30
Garland, Colin 193; *1, 124*
Garrick, Neville 123
Garvey, Marcus 39, 72, 93, 94, 119
Gattorno, Antonio 74, 76–7; *38*
Gauguin, Paul 35, 45, 73, 89; *23*
Gelabert, Florencio 246
A Gentleman at the Gate (Persaud) *113*
geography 12–14
George, Milton 219–20, 239; *145*
Ghetto Biennale 115
Ghosting the Archive (Piper) 264; *184*
Gilbert, Ernesto 63
Gitana Tropical (Manuel Garcia) 70, 74, 80; *37*
Giudicelli, Paul 162; *100*
Gleave, Joseph Lea 63, 65
Glissant, Edouard 243
Global Council for the Restoration of the Earth's Environment series (Xavier) 199–200; *128*
globalization 243
Goldman, Shifra 165
Gonzalez-Torres, Felix 226–9, 242; *151*
Gordon, Leah 115–17
Goya, Francisco 43
graffiti 114
Granell, Eugenio Fernández 90
graphic art
 Cuba 170–3
 Puerto Rico 160–1, 168–70, 173
graveyard crosses 105
The Great Master (Hyppolite) 104; *58*
Greater Antilles 12, 27, 31
Greaves, Stanley 184; *118*
Group Material 226
Grupo Minorista 73–4
Guadeloupe 114, 185
Guardarropía series (Paiewonsky) 266–9; *186*
Guevara, Che 172–3; *164*
Guianas 13, 30
The Gulf Stream (Homer) 46, 198; *24*
Guyana
 Amerindian revival 196–7
 black nationalism 158
 geography 13

independence 156
migration and ethnic groups 16
Moore 125–6
political art 178–80, 184
statue removal 59
Guyodo (Frantz Jacques) 114

H

Haacke, Hans 226
Haiti
 art schools 86–7, 88–9, 110
 CARICOM 157
 déchoucage campaign 62
 exhibitions 86, 87
 Hotel Oloffson, Port-au-Prince *93*
 language 17
 markets 147, 148; *97*
 migration and ethnic groups 16
 political art 176–8
 'Primitives' 87–8, 103, 110–13, 146–7, 148, 176
 revolutionary art 38–41
 School of Beauty 214–15, 223
 street art 114–15
 tourism 25, 146–7, 148, 154
 voudou shrine 41; *19*
Haitian Revolution 15, 37–8, 41, 87, 274
Hall, Stuart 16, 190, 243
Hammons, David 19
hand symbolism 42–3
The Happy Smilers: Duty Free Shopping (Ward) 257–9; *179*
The Harder They Come (film 1972, Henzell) 180; *114*
Harlem Renaissance 72, 93, 99
Harris, Wilson 196
Hart, Armando 245
Havana Club (Los Carpinteros) 247–9; *166*
Havana Postscript (Boxer) *146*
Heaven and Earth (Duffaut) 106; *61*
Hélénon, Serge 185; *120*
Henri Christophe, King of Haiti 38
Henzell, Perry 180; *114*
Hernández Cruz, Luis 166–7; *104*
Higher Institute of Art (ISA), Havana 157

Hill, Ken 142
Hispaniola 12, 31, 38
The History, Civil and Commercial, of the British Colonies in the West Indies (Edwards) 35
Holder, Boscoe 101; *56*
Holy Trinity murals, Port-au-Prince 107–10; *62, 63, 64*
Holzer, Jenny 226
Homage to Trinidad (Portocarrero) 83
Homar, Lorenzo 160, 168–70, 198; *107*
Homer, Winslow 46; *24*
Hope-Pinker, Henry Richard 59
Horse of the Morning (Manley) 93–4; *50*
Hotel Oloffson, Port-au-Prince, Haiti 147; *93*
hotels 140, 144, 147; *93*
houngans 103
Huggins, Nadia 265
Huie, Albert 97, 145; *52*
Hurricane from the North (Rivera) 161
hurricanes 199
Hurston, Zora Neale 72
Hyde, Eugene 181–2, 212; *116*
Hydes, Bendel 203; *132*
Hyppolite, Hector 87, 103–5, 106, 148; *58*

I

I Am Queen Mary (Ehlers & Belle) 69; *35*
I Am Sugar series (Rawlins) 276; *193*
Ian Fleming Introduces Jamaica (Rae) 147
iconoclasm 53
Idyllic Marriage series (Nanan) 131; *82*
If Anything Happens, I Was Not Here (Ramírez) 252
Impressionism 49
indenture 38
Independence Wars 49
Indigenism 11, 72, 73, 79–83, 86–7, 159, 162, 229
installation art 221, 226–9, 238, 244, 249, 251, 253–5, 257
Institute of Jamaica 95–7, 145, 181

Institute of Puerto Rican
 Culture 168–70, 173
Instituto Superior de Arte (ISA)
 243
'Intuitives' 25, 124–5, 147
ireme 133
Ishi Butcher, Ras 123
Isla jugando a la guerra (Bedia)
 79
Island 70 (Martínez) 174–5; *110*
Istoria de la isla series (Ferrer)
 14; *4*

J
Jackson, George 199
Jackson, Rhoda 144–6; *92*
Jamaica
 1970s 180–2
 abstraction 182
 artists' associations 167
 black nationalism 158
 colonial art 35–6
 creolization 31
 emancipation monuments
 66–9
 independence 156
 'Intuitives' 25, 124–5, 147
 Jonkonnu 135–7
 photography 44
 Prehispanic art 30
 Rastafarianism 119–20, 123
 tourism 140–1, 142, 144–5,
 147–8, 154–5
Jamaica School of Art 97
Jamaican Art (Boxer) 146
Jamaican Revival religions
 117–19
Jamaican School 92–7
James, C.L.R. 101
James Valentine and Sons 45;
 22
J.C. Duvalier en Folle de Marié
 (Duval-Carrié) 178; *112*
Jérôme, Jean-René 214, 215; *141*
Jesus and his Mammie (Roy) *122*
Johanaan (Peace) (Moody) 97–9;
 55
John Canoe in Guanaboa Vale
 (Tabois) *85*
Johnson, Lyndon B. 168
Johnston, Harry 41; *19*
Jolimeau, Serge 106
Jonkonnu 17–18, 19, 43, 135
Jordanites 125
Joseph, Jasmin 109, 176; *111*

Joseph, Tam 139; *89*
Joséphine de Beauharnais
 (Dubray) 59–60; *32*
The Judge of Nations (Bush)
 120–3; *72*
Judgement Day (Artwell) 120; *71*
The Jungle (Lam) 9, 83–4, 86; *2*
Junkanoo 137; *86, 88*
*Junkanoo Cow Face: Match Me If
 You Can* (Ferguson) 88
Junkanoo Ribbons (Malone)
 137; *86*

K
Kahan, Sadiq 54
Kalatozov, Mikhail 172
Kalinago 27, 30
'Kapo' Reynolds, Mallica
 117–18, 147–8; *69*
Kcho (Alexis Leyva Machado)
 246–7; *165*
Kibii Wi Koni (Pinas) 255; *175*
Korda, Alberto 172–3
Košice, Gyula 164
Kruger, Barbara 226

L
La Case de Damballah (Savain)
 86
*La Cueillette des Fruits, ou Aux
 Mangos* (Gauguin) 23
La Divina 131–2
La Muerte en Peloto (Eiriz) 216;
 142
La Sirèn (Celeur) 68
Labadee Craft Market, Haiti 97
Lam, Wifredo 9, 12, 72, 73,
 83–6, 87, 97, 103, 129–30, 143,
 162, 261; *2, 44*
Landaluze, Víctor Patricio de
 25, 43–4; *21*
landscape art
 19th century 46–8
 aesthetics and politics
 192–3
 Chapman-Andrews 201–2
 colonial 35–6
 Dunkley 97
 Savain 86
 Western artists 46
language 16–17
Laouchez, Louis 185
Lara, Magali 129
A Last Day in the Country
 (Chapman-Andrews) 130

Last Supper (Obin) 109; *63, 64*
Latamie, Marc 198, 250; *127*
Laughlin, Nicholas 265
Laycock, Ross 227
Le Carcan (Vilaire) 230; *154*
Le cherche lumière (Hélénon)
 120
Le Roi Lion (Joseph) *111*
League of Coloured Peoples 99
Lebruin, Rico 182
Léger, Fernand 79
Leigh, Simone 275
Leonard, Sean 265
Leong Pang, Amy 101
Lester, Michael 144, 146
Lévêque, Gabriel 109
Lezama Lima, José 80
LGBQT issues 224–7
Liautaud, Georges 105–6; *60*
Libro Oscuro series (Alom) 250;
 170
Lick and Lather (Antoni) 262;
 182
Lind-Ramos, Daniel 130; *81*
L'Intemporel (Malraux) 112
The Little Rascals (Borrero) 49;
 27
Lloyd, Errol 190
loas 41, 104, 105, 113, 115
Locke, Hew 55, 56; *30*
London Group 93
López, Elvis 255–6; *176*
Lora Read, Marcos 251–2, 253;
 174
Lorde, Audre 243
Los Carpinteros 247–9; *166*
Los Guajiros (Abela) 80
Los Once 162, 164–5
Lucia (film 1968) 171–2; *108*
Ludwig, Peter 245

M
Mabille, Pierre 87, 103
Machado, Gerardo 73, 79
Machine Lever Structure
 (Pellerano) *102*
Madí 164
Magloire, Stevenson 113
Magritte, René 201
Mahogany Form (Patrick) 204;
 133
mail art 199
Malone, Brent 137; *86*
Malraux, André 112
ManCrab (Minshall) 134–5; *84*

Manley, Edna 92–4, 95–7, 102, 144; *49, 50*
Manley, Michael 150, 180, 181
Manley, Norman 93
Mano Poderosa, La 42–3; *20*
Manuel García, Victor 70, 74–6; *37*
maps 13–14, 198
María María (Lind-Ramos) 130; *81*
Marín, Muñoz 160
Market Women (Manley) 93
markets 93, 147, 148–9; *94, 97*
Marley, Bob 123, 154, 230
Maroons 30, 189, 254–5
Marriott, Alvin 94–5; *51*
Mars, Tessa 117, 274; *192*
Martí and the Star (Martínez) 173
Martí, José 49, 73, 129, 173, 245
Martín Fierro journal 159
Martínez, Juan A. 73
Martínez Pedro, Luis 162, 165; *103*
Martínez, Raúl 165, 171, 172, 173–5, 183, 239; *108, 110*
Martinique 45, 46, 59–60, 198, 229
Martorell, Antonio 168, 236–7; *106, 160*
masquerades 17–18, 43, 131–9, 161
Maurin, Nicolas Eustache *18*
Max Díaz, Lope 167; *105*
McKay, Claude 72, 270
McQueen, Steve 275
McShine, Kynaston 159
Memory of the Colonial Past (de la Nuez) *76*
Mendieta, Ana 128, 133, 190, 204–6, 209, 239, 249; *134, 135*
Mendive, Manuel 127–8; *77*
Menocal, Armando 48
Merengue (Colson) 89; *46*
Metamorphosis (Acosta León) *143*
Mexico 70–1, 89, 245
Mialhe, Frédéric 44
migration 20, 38, 54, 89–90, 139, 158, 162, 185–6, 235, 259, 274
Milligan, Robert 54
Minaya, Joiri 66
Minimalism 166
Minshall, Peter 133–5; *84*

modernism 11, 72–3, 87, 88–9, 92–3, 145, 156, 164–5, 173, 197
Moiwana monument (Pinas) 254
Montañez Ortiz, Raphael 186
monuments
 colonial art 33, 60–3
 Columbus 56, 63–5; *33*
 emancipation 66–9
 iconoclasm 53–60, 62; *29*
 Moiwana 254
Moody, Harold 99
Moody, Ronald 97, 190; *55*
Moore, Philip 125–6; *75*
Morales, Eduardo 48
Morel, Yoryi 89
Morrison, Keith 235–6, 239; *159*
Morrison, Petrona 228–30, 250; *152*
Mosquera, Gerardo 243
Mother and Child (Watson) 212; *139*
Mother Sallys from Crop Over (Boyce) *183*
Munch, Edvard 79
Munroe, Kishan 270–4; *191*
muralism 71, 89, 97, 107–10, 114, 144; *67*
My Comrade (Eiriz) 216
My Friend Said I Was Too White (Davis) *158*
My Homage to Ché (Esson) 245; *164*

N
Naipaul, V. S. 11
Nanan, Wendy 130–1; *82*
Nanny of the Maroons series (Cox) 259
The Narrative of a Five Years Expedition against the Revolted Negroes of Surinam (Stedman) 37; *17*
National School of Fine Arts, Dominican Republic 89
nationalism, cultural 70–2, 87, 93, 102, 145, 159
The Nativity (Benoit) 107–9; *62*
natural disasters 198–9
naturalism 88–9
Neel, Alice 74
Négritude movement 70, 72, 83, 87

Negro Aroused (Manley) 93, 95–7, 102; *49*
A Negro hung alive by the Ribs to a Gallows (Blake) *17*
The Neighbourhood Project (Atkinson) 269; *187*
Nelson, Horatio 56; *30*
Nelson (Locke) 56–9; *30*
New Cuban Art 243–50
New Realism 22
New York diaspora 186, 226–8
New York School 159, 162
Newton, Huey 69
Night Journey (Bowling) 126
Nine Night (Pottinger) 97; *53*
Nocturne series (Brooks) 202–3; *131*
Noguchi, Isamu 9
Non-Aligned Nations movement 157
Noticias de Arte journal 162
Notting Hill Carnival 139
Now (Clarke) *119*
Nude in Front of Mirror (Báez) 213; *140*
Nueva Bandera (Sánchez) 256–7
Nuptial Dream series (Rodríguez) 151; *95*

O
obeah 101, 118
Obin, Philomé 87–8, 107, 109; *45, 62, 63, 64*
Obin, Sénèque 88
Ogou 41
Oller, Francisco 49–52, 91; *28*
Olmec Maya – Night and the Olmec (Williams) *125*
O'Neill, María de Mater 239; *161*
Only in Our Imagination series (Atkinson) 269; *187*
Op art 159, 166
Operation Bootstrap 159–60, 167–8
Organ Theft (Capellán) *172*
orishas 84
Ortiz, Fernando 17, 72, 84, 243
Ortiz, Ralph 186
Our Daily Bread (Frade) 91, 256; *47*
Outsider art 125
Oviedo, Ramón 176, 218–19; *144*
Oxford University 54

P

Paiewonsky, Raquel 266–9; *186*
Palmer, Eugene 209; *137*
Palo Monte 127, 129
PARADISE.jpg (Blue Curry)
154; *96*
Parallel Cults (Pérez Bravo) 169
Parboosingh, Karl 212
Pasaporte Portacasa (Martorell)
236–7; *160*
Patrick, Winston 203–4; *133*
Patterson, Ebony G 193–6, 270;
190
Paul, Dieuseul 110
Peace and Love (Watson) 123;
73
Peasant from Cibao (Morel) 89
Peck, Raoul 275
Peláez, Amelia 80–3, 84, 162,
172; *42*
Pellerano, Soucy de 164; *102*
Péralte, Charlemagne 87
Pérez Bravo, Marta María 249;
169
Pérez, Martín 'Tito' 189; *121*
performance art 127–8, 186,
204–5, 238, 244, 249, 259
Persaud, Bernadette 178–9,
193; *113*
Peters, DeWitt 86, 103
Phillips, Ruth 147
photography 44–5, 142, 209,
238, 249–50, 259, 264, 276
Picasso, Pablo 83–4, 89
The Pickpocket (Daley) *74*
Pierre, André 103, 113
Pierre-Louis, Prospère 110; *65*
Pike, John 144
*Pimper's Paradise – The
Terra Nova Nights Edition*
(Thomas) 270; *189*
Pinas, Marcel 254–5; *175*
Pineda Barnett, Enrique 172
Piper, Keith 262, 263–4; *184*
Pissarro, Camille 46, 49
plantations 14, 17–18, 19, 33,
38, 84, 235, 263
In a Plate of Salad (Ramírez)
253; *173*
*Pleasure Island: The Book of
Jamaica* (JacksonChapman)
144; *92*
The Poet (Clarke) 184–5
Pogolotti, Marcelo 74, 78–9; *40*
Pollard, Ingrid 209–11; *138*

Ponce de León, Fidelio 79,
215; *41*
Pop art 174, 270
Portafolio de Plenas 160–1; *98*
Portocarrero, René 80, 83, 87,
133, 162, 172, 249; *43*, *83*
Portrait of Governor Ustariz
(Campeche) 33; *13*
*Portrait of Louise de Frense
Holder* (Holder) 56
Post-Impressionism 97
Poto Mitan School 110
pottery 31
Pottinger, David 97; *53*
Pou, Miguel 91–2; *48*
Prehispanic art 27–30
Prelude (Vásquez) *171*
Price, Lucien 87, 88–9, 162
Price-Mars, Jean 86, 117
'Primitives' 87–8, 110–13, 146–7,
148, 176
primitivism 25, 73, 74, 84, 113
printmaking 160, 168–73, 213,
221
Proyecta group 167
The Puerto Rican Print (CAP)
160
Puerto Rico *see also* Vodou
abstraction 159–60, 161–2,
165–7, 173
art schools 160
Columbus 155–6
commonwealth of the US
157, 159–60
contemporary art 251
geography 14
graphic art 160–1, 168–70,
173
Hurricane Maria 130
language 17
nationalism 90–1
Oller 49
Prehispanic art 28
santos carvings 42–3; *20*
Young Lords party 186, 257

Q

The Queen Erzulie (Saint-Brice)
105; *59*

R

Ra, Omari S. 233–4; *157*
race 19–20, 184
*A Race of Dreamers: Portrait of
Ciquí* (Pou) 92; *48*

racial activism 158
radicalization 156, 158
Rae, Norman 147
Rajé series (Cox) 259; *180*
Ramírez, Belkis 251–3; *173*
Ras Akyem Ramsay 123, 232–3;
156
Rastafarianism 93, 119–20, 123,
154, 232
Rauschenberg, Robert 173
Rawlins, Richard Mark 276;
193
Reality/Representation
(Morrison) 129; *152*
*Redemption Song (Emancipation
Monument)* (Facey) 66–9; *34*
Regatta (Kcho) 247; *165*
reggae music 180
Relations (Sánchez) 129
religion *see also* Santería;
Vodou
creolization 31
Holy Trinity mural 107
iconography 251
Jamaican Revival 117–19
Palo Monte 127, 129
pantheism 84
Rastafarianism 93, 119–20,
123
sacred art 41–2, 103, 113
Taíno 27, 206
reliquary 29–30; *12*
Renaissance in Haiti (Selden) 89
Revival Goddess Dina (Kapo)
117; *69*
Rhodes, Cecil 54
Rican/Structions series
(Sánchez) 256; *177*
Rio Cobre (Robertson) *15*
The River Trinidad Carnival
134–5; *84*
Rivera, Carlos Raquel 161
*Rivoli, About the Place from
Where the Blood Flows –
Cruel Project* (Garaicoa) 167,
168
Robertson, George 35–6; *15*
Roche Rabell, Arnaldo 221; *147*
Rodman, Selden 87, 88, 107,
110, 148
Rodney, Walter 180, 242
Rodríguez, Dagoberto 247
Rodríguez, Fernando 151; *95*
Ron & Coca-Cola (Alvarez) *10*
Roncador Cay (Hydes) 203; *132*

Rosado del Valle, Julio 160, 161–2; 99
Rose, Sheena 270; *188*
Rostgaard, Alfredo 171, 173; *109*
Roy, Namba 189; *122*
Rubens, Peter Paul 77
Rude Boy style 181
Ruiz, Noemí 166

S

sacred art 41–2, 103, 113
Saint-Brice, Robert 103, 105, 110; *59*
Saint-Fleurant, Louisiane 110
St Lucia 16, 199–200
Saint-Rémy, Joseph 41
Saint-Soleil School 105, 110–13
St Thomas 46
St Vincent 30, 35
Salkey, Andrew 190
San Alejandro Academy, Havana 48, 80, 127
San Isidro Movement 266
Sánchez, Juan 256–7; *177*
Sánchez, Tomás 201, 243; *129*
Santería 9, 41, 84, 126–7, 249
santos carvings 42–3, 170; *20*
Savain, Pétion 86, 97
School of Beauty 214–15, 223
School of Havana 80, 172
Scott, Dawn 240–2; *163*
Scott, William E. 86
sculpture *see also* monuments
 cultural nationalism 92–9
 decolonization 66–9
 diaspora 262
 ferroniers 105–6, 230
 kinetic 164
 landscape art 205–9
 Maroons 189
 political art 230–2
 religion 117, 131–2
 Taíno 29
sea 192–3
Seaga, Edward 118
Sejourné, Bernard 214
Selassie, Haile 119
self-images 219–20, 235
Self Portrait as a Heel (Basquiat) *7*
Self-Portrait I (Collazo-Mattei) *150*
Self-Portrait VIII (O'Neill) *161*

Senghor, Léopold 70
Senior, Olive 196
Sicre, Juan José 74
The Siesta (Callazo) 48; *26*
Silueta series (Mendieta) 204–5
Similien, Emilcar (Simil) 214
Sirène Diamant (Liautaud) 105; *60*
Sketches of Character (Belisario) 17–18, 43, 44; *5*
slavery 14, 16, 31, 36–7, 41, 60, 230
Social Critic series (López) 255–6; *176*
Society of Independents 101
Solás, Humberto 171
Soledad Brothers 199
Sontag, Susan 173
Soto, Armando 186
Soto, Leandro 243
Soy Cuba (film 1964) 172
Spanish Civil War refugees 89–90
Spatial Multivision (Darié) 162–4; *101*
Spirit of the Carnival (Joseph) 139; *89*
Spirit (Pierre-Louis) 65
statue removal 53–4, 56, 62; *29*
Stedman, John Gabriel 37
Steiner, Christopher 147
Steppe series (Chen) 230–2; *155*
Sterile Echo (Oviedo) 218–19; *144*
Stermer, Dugald 173
Still Life (Peláez) 80–3; *42*
Stollmeyer, Hugh 101
Straw Market, Nassau, Bahamas 148–9; *94*
street art 114–15; *67*
Studio Museum, Harlem 186
Suárez, Jaime 206–9; *136*
subversiveness 18–19
sugar 36, 78–9, 84, 174–5, 198, 263, 276
The Supper (Ayón) *80*
Surinam 13, 16, 157, 254
Surrealism 83, 89, 90, 214–15, 218
Suture series (Breleur) 229–30; *153*
The Sweet Gossip series (Rose) 270; *188*

T
Tabois, Gaston 135–7, 147–8; *85*
Taíno 27, 28–30, 63, 170, 186, 206, 221; *11*, *12*
Taller Alacrán 168, 173
Taller Alma Boricua 186–9
Tejada, José Joaquin 49
Télémaque, Hervé 22; *8*
Temporal (Tufiño) 198; *98*
Ten Views in the Island of Antigua (Clarke) 36; *16*
terminology 25–6
Territorial Waters No. 14 (Martínez Pedro) 165; *103*
Theatre of Destruction (Montañez Ortiz) 186
There is a Meeting Here Tonight (Greaves) 184; *118*
Third World movement 157, 180
Thoby-Marcelin, Philippe 103
Thomas, Mary 69
Thomas, Phillip 270; *189*
Thompson, Krista 45, 142
Three Kings Weep (Patterson) 270; *190*
Tiga (Jean Claude Garoute) 110
Torres-García, Joaquín 159
Torres Llorca, Rubén 243
Torres Martinó, José 160
Totem Telurico (Suárez) *136*
tourism 24–5, 45, 60, 62, 66, 123, 140–5, 146–55, 259
tourism brochures *91*
Toussaint Louverture, François-Dominique 37–8, 39–41; *18*, *45*
Toussaint L'Ouverture in his Camp (Obin) 45
Toussaint Louverture (Maurin) *18*
Traba, Marta 161–2
Transformable Structures (Darié) 164
Trinidad
 black nationalism 158, 184–5
 Black Power 182–3
 colonial art 46
 cultural nationalism 101
 East Indian population 131–2
 independence 156
 migration and ethnic groups 16
Trinidad Art Society 101–2

Trinidad Carnival 133–5; *84*
Trujillo, Rafael 63, 89–90, 156
Tsereteli, Zurab 65–6
Tuberculosis (Ponce de León)
 79; *41*
Tufiño, Rafael 160–1, 198; *98*

U
United Federation of Taíno
 People 30, 66
United Kingdom *see* Britain
United States 38, 74, 142–3,
 156, 186
The Universal Human Experience
 series (Munroe) 270–4
Unpacking Culture (Phillips &
 Steiner) 147
Untitled (Benjamin) *149*
*"Untitled" (Billboard of an Empty
 Bed)* (Gonzalez-Torres) 227
Untitled (Chambers) 18–19; *6*
"Untitled" (Fortune Cookie Corner)
 (Gonzalez-Torres) 227
Untitled (Giudicelli) *100*
Untitled (Pérez) 189; *121*
"Untitled" (Portrait of Ross in L.A.)
 (Gonzalez-Torres) 227; *151*
urbanization 20

V
validity 12
Vanguardia 73–80
Vásquez, Víctor 251; *171*
Vejigantes (Rosado del Valle)
 161; *99*
Venegas, Haydee 33
Vermay, Jean Baptiste 48
Victoria, Bismarck 9–10; *3*
Victoria, Queen 56, 59; *31*
video 221, 263, 264, 270
Vilaire, Patrick 110, 230; *154*
Virgin Islands 69
*A Visit to the Tropical Art
 Museum* series (Garciandía)
 23–4; *9*
Vodou 26, 30, 41, 86, 87, 103–4,
 106–7, 113–14, 115, 117; *19*
Voegeli, Alfred 107, 109
von Humboldt, Alexander 36
Vorticism 92–3

W
Walcott, Derek 18, 192–3, 200
Ward, Nari 257–9; *179*
Warhol, Andy 173

Watson, Barrington 212; *139*
Watson, Osmond 123, 135; *73*
Webster, Burnett 94
Wedding at Cana (Bigaud)
 109–10
Westmacott, Richard 56
Whistler, Hector 144, 146
Whittle, Alberta 276
Wickstead, Philip 36
Williams, Aubrey 190, 196–7;
 125
Williams, Denis 126
Williams, Eric 157, 183, 242; *117*
Wilson, Fred 242
Windrush memorial 54–5
Woman with Pigeon (Jérôme)
 215; *141*
women 117, 263, 266–9
Women by the River (Gattorno)
 76, 78; *38*
Wordsworth's Heritage (Pollard)
 209–11; *138*
Woss y Gil, Celeste 89
The Wretched of the Earth
 (Fanon) 73

X
X, Malcolm 158
Xavier, Llewellyn 199–200; *128*

Y
yarn bombings 55–6
Yevtushenko, Yevgeny 172
Yo Mama's Last Supper (Cox)
 259
You Have to Dream in Blue
 (Roche Rabell) 221; *147*
Youcahuna 27
A Young Jamaican (James
 Valentine and Sons) 22
Young Lords party 186, 257
Young, William 35

Z
zemis 27, 28, 29–30; *12*
Zion Revival 117

"This kind of book at this kind of price
is what art publishing should be about"
—*New York Times Book Review*

"An extraordinarily rich and varied series"
—Linda Nochlin

The World of Art series is a comprehensive,
accessible, indispensable companion to the history
of art and its latest developments, covering themes,
artists and movements that span centuries and
the gamut of visual culture around the globe.

You may also like:

**Art and Architecture in
Mexico**
James Oles

Art in California
Jenni Sorkin

**The Art of Mesoamerica
From Olmec to Aztec**
Mary Ellen Miller

**Black Art
A Cultural History**
Richard J. Powell

Contemporary African Art
Sidney Littlefield Kasfir

**Latin American Art
Since 1900**
Edward Lucie-Smith

**Movements in Art
Since 1945**
Edward Lucie-Smith

Oceanic Art
Nicholas Thomas

World of Art

For more information about
Thames & Hudson, and the World of Art
series, visit **thamesandhudsonusa.com**